Photographing Your Baby

Tips for Taking Great Pictures

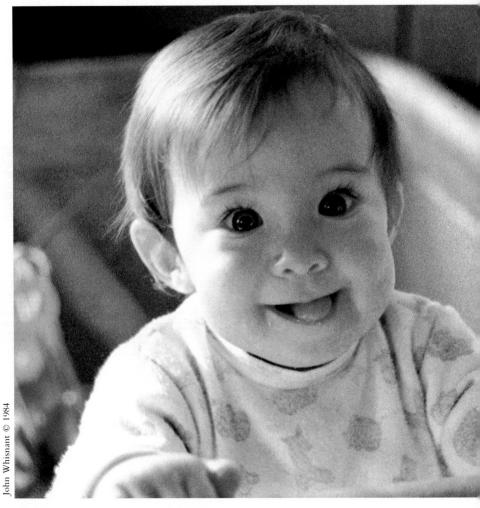

By the Editors of Eastman Kodak Company

Photographing Your Baby

Addison-Wesley Publishing Company

Reading, Massachusetts Menlo Park, California Wokingham, England Amsterdam Don Mills, Ontario Sydney Singapore Mexico City Tokyo Santiago San Juan Bogotá Copyright © 1984 by Eastman Kodak Company and Addison-Wesley Publishing Company

All rights reserved. No part of this publication may be reproduced, stored in a retrieval system, or transmitted, in any form or by any means, electronic, mechanical, photocopying, recording, or otherwise, without the prior written permission of the publisher. Printed in the United States of America. Published simultaneously in Canada.

Cover photograph: © Sam Campanaro and Martin Czamanske/Eastman Kodak Company

Kodak, Kodacolor, Kodachrome, Ektachrome, Plus-X, Tri-X, Panatomic-X, VR, and Carousel are trademarks of Eastman Kodak Company. Where other designations appear in the book for which the publishers are aware of a trademark claim, the designations have been printed with initial capital letters — for example, Plexiglas.

The color separations and camera work for the text were supplied by International Colour Services, Inc., of Rochester, New York; for the cover, by Color Response, Inc., of Charlotte, North Carolina.

W. A. Krueger Company of New Berlin, Wisconsin, printed and bound the book on 70-pound Warrenflo stock from Lindenmeyr Paper Company.

The text was set in Bembo by DEKR Corporation of Woburn, Massachusetts.

Library of Congress Cataloging in Publications Data

Main entry under title:

Photographing your baby.

Bibliography: p. Includes index.

1. Photography of infants. I. Eastman Kodak Company. TR681.I6P49 1984 778.9'25 84–16788 ISBN 0-201-11698-7 (pbk.)

Contents

Introduction

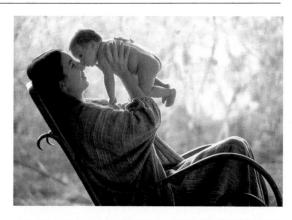

The Joy of Photographing Babies

8

Part One

Tools and Techniques	20
A Primer on Photo Terms	22
Cameras	26
Lenses	30
Film	34
Outdoor Lighting	38
Indoor Lighting	42

Flash	44
Point of View	46
Composition	48
Timing	52
Professionally Speaking	54

Part Two

Photographing Your Baby	58
Pregnancy	60
In the Hospital	62
Caring for Your Baby	68
Getting to Know Your Baby	70
Becoming a Mother	74
Becoming a Father	76
Becoming a Family	78
Grandparents	82
Special Occasions	84
Milestones	86

Playmates	88
An Emerging Personality	94
A Baby's World: Indoors	102
A Baby's World: Outdoors	110
Portraits	118
Close-ups	122
Beyond the Snapshot	126

Part Three

Enjoying Your Photographs	132
Announcements	134
Albums	136
Framing and Enlargements	138
Glossary	140
Bibliography	141
Index	142

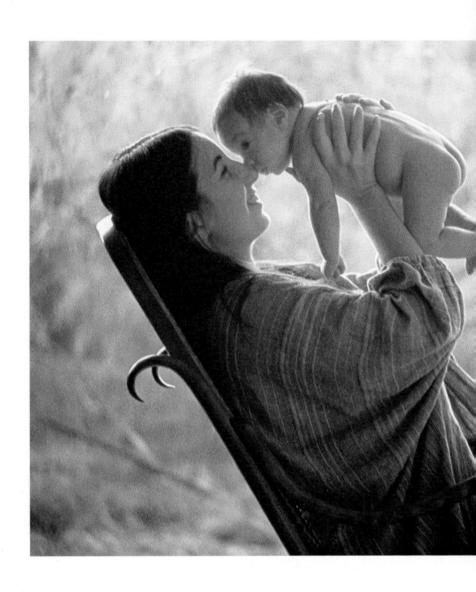

Introduction

The Joy of Photographing Babies

The Joy of Photographing Babies

t should come as no surprise that few photographic subjects rival babies, either in popularity or in the sheer volume of pictures taken each year. Who can resist the toothless grin of an infant or the peaceful bliss of a mother embracing her child? Today's parents, whether armed with easy-to-use instant cameras or elaborate 35 mm gear, waste little time before they start snapping images of their newest born. And little wonder — infancy is

Often good photographs are made by concentrating on a small part of the scene. By excluding the father's head and showing only his hand holding a sleeping baby, the photographer has revealed the contentment and security a child feels with his father.

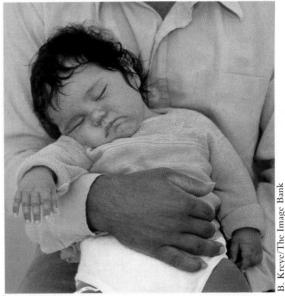

life's most fleeting period, a time when a new mind and body develop rapidly and dramatically. Photographs can provide a chronicle of your child's early life as well as a precious stock of memories.

Even in the early days of photography, the family portrait was a popular motif. Capturing the family in all its joys and sorrows, its rituals and holidays as well as its day-by-day life, is still the primary joy of the photographer. Although each family member is significant,

Don Maggio

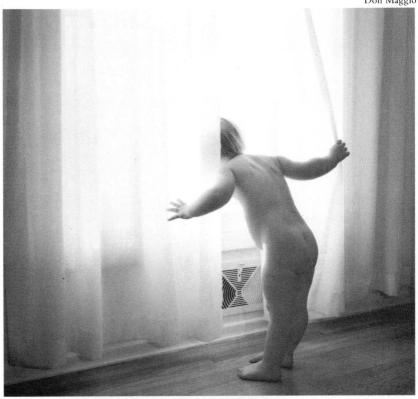

John Whisnant © 1984

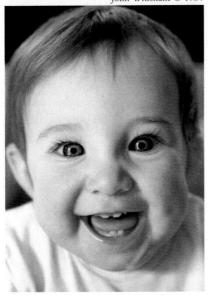

This image tells as much about the baby as a close-up portrait because it describes his innocent curiosity by capturing his characteristic movements and stance.

Chances are the dimple will remain in this baby's cheek, but the face will never be quite the same.
The photograph will kindle the memory for years to come.

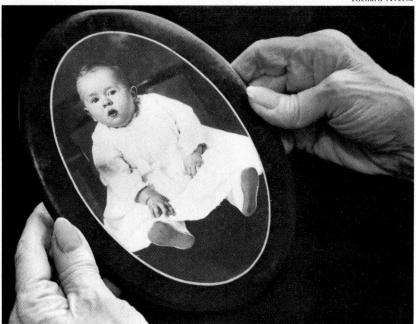

For well over a century, baby pictures have been among the most popular and well preserved of all photographs. Their appeal is ageless.

there is little doubt that it is the arrival of a new family member that most inspires the photographer.

Yet photographing your baby is more than just keeping a visual ledger; it is also a highly gratifying way to spend time with your child. Discovering your baby through the lens can be both refreshing and rewarding.

Baby pictures have a way of being all things to all people. How many distant loved ones have thrilled to the arrival of a packet of pictures as if it were a visit from parents and baby themselves? Or what of the awe of the father and mother who have been with their baby every day and yet are reminded, through photographs, of all the little details so swiftly forgotten? Photographs are also the perfect tool for determining which family member your baby resembles — a favorite pastime for new parents. Studying your baby's personality, features, and

N. Jay Jaffee

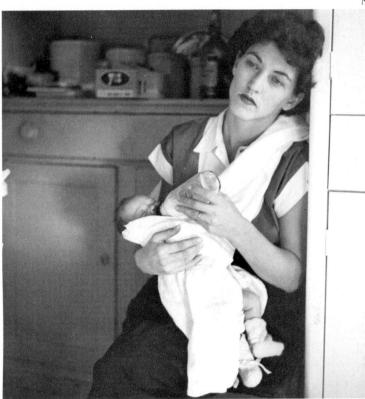

The timeless exhaustion of motherhood is gracefully expressed in this classic photograph, taken with a $2\frac{1}{4} \times 2\frac{1}{4}$ Rolleiflex camera, circa 1953.

N. Jay Jaffee

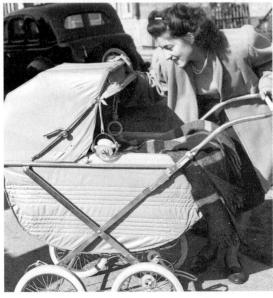

Although the baby's presence here is implied rather than revealed, this charming photo reflects the wonder parents feel upon the arrival of a new family member.

Niki Mareschal/The Image Bank

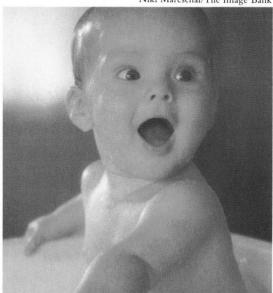

Moments of pleasure or surprise make perfect photographic subjects. Each picture tells a story about a new experience. Babies and bath time are usually a sure-fire combination for delightfully memorable photos.

Anne Lennox

As it has since the early days of photography, the formal portrait seems to transcend time while underscoring a youngster's individuality. This boy's solemn expression reveals an intriguing mixture of vulnerability and selfconfidence.

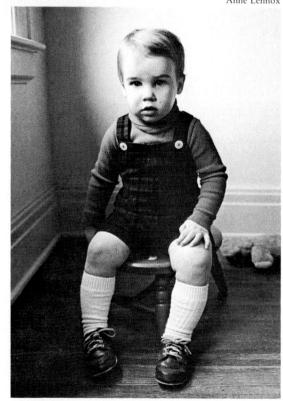

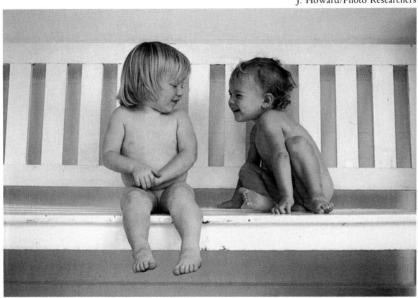

expressions helps underscore a sense of family history. Quite literally, pictures capture the times of our lives.

Baby pictures are also the major visual link children and adults have to their own early years; no one scrutinizes baby pictures like the subject himself, some years hence. The images of a baby's early years are sure to include those of the mother and father as they grow into their new roles as parents. Grandparents and other relatives, as well as friends, are also important players in the evolving drama. Many of us have fond memories of poring over our baby albums, or of discovering a new perspective on our parents or grandparents through old photographs. However your own link with your past has been forged, you'll want to make your child's photo album an equally cherished treasure.

As evidenced here, babies are unmatched in their candor before the lens. The enthusiasm of these two friends, highlighted by the uncluttered background, conveys a carefree summertime mood that is a metaphor for the innocence and joy of childhood.

You may find that your pace in picture-taking slows considerably by your child's first birthday. However, you may also find as your infant becomes a toddler — walking, talking, interacting with others and his environment — that there are new challenges for creating memorable photos. To keep your images fresh, try experimenting with different locations and techniques.

You may think that to be a successful photographer you need the mind

Sometimes making the ideal picture means being in the right place at the right time.

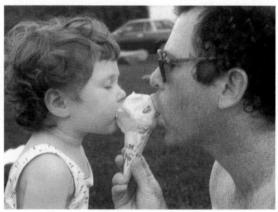

ısan Dangel

of a computer, an eye that never blinks, and the leisure time of a crowned prince. Not so. Thanks to today's easy-to-use cameras, photography is still an art for everyone. With a little luck, even a beginner can create a masterpiece at a finger's touch.

To take good snapshots, it helps to have a sense of the unexpected. You merely need to frame your image and release the shutter — no posing, pondering, or technical trickery required.

If you tend to be a careful, contemplative photographer, whatever your equipment, snapping a few random photos of your baby every week can help develop your spontaneity, timing, and framing skills. You can be more casual in

Doe Coover

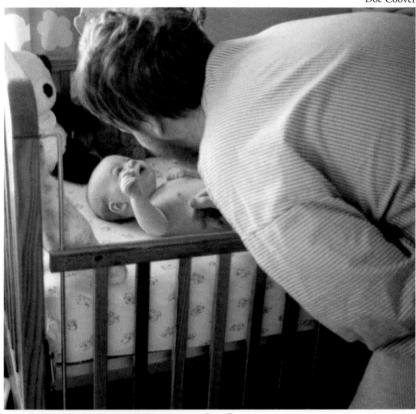

Sam Campanaro

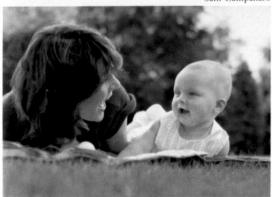

The photographer's decision to lower the camera to ground level enlivens this photo, as mother and child share a moment of animated conversation.

This snapshot effectively captures an early morning greeting between father and son, as the light from the window illuminates the baby's face.

The frilly white background, yellow suit, and quintessential yawn all combine to make a memorable image of babyhood.

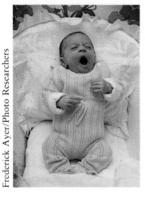

Black-and-white film can also be used for a dreamy effect, as illustrated in this beautiful photograph taken by Neal Rantoul a few hours after his daughter's birth. A skylight filter coated with a thin layer of rubber cement was used effectively to soften and diffuse the image.

selecting settings than for your more crafted pictures. The moment your child enters a room, or at any large gathering where you won't want to be encumbered by many gadgets, a simple camera and the ease of snapshots will enable you to capture the moment.

Many people have discovered that staying relaxed while photographing babies can become a problem. Juggling the considerations of lighting, composition, and camera while trying to control a wiggling infant or mischievous toddler can create understandable tension. So, too, can waiting for the "perfect" pose. Your baby may be beaming one moment and wailing the next; just as you're ready to release the shutter, your toddler may decide there's something more interesting in the next room.

The best way to avoid the jitters is to let your baby be your guide. The warmth and freshness arising from unrehearsed pictures are often more pleasing than the thoroughness of carefully posed photos. Though you need to take time to study the components of your image and select a visual perspective from which to frame the scene, don't lose sight of your primary subject. Be prepared to take several pictures each time, and try to keep your patience and sense of humor.

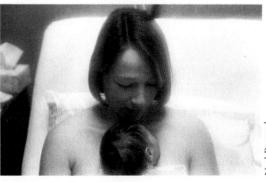

eal Rantoul

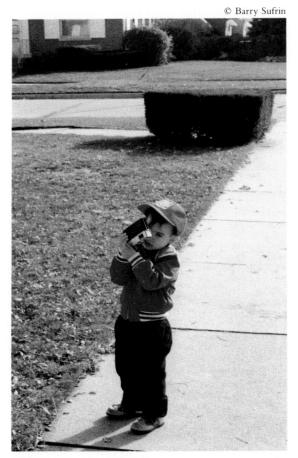

Don't forget to relax and enjoy your role as baby photographer. . . . Before you know it, your little baby will be peering down the lens at you.

Don't worry if your baby isn't smiling in every picture. Yawns and even a sob or two are also precious. A pensive mood can illuminate your child's personality as much as a joyous one.

Most important, however, is having fun behind the camera — because before you know it, your little baby will be peering down the lens at *you*.

Part One

Tools and Techniques

A Primer on Photo Terms

Although this book isn't crammed with technical terms, a few occur often enough that you should become familiar with their meanings.

Exposure is the amount of light that reaches the film inside the camera. Although some films may require more light than others to make a picture, each particular film requires a specific amount of light. If the film receives too little light, it is underexposed and the picture appears too dark. If the film receives too much light, it is overexposed and the picture appears too light. If you have a 110, disc. instant, or autofocus 35 mm camera, vou probably have no control over exposure because it is usually set solely by the camera. With 35 mm single-lens reflex (SLR) cameras and some non-SLR cameras, however, vou generally can control the exposure if you so desire. (See pages 26-29 for more about cameras.)

Accurate exposure is most important when you use slide films because the film in the camera becomes the final picture. If the exposure is wrong, the slide shows it. Accurate exposure is not so critical

Overexposed

Correctly exposed

This exposure series was made on slide film. Only the correctly exposed picture yields tones that appear just right — neither too light nor too dark. If the same series were done on print (negative) film, all the pictures would appear to be correct because print film is more tolerant of exposure errors.

Underexposed

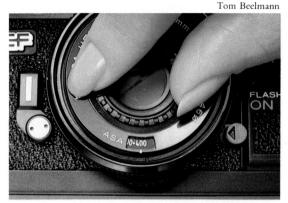

The first step toward obtaining correct exposure with 35 mm cameras is to set the film's speed on the camera's film-speed dial. Film speed is indicated by an ISO (ASA) number on the film box and film magazine.

when you use negative films, because the film in the camera becomes the negative, an intermediate stage. If the exposure is slightly off, the negative can be manipulated when the print is made to compensate. In any case, exposing film accurately is always recommended.

Since lighting may vary from a brilliant sunny day to dim twilight, the camera has controls that you or it sets in order to deliver the correct amount of light to the film. These controls are the lens diaphragm and the shutter. The lens diaphragm can set an adjustable opening, the aperture, from large to small to regulate the incoming light. The shutter, a moving curtain or set of blades, is like a door that opens and shuts to determine how long the light coming through the aperture strikes the film. A light meter built into the camera measures the

brightness of light in the scene and indicates which combinations of aperture and shutter speed will result in the amount of light required by the film.

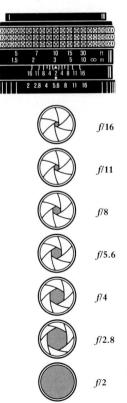

On adjustable 35 mm cameras, setting the aperture ring determines the aperture size. Each larger f-number means that the aperture lets in half the amount of light of the lower f-number. Changing from one f-number to the next changes the exposure by 1 stop. Similarly, changing from one marked shutter speed to another also changes the exposure by 1 stop.

Although regulating exposure is an important function of the aperture and shutter, each has another function that can also be important. But first you must find out if you can set the aperture or shutter speed on your camera. Even if you have an automatic 35 mm SLR camera, you may have the option of taking the camera out of its automatic mode (or overriding it) so that you can choose the aperture and/or the shutter speed; refer to your camera manual.

The size of the aperture affects depth of field. Depth of field refers to the foregroundto-background area within the picture that appears in focus. A wide aperture (f/1.8 or f/2) gives comparatively little depth of field. For example, if you were to focus on a baby 5 feet away with a normal camera lens set at an aperture of f/1.8, the depth of field would be only 3 inches. But if you used a small aperture, f/16, the depth of field would be over 2 feet. Using a small ap-

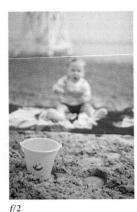

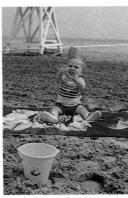

f/8

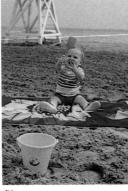

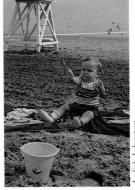

f/16

Depth of field increases as larger f-numbers (smaller apertures) are used. The camera was focused on the bucket for each picture. At f/2 only the bucket appears in focus. At f/8 the baby appears sharp but the lifeguard chair is still blurred. At f/16 everything from foreground to background appears sharp.

Don Buck

erture (large f-number) is important when you want both foreground and background to appear sharp. On 35 mm cameras, the depth of field for a given aperture is indicated by a depth-of-field and distance scale on the lens.

Shutter speed is important when you are taking pictures of moving subjects. The marked shutter speeds are 1, 1/2, 1/4, 1/8, 1/15, 1/30, 1/60, 1/125, 1/250, 1/500, and 1/1000 second. A fast shutter speed, such as 1/500 second, gives a sharp picture of most moving subjects. A slower shutter speed, such as 1/60 second, may blur a moving subject. Generally, you will probably prefer to show your baby in sharp focus, but sometimes a blurred subject strongly conveys the feeling of motion.

When photographing a baby on the go, use a fast shutter speed (1/250 second or faster) to freeze motion or a slower shutter speed if you want the subject to be blurred. These photographs show the difference in results between shutter speeds of 1/30 second (left) and 1/500 second.

Cameras

So that you will be prepared to capture your baby's changing expressions without missing the "decisive moment," get to know your camera before your baby arrives. This photographer's instinctive knowledge of his equipment helped him snap his baby's characteristic smile. Choosing a camera is a very personal decision. You should feel comfortable and confident about using all of your photographic equipment when you begin a project as important as photographing your baby. After carefully reading the manual that comes with your camera, practice is the best way to ensure that you know all the functions of your camera, so start using it early on. If you plan to use a new camera to photograph your baby, be sure to begin taking pictures during pregnancy to build up

an instinctive knowledge of your camera's — and your own — capabilities.

Cameras are available in a variety of sizes and styles, and while many parents today seem to prefer the 35 mm camera (see pages 28–29), there are also several simpler cameras that can effectively do the job of chronicling your baby's first months.

Hand-held automatic cameras offer mobility and allow you to take spontaneous pictures from just about any angle you choose. Disc and 110 cameras are

Barry Sufrin

Don Buck

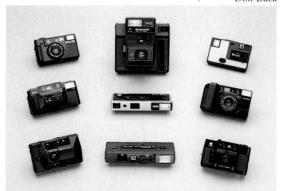

A variety of simple cameras is available. Many are fully automatic and have built-in flash, leaving you with no task other than releasing the shutter.

convenient and easy to use. The film is housed in a plastic disc or cartridge that slips into place easily, so there is no chance of loading your film incorrectly.

With many disc cameras, once the film is loaded, your only task is to take the picture; some will even turn on the flash when required. With most 110 and disc cameras, no focusing is required because the lens focus is preset at the factory. A picture taken from roughly 4 feet or farther away will be sharp. Many disc and 110 cameras also have a built-in telephoto or close-up lens. Few of the 110, disc, or other simple cameras have interchangeable lenses, however — a drawback for the more creative photographer.

Instant-picture cameras, another alternative, have many of the same features as disc and 110 cameras, but they deliver a final print shortly after you've ex-

posed the film. Many people enjoy using instant cameras at parties or family get-togethers because everyone can view the results at the same time.

Autofocus 35 mm cameras should also be considered. These cameras offer much more than just automatic focusing. Easy to use, most of them also give you automatic film advance, automatic exposure, and built-in flash, and one model even talks to you. They are compact in size, and their 35 mm format means that you can choose from the many 35 mm films available. Although a few manufacturers offer accessory lenses that can be attached to the front of the camera lens, compact autofocus cameras generally do not accept interchangeable lenses, thus limiting your ability to experiment with aperture settings to vary depth of field, or change shutter speeds.

If compactness is your main concern, you may prefer a 35 mm rangefinder camera. Even smaller than autofocus cameras, many nonetheless offer full or partial exposure automation. Some have built-in flash while others require an add-on flash unit. The photographer manually focuses the rangefinder camera by turning the lens until two images seen in the viewfinder merge and overlap. Many serious baby watchers choose the 35 mm single-lens

reflex camera. It's idealfor parents who enjoy the challenge of experimenting with various techniques and different lenses. Today's 35 mm cameras are highly automated, and many feature a fully automated exposure capability that determines aperture and shutter speed. All you have to do is focus.

A simple SLR camera with manually operated exposure is slightly harder to use because it requires that you set the exposure. A needle or blinking light tells you

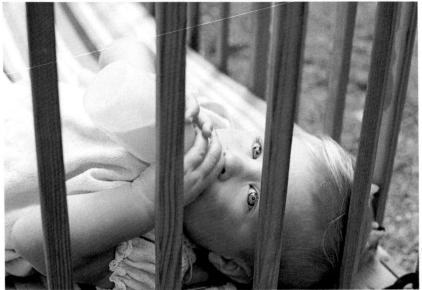

Thris Pull

Most SLR cameras let you experiment with aperture settings to vary depth of field and thus emphasize foreground or background (or both). This photographer used the slats of a playpen for a unique approach to this close-up.

The 35 mm SLR camera is a popular choice for the creative baby photographer. Many models are available, and most have automatic settings that allow you to concentrate on picture-taking. An advantage is their ability to accommodate interchangeable lenses.

when your selected combination of shutter speed and aperture is right. Semiautomatic exposure systems with aperture-priority exposure are also available. On these cameras, you set the aperture and the camera determines the proper shutter speed. If you choose a small aperture, be sure that the camera does not select a shutter speed that is too slow, causing an active baby to appear blurred. A shutter-priority system works in the opposite way, though with this method the camera may choose a large aperture, limiting the depth of field and blurring one of two widely separated subjects.

Depending on the camera, other forms of exposure automation are also available. However, if a camera offers several modes of exposure automation, instead of benefiting from creative freedom you may miss great photographic opportunities while you try to decide which exposure option to choose. You don't need the most advanced and sophisticated camera to take good pictures; you just need a reliable one.

Lenses

One of the advantages of 35 mm SLR cameras is their capacity for accommodating various lenses. There are three main categories of lenses, and their ranges are described in millimeters. They are wideangle (18 to 35 mm), normal (40 to 55 mm), and telephoto (85 to 300 mm). The normal lens, standard equipment on cameras, suffices for most situations. Compared to a normal lens, a wide-angle lens shrinks a subject in size and includes more of the surroundings. A telephoto lens magnifies a subject and includes fewer surroundings. As you become more interested in photography, you may want the versatility of additional lenses.

Each situation will determine the lens you prefer, so before you begin taking pictures, consider whether your baby will be photographed indoors or out, whether you want close-ups or pictures that reveal your baby's environment, and whether you prefer candid images or more

The use of focus for emphasis is a technique that is easily achieved by using a telephoto lens at a wide aperture. Zooming in on a particular portion of your baby's anatomy is a good way to vary your images and test your creative skills.

Robert Clemens

Lenses are available in a wide range of sizes and types. Shown here are a 28 mm lens (left), a 35 to 105 mm zoom lens (back), a 135 mm lens (right), and a 50 mm lens (front).

posed pictures of your baby. Many professional photographers carry more than one camera at a time with a different-size lens on each. You might consider this if you have several cameras.

When you're photographing outdoors, the added magnification of a 135 mm or 200 mm telephoto lens will let you catch a roving child on film without having to run after her. Once your baby makes the transition from crawling to walking, this feature will be a boon to your photographic efforts.

For portraits, an 85 mm to 135 mm telephoto lens is usually best. Some photographers prefer a 105 mm lens because it allows you to keep your distance while taking candids and is not so long and cumbersome that it hampers your ability to move about freely. Be

sure to focus accurately with longer lenses because of their limited depth of field, and use a fast shutter speed — 1/125 second at least — to avoid blurred pictures caused by camera shake.

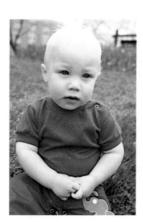

With a 35 mm lens used close up, this baby's face appears broader and slightly distorted.

John Menihan

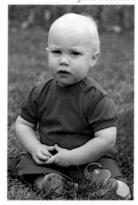

A 105 mm lens creates a more accurate portrait and renders features true to life.

If you want to include more of your child's surroundings or if you are in a cramped setting (in a favorite cozy corner, for instance) where it may be difficult to back up. you will benefit from a wide-angle lens. With a wide-angle lens, you can more easily keep near and far elements in focus, especially when vou use a medium or

A zoom lens is helpful for taking candid shots of babies. It has a continuously variable range of focal lengths, so one zoom lens can be used as an alternative to two or more fixedfocal-length lenses. Two of the more popular zooms are the 80 to 200 mm and the 35 to 105 mm, because they cover such a broad range of focal lengths.

This series of photos illustrates how a zoom lens can replace several lenses of different focal lengths. While standing in one spot, the photographer used a 35 to 105 mm zoom lens at 35 mm (left), 70 mm (center), and 105 mm (right).

small aperture. A 28 mm or 35 mm wideangle lens is best because either one is easy to handle; wide-angle lenses of shorter focal lengths, like the 18, 21, or 24 mm lenses, require a good deal of expertise in handling to avoid distortion. Although a wide-angle lens will more easily keep near and far elements in focus, you must be careful to minimize distortion. Remember to keep your subject away from the edge of the frame and out of the extreme foreground.

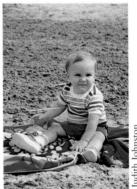

With a zoom lens you can easily change focal lengths, photographing your baby in her surroundings at one moment and coming in for a close-up portrait in the next. Once your baby learns how to crawl, which usually takes place at about six or seven months, you'll find that she is constantly exploring; at this time a zoom lens may become an important part of your gear. Older babies may be distracted by your presence as well as by your movements: in that case the zoom lens will en-

© 1984 Paul Souza

able you to photograph without intruding or making yourself conspicuous.

To create a sentimental. soft-focus effect in your images, you might try placing a special soft-focus filter over your lens. Or you can improvise with a piece of tightly woven material such as a stocking. You can also experiment with mood by throwing the image out of focus in the camera. Or, if you are adept at developing your own pictures, try throwing the image out of focus

in the enlarger.

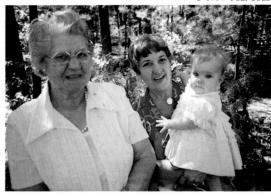

This photograph of greatgrandmother, grandmother, and child was taken with a 24 mm wide-angle lens, which allowed the photographer to reveal the sundappled background.

With a normal lens, the baby's face and blanket are distinctly outlined.

With a soft-focus filter on the lens, a gentle haze softens the baby's face and blanket, creating a nostalgic, pictorial image. Though the baby's features are clearly discernible, the overall effect is dreamlike.

Film

Film comes in three

types: color print film, color slide film, and

black-and-white film.

Although 35 mm camera users can choose from a wide variety of each film type, users of smaller-format cameras have considerably fewer choices. For instance, only color print film is made for disc cameras. By far, the most popular type of film is color print film, which yields a negative used to make postcard-size prints (or enlargements). Color print film is popular because it's easy to use, and because most people prefer to have prints they can pass around or mount in albums. Color print film is also more forgiving of ex-

posure errors than slide

film. Even when the

exposure is a bit off, you'll get good prints. Kodacolor VR 200 and, Kodacolor VR 400 are two versatile color print films. They let you work easily in bright or dim light, give sharp results, and are available for different-format cameras.

When photographing mainly in dim light, you will need a fast film, such as Kodacolor VR 1000 or VR 400. These films are specially color-balanced to produce acceptable colors without filters when used with common household lighting. The use of a blue 80A filter will provide even better color results in tungsten lighting.

Slide film produces a transparent picture that is normally used with a

When using color film in a 35 mm camera, you can use either print film (top), whose final result is a print, or slide film, whose final result is a slide.

Even in dim household lighting, high-speed film (in this case Kodacolor VR 1000) enables you to take photos without using a flash — a boon since the sudden illumination of flash may be distracting to your newborn.

projector or hand-held viewer. With an additional step, slide film can be used to make prints; conversely, the negative from color print film can be used to make color slides (or black-and-white prints). The widest variety of color slide films is available for 35 mm cameras.

Unlike color print film, slide film requires precise exposure. If exposed improperly, the image will be either too dark or too light.

Kodachrome 64 film and Kodak Ektachrome 100 film are two popular films that give fine results when used in daylight or with electronic flash. However, any daylightbalanced color slide film will give your pictures a vellowish cast when shot indoors with tungsten bulbs (regular lamp bulbs) as the primary light source. Although this color cast can be corrected with a blue 80A filter, the filter

blocks so much light that the shutter speeds are often unacceptably slow. Tungstenbalanced films such as Kodak Ektachrome 160, ISO 160, will give nor-

Usually daylight slide film should not be used with tungsten lighting, but in this case the yellow cast it creates adds to the warmth of the picture.

McBride/The Image Bank

mal coloration indoors with household lamps (not fluorescent lighting). If used outdoors without an orange 85B filter, they will lend a bluish cast to your photos. The documentary effect of black-and-white photos gives the impression of history in the making.

Some photographers like the documentary quality that black-and-white films provide. Others also prefer them because the resulting prints possess a subtle mood, sometimes stark, sometimes elegant.

If you're taking outdoor pictures of your baby, you can use a sensitive, fine-grained ISO 125 film such as

Kodak Plus-X pan film. In dim light, by using Kodak Tri-X pan film, ISO 400, the movements of an active baby can be frozen in your image. Try Kodak Panatomic-X film, ISO 32, for a portrait, especially one that you expect to blow up very large. Even when greatly enlarged, this will provide a crisp, detailed image. Plus-X film and Tri-X film are dependable, all-around films.

Once you decide upon color or blackand-white film, choose a film whose speed is appropriate for the amount of light you'll be working with. Film speed is indicated by an ISO (formerly ASA) number on the film box or cartridge. The higher the ISO number, the more sensitive the film is to light, and the less light you will need to create a clear image.

The basic film speeds are low (ISO 25 to 32), medium (ISO 64 to

In bright light you can use a low- or medium-speed film, even when photographing active babies. For a sharp rendition, use a fast shutter speed (1/250

second or faster).

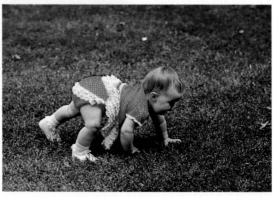

Fom McCarthy/The Image Bank

200), high (ISO 250 to 640), and very high (ISO 800 and up). An ISO 400 film needs but half the light of an ISO 200 film. Although slower-speed films generally produce sharper images than high-speed films, the difference usually isn't noticeable unless you make big enlargements. Slow films are easy to use in bright light, but faster films should be selected if you plan to work on overcast days, in dim light, or with moving subjects.

Whatever your decision, be sure that you have an adequate supply of film. Babies' moods, expressions, and activities are continually

changing from moment to moment. Once you get started, particularly when your child is in a cooperative mood, you may want to make as many as 24 or 36 exposures at a time. Be sure to keep film handy so that you'll be ready at all times. Your baby's first real smile, first tentative steps, or early attempts at creeping or rolling over may occur when you least expect it - and a curious, enthusiastic child is not about to wait to discover the world while vou run out to buy film!

John Menihan

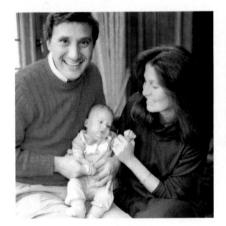

Using available natural light from a window and high-speed film, you can take indoor pictures without a flash that still possess sharpness and vibrancy. This photo was taken with Kodacolor VR 1000 film.

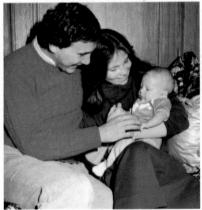

When lower-speed film is used indoors, a flash is necessary to provide sufficient light.

Outdoor Lighting

Light illuminates all we see and makes color, shape, and form visible. Light is also the rudiment of all photography, for without it the medium could not exist. Most baby photographers prefer natural light because it can infuse an image with any number of moods. The secret is not the quantity of light, but its quality and effects.

When you study natural light, you'll see that direct light creates deep shadows that can give a subject a highcontrast, hard-edged look. Yet if a cloud diffuses the sunlight, the harshness melts away, the shadows disappear, and a softer vision is created. In fact, although few people think of using flash on a bright, sunny day, it can be used to soften shadows.

With subjects as impulsive and unpredictable as babies, hazy, overcast days are a treat for the photographer who wants to zero in on a subject. You can photograph from a variety of angles and be confident that the image will be pleasingly lit. Similarly, shaded areas

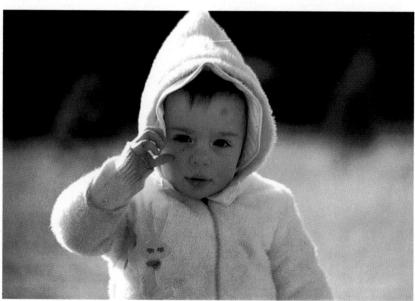

Nanette McCaffrey

Natural sunlight can create interesting shapes, high-lights, and shadows. The old adage that you should photograph only with the sun behind your back doesn't always pay off.

This child's pleasant expression would have been ruined by squinting into harsh sunlight.

Derek Doeffinger

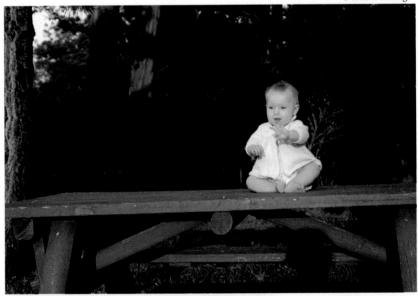

Don A. Sparks/The Image Bank

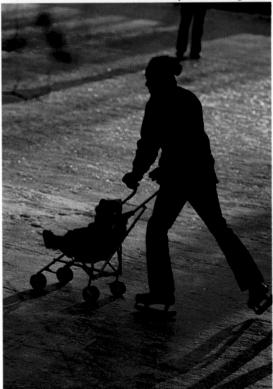

A patch of sunlight in a shaded, woodsy setting provided the perfect place to photograph this happy youngster. The empty picnic table, with the baby seated slightly off-center, adds a warm tone and an interesting linear element to the composition.

A dark winter afternoon and a crystalline surface supplied an opportunity for an interpretive picture that is all the more appealing because of the shadow patterns.

offer safe refuge from deep shadows and protect your baby's eyes from the sun's unobstructed light.

There are many ways to take pictures in direct sunlight, so don't feel bound by the old adage that says you must photograph with the sun at your back. While the sun that shines over your shoulder may produce well-lit pictures, it also streams right into your baby's eyes and makes him squint. Try to position yourself with the sun at your side, and think of ways to project light onto

some of the areas that are shrouded in shadow. To avoid giving the image an overly light-and-dark look, keep an eye out for reflecting surfaces that will cast extra light onto your image. Gravel, cement, and stone surfaces are good for this, as are sand, snow, and water. Try holding a white towel on the side of the baby, away from the sun but outside the frame, or even dress him in white clothes if you are taking close-ups. When using sidelighting, increase exposure by one *f*-stop.

This soggy sleep was photographed outdoors from directly overhead. The haphazard arrangement of toys, offset by the sense of security suggested by the thumb and blanket, makes this an evocative photo of an ordinary nap.

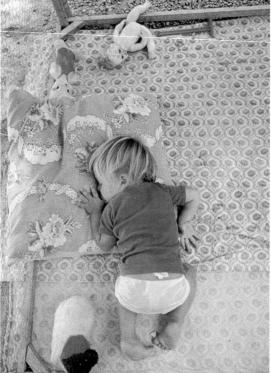

Jacques Alexandre/The Image Bank

Michael Lutch

Backlighting, which occurs when the photographer is facing the sun, is one of the most effective ways to combat the harsh effects of direct sunlight. The sun will create an attractive glow of light around the baby's hair, and the child's face will be softly lit by skylight. As a rule, increase the exposure by 1-1/2 fstops when you use backlight.

A flash can also help you achieve a more balanced picture if your subject is backlit.

Color is another important by-product of light. Even if you are photographing your baby in a monochromatic environment such as a meadow, it's important to know how the color of the grass and your baby's clothes and skin will look at different times during the day. Because the actual tint of the sun's rays changes from hour to hour, so will the look of your pictures. Sunrise and sunset provide a rosy hue, twilight adds a touch of blue, and the middle hours of the day offer a less discernible spectrum of neutral shades. Each of these colors will affect the mood of your photographs, so choose the hour of your photo session accordingly.

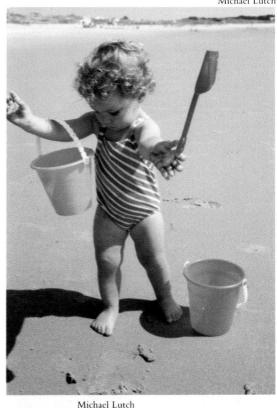

This photographer used the sand as a plain back-ground. The red, yellow, and blue playthings add visual interest, and shadows cast on the ground enhance rather than detract from the composition.

Soft outdoor lighting accents the fragile shape of this baby's arms and legs and preserves the subtle hues of the fabric. The carriage top provides a protective shadow, helping the photographer capture the baby's contented expression.

A dark background and

from a nearby window

create a quiet mood that

aptly reflects the child's

soft, subtle light streaming

Indoor Lighting

When taking pictures indoors, you can choose from three types of lighting: natural light from outside, artificial household lighting, or flash (see pages 44-45). Taking pictures with natural light indoors can be as easy as placing the subject near a window, or as tedious as waiting for bad weather to pass. As with outdoor light, indoor natural light is best when it is softest. so if your favorite window is flooded with sunshine, hang up a sheet or sheer fabric to diffuse the intensity, or move to a window out of direct sunlight.

Use reflectors and white surfaces to fill in light just as you would do outside. A large piece of white poster board is easy to work with. Always look for ways to use props, garments, furniture, or fabrics as additional reflectors to illuminate unwanted shadow areas

Because light is almost always less intense indoors, it's wise to use a lens with a large maximum aperture, preferably f/2.8 or greater. A high-speed ISO film is best. Kodacolor VR 1000 film offers excellent results in dim light, or use Kodacolor VR 400 film where light is more plentiful.

With all artificial lighting situations, color balance is a concern. Most films are balanced to give natural-looking results when used with daylight or electronic flash. If you photograph by incandescent light, you can partially correct this color imbalance by us-

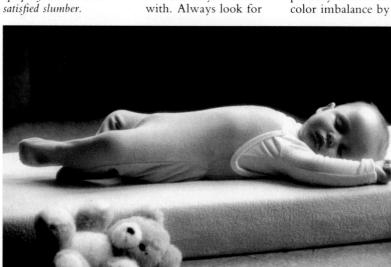

Sandra Lousada/Woodfin Camp

P W Grace/Photo Researchers

ing a high-speed color negative film such as Kodacolor VR 400 or VR 1000 film. These films will usually give acceptable results with both tungsten (regular lamp bulbs) and fluorescent lights. To correct the color fully when shooting with tungsten lights, use a blue 80A filter with a daylight-balanced film or a film balanced specifically for tungsten light. Or avoid the color balance problem altogether by using flash with your normal film.

When you photograph by available light indoors, it is most important to position the baby within range of the light without forcing her to hold still or stay in only one spot. The most popular solution is to place the baby on a bed or couch near a window (the bigger the bed or couch the better). Rooms with windows on different walls are better still, since the light is more generalized and you can shoot from several different angles. For infants and newborns, place the crib between the windows.

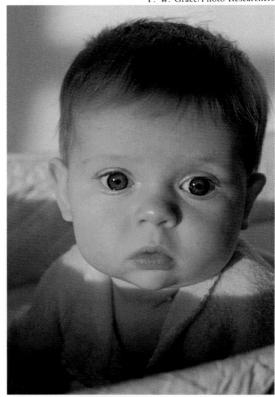

The natural shadows and areas of light highlight this baby's round face and bright eyes.

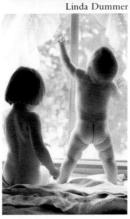

Backlit figures against a window create a pictorial effect and give a sentimental rather than a documentary view. When using backlighting, increase camera exposure 1-1/2 stops (if you have an adjustable camera) unless you want silhouetted figures.

Flash

Although the brief flare of a flash may occasionally startle your newborn or distract an older baby, a flash lets you take pictures anytime, anywhere. Its ease of use and almost guaranteed results are its strongest recommendations. Flash offers an excellent means of capturing a fleeting expression, a wave of the hand, or the newly

Chile Sullivan

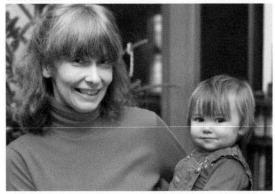

Taken with flash, this photo utilizes the matching grins of mother and daughter — as well as their similar outfits — to compose a charming photograph of holiday cheer.

learned crawl of a baby who just won't sit still.

If your camera does not have a built-in flash mechanism, you'll find that an automatic or dedicated flash works very well. A dedicated unit operates in conjunction with a specific camera, often automatically selecting the flashshutter speed when attached to the camera. In some units a sensor located in the camera behind the lens determines the proper amount of light, relays it to the flash unit, and then turns it off.

If your camera doesn't automatically select the right shutter speed to accompany the flash, be sure to adjust it properly; many cameras should be set at 1/60 second when used with a flash. In most cases you need only attach the unit to the camera or connect it with a cord, set the flash-shutter speed, and then set the film's ISO speed on the flash unit's calculator dial, which will indicate the flash power mode and lens aperture at a certain range. Because of the many varieties of cameras and flashes available, vou should refer to your camera and flash manuals to learn the appropriate procedures.

Whenever you use a flash, be sure that the batteries are fresh so that the flash will recharge quickly. You won't want to miss a sudden shift in mood. reaction, or position. In order to know when vour batteries are depleted, you might wish to attach a tiny piece of masking tape to the unit labeled with the date when they were last changed. Make sure that you wait a few seconds after the "ready" light goes on before you take your pictures. If you jump the light, the flash may not be at full power, or it may not fire at all.

Anthony A. Boccaccio

Always avoid aiming directly at a shiny surface when using a flash. Step to the side to find a better angle or your picture will contain an unwanted glare. For a softly lit image, it's best to bounce the flash by aiming the light at a white surface, such as the ceiling, a wall, or a reflector card. This will create more natural shadows and make your photographs less harsh. If you're using color film, never use a colored reflector because it will cause a tint on the subject. With blackand-white film, however, it's quite safe to use colored areas for the bounce.

Bounce flash is most easily achieved with a unit that has a movable head or with a manual flash unit. While the head points at the bounce surface, the light sensor on the flash points at the subject. If your flash doesn't have a movable head or sensor, set it on manual, or simulate a manual flash by covering the sensor with your finger. If the head and sensor are not aimed in different directions, the sensor will turn off the light when the bounce surface rather than the subject is properly lit. When bouncing your flash, work at a closer range than you would when using direct flash. Just make certain to cal-

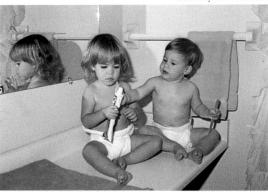

culate the proper flash-to-subject distance by determining the length the light will be traveling from the flash to the bounce surface to your baby. Then, to allow for light loss due to scattering and absorption, open the aperture 2 f-stops beyond what is indicated.

A flash enabled this photographer to make an indoor photo of two siblings exploring a mysterious adult ritual.

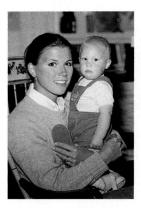

Although direct flash usually creates good pictures, a busy background here competes for attention with mother and son, distracting the eye.

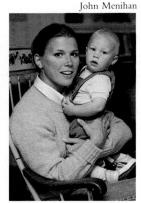

A bounced flash adds warmer tones and shadows to the background clutter. Bounced flash, however, is a tricky technique that you should practice before you use it for "one-chance" photos.

Point of View

One of the most intriguing attributes of a camera is that it can see from any angle. A camera has no "eye level"; its vision extends from whatever vantage point the photographer chooses and can capture images from perspectives many of us normally ignore.

Too many pictures of your baby, taken from a standing viewpoint, may begin to look like experiments in aerial photography. As a rule, subjects shot from a high angle look shorter and less imposing than they really are. By contrast, subjects viewed from a lower angle appear taller.

Whenever possible, try to focus on your baby at her level. If you don't want to get down on the floor, place her on a bed or sofa. Move up close and then pull back; see if you can find an angle that is lower than your baby. You will be amazed to discover how your view of the scene changes.

When experimenting with different camera angles, don't forget that you are not always obliged to photograph straight on. Try snap-

It's thanks to illustrative images like this that we begin to get an idea of how a baby sees the world.

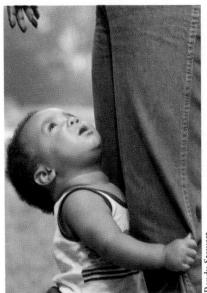

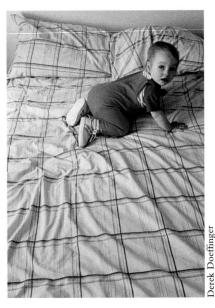

The fleeting expression on the baby's face as she turns her head, positioned on the far end of a large bed, plus the geometric patterns of the sheets enhances the sense of realism and immediacy.

Ulrike Welsch. Reprinted with permission from Faces of New England, Dublin, NH

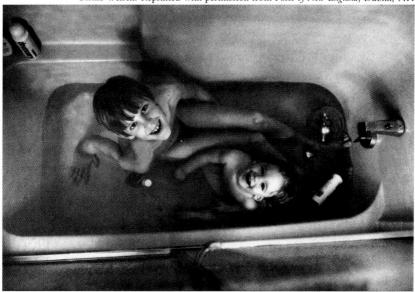

ping your baby's profile or making an image from behind. As you change position, keep an eye on the objects in the back- and foregrounds of the frame. They, too, will change in proportion. Finally, use these elements to draw attention to your primary subject. For instance, if your baby is playing with a stuffed animal, don't ignore the toy. Instead, find a camera angle that will reveal the baby's stature in proportion to the stuffed animal.

Visual distortion is an important consideration in choosing a camera angle. From certain angles, small objects like babies look larger or smaller than they really are. Photographing upward from the level of

your baby's feet will result in an image that will tend to inflate her appearance. By contrast, the familiar downward focus often makes babies — particularly newborns lying in their cribs — seem especially small. Distortion is not always undesirable. Many photographers intentionally distort their images for dramatic effect or to emphasize a certain subject or part of a subject. So if you purposely try to make your baby look a little more imposing than she really is, the resulting image may well be more engaging.

The camera can explore perspectives most people rarely imagine, much less experience. This overhead point of view offers an appealing change of pace.

Composition

The composition of a photograph — where and how objects are arranged in the frame — is one of the most important elements in making an eye-catching picture. When photographing your baby, the action and surrounding objects may be limited; good composition is thus an excellent way to ensure a lively, appealing image.

Phoebe Dunn

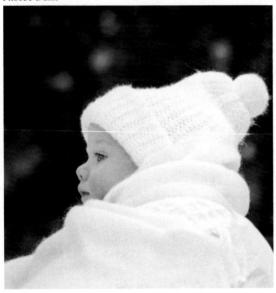

This profile composition is enhanced by the baby's lustrous outfit set against the dark background, resulting in a statuesque vision.

The critical components of composition are: where to place the primary subject in the frame, what other objects or people to include, how to use them to draw attention to the subject, and whether to frame the scene vertically or horizontally.

There is no patented formula for positioning your baby in the frame. Just remember that he is the most important component of the image, and everything else should draw attention to him. But you should not automatically assume that he ought to be in the center of each frame. For example, if your baby is crawling or walking across the room, you should suggest his movement from left to right, since that's the way our eyes move most comfortably. Because he is heading across the frame. the format should be horizontal, and you should keep him in the left-hand portion of the viewfinder so that there is plenty of room for him to move forward. This gives the image a certain dynamism as well as a sense of purpose.

It is important not to clutter your photographs with extra obiects; a busy photo is rarely strong and cohesive. Still, there may be instances when you have more than one baby, several adults, and plenty of toys on the scene. This is when you have to be careful that the background doesn't add to the confusion. Look for a simple background that tempers the image.

Always try to vary your compositions, even when you are photographing your baby in the simplest manner. A vertical frame for close-ups of

Shoshava Wick Chueck

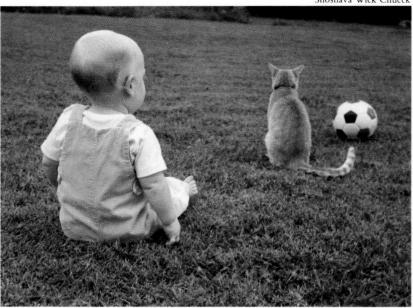

the face is often effective. Try focusing on parts of the body — hands, feet, elbows, and knees — and make them the primary subjects of your pictures. An image as simple as a baby's tiny foot emerging from beneath a blanket can be as warm and endearing as the most elaborate portrait.

When photographing outdoors, try to use elements like the sky or the terrain to lend balance and dimension to your pictures. For instance, an image framed from a low angle that shows your baby standing in front of a green bush set against a blue sky can be far more appealing than a tightly cropped head shot that doesn't indicate that the scene is outdoors.

Color should also enter into your thinking as you compose your images. Look for objects and scenes whose colors will enhance one another. Primary hues almost always do this. Familiar natural environments like the seaside, with its white beaches, blue seas, and dramatic early-morning and late-afternoon natural light, are ideal for posing a baby dressed in red or yellow, or with a ball or toys of similar shades.

Finally, don't hesitate to study the photographs of some of the masters to develop a better sense of composition. A little imitation may improve your own photographic instincts.

By arranging the baby, the cat, and the ball in a diagonal line, and then photographing them from behind, the photographer created an amusing and intriguing picture.

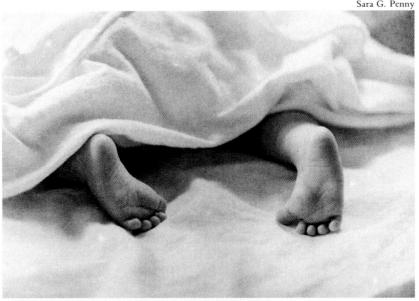

Derek Doeffinger

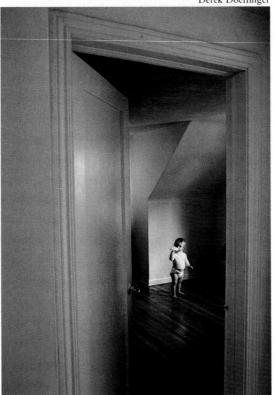

You need not always show the whole child to make a strong picture. These feet poking out from a sheet makes this a tender portrait of a sleeping baby.

From this distant perspective, the baby's diminutive stature does not detract from the image. The light on the child and the visual impact of the architectural angles and colors of the walls and floorboards bolster the effect.

Linda Benedict-Jones

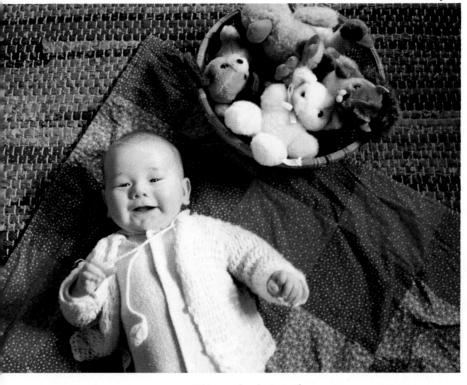

This overhead view of a smiling baby, with arms extended, invites you to lean down to pick her up. The basket of stuffed animals placed nearby adds a charming accent.

Timing

Timing — releasing the shutter at just the right moment to capture the image you want — is the wild card of photography. No amount of equipment or instruction can ensure that you'll get it right, yet no accomplished photographer can be successful without it. It is often a key factor in making an effective image.

vironment and start taking pictures, concentrating either on body poses or facial expressions. Take plenty of pictures — this may be a good time to use black-and-white film, since it's less expensive — and make notes, written or mental, about how you're doing. Remember to give every shot just an instant's lead time, re-

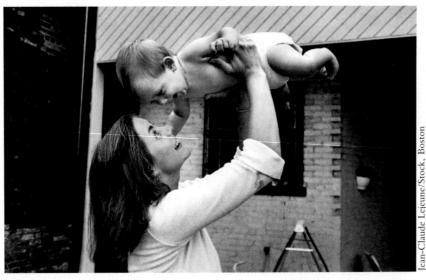

Babies invariably love to be airborne. This photographer waited until the baby was perpendicular to the mother to capture the exuberance of the moment and their shared sense of buoyant freedom. To develop your timing, study your baby's movements and expressions. Get to know what prompts your baby to smile, squint, or scowl. Always try to anticipate an action, gesture, or reaction.

Don't hesitate to put your observations to work behind the camera. Good timing comes from much practice. Place your baby in a simple, uncluttered enleasing the shutter a split second before the desired action unfolds. Later, go over your prints with your notes, trying to recall your mistakes as well as your triumphs. Trial and error are your best instructors.

Remember that your baby will undertake new ventures unexpectedly. More than one parent has been busy framing a picture of her

Georges Rosemberg/The Image Bank

baby standing when suddenly he decides to take those first few unassisted steps.

Most important of all, don't wait for your pictures to happen. Carry your camera with you and seize every opportunity to use it. No matter how adept you may be at mentally anticipating a moment, if you are not pressing the shutter you will miss the unexpected. As any master of the decisive moment will tell you, next to good luck, there is no greater asset than an eye for serendipity.

The outstretched arm of this toddler, clearly on the edge of his chair, enhances the sense that the photographer has caught him just on the verge of a new discovery.

(Above) The photographer may have waited an hour for this shot or snapped it on the spur of the moment. Either way, he had to release the shutter a split second before the figure in the background moved into position.

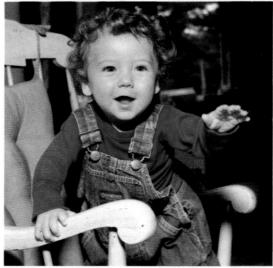

Professionally Speaking

ew photographers have worked with babies longer and with greater success than Suzanne Szasz and Phoebe Dunn. Ms.

Dunn has specialized in baby-oriented photo ad campaigns, and Ms. Szasz has concentrated her efforts on books and magazines for over thirty-five years. Each brings a unique style and technique to her work, and both agree that the key to their success has been to understand and enjoy children. As Suzanne Szasz comments, "Babies are hard to fool. They don't mince their emotions. If you can't respect them and their needs, even at the expense of their pictures, you needn't bother taking out your camera."

Ms. Szasz's credo is invisibility. "When I work, I want the baby to feel as if I'm not there. I love kids, but I'm not there to play . . . I'm there to record as a passive witness." Fascinated with child development, she has documented the growth of some subjects from infancy to motherhood and early middle age.

Ms. Szasz rarely works in a studio and avoids using electronic flash whenever possible. "It's not that I'm a purist," she says. "It's just that it's so much better when a baby is in a familiar environment with a minimum of distractions. One pop of a strobe and you may get a good picture, but from then on the baby is either frightened or looking for that strobe."

Photographer Suzanne Szasz quietly and unobtrusively pursues her subjects until, as in the case of this girl investigating the plant, she sees the pose she is seeking.

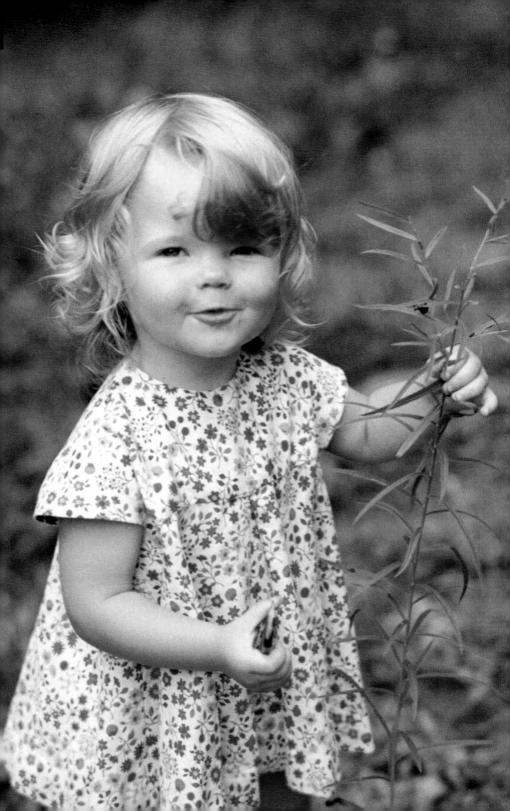

Suzanne Szasz uses only 35 mm SLR cameras and a wide variety of lenses and filters. Her artificial lighting gear consists of a handful of stand-up and clipon photo flood lights and an infrequently used strobe. Her favorite advice to the prospective photographer of babies: "Practice with cats; they are independent, not always cooperative, and *very* photogenic."

Like Suzanne Szasz, Phoebe Dunn also stresses the importance of respecting babies as photographic subjects. "Babies know instinctively who's a stranger and who's not," she notes, "and they know who knows how to hold them and who doesn't. In some subtle ways, they know when they want to be photographed and when they don't. A photographer must be able to respond to all these things."

Because she is often on assignment for large corporations, Ms. Dunn works in her Connecticut studio as well as on location. She can't always tailor her work to a baby's mood or feelings, and thus she interacts more actively with her subjects than Ms. Szasz. "I have to do a lot of planning. For example, with a baby food shot, I have to make sure the mother has taste-tested the product with the baby to avoid any unexpected grimaces."

Phoebe Dunn

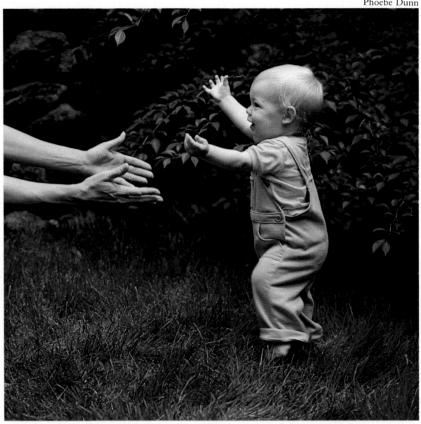

Ms. Dunn comes to every assignment armed with an array of her own time-tested techniques. She prefers not to have the baby looking directly into the camera. "Babies reveal much more about themselves when they are engaged in an activity than when they are merely staring at an object." When she does confront the age-old problem of getting a baby to look into the lens - to emphasize the eyes, for instance — she tends not to use props or other people to catch the baby's attention. "Balloons often pop, and then you've lost everything. So I like to make little noises that draw the baby's glance. Subtlety is the secret."

Phoebe Dunn kept her lens trained on the baby, while including just enough of the parent's outstretched hands, to give her image an unmistakable narrative quality.

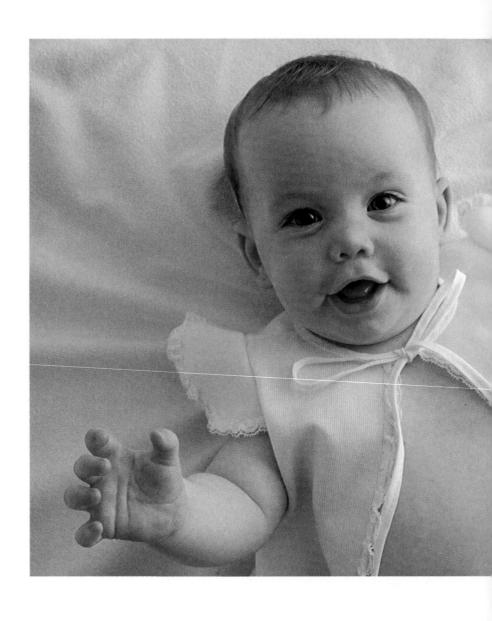

Niki Mareschal/The Image Bank

Part Two
Photographing
Your Baby

Pregnancy

regnancy is a time for planning and preparation, and taking pictures will help you remember these special activities. There will be many moments you'll cherish: picking out a crib, modeling maternity clothes, decorating the baby's room, a surprise baby shower. If the mother-to-be is taking a prenatal exercise class, there is generally enough bending and stretching to inspire some interesting images.

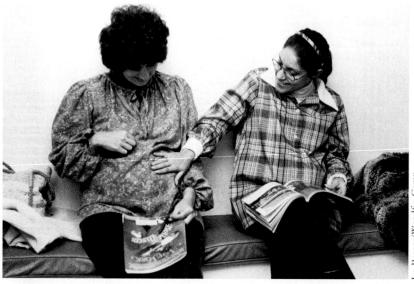

Berger/Woodfin Cam

During the months of waiting, making photographs may help you temper your impatience and anxiety. A trip to the doctor's office, shared here by two expectant mothers, is one of many moments you'll want to record.

The casual atmosphere of childbirth classes lends itself to candid photographs, including those of your classmates and instructor (always ask first if they're willing to be photographed). If you attend a reunion after the babies have been born, a photo of the infants propped up next to each other on a couch or chair — or with their irrepressibly proud parents — is well worth the infant chaos it may cause. When photographing groups of adults, try to get people of differing heights next to each other. A wide-angle lens may help if there is a large crowd.

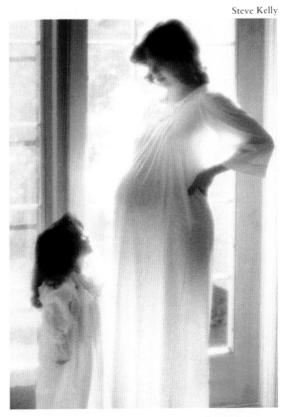

Recording your baby's growth in utero by photographing the mother's changing silhouette is a favorite pastime of many fathers. This expectant dad posed his wife and daughter against the window to take advantage of the softening qualities of shadows and light.

Don't hesitate to take plenty of pictures, since the odds are that someone will blink or stray out of the frame.

An obvious way to begin to chart your baby's growth before birth is by chronicling the expanding profile of the expectant mother. Use a plain background, such as a wall, curtain, or drawn shade, so that her form will be clearly distinguished. Try to take a photo each month to create a sequence of images.

Portraits can help capture the "special glow" that pregnancy brings, as well as the emotions it evokes: trepidation, hope, serenity. You can fill the frame, or pull back a bit to reveal more about the mood.

In the Hospital

fter nine months of waiting, nothing compares with the excitement of labor and delivery. Some couples feel that the birth

process is too private for pictures; others

want to document every second.

Most hospitals have regulations about photographic procedures and equipment. Once you've decided on the kinds of pictures you'd like to take, check with your physician or midwife regarding hospital policies on photographing in the labor, delivery, or birthing room. Whether you know in advance of a caesarean delivery or not, it's wise to ask if the father would be allowed to be present and take photos if he desires.

If possible, try to take a photo just before leaving for the hospital or in the very early stages of labor. Here the mother cheerfully offers a victory sign, aware of but undaunted by the hard work ahead.

If you have doubts about your ability to handle a camera while fulfilling your primary role as birthing coach, you might consider asking a friend, relative, or nurse to take some photos.

If the lighting permits, it's best to use a fast (ISO 1000) film and forgo the flash to avoid distracting the doctors or disturbing the newborn. If the hospital allows, you may be able to use a flash in the recovery room or maternity ward.

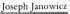

After the baby is born and has been examined by a doctor, she will be cleaned, measured, weighed, and footprinted. These historic events are good opportunities for memorable photos.

If you are taking existing-light pictures (unaided by flash), maternity ward lights may add some unwanted colors. Fluorescent lights typically add a

After a rest, the mother poses with her newborn in this eloquent portrayal of a new life.

greenish tinge to daylight film, and tungsten lights give a yellowish tinge. Although filters that attach to the camera lens can shift colors back to normal, there's an easier way to get acceptable Pictures taken with daylight-balanced film under fluorescent lighting have a greenish tinge, as seen in the picture on the left. The effect is most pronounced on slides but on print films is often slight enough to be acceptable. A fluorescent-daylight (FLD) filter, used for the picture on the right, gives normal coloration.

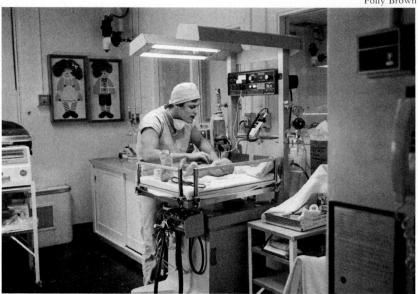

Although the photographer has stepped back to include the hospital nursery, the young father's playful yet gentle expression makes this a surprisingly intimate image. Oblivious to the bright lights and sophisticated equipment, he coos to his tiny son, cementing a strong early bond between father and child.

color. Use a high-speed color negative film, such as Kodacolor VR 400 or 1000 film. These films are partially color balanced to give acceptable results under common artificial lights. Or you can avoid the problem by using electronic flash or black-and-white film.

If you still demand the best color possible, use filters that screw onto the front of the camera lens. For daylight-balanced color film under fluorescent lighting, use an FLD (fluorescentdaylight) filter. For daylight-balanced film under tungsten lighting, use an 80A (blue) filter; be aware, though, that because of its density you may have to use a slow shutter speed. Both kinds of filters are available from most photo dealers.

Your first few days as a family will be filled with awe and discovery. Most newborns tend to sleep a lot, so don't expect your baby to be a particularly cooperative photographic subject.

Nevertheless, this is a good time to get some portraits and close-up pictures. Newborns are most easily photographed from directly above, while they are lying on a bed or bassinet. Or they can be held in a parent's arms for a different perspective. Try a three-quarter angle as well as a full-face portrait. To eliminate extraneous details, drape a blanket over them. Other images you may want to capture include father or mother holding the baby's tiny hand or foot in his or her hand; flowers or balloons sent by friends; early attempts at feeding (newborns tend to eat every three or four hours, so you'll have plenty of opportunities to try); the baby's face placed next to a parent's or sibling's to give a sense of scale.

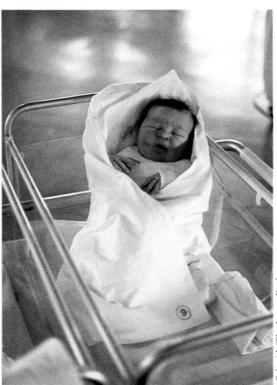

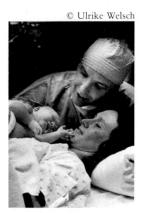

Soon after birth, mother and father meet their baby. Their intense gazes, showing a mixture of pride and hard work, direct attention to the sleeping infant. The tight composition emphasizes the new family as a unit.

As this newborn waits alone in a hospital, swad-dled in blankets and propped up in the bassinet, the tiny figure suggests the vulnerable dependence of infancy.

Schmidt/The Image Bank

By placing the mother and baby near a window, you can take advantage of the available light to create a soft, sentimental picture that reflects the cozy intimacy of the experience. Natural light filtering through a window provides soft illumination for your picture; avoid harsh sunlight. A normal lens, with a wider maximum aperture than a wide-angle or telephoto lens, lets you use faster shutter speeds so you can hand-hold the camera even in dim light.

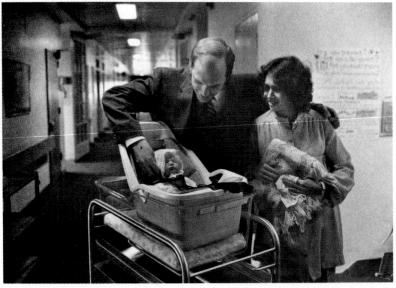

Ulrike Welsel

With fitting symbolism, this departure from the hospital is made to look like the beginning of a long journey. The father's outspread arms and both parents' attention focused on the baby prevent the picture from becoming too static.

If the hospital allows, you may also wish to take some pictures through the nursery window. Place the camera right up to the glass to minimize the reflection. If you stand back a little, check to make sure that no reflections from interior lights can be seen in the viewfinder. If there is a glare, change your position. Avoid using flash, since its light may bounce off the glass, creating a bright flare in your picture. In low lighting use a fast film (ISO 1000).

The day you leave the hospital you will experience a sense of freedom, adventure, and maybe a little fear that you'll want to capture on film. Include a house or car that, when viewed later, will reveal the season and era. If you're going home by car, be sure to take a picture of your baby's first ride in the car seat. She will look quite small, but in just a few months she'll be sitting up and observing everything.

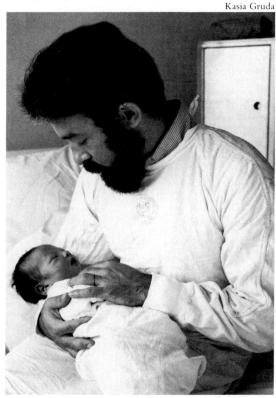

The active duties of fatherhood begin in the hospital. This photograph is nicely balanced with father and baby facing each other; their hair and the father's beard form a pleasant contrast to the white hospital environment. Robert Clemens

It's a good idea to be photographically ready in advance. You don't want to discover too late that you've brought the wrong film or too few rolls, so pack a camera bag in advance. Be sure to bring along:

 at least one 35 mm SLR or autofocus camera (loaded with film)

 extra lenses (28 mm or 35 mm wide-angle lens)

 at least five extra rolls of film, preferably 36-exposure color-negative film, including at least two rolls of ISO 1000 and one roll of slower film (ISO 200) for portraits

 FLD filter for use with fluorescent lights; or highspeed color-negative film such as Kodacolor VR 400 film

• fresh batteries

· flash unit

 disc camera and film (or backup camera)

 lens-cleaning paper and lens-cleaning fluid

hile you are immersed in learning about your baby, you may lose sight of how rapidly he is growing and how quickly

your tasks as a parent are changing.

After you've mastered swaddling and diapering — lessons worth recording on film — feeding the baby remains a favorite photographic subject. You may want to use a diffusion filter to photograph a nursing mother, to give the image a soft, painterly effect. Position

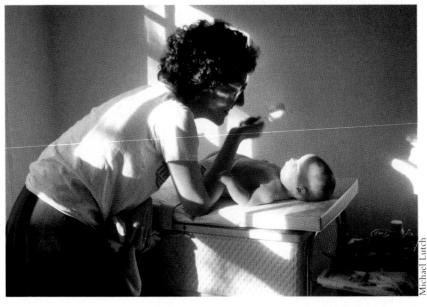

An interesting pattern of light makes this picture of affectionate play as the baby is being diapered especially effective.

yourself at an angle and keep the composition tight. Pay attention to intimate, personal details: the baby's tiny clenched fist, his beatific smile when the meal is over, the curve of the mother's neck.

When your baby begins eating cereal and other solids, new photographic vistas are opened up. Babies offer priceless reactions to new foods; it's worth planning ahead to set up the photo. However, be prepared for a messy session! Babies have an uncanny ability to

fling food everywhere, so consider using a skylight or UV filter to protect the lens. A sequence of events — getting the cereal ready, spoon to the mouth, food flying — will make a humorous and revealing series.

Bath time provides a delightful array of photographic possibilities. You'll need your spouse present, since one hand must always remain on your active bather. In a cramped space you may want to use a wide-angle lens. Because of the high level of activity, you may want to use flash, which will freeze the droplets of water along with your baby's waving hands or feet. Have your camera and flash preset, loaded with film, and protected. Mom or Dad with baby in the bathtub also makes a charming photo; the tiny baby peering over the edge of the tub contrasts nicely with the larger adult. If it's summertime, try bathing your baby outdoors in a large basin or bucket to take advantage of natural light.

Keep the camera and flash unit dry to avoid damage. Because of possible shock hazard from the flash, be especially careful not to drop the flash unit or a camera with built-in flash into the water.

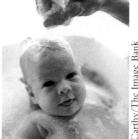

Bath time is always a favorite for babies as well as for parents. Using a vertical format, as this photographer did, may help you block out extraneous details and tightly frame your soapy child.

You won't want to miss the amazing faces that children display when they taste new foods. Mealtime offers a great opportunity for dads to pitch in and moms to pick up the camera.

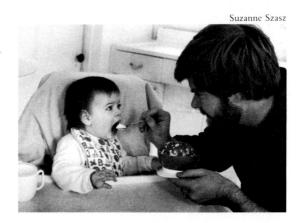

om McCarthy/The Image Ban

Getting to Know Your Baby

nlike diapering, feeding, and other more mechanical tasks, no one can teach you how to know your baby. The keys to your baby's personality are her moods, gestures, and expressions; the pictures that capture those feelings will chart the beginnings of a lifetime of emotional interplay. To get the best pictures, observe your baby carefully. Fortunately, this comes naturally to most parents. Engage your baby in play and watch how she reacts. Try to learn the difference between a frown and a scowl, a smile of contentment and one of humor. As you better understand the cause-and-effect re-

The special bond between father and daughter begins the moment they meet. This father expresses his love and concern in the gentle, caring way he cradles his daughter and in his tender gaze.

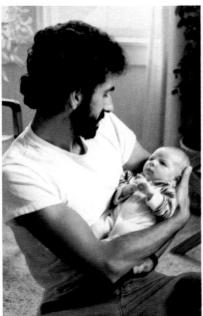

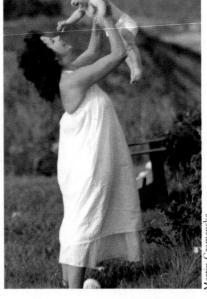

Parents take great joy in lifting their babies up into the air to gaze at them. Photographing your spouse as he or she plays with your baby will help you get to know both baby and partner better.

lav laffe

Simon Cherpitel/Magnum Photos

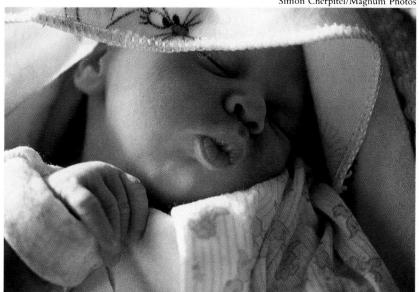

lationship between your baby's environment and her emotions, you will be able to anticipate her expressions.

Babies will usually lean toward things that please them. A finger placed in the mouth or on the chin usually denotes curiosity or deep concentration. Watch, too, for those comical looks the raised eyebrows or pursed lips — that all babies seem to engage in. Often an infant's expression is reminiscent of a parent's or relative's. If your baby smiles just like Grandma did or furrows her brow the way an aunt or uncle does, you won't want to miss that expression with your camera. If you photograph in close, make sure the depth of field is adequate.

As your baby gets older, you will recognize a host of more mature emotions, from anger and jealousy to affection and gaiety. Photographically, the secret is always the same: to see the picture the instant before it happens, and then to snap it without breaking the flow of your baby's actions and feelings.

Details help define a person's character, and babies are no exception to this rule. A baby in a blissful sleep with his lips happily pursed reveals that he is at peace.

Bonnie Freer/Photo Researchers

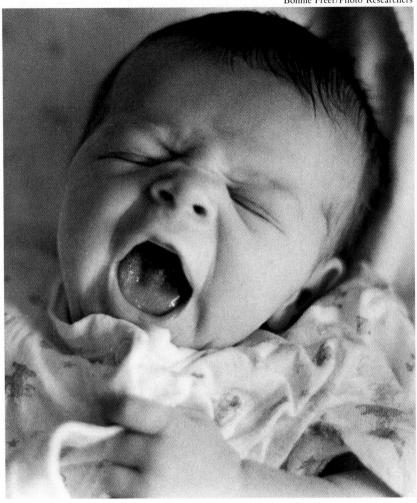

By watching and observing the details of your newborn's behavior, you'll be able to select those expressions and moods that seem to be uniquely his.

Michael Lutch

John Vaeth

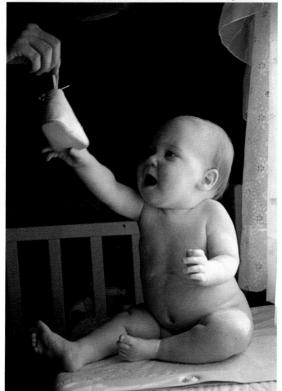

If you photograph your baby in the same setting at various intervals, you'll create a dramatic record of growth. Use any object that provides a sense of scale, such as a chair, crib, or large stuffed animal.

By dangling a shoe in front of his baby, this parent not only got the opportunity to observe his baby's reaction, but managed to elicit a priceless pose for the camera. The use of natural light to bisect the image gives the picture an added sense of dramatic tension.

Becoming a Mother

otherhood is an experience encompassing a wide array of emotions. The bond between a mother and her child begins even before the baby's birth. With the entry of the child into the world comes an overwhelming sense of commitment and joy, with increased responsibility and demands.

As a photographer, look for images that portray a mother and child's unique and intimate rapport. It's best to use strong diagonal arrangements, such as a mother lifting her baby, with outstretched arms, as she gazes at him. If the mother is looking up or down at her baby as she holds him, the composition will be more interesting than a side-by-side pose. You might try an overlapping

The backlit leaves of a nearby tree provide an appealing background for a mother joyously gazing at her infant.

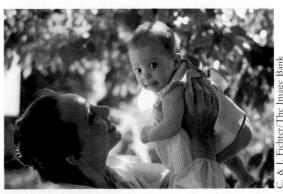

Arthur McLaughlin

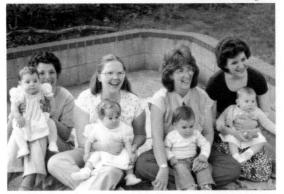

The slightly varying heights and expressions of this group of babies contrast nicely with the more posed smiles of their mothers, suggesting both a bond of friendship as well as motherhood.

Ellis Herwig/Stock, Boston

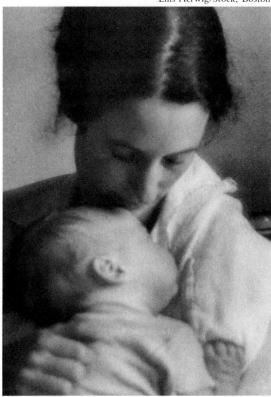

This classic pose of a baby sleeping peacefully on his mother is compositionally much more successful than a side-by-side arrangement.

composition such as the mother holding the baby in front of her. If she looks at the baby rather than the camera the child remains the focal point of the picture.

Since it's difficult to light two people well with strong directional lighting, whenever possible photograph in soft, diffuse lighting such as on an overcast day. Or try placing your subjects near a window and use a white card or cloth as a reflector to lighten the shadows. This may also be an ideal time to photograph three generations of motherhood. When composing group photos, be sure to stagger the pattern formed by the heads. For instance, you may pose the grandmother seated and holding the baby while the mother remains standing.

Becoming a Father

oday's fathers are increasingly involved in many aspects of practical child care: diapering, bathing, feeding, rocking. A father is also a favorite playmate and can often be seen tumbling in the grass with his child, bouncing the baby on his knee, tickling her, or gleefully tossing and catching her in his arms. A newborn looks especially endearing when cradled in her father's arms or resting comfortably on his wide chest. Older babies love to be carried on their father's shoulders.

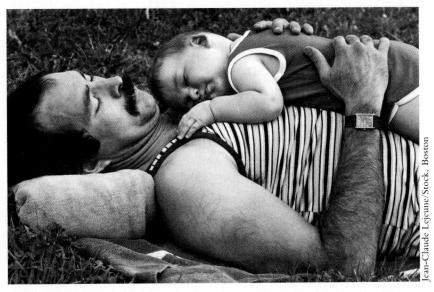

Though fathers and babies love to roughhouse, there's a special intimacy shared in a quiet snooze. A watchful mother took advantage of this intimate time-out, framing her subjects tightly.

Because such play is often animated, you should be prepared by cocking the shutter and by presetting the focus on an SLR camera. In capturing images of a father's more tender moments with his child, you might want to show your baby full face and Dad in a three-quarter profile. A serious moment of reading together, a proud Dad pushing the baby in a carriage or stroller, or a peaceful snooze can also reveal that special paternal bond.

Wayne Miller/Magnum Photos

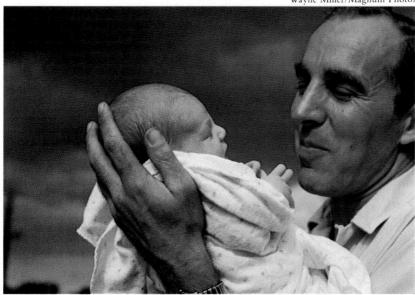

In this close-up of a father's proud expression, the father's hand reveals the newborn's tiny size, lending a sense of scale to the image.

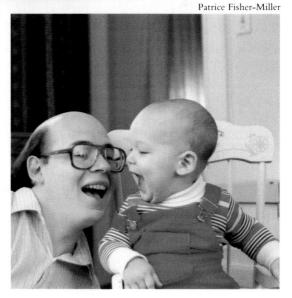

The photographer has perfectly captured the marvelously playful animation of this moment and the close relationship between parent and child, as father and son join in a harmonious duet.

Becoming a Family

or some, the arrival of a child makes a couple a family. Even when there are other children in the family, a new baby changes the dynamics of living together. For a sibling, the arrival of a new baby is an exciting event, though it may require some difficult adjustments. Taking group photographs is an excellent means of making your older child or children feel that they are still an important part of the family. Although your most dynamic pictures may come after your baby is old enough to share toys and games, don't hesitate to photograph your newborn with his sibling(s). Supervise your toddler or grade-schooler gently holding the new baby or tucking him in his crib. Let older children look through the viewfinder and

This photo captures a subtle sense of sibling rivalry and intimacy as the baby gazes in adoring fascination at his sister, while she looks knowingly at the photographer.

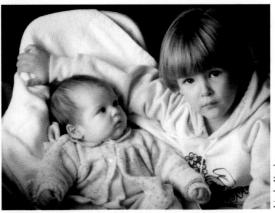

inda Kosko

snap a few pictures. Keeping them involved can help discourage feelings of rivalry that may be brewing.

As your children get older, you might want to bring more of their world — toys, props — into the images of the new baby. It's better not to direct them too much; let them react to each other, rather than to you or the camera. Timing is critical when photographing interacting

Ben Ranada

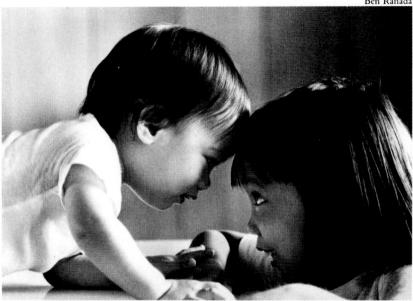

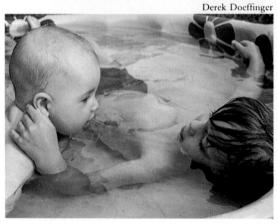

By stooping to the children's level and moving in close, the photographer created a warm portrait of sisters that makes the viewer feel part of the scene.

children. Whenever possible, take your pictures surreptitiously so that you don't interrupt the action; you may even wish to use a telephoto lens so that you can keep your distance. Once children become aware of the camera, they often react by becoming shy, contrary, or overly anxious to perform.

An enjoyable activity such as swimming will provide a good opportunity for you to capture the many different aspects of the special relationship siblings share.

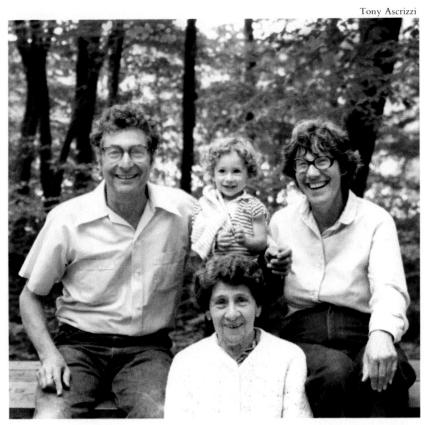

A photo that includes many family members is always a favorite. For this photograph of great-grandmother, grandparents, and child, the photographer used an ordinary picnic bench to assemble the family.

By keeping your compositions tight, you may be able to avoid problems in obtaining proper lighting for your subjects. Try photographing at the child's eye level for an insight into his world view. Indoors, fast film and wide apertures of f/2 or f/2.8 work best with available light, but if your children are very energetic, use flash. Outdoors, fast film will let you use a small aperture for greater depth of field and a fast shutter speed (1/250 or 1/500 second) for freezing action.

Suzanne Szasz

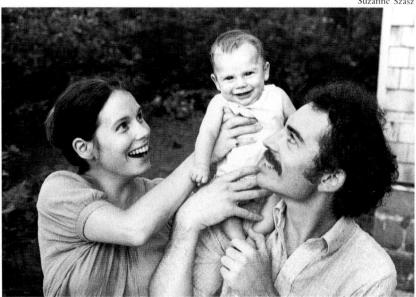

Whether your baby is the first or the fourth, his birth creates an excellent opportunity to take pictures of your entire family. Position the group tightly in a varied arrangement rather than in a static-looking row. If you have a large family, you may wish to create three tiers, with one group standing, a second sitting on a couch, and a third group on the floor. Even with just three subjects, a staggered arrangement, as seen here, is preferable. A regular lens is generally adequate, but in a confined area you may want to use a 28 mm or 35 mm wideangle lens, or an 85 mm to 135 mm moderate telephoto lens for smaller groups and more intimate portraits. Use your camera's self-timer if you wish to include yourself in the photograph, or ask a friend to snap the image after you've set it up.

In the flurry of excitement surrounding a new baby, parents often forget that they make interesting photographic subjects, too. Ask a friend to make an informal family portrait, or use your camera's selftiming device to capture your baby interacting with his very best friends.

Grandparents

he birth of a baby is not only a milestone in parents' lives, but a long-awaited, joyful event for grandmothers and grandfathers. During the first days home from the hospital, a grandparent may be called upon to lend a helping hand. Later, visits with Grandma and Grandpa become special events.

Whatever your situation, you'll no doubt want to record the special relationship that children and their grandparents enjoy. Try to capture revealing images as Grandfather tells a favorite family tale or Grandmother feeds the baby a bottle, wistful for the short time ago she was feeding her own daughter.

With an older person in the image you should pay even more attention to the quality of light. Strong directional lighting brings out harsh lines, so for a more flattering image use soft lighting, or try a diffusion filter that will cause light to spread, obscuring details. A full-face

Sometimes photographing unobtrusively while baby and grandparent interact will render an effective image. These playmates were snapped in a moment of obvious mutual enjoyment.

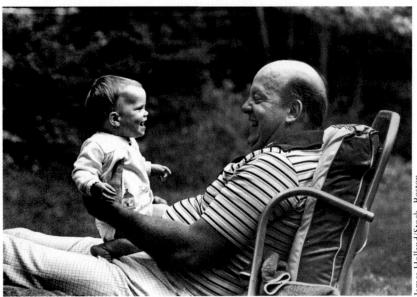

ames Holland/Stock, Boston

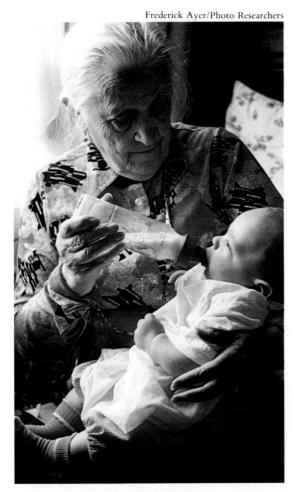

Take advantage of a quiet moment when Grand-mother or Grandfather is bathing or feeding the baby to capture their special relationship. This photographer used the window light to soften the grandmother's features and to brighten the youngster's face.

portrait may be more becoming to an older person than a three-quarter view. An 85 mm to 135 mm telephoto lens allows you to focus intimately without intruding. At times, however, you may want to emphasize the dramatic contrast of young and old by shooting in strong light, or by focusing on a grandparent's aged hand clasping the grandchild's little one. If the grandparents are shy in front of the camera, try to photograph them while they're involved in an activity with the baby and take your pictures without fanfare.

Special Occasions

he first two years of a baby's life are steeped in ceremonies and holidays. Among the earliest and most frequently photographed are religious corresponded are religious corresponded.

graphed are religious ceremonies such as a baptism or bris. Do some research ahead of time to find out the size and lighting of the church or temple, and then determine your film, lens, and flash needs (see pages 30–37, 44–45). Also check with the rabbi, priest, or minister to ensure that picture-taking is permitted.

Like all occasions that bring family and friends together, these events are a good opportunity to use your photojournalistic instincts to capture the warmth, emotions, and highlights of the day. When you plan your photos, keep in mind the scope of activities you'd like to cover: the ceremony itself, the congratulations extended to parents and relatives,

Christmas and Chanukah are always favorite times to take pictures. Make certain to photograph the events leading up to the holiday as well as the day itself. This family found a Christmas tree outing to be a perfect time to show their baby's tiny size in relation to the world around him.

m Campa

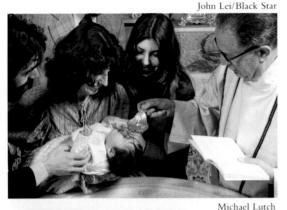

Almost every ceremony has its "decisive moment." Make sure you are ready when the most important aspect of the ceremony occurs, as this photographer was when the infant received the sacrament of baptism.

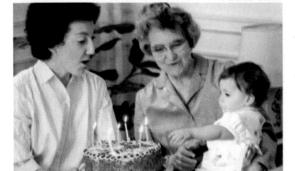

Not much can compare with the excitement of a first birthday. Showing the mother and baby in profile and the grandmother full face helped to vary this composition.

conversations among members of the extended family, and any festivities that follow the service. A group portrait is usually a good idea (see pages 78–81).

Secular and religious holidays are also events that you will want to record. A photo taken each Christmas, Halloween, or Passover will serve as a reminder of your child's growth. Make an effort to include appropriate symbols of the holiday; dozens of tightly cropped pictures of your baby being held by various relatives won't provide a clue as to whether it's Fourth of July or Chanukah.

Milestones

ther special occasions mark a child's first two years: milestones in your baby's physical or social development. A short list of these "firsts" includes baby's first bath, first outing, first smile, first tooth. first time rolling over or sitting up, first time standing, first steps, and first haircut (to name a few!).

Try to vary the way you record these milestones. Alternate the settings indoors and out. Pose your baby alone and with others. Even if your picture of the "first" step is actually the tenth, don't feel as if you've failed.

Perhaps the most important first for any baby is the first birthday. A birthday party for a one-year-old can also be a feast for the eager photographer. Be sure to get photos of the cake and decorations, as well as the favors and gifts. But don't be put off by the charming chaos of the party. Once the presents are open (and in use), your camera can record the lively antics of children doing what

Framing the image vertically may help you focus tightly on bath-time procedures. This mother's red blouse adds a visually pleasing effect in contrast to the white sink.

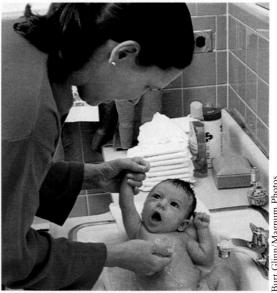

Burt Glinn/Magnum Photos

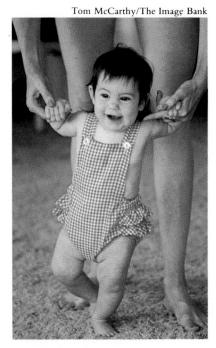

With her mother's help, this baby takes her first steps. The photographer got down low to create an intimate view and used the neutral-colored rug as a background, blocking out extraneous elements.

A first haircut can be a delightful or a traumatic experience, but it is almost always an occasion to be photographed. Here the little girl seems willing but cautious of the first snip.

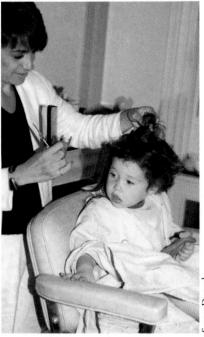

san Dang

comes naturally: playing. You may find it easiest to capture the events by using flash. But if you'd like to get a more natural feeling (including the burning candles), use high-speed film (ISO 400 or higher). Turn on some room lights and try to use a shutter speed of 1/125 second or faster. A nice touch is to take a group portrait of the parents and children attending the party. Choose an uncluttered background — if you can find one such as a fence or steps outdoors or a wall or stairway indoors. Finally, don't forget to record the tired aftermath of this once-in-a-lifetime event — sleepy baby, discarded wrapping paper, and all.

Playmates

s your baby grows, he will become more and more aware of the diverse world around him. Although his main loyalty will

remain to his parents, he will increasingly enjoy playing with other children and family pets. If there are no other children in your family, you may want to get in touch with other parents whose children can get together with yours on a regular basis. Photographing the group's development — physically and socially — can provide a wonderful chronicle of your baby's individual style.

When you're photographing two or more children playing, you may want to use a long-focal-length lens of about 135 mm so that you can take your

By stepping back to include the woodsy background, the photographer has captured these two friends at play, their simple white clothing underscoring the innocence and lushness of the scene.

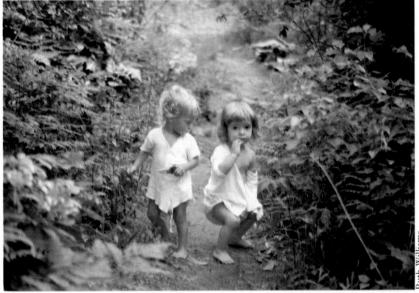

pictures unobtrusively. Indoors, flash will light your subjects while freezing the action. Outdoors, toddlers playing with balls or hoops are a delight to watch and record. If you're photographing a sequence — your toddler scooting after a

cuth Willia

Jan Lukas/Rapho

Suzanne Szasz

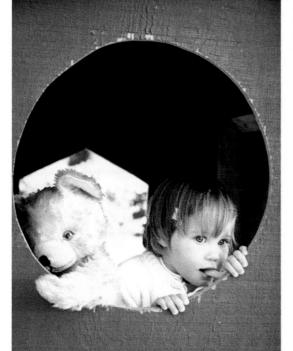

Tight framing and subtle lighting make this intimate moment between siblings an endearing photo of their close tie.

A contemplative toddler mimicked her favorite playmate's pose, and the photographer used a circular window to enhance the composition.

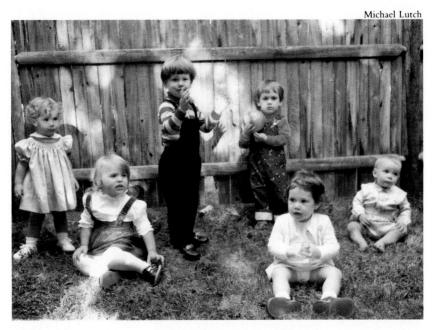

A variety of stances, positions, and expressions echoed by patchwork lighting makes a potentially ordinary group shot into a statement about the unique personality of each of these youngsters.

ball or dancing ring-around-the-rosy — try fixing your camera in one position and letting the baby move across the frame. The fixed elements in your composition — a tree or other stationary object — will provide a contrast for the progress your baby makes as he moves toward the ball or around the circle.

The family dog or cat is often a baby's first and dearest companion. You will probably want to stay close by to supervise their play, even though animals seem to tolerate more roughhousing from children than they would from adults. A normal or wide-angle lens may be best. Again, there will be lots of sequences for you to capture, as well as tender moments of a child's first tentative contact with the animal, a playful nuzzling, or an intimate snooze. A children's petting zoo or farm will also afford many humorous pictures.

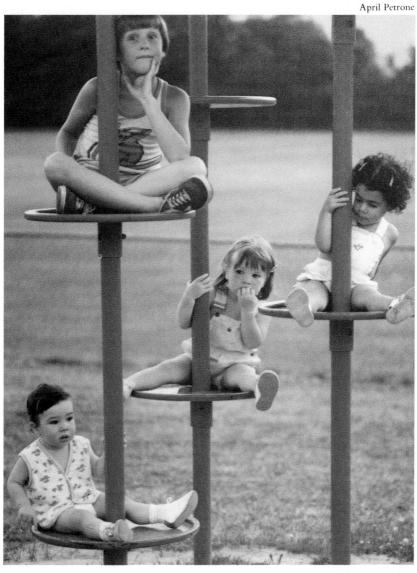

Outdoor playgrounds offer an opportunity for the more creative photographer to experiment. By posing the kids at staggered heights on the plates, the photographer created a picture that entertains you wherever you look within the photo.

Suzanne Szasz/Photo Researchers

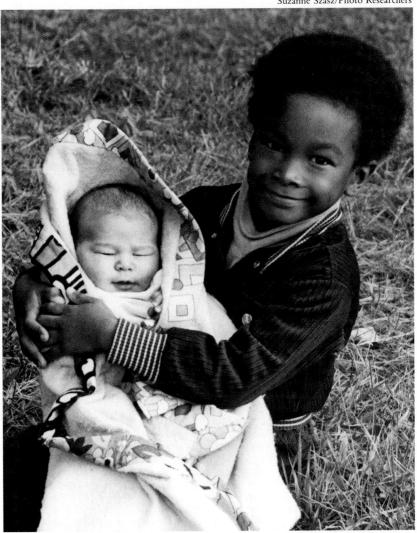

This four-year-old proudly displays his baby sister against a contrasting grassy backdrop.

Jo Ann Pender

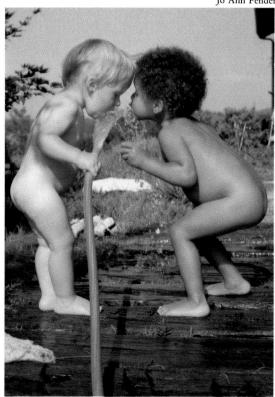

Although the faces of the subjects aren't even in full view, the photographer unobtrusively captured their glee as they both lean toward the hose's refreshing spray.

Photographed against a white background, these droopy, sleeping babies are seen in a moment of pure spiritual and physical kinship.

Sam Campanaro

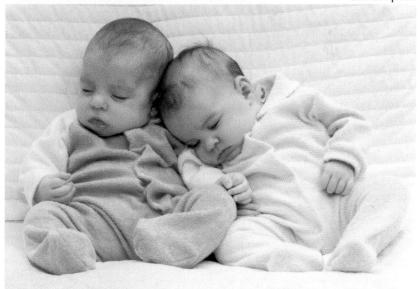

An Emerging Personality

erhaps the greatest pleasure parents experience is observing how their baby's growth and development reveal her own special personality. As your baby achieves each developmental stage, from lifting her head, to sitting up and crawling, to becoming an independent toddler, those personality traits that were apparent early on — the cautious, quiet baby or the rambunctious, adventurous child - are more clearly defined as new ones emerge.

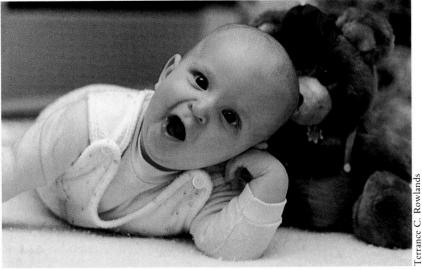

A child's personality is an indelible force. The observant photographer who has honed his timing and is ready to exploit the expressions elicited by props like this teddy bear will be at no loss for photographic opportunities.

As your baby grows, her moods and expressions, as well as her interests, change quickly. At one year she may dance to records all day long. A month later she may befriend a doll, devoting all her attention to this new pal. Parents are often amazed at the unpredictability of their children. One day they're as sociable as kittens, and the next they shy away from everyone but their mother.

The best way to capture all of these exciting developments on film is in candid situations rather than formal sittings. You will have more success photo-

James Larson

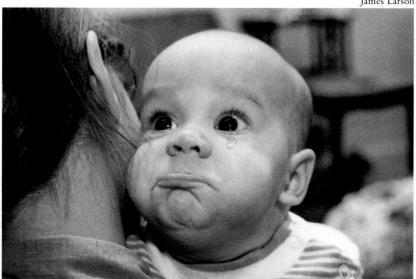

graphing your baby surreptitiously if she is either unaware of the camera or so accustomed to it that she scarcely notices its presence. Of course, some children are performers from an early age and love to pose. But it's fun to catch even these uncamera-shy youngsters unawares.

Try to focus on what is unique to your child and what circumstances will bring those qualities out for photographing. Representing a wide range of emotions and reactions will help you convey the many aspects of your child's personality. She doesn't need to smile for every picture, although a baby who is tired or angry one moment may surprise you by being charming and cooperative the next. Sometimes a photograph that communicates disappointment, anger, or sadness will help to recall a particular day or period in your baby's life. Even an expression of fear or apprehension may be worth capturing on film; what fascinates your six-month-old, such as a large dog or a friendly doctor, may terrify her three months later.

The inclusion of the mother in this photo places the scene in context; she has obviously picked up the baby to console him. The tearful pout leaves no doubt as to his momentary misery.

Moos-Hake Greenberg/Photo Researchers

The conflict between shyness and curiosity is revealed by a boy who clutches at and hides behind his father's leg, yet peers around to keep a wary eye on the photographer.

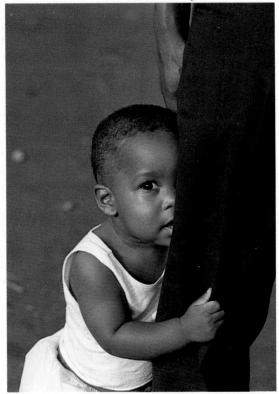

As your child begins to gain a sense of herself, her expressions of delight will be boundless. The exuberance of a fourteen-month-old greeting ocean waves for the first time or an eighteen-month-old building a tower of blocks are moments parents will want to savor. Your child engrossed in playing or learning is a particularly apt photographic subject. A thoughtful, pensive, or dreamy pose can be very evocative. Don't forget that what seems simple to you — a belly button or a crawling ant — is cause for serious contemplation for a toddler.

Alice Kandell/Rapho

The photographer has used the image of a toddler clutching a worn blanket — the classic symbol of security — to evoke a pensive mood. Body language plays no small part in the expression of a baby's thoughts and feelings.

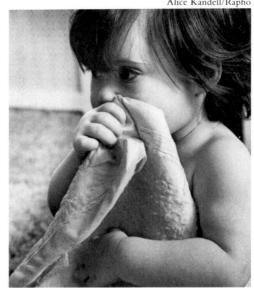

Cyrisse Jaffee

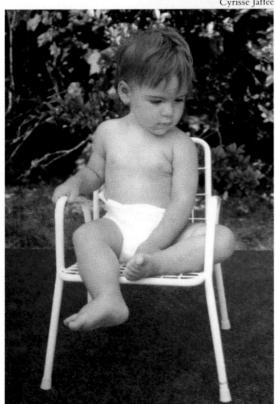

The demure gaze of the child, set against the rich hue of the carpet, conveys a sense of serenity and contemplation.

There are two helpful hints to taking candid baby photographs: be alert, and be patient. A wonderful picture can unfold at any moment, even though at times it may seem that your baby isn't interested in posing for the camera. If, however, your baby simply isn't in the mood, don't force her — she'll begin to associate the camera with an unpleasant experience. Forget the session and try later. Babies are much more spontaneous and unaffected than adults, and they'll let you know in no uncertain terms when picture-taking isn't a good idea. Although you don't need to direct your young subject, there are a few tricks of the trade that you might use from time to time to inspire an expression of awe or amusement. Try tying a balloon to your camera, or put something colorful on your

Even though some light is shining directly into the child's face, causing the shadows, the effect is slightly softened by light coming from behind her head and the light bouncing up off her sweater.

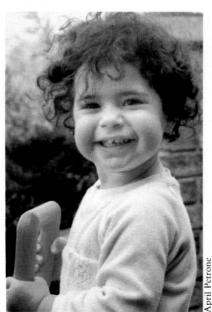

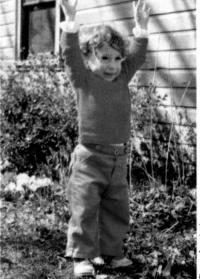

Tony Ascr

This youngster's pose and expression of triumphant accomplishment perfectly capture a toddler's growing sense of self.

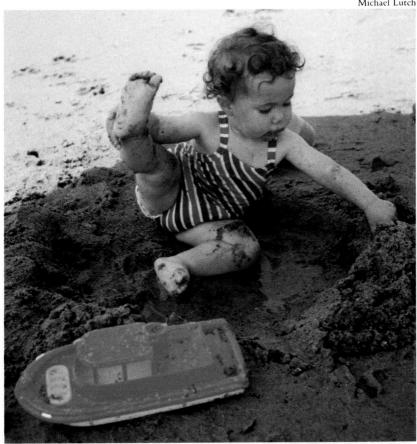

head. Puppets and songs are also useful tools. Babies, particularly older babies, have a keen sense of humor. Even a simple game of peekaboo can inspire squeals of delight.

A medium telephoto lens of 85 mm to 105 mm will let you record your child's changing expressions from a distance, even in an average-size room. A lens of this focal length will also help you avoid the distorted features that may result if you try to take a close-up of your baby's face using a normal lens. Choose a position that will not interfere with your baby's activities. If you're working outdoors, a telephoto zoom will allow you

This image provides an excellent example of using soft skylight when in the shade to illuminate your baby, while still capturing the brightness of sunlight in the background.

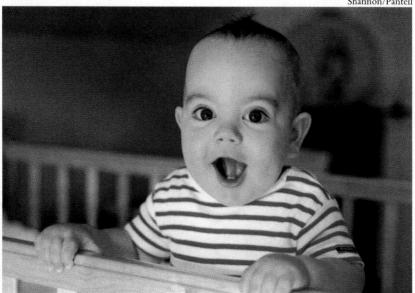

This father zoomed in for a delightfully close encounter with his son just at the right moment.

to zero in on your child's expressions without getting too close to the action. Although you should always be prepared with the right equipment, allow yourself the freedom either to watch your baby without directing or to interact and cause her expressions to change. You'll be surprised to find how a shadow on a wall, a shaft of light, or a cool breeze will affect your baby's expressions without your saying a word. And the more you watch your child through your camera lens, the more you will realize that even at this early stage of development she is a rainbow of feelings, moods, and faces.

> Caught in a delicious moment of glee as she perches on the edge of her childsize lawn chair, this little girl proclaims her high spirits. The bright sunlight filtering through the trees and the green of the grass set off her fair-haired sense of style.

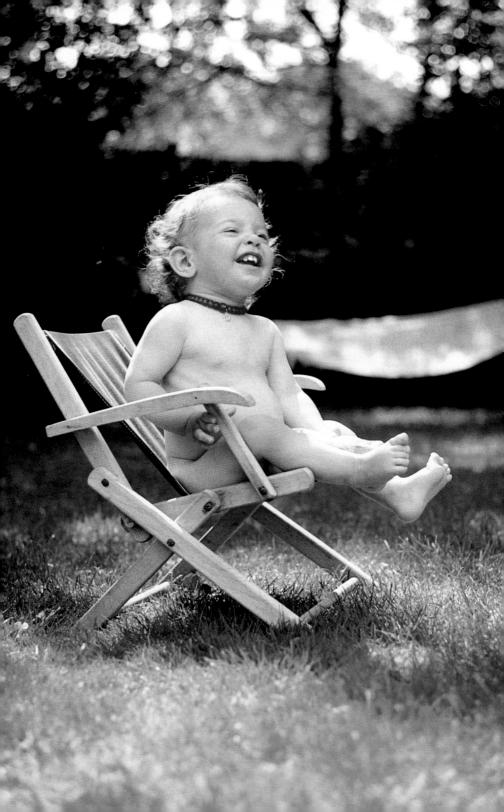

A Baby's World: Indoors

ven if you live in the most temperate climate, chances are that your baby will spend a lot of time indoors. In addition to lighting considerations, you should give some thought to using the many props available indoors to enhance your pictures, particularly during playtime.

Infants and newborns will amuse themselves with objects such as mobiles and rattles in their cribs or playpens. When depicting these scenes, try not to peer down on your baby. If you can, position your lens between the rungs of the crib or playpen, framing your image from the level of the crib mattress. Try to ensure that the mobile or rattle is adequately portrayed in the frame, because it is what differentiates the image

There is a whole range of indoor activities through which babies imitate their parents. A source of great humor, photos like this one are also effective in revealing your baby's size in relation to surrounding objects.

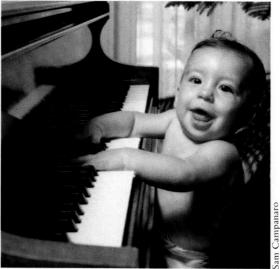

from other informal portraits of your child. Don't labor too long trying to draw the gaze of a very young baby; there will be plenty of time for that in the years to come. Toys will make a slightly older baby even more comfortable in his crib or playpen, so don't always take

Edgar Gelabert

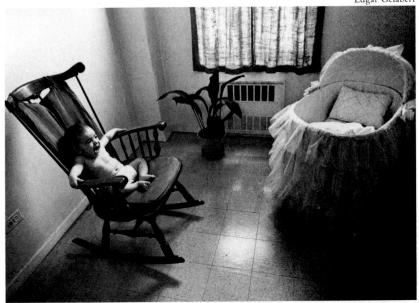

Lenora Henard

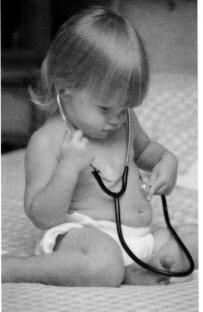

The strong geometry of this photo enhances the way this baby, totally at ease and in charge, happily surveys the scene.

By giving the baby a prop to play with, the photographer was freed from

trying to maintain the baby's interest and could concentrate on the photography. The choice of an unusual prop, a stethoscope, triggers the viewer's interest.

y his playthings for a pristine image.

away his playthings for a pristine image. Although you should avoid a cluttered, haphazard picture, it doesn't hurt to portray your baby with his usual playmates.

By using a high camera angle and waiting until the child looked up, the photographer established a conventional adult view of the child.

For several months new babies see the world from a rather limited perspective — from their crib, propped in a seat, or carried in a parent's arms. Once they learn to crawl, "cruise," and then toddle, their world opens up dramatically. In their travels and discoveries, babies find themselves in settings that adults rarely explore (unless they're following babies). A favorite place to play is on the rug or floor. If your rug is patterned, you might want to try placing a sheet or blanket over it to provide a plain background. If you hold your camera at a downward angle so that the floor or rug is your background, you will block out extraneous details like the legs of chairs or tables. With a wide-angle lens, however, keep the camera parallel to your subject to avoid distortion.

© Barry Sufrin

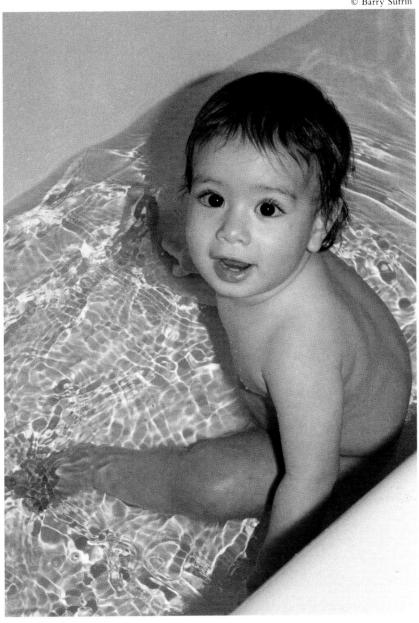

The vertical framing and the "splintered" look of the water reflecting the flash creates a most unusual foil to this youngster.

Derek Doeffinger

The stark simplicity of this baby on her rocking horse depicted against the white wall and the curious dog peering around the corner are sufficient to capture the viewer's interest.

Your child's quiet times at home can also be a reservoir for heart-warming pictures. Your baby asleep in the crib on a sweltering afternoon, perched on a brother's knee, gazing out a window, or intensely involved in coloring or reading — all are poses you'll want to frame in a soft light to enhance the feeling of tranquillity.

One aspect of a baby's indoor activities that is not especially quiet is mealtime. The concentration and special body choreography of spoon feeding — the clasped fist around the spoon, the raised arm, the open mouth, the hits and misses — provide abundant humor. Every child ought to be able to look back at a picture of his face covered with ice cream, his hair drenched with vegetable soup, or the table in front of him finger-painted with spaghetti.

Meal- and snack-time photos are lively and colorful. Generally, get in close. This is one time when the subject and props are all in the same locale and position, so you won't have to worry as much about composition.

With toddlers, the opportunities to photograph indoor play are many. More complex toys, from building blocks to miniature shopping carts, as well as stuffed animals, add much variety to your photos. A worn teddy bear and a floppy doll are not only photogenic in their own right, but they are excellent devices for indicating your child's size and growth. They are also objects of some of your child's most adorable behavior. A toddler offering his bottle to a teddy bear, having

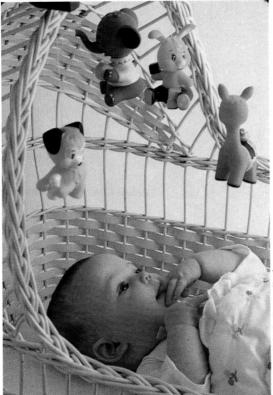

The color of the mobile against the white wicker of the cradle sets the mood for this idyllic scene of infant play.

Niki Mareschal/The Image Banl

This little boy's wink and smile as well as the facelevel viewpoint lift this photograph out of the realm of the ordinary.

a picnic with an entourage of furry "friends," or taking a beloved rubber duckie for a walk in the stroller can become priceless souvenirs.

Your child may also find countless other indoor delights. Mastering two or three steps, dancing to a favorite record, and "washing up" the dishes are some that may become important routines. An older toddler may find particular amusement in dressing up in Mom or Dad's shoes, clothes, or jewelry, often with hilarious results.

Take advantage of your baby's concentration in play to capture expressions of engrossment, laughter, affection, and inquisitiveness. Keep your compositions simple and illustrative. Use reflectors or your own light-bouncing devices to combat heavy shadowing. Take advantage of natural light whenever you can; it is less disruptive than flash.

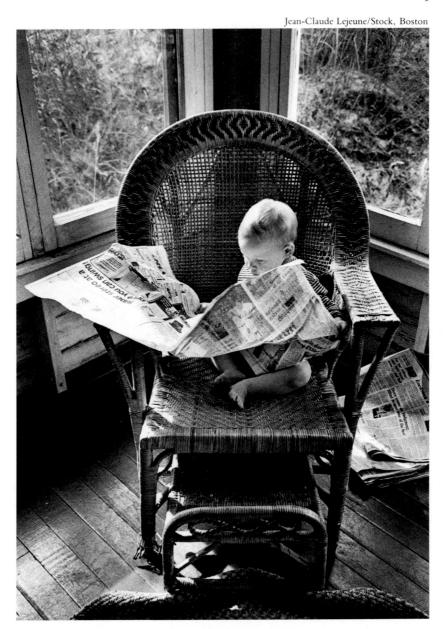

The wicker chair, traditional rug, and clear view of the foliage outdoors seem predictable enough for a portrait setting, but the baby engrossed in the newspaper converts the image into a witty parody. Notice how the baby is backlit through the windows, yet the light bouncing off the newspaper fills the shadows on his face.

A Baby's World: Outdoors

abies — like the rest of us — come alive in fresh air. A child's obvious delight in natural settings makes it a perfect time to snap pictures that capture her discovery of the wondrous world outside.

Because at first you will be protecting your baby from sunlight, wind, or cold — carrying her in a front pack or wrapping her up in blankets — it's important to frame close-up or special-angle photos that give prominence to her face and exposed features. Newborns will look tiny if you photograph them from too distant a vantage point.

Outdoors, a lush, green, grassy area as background will provide contrast and visual interest. In winter, snow can serve the same purpose. Tilting your

The photographer stepped back to include the cause of this child's fascination and pleasure — a large puddle, just right for splashing and wading through.

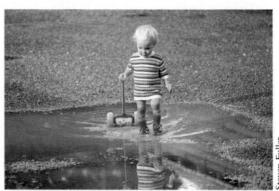

Cyrisse Jaffee

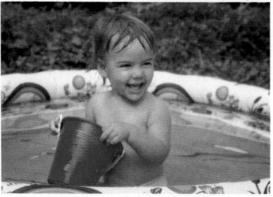

A portable backyard pool is an easily accessible source of photos that reveal your baby's revelry in water play. Here the plain green grass background effectively sets off the bright blue of the pail, which in turn picks up the colorful pattern of the pool.

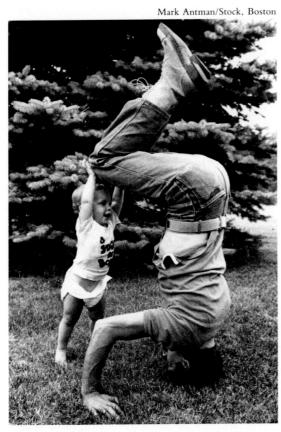

This humorous interaction between father and daughter is immediately striking because of its unusual circumstances and the child's apparent satisfaction in supporting her father's efforts. The strong vertical lines of the photo emphasize a dramatic sense of scale.

camera up will show your baby against the clear blue sky or the cohesive pattern of the leaves of a tree. Bright colors, reflections, or patterns, however, tend to draw the viewer's eye away from the subject. Wherever you go, look for naturally occurring frames, such as an archway, a brick wall, or a patch of flowers.

Babies of all ages also enjoy water; a pool, puddle, lake, river, or ocean will probably figure prominently in your summertime pictures. Be sure to take into account the water's reflective qualities. The rebounding light may alter the mood or color of your image by enhancing a serene scene, a vividly bright day, or a melancholy gray day. If the

Playground equipment — and the fun children have using it — offers innumerable photographic opportunities, so be prepared to take a succession of photos. A bright red outfit accented by boldly striped socks herald this child's triumphant solo on a slide.

scene is back- or sidelit, increase the exposure one or two f-stops to obtain details in shaded faces. White or light-colored sand may also require an additional stop of exposure beyond that indicated by the camera meter.

A pleasant, sunny day is certain to tap new sources of energy in your baby. If she is crawling or walking, try to catch the action. Look for a sense of narrative in her movements and gestures. For instance, if you snap your picture a split second after she splashes the water, you'll capture the drops while they are still in the air. If the wind is rushing by, look for the sense of movement not only in your child's hair, but in her expressions of astonishment or rapture. Time

A sequence of photos often best illustrates a historical event, in this case the baby's intrepid plunge into the pool. In the final photo, the mother's grin conveys her own joy and excitement about her child's accomplishment.

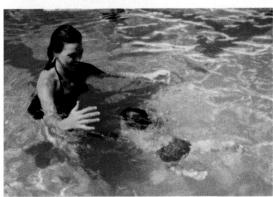

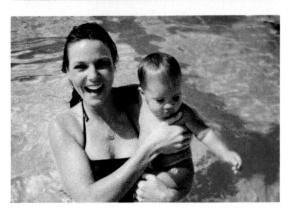

This close-up offers an interesting study in the faces of mother and child. As the baby leans back, her serious expression contrasts with the mother's welcoming smile.

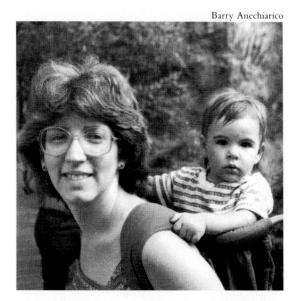

your exposure to capture the extension of her stride; lower your camera angle to record the assertiveness of a standing pose. Include all the details that will explain an episode. If Daddy is standing on his head and his daughter is giggling while she helps to hold him up, make sure Dad is included, too.

Another category of outdoor imagery surrounds the contemporary routine of everyday living. Many babies are frequently on the go with their parents. Riding in cars, carriages, and strollers, they are a community of commuters unto themselves.

In addition to photographing your baby posed in a particular means of transport, try to develop a visual sense of the environment and the tasks and activities being performed around her. A trip to a shopping center or a carnival won't be adequately recalled in a series of closeups of your baby in the stroller. Pull back just enough to show off the complementing elements of the scene.

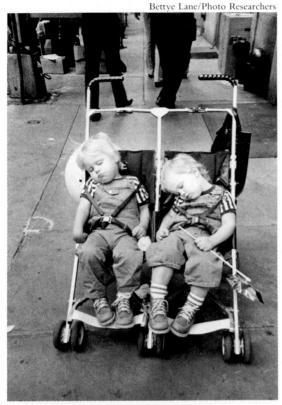

Sooner or later the rigors of outdoor activities catch up with babies, as with the rest of us. These twin parade-watchers strike an unlikely symmetrical pose aided by the design of their stroller and the photographer's choice of vertical framing.

This brook is a refreshing change from the pools and beach scenes that often dominate images of youngsters in the water.

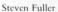

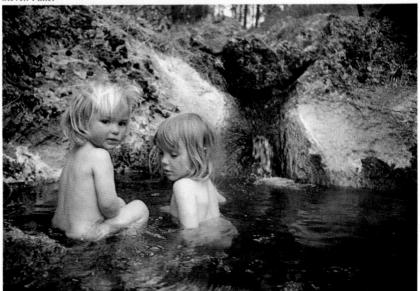

Here the photographer has made the setting the primary focus of the image. The exuberance of parent and child enjoying an outing on a bright, sunny day heightens the overall visual impact.

Although most of your pictures may be made in conventional settings, experiment with unusual places. At a parade, zoom in on your baby sitting on her parent's shoulders above the crowd. An outdoor sculpture, a ruined building, the props in a children's museum or zoo, a dock or train station, or even a cemetery may help illuminate your child's size, sense of innocence, seriousness, or fresh enthusiasm.

Gary Crallé/The Image Bank

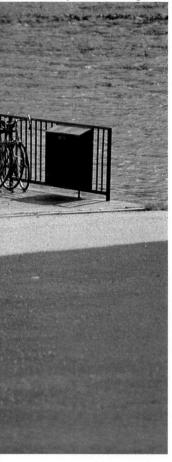

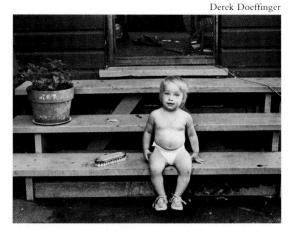

The slightly worn, oldtime setting creates a stimulating contrast to the hearty, bright-eyed baby. The brush on the step and the cluttered floor behind add to the picture's aura of gritty authenticity.

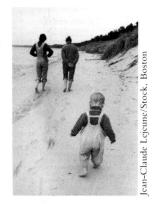

Each type of outing will inspire your baby's curiosity as she constantly discovers the details adults take for granted. The leaves of a tree, a snow-flake, an ant, the blare of a car horn, or pebbles in a driveway will all be new to your child. A baby interacts with the outside world with all five senses, not just her eyes. Using your photographic eye will allow you special insights into this amazing developmental process.

This photograph of a child, lingering behind two adults on an empty beach, the adults engrossed in conversation and the child intent on his own discoveries, suggests the toddler's burgeoning self-confidence and independence.

Portraits

lthough formal portraits are the specialty of professional photographers, you too can create fine informal portraits. Good

portraits are often made unexpectedly, when a subject reveals a unique aspect of his personality. A successful portrait, whether candid or posed, tells us not only what a subject looks like, but what he feels, distilling in an image the essence of a character.

You can take a portrait of your baby anywhere — indoors or outdoors, with existing light or flash. In attempting images that will reveal your child's unique personality, try to eliminate extraneous details. A plain background such as a wall, blue sky, patch of gray pavement,

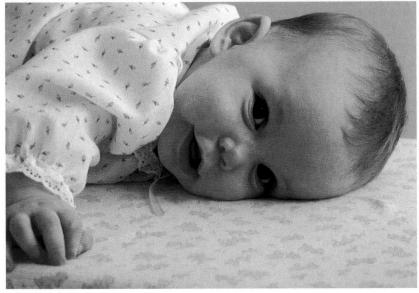

Niki Mareschal/The Image Bank

A sure-fire way to get your baby's attention is to photograph from his eye level. All too often, portraits made from an adult level lack the intimacy gained by using an eye-to-eye view.

Bob Witt/The Image Bank

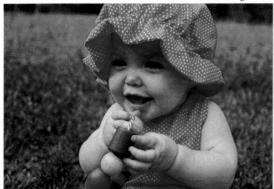

The brightly-colored cap creates a perfect frame for this baby's face, complemented by the matching outfit and the primary colors of the wooden beads. The grassy background provides no distractions and adds a rich tone to the photo.

David Woo/Stock, Boston

Newborns sleep and eat most of the time, so it may take a little imagination and patience to make a revealing portrait. This parent snuggled his baby boy in a blanket and took the photo just as the baby raised his hand to his cheek.

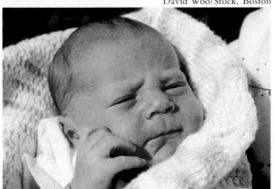

Sam Campanaro

or smooth, white sand will ensure that your baby shines as the star subject. When photographing an older baby's profile, use a medium-speed film such as Kodacolor VR 200 film. If the light is dim, a 400-speed film will work well.

Because a head-on portrait is sometimes too symmetrical, your portraits may be more dynamic if you occasionally experiment with a three-quarter view. Although newborns are best photographed on their backs from a position directly above, a five- or six-month-old baby can be placed on his belly and photographed with your camera level to his chin. A tripod and cable release can be very helpful tools in taking portraits, allowing you the freedom to interact with your subject. As your child smiles,

Clothing and posture can indicate a child's age and development. This baby is pictured in a favorite wintertime outfit, crawling assuredly toward an admiring photographer.

laughs, and communicates with his favorite photographer, you can use the cable release to snap the shutter unobtrusively.

Portraits taken when your baby is in familiar surroundings provide a sense not only of his personality, but also of his world. You may want to place him in a play area, cuddled in a favorite cozy blanket, or with a toy. A wide-angle lens will let you take in more of the scene, but to avoid distortion hold your camera parallel to the baby and keep his face away from the edges of the frame. Clothes and props will help reveal a baby's stage of development. You may want to capture his first appearance in sunbonnet or snowsuit; or try handing him a ball, rattle, doll, or a dish of ice

The photographer positioned the baby on a sofa next to a window to take advantage of the soft light filtering through.

Anne Len

cream. A prop also helps keep your baby content while you take your pictures, but be sure to frame the image so that it doesn't overpower your baby's face. By including only a portion of a prop in the frame, you can communicate its importance to your child without making it the dominant element in the picture.

When possible, use available light to its best advantage. Outdoors, an overcast sky or a shady spot will create a soft, diffuse light that enhances your ba-

by's features. With slide film you can try an 81A or 81B (amber-colored) filter to warm skin tones in pictures taken on a cloudy day or in shade. Indoors, placing your baby near a window will allow you to benefit from sunlight without its harsh shadows. You can use a large white card or a sheet to fill in dark areas of the face, controlling the light's intensity by moving the card closer or farther away from your baby. Also try sidelighting your subject to create shadows that will bring out his delicate features, or bounce a flash off the ceiling or wall to soften the light. If your baby has blond or curly hair, you might try backlighting to accentuate it.

Jeanne M. Schneider

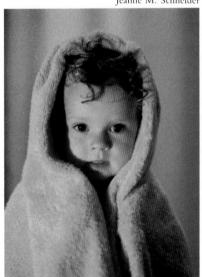

Portraits can be made anywhere and anytime, not just in formal sessions, and bath time is as good a time as any. Wrapped in a neutral-colored towel against a blurred background, this child looks like a squeaky-clean angel. Steve Kelly

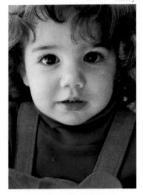

A bright red jumper and green turtleneck contrast with this baby's fair skin. Patterned clothing may detract from your subject, but colorful clothing often enhances a delicate face.

Outdoor portraits are best made on overcast days or in shady spots. Using a monochromatic background like the grass or sky will help offset your subject, brightened here by the primary colors of the child's clothing.

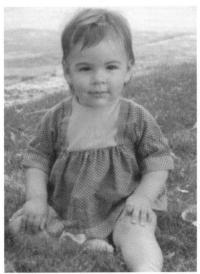

risse Jaffee

Close-ups

lose-up photographs are often the most effective means of capturing the small details that accent your baby's world or appearance. These images can reflect the intense emotional attachment that exists between parent and child. The best close-ups not only illuminate tiny details, but illustrate their meaning. A close-up of your baby's hand in the palm of her grandmother's can evoke the love and future they share. The honesty and clarity

The tight composition of this photograph, further enhanced by the closefitting hat, lets the viewer focus closely on this baby's intense determination.

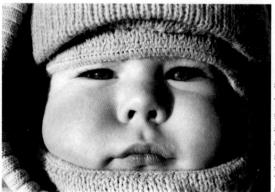

redrik D. Bodin/Stock, Boston

in a baby's gaze, the arch of a brow or curl of the toes, project her personality with great power and simplicity.

The closer you and your camera get to your subject, the shorter the depth of field. To prevent it from shrinking too much, use a small aperture setting (f/8, f/11, or smaller), and try to keep the primary subject of your image parallel to the surface of your lens and the film behind it. For example, instead of focusing on your baby's hand and arm reaching out to the camera, focus on one element, such as her extended fingertips, that falls directly on the same vertical plane as the lens and film. At short distances movement seems greatly exaggerated. To avoid blurring, don't use slow films or slow shutter speeds.

With the normal camera lens you can take only moderate close-ups. To get closer than the normal lens allows, vou need one of several accessories commonly available for 35 mm SLR cameras: supplementary close-up lenses, extension tubes, or a macro lens. The first two are fairly inexpensive; the macro lens costs a bit more. Commonly sold in groups of three, supplementary close-up lenses screw onto the front of the lens like filters. They can be used individually or together. Extension tubes, also usually sold in groups of three, are simply tubes that vou fasten between the lens and the camera body. They, too, can be used singly or in combination, depending on how close you'd like to get. A macro lens is designed to permit close focusing. It allows you to record many subjects, such as a newborn's head, at actual life size. Macro lenses are increasingly popular with advanced amateur photographers.

The classic artistic motif of two clasped hands is just a part of the allure of this beautifully framed image.

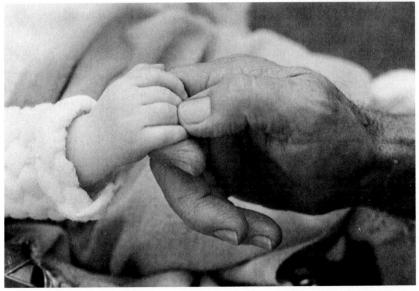

lames Holland/Stock, Boston

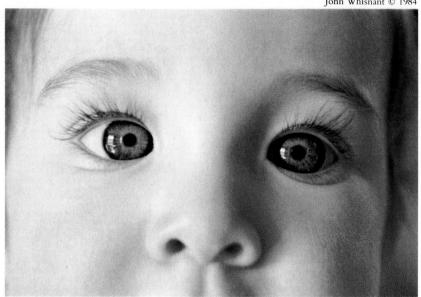

Robert Clemens

Supplementary close-up lenses (front), extension tubes (left), and a macro lens (right) are popular accessories for taking close-up pictures.

Though the blue eyes dominate this close-up image, it is the baby's long, wispy eyelashes that make it unique.

The photographer has artfully framed this image to accentuate the appealing contours of the newborn's face. The perfectly sculpted look of the infant's features evokes the tranquil beauty of numerous fine art photographs.

Judith Black

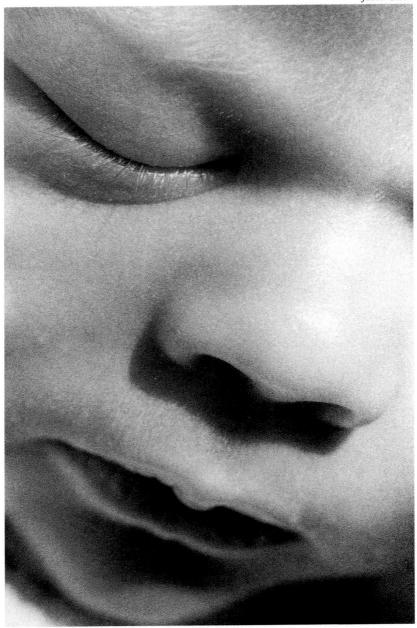

Beyond the Snapshot

s you become more confident in your ability to conceptualize and execute pictures, you may want to try to create more interpretive photographs of your baby.

Photographs that go beyond the snapshot can employ an unusual technique, interesting props, or a dramatic juxtaposition of light and shadow. In some cases your baby's face ceases to be the focus of the photo, and a distinct mood is created by the overall feeling of the image. If you use props in this kind of portrait, choose them carefully to help convey your message, whether it's an old-fashioned feeling or an abstract theme. Wonderful portraits can be made of babies next to mirrors or in unexpected environments, such as an empty room or a tent.

An artful composition is enhanced by an interesting combination of contrasting light and shapes that lead the eye to the baby standing by the window.

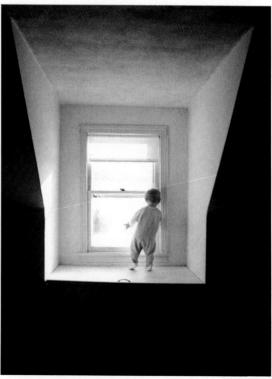

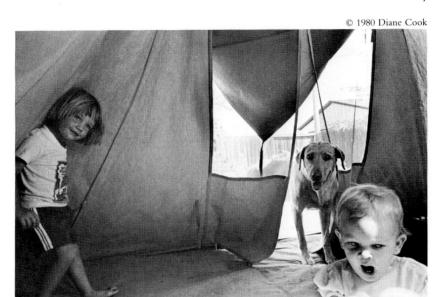

Whenever possible, try to communicate your ideas fully. Use the colors of the scene or the particular lighting you've chosen to accentuate your interpretation and enhance the mood. In some cases you may want to inject some motion into the image. Have your baby wave his hand or turn his head. Practically all the tips and techniques discussed in this book can be put to use in an interpretive image; but as with all photography, it is the clarity of concept and execution that is most important.

One technique that is very effective in pushing a visual idea beyond the snapshot genre is to photograph in sequences. Pictures of your child climbing and descending a slide, piling blocks until the pile topples over, or simply getting dressed are but a few examples. Before making a sequence, study your child's actions and in your mind break the activity down into frames. Be sure the lighting is expansive enough that your baby can move around the room if he decides to. You won't want to stop for anything.

Moods, impressions, and preconceived notions can fluctuate enormously in the split seconds it takes to press the shutter. Here, masterful timing and a precise viewpoint put the viewer inside the tent.

Don't rush yourself, yet be ready to decrease or extend the number of frames you expose.

Another effective interpretive technique is multiple exposure — superimposing or juxtaposing images on one frame. Some modern SLRs have a special control that allows you to trip the shutter several times without advancing the film. Others allow you to depress the rewind button while cocking the advance lever. Any camera with a B or T setting will let you make multiple exposures by leaving the shutter open and covering the lens with dark cardboard between exposures.

Another artful technique for making an unusual image of your baby is to play tricks with scale. Images that have broad backgrounds with nothing in them

The bright, rich colors of the towel and the grass blend with the rough textures of each and the graceful sweep of the towel to make this a striking image.

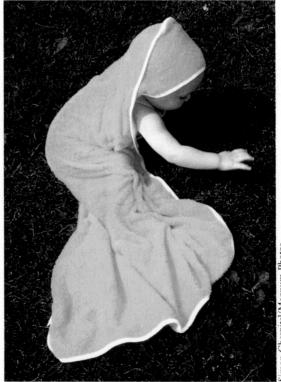

Cherpitel/Magnum Pho

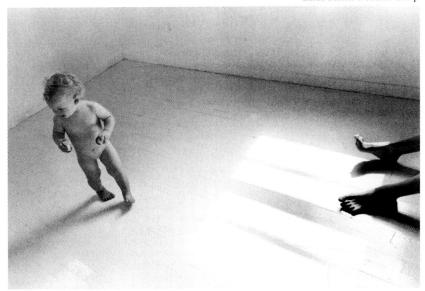

Patrick O'Neill Duggan

to indicate the size relationship to subjects in the foreground — like a grassy field and wide blue sky — can be used to alter the viewer's perception of your baby's size with respect to another object. You can, for example, position your baby twenty yards in front of a car in a grassy meadow, and by framing the scene at grass level make it look as if he is towering over what appears to be a nearby automobile. You'll need to use a small aperture (f/11 or f/16) to obtain sufficient

The unusual tilt of the child and the adult feet are juxtaposed with the sharp right angle of the floor and the rectangular shafts of light, making this a remarkably striking image.

A little whiff of theater, even a bit of burlesque, can add a distinctive tone. This photographer deftly panned his camera to capture the scene. To pan, take the picture while the camera is moving, as you track the subject in the viewfinder, using a shutter speed of 1/60 second or slower.

Using Kwik-Print, a graphic arts proofing system that allows for infinite layers of colors and unusual tones, Bea Nettles has created nearly surreal images that neatly capture two generations of fathers (above) and mothers (at right).

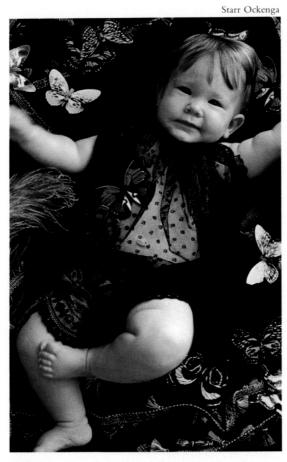

Interpretive images often use color and fabric to impart a magical effect. By combining a fanciful costume with the baby's lyrical pose, Starr Ockenga has infused this image with a wonderful sense of whimsy.

depth of field. Don't become too absorbed in the technique at the expense of the concept of your image. If the juxtaposition of your baby and the other object isn't evocative, the best techniques and equipment won't save the picture.

Part Three
Enjoying Your
Photographs

Announcements

Annette LaMond and Joseph Moore

sing a photograph of your newborn as part of the birth announcement can help make it a very memorable document.

Friends and relatives can catch a glimpse of your child, along with the vital statistics that are generally included: time of birth, weight, length. If you add a poem or quotation, the birth announcement can be a creative opportunity to express the joy a new addition to the family brings.

To get an attractive picture of your baby for a birth announcement, you may have to wait several days for the baby to recover from the rigors of birth.

loseph Mc

Many parents take the photo themselves and rush their film to an overnight processor for printing. Others opt for an announcement bearing a copy of their baby's footprints, while those who don't feel pressed for time wait to take a picture of the new baby at home, in the arms of an older brother or sister. Some hospitals also have photographers available.

Steve Kelly

This photo enthusiast made his own card by enlarging on black-and-white paper in the darkroom. You could design your own card by using a photograph on construction paper along with a handwritten message.

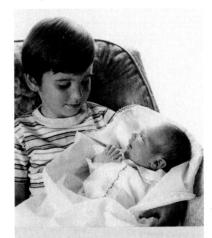

Michael Meets New Family Member

In a statement issued today at 56 Bent Oak Train, Fairport, 3,9-year-old Michael Boas announced that, as promised, his parents have introduced a new family member. Laura Beth Boas officially became Michael's sister at 5:22 a.m. on june 15. Michael commented that Laura's weight of 8 lb 2 oz was light enough to hold for short periods. "At only 2014 inches fall, though, Laura is a bit small for neighborhood sports activities right now," according to Michael. "But I'm sure that she'll be big enough to play tennis with me in a couple of weeks."

Commenting on Michael's statement, parents Caland Keith Boas noted that while Laura does have plenty of spirit, it is doubtful that she would be tennisfit by the Fourth. "However," they added, "if Laura wants to start practicing her serve later this summer, we won't stand in her way."

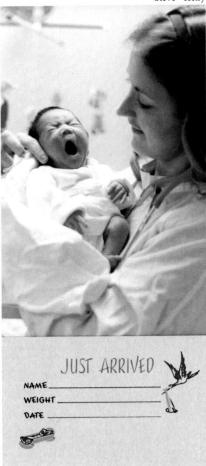

Using a photograph as part of the birth announcement will add a personal touch. After you choose the best picture of your newborn, you can select the style of announcement you prefer from your photo dealer, or create one yourself.

erhaps the greatest pleasure that comes with photographing your baby is viewing the results and sharing them. For this rea-

son, how and where you store your pictures is important. Perhaps the most popular choice of storage is a photo album, available in many shapes and sizes. There are many options, including albums that hold individual pictures in plastic sleeves; require your mounting images with some sort of adhesive; have small corner sleeves into which photos will fit quite securely; or have a thin plastic overlay that covers the image.

When buying an album, look for one of acid-free materials, such as 100% rag paper. Before using any pastes or glues on the paper, check that they have been specially produced for mounting photographs. Some adhesives, such as starch paste, animal glue, rubber cement, and contact cement, should not be used because they may damage pictures over time. Don't mount pictures on facing pages unless each page is equipped with

protective plastic sheets.

When selecting pictures to go in an album, be sure to edit carefully. Avoid images that are repetitive, yet don't be afraid to include a favorite photo that may not reflect your greatest technical artistry. Arrange your images in sequence, and if possible try to develop a certain narrative theme. For instance, you might want to group together images that illustrate a day in your baby's life: getting up, eating breakfast, dressing, and so on. Try to vary the size of your prints if your album can accommodate that. And don't be afraid to crop a print if you think it will increase its impact.

A variety of albums is displayed here. A pocket-size mini-album is always handy to carry with you; it protects your snapshots from the wear and tear of repeated showings.

Store your albums in a cool, dry place away from direct sunlight. Heat and humidity can damage photos. Stand the albums upright and don't crowd them together.

Those who take slides often save their images in circular slide trays. Others prefer transparent album pages with individual slots that hold twenty slides. Avoid the stiff plastic pages made of polyvinyl chloride (PVC) because they may interact chemically with your slides and deteriorate the images. Instead, choose pages made of polypropylene.

Framing and Enlargements

Il parents have certain pictures of their children that they just can't leave for occasional viewing in an album or slide tray. In

an attractive frame, these images can give you pleasure every day, hanging on your

wall or resting on a table.

Be sure to choose a frame that is not so ornate as to draw the eye away from the image. It is usually best to select a frame whose color blends with those in the picture. Frames are available in metal, including silver or gold, wood, Plexiglas, and cloth. They can be purchased in varying sizes and shapes, from a rectangle to a heart or oval.

You can frame pictures of all sizes, though very small or very large prints may be difficult to place in a room. You may want to consider a multi-frame, one that contains several different framing possibilities of size and shape in one unit. Or you might like to reserve a wall to display a wide variety of framed pictures of your family. Avoid putting your framed pictures in too much sunlight; the light will cause the images to fade.

You'll probably want to provide an interior frame for your photo, to highlight the composition and strengthen the emphasis of the image. You can purchase an interior frame, or matte, in most photographic, art-supply, and stationery stores. These come precut in various sizes and shapes, or you may be able to order them to fit the particular specifications of

your photo.

If you are not versed in the often complicated craft of framing, you might prefer to turn the job over to a professional. However, you may want to utilize the framing kits available in photo and art-supply stores to do it yourself.

Frames are ideal for showing off your favorite photos. Try experimenting with different shapes and fabrics, and alternate your photo selections for your personal gallery of images.

You may find that once your pictures have been developed, you'd like to see certain pictures enlarged. An informal portrait, a candid shot, or an interpretive close-up would be likely candidates. Most color printing labs will accommodate your needs. If you're photographing with black-and-white film and have your own enlarger, you can correct framing errors by cropping out unwanted parts of the image. If you plan to make big enlargements, you may want to use a very sharp, fine-grained film, such as Kodacolor VR 100 film, that renders sharp images even when greatly enlarged.

Aperture A fixed or adjustable opening in a camera through which light enters to reach the image plane. Aperture size is usually calibrated in *f*-numbers — the larger the number, the smaller the lens opening.

Backlighting Illuminating a photographic subject from behind so that the subject stands out vividly against the background, sometimes producing a silhouette effect.

Color balance The relative trueness of the colors in color reproduction. Films are balanced to give accurate color rendition in a specific light source, such as daylight or tungsten light.

Cropping Eliminating unwanted elements in a photo during enlarging or by trimming the print.

Daylight film A color film suitable for use in average daylight or with electronic flash and blue flashbulbs.

Depth of field The distance range between the objects nearest and farthest from the camera that appear in sharp focus in a photograph. Generally, depth of field depends on the focal length of the lens, the distance from the lens to the subject, and the lens opening (the smaller the opening, the greater the depth of field).

Exposure The amount of light allowed to act on a photographic material, which is the product of the illuminance (controlled by the lens opening) and the duration (controlled by shutter speed or enlarging time) of light striking film or paper.

Focal length The distance between the film and the optical center of the lens when the lens is focused at infinity. The focal length of the lens of most adjustable cameras is marked in millimeters on the lens mount.

Frontlighting Light shining on a subject from the direction of the camera.

Graininess The sandlike or granular appearance of a negative, print, or slide. It results from the clumping of silver grains or dye particles during development of the film.

ISO speed The emulsion speed (sensitivity) of film as determined by the standards of the International Standards Organization.

Macro lens A lens that provides continuous focusing from infinity to extreme close-ups, often to a reproduction ratio of 1:2 (half life-size) or 1:1 (life-size).

Normal lens A lens that makes the image in a photograph appear in perspective similar to what the eye sees. A normal lens has a shorter focal length and a wider field of view than a telephoto lens, and a longer focal length and a narrower field of view than a wide-angle lens.

Selective focusing Choosing a lens opening that produces a shallow depth of field. Usually this is done to isolate a subject by causing other elements in the scene to be blurred.

Shutter Blades, a curtain, a plate, or some other movable plane in a camera that controls the time during which light reaches the film.

Stopping down Changing the lens aperture to a smaller opening; for example, from *f*/8 to *f*/11.

Telephoto lens Any lens having a focal length longer than what would be normal for a specific camera.

Transparency A positive photographic image on film, viewed or projected by transmitted light (shining through film).

Wide-angle lens Any lens having a focal length shorter than what would be normal for a specific camera.

Zoom lens A lens in which the focal length can be adjusted over a wide range.

- Blankenstein, M. Van, and Welbergen, U. R. Development of the Infant: The First Year of Life in Photographs. New York: James H. Heineman, Inc., 1975.
- Editors of Eastman Kodak Company, Rochester, New York: Electronic Flash (KW-12), 1981. How to Take Good Pictures (AC-36). New York: Ballantine Books, 1982.
 - KODAK Guide to 35 mm Photography (AC-95), 1983.
 - KODAK Pocket Guide to 35 mm Photography (AR-22). New York: Simon and Schuster, 1983.
 - Lenses for 35 mm Cameras (KW-18), 1984.
 - Photographing with Automatic Cameras (KW-11), 1981. Using Filters (KW-13), 1981.
- Fearnley, Bernard. *Child Photography*, 2d ed. Woburn, Mass.: Focal Press, 1979.
- Franklin, Linda C. Baby Pictures (Old Fashioned Keybook Photo Album Series). New York: Tree Communications, Inc., 1982.
- Lesy, Michael. *Time Frames: The Meaning of Family Pictures*. New York: Pantheon, 1980.
- Lewinski, Jorge, and Magnus, Mayotte. *The Book of Portrait Photography*. New York: Alfred A. Knopf, 1982.
- Mager, Alison, ed. *Children of the Past in Photographic Portraits*. New York: Dover Publications, 1978.
- Mitton, Bruce. Photo Display. New York: Dolphin/Doubleday, 1980.
- Nibblelink, Don D. *Picturing People*. New York: Watson-Guptill Publications, 1975.

- Nibblelink, Don D. and Minoca. *Picturing the Times of Your Life*. New York: Watson-Guptill Publications, 1980.
- Taylor, Herb, ed. *Basic Child Photog-raphy* (Modern Photo Guide Series). New York: Doubleday, 1982.
- TIME-LIFE, Inc. *Photographing Children* (TIME-LIFE Library of Photography). Alexandria, Va., 1983.

Other Books about Photography from Eastman Kodak Company and Addison-Wesley:

The Joy of Photography

This classic guide has inspired millions of camera owners to create better photographs. Illustrated with over 600 photographs, it provides a comprehensive look at how to develop a personal style of photography, how to choose the right techniques and equipment, easy-to-follow darkroom procedures, and how to enjoy your photos fully.

More Joy of Photography

Over 500 photographs from world-famous photographers and amateurs illustrate 100 specific ideas for more creative photographs, including special effects, experimenting with unusual techniques and situations, and exploring new sources of imagery.

The Joy of Photographing People

A lavishly illustrated guide that will help you capture the special essence of people on film, from portraits and candid street photographs to weddings, sports, and high-fashion photography.

Albums, 136–137 Announcements, 134–135 Aperture, 23–25 Artificial lighting, 42–43, 63–64 *See also* Flash ASA number. *See* ISO/ASA number Autofocus 35 mm camera, 22, 27

Baby care, 68–69
Background, 48, 49, 80, 106, 110–11, 118–119, 121
Backlighting, 41, 74, 109, 121
Baths, 69, 79, 86
Birth, 62–63
Birthdays, 85, 86–87
Black-and-white film, 18, 34–36, 45, 64
Blurring, 25, 29, 122
Body language, 97
Bounce flash, 45

Camera angles, 17, 46-47, 49, 51, 79, 104, 105, 118

Cameras:

exposure control on, 22, 23 selection of, 26–29
Candid pictures, 94–101
Ceremonies, 84–85
Close-up lens, 123, 124
Close-ups, 40, 48–49, 122–125
See also Portraits
Clothing, 119, 120, 121, 131
Color:

composition and, 49 flash and, 45 light and, 41, 42–43 Color balance, 34, 42–43, 64 Color print film, 34–35, 36, 64 Color slide film, 35, 36, 121 Composition, 48–51, 122, 126

Daylight film, 35 Depth of field, 24–25 Diapering, 68 Diffusion filter, 68 Disc camera, 22, 26–27, 34 Distortion of images, 47 Dunn, Phoebe, 54, 56–57

Enlargements, 139 Exposure, 22–25 automatic, 24, 29 multiple, 128 semiautomatic, 29 Expressions. *See* Close-ups; Personality Extension tubes, 123, 124

Family groups, 78–81 Fathers, 64, 65, 66, 67, 69, 70, 76–77 Feeding, 68–69, 83, 89, 106–107 Film, 34–37 black-and-white, 18, 34, 36, 45, 64 color print, 34-35, 36, 64 color slide, 35, 36, 121 for hospital pictures, 67 indoor lighting and, 43 Film speed, 23, 34, 35, 36–37, 62 Filters, 18, 35, 43, 63, 64, 67, 68, 121 Flash, 35, 41, 44–45, 69 FLD filter, 63, 64, 67 Fluorescent lighting, 36, 43, 63 F-number, 23, 24 Framing, 138–139

Grandparents, 75, 80, 82-83

Haircuts, 87 Holidays, 84–85 Hospital photographs, 62–67

Indoor lighting, 42–43, 62, 63–64, 66, 68, 80, 108, 109

See also Flash
Indoor pictures, 102–109
Instant cameras, 22, 27
Interpretive photographs, 126–131
ISO/ASA number, 23, 36–37, 42
ISO 125 film, 36
ISO 200 film, 37, 67
ISO 1000 film, 34, 37, 42, 43, 62, 64, 67

Kodachrome 64 film, 35 Kodacolor VR 100, 139 Kodacolor VR 200, 34, 119 Kodacolor VR 400, 34, 42, 43, 64, 67, 119 Kodacolor VR 1000, 34, 37, 42, 43, 64 Kodak Ektachrome 100 film, 35 Kodak Panatomic-X film, 36 Kodak Plus-X pan film, 36 Kodak Tri-X pan film, 36 Kwik-Print, 130

Positioning, 48, 120 Lens diaphragm, 23 Pregnancy, 60–61 Lenses, 30–33 for candid shots, 99-100 Profile, 48 with children playing, 88 Rangefinder camera (35 mm), 28 close-up, 123, 124 Reflectors, 40, 41, 42, 45, 75 with indoor lighting, 42 normal, 30, 123 telephoto, 30, 31, 81, 99-100 Sequences, 127 wide-angle, 30, 32, 33, 69, 81, 104 Shadows, 38, 39, 41, 45, 121 See also Lighting zoom, 31, 32–33, 99–100 Shutter, 23 Lighting: flash, 35, 41, 44-45 Shutter speed, 23, 24, 25, 29 in bright light, 34 of grandparents, 82–83 indoor, 42-43, 62, 63-64, 66, 68, with flash, 44 80, 108, 109 Siblings, 78–81, 89, 92 Sidelighting, 41, 119, 121 outdoor, 34, 38–41, 80, 98, 99, 100-101 Silhouette, 61 for portraits, 120–121 Single-lens reflex (SLR) cameras, 22, 28–29, 30, 123 Light meter, 23 Skylight filter, 18 Sleeping, 71, 75, 76, 93 Macro lens, 123, 124 Slide films, 35 Milestones, 86–87 exposure and, 22 Mothers, 61–63, 65, 68, 70, 74–75, filters for, 121 95, 113, 114 SLR. See Single-lens reflex cameras Motion, 25, 88 Soft-focus lens, 33 Multiple exposure, 128 Special occasions, 84–85 Sunlight, 38-41, 121 Natural lighting: See also Outdoor lighting indoors, 42, 66, 108 outdoors, 38-41 Szasz, Suzanne, 54–56 Negative films, and exposure, 23 Telephoto lens, 30, 31, 81, 99-100 Normal lens, 30, 123 35 mm cameras: aperture size on, 23 110 camera, 22, 26–27 aperture and shutter speed on, 24 Outdoor lighting, 34, 38–41, 80, 98, autofocus, 22, 27 99, 100–101 exposure control on, 22, 23 Outdoor pictures, 110–117 rangefinder, 28 SLR, 22, 28–29, 30, 123 Panning, 129 Timing, 52-53, 127 Personality, 70-73, 94-101 Perspective, 46-47, 50 See also Candid pictures Tungsten lighting, 35, 36, 43, 63 Pets, 90 Photo albums, 136–137 Viewpoint, 46–47, 127 Photographers, professional, 54-57 Photo terms, 22–25 See also Camera angles Play: Walking, 87 indoor, 107-108 Water, reflective qualities of, 111-112 outdoor, 112-117 Wide-angle lens, 30, 32, 33, 69, 81, Playmates, 88–93 Point of view, 46–47, 127 See also Camera angles Zoom lens, 31, 32-33, 99-100 Portraits, 118-121, 126

See also Close-ups

Manu facturing

Manufacturing

Eastman Derek Doeffinger Editor Paul F. Mulroney, Jr. Kodak Managing Editor Charles W. Styles Production Supervisor Company Annette L. Dufek Production Michelle Crawforth Editorial Jean Leavy-Ells Editorial Jane Peck-Landsman Editorial Technical Photography Jacalyn Salitan Coordinator Don Buck Technical Photography Robert Clemens Technical Photography John Menihan Technical Photography Cyrisse Jaffee Editor Addison-Wesley Publishing Doe Coover Editor-in-Chief Lori Snell Production Supervisor Company Barbara Wood Production/Operations Manager Designer, WGBH Design Paul Souza

Jim Georgeu Ann DeLacey

Praise for The Lost German Slave Girl:

"Bailey brings a lawyer's eye to the court records and creates a courtroom drama from the raw data. . . . He deals deftly with his often-inscrutable heroine. . . . Bailey is a glib and readable writer, and he offers a page-turner of a story.

—The Times-Picayune (New Orleans)

"Bailey limns in engrossing detail the complex investigations, strategies and legal arguments."

—The Atlanta Journal-Constitution

"John Bailey tells her engrossing story . . . with polish and verve, weaving history and mystery neatly together. Along the way, he gives readers a thorough tour of early New Orleans, where raffishness and aristocracy coexisted by mutually ignoring each other. . . . He has crafted a compelling tale of one woman's complex life story and . . . given readers a revealing look at one of the darker periods of American history."

—The Miami Herald

"The Lost German Slave Girl is a marvelous page-turner with unique and fascinating insights into the institution of slavery in the pre-Civil War South intertwined with a heartbreaking story of misfortune."

-Winston Groom, author of Forrest Gump and 1942

"Bailey . . . does a fine job of resurrecting the ambience and cultural atmosphere of New Orleans in the 1840s. . . . An eye-opener to the racism that's so deeply embedded in the fabric of American society."

—Kirkus Reviews

"[Bailey] weaves a deft and captivating plot with astonishing detail culled from historical and archival records. Highly recommended."

—Library Journal

"Bailey . . . relishes telling this remarkable story as the courtroom drama it was, peppering it with fascinating tidbits of Louisiana history and elegant explanations of the law. He fleshes out every angle, every character, and pinpoints the legal pitfalls and triumphs with equal zeal."

—Milwaukee Journal Sentinel

"An immensely readable courtroom drama for readers who like their history to be serious, but also compelling and entertaining."

—Book News

"Bailey adroitly uses transcripts and newspaper coverage of this case . . . to illustrate the ironies and idiocies of slavery from a unique perspective." —NJ.com

"Fascinating history . . . an exhaustive account . . . His tale reads like a whodunit mystery novel, full of courtroom drama, twists and turns, shocking surprises, and disappointment. Be warned: this book may be impossible to put down until Sally's fate is revealed. A"

— On-the-Town

"A rare achievement—a book that is both important and spellbinding. Important because John Bailey takes us another step closer to the mad and evil heart of slavery, which twisted every household, every courtroom and every community it got hold of. Spellbinding because Bailey re-creates a young nation, a bawdy city and a stirring struggle for a young girl's freedom with grace and page-turning drive." —David Von Drehle, author of *Triangle: The Fire that Changed America*

"[This] marvelously vivid account of the legal maneuverings, of the successive court trials where Sally's fortunes continually seesawed, reads like a splendid thriller. . . . An accomplished writer, [Bailey] provides engaging pen-sketches of the chaos, exhilaration, and many horrors of life in New Orleans. . . . What Bailey himself makes of all this is left—in the manner of the best thriller writers—until the very last page."

—The Sydney Morning Herald Spectrum

"John Bailey's stupendous book, based on a true story . . . is a splendid reconstruction. . . . It's a wonderful read."

—Australian Country Style

"A living, breathing morality tale delivering timeless messages about freedom, truth, and justice . . . One person is carefully spared critical exposure, however—the woman at the human heart of this story, Salomé-or-Sally. That's until the last page of the book. Then Bailey finally breaks the suspense, delivering his own unforgettable verdict."

—Australian

LOST GERMAN GIRL

Also by John Bailey

The White Divers of Broome: The True Story of a Fatal Experiment

LOST GERMAN SLAVE GIRL

The extraordinary true story of Sally Miller and her fight for freedom in Old New Orleans

JOHN BAILEY

Copyright © 2003 by John Bailey

All rights reserved. No part of this book may be reproduced in any form or by any electronic or mechanical means, including information storage and retrieval systems, without permission in writing from the publisher, except by a reviewer, who may quote

brief passages in a review. Any members of educational institutions wishing to photocopy part or all of the work for classroom use, or publishers who would like to obtain permission to include the work in an anthology, should send their inquiries to Grove/Atlantic, Inc., 841 Broadway, New York, NY 10003.

First published in 2003 in Australia by Pan Macmillan Australia Pty Limited, Sydney, Australia

> Published simultaneously in Canada Printed in the United States of America

FIRST GROVE PRESS EDITION

Library of Congress Cataloging-in-Publication Data

Bailey, John, 1944 Dec. 15-

The lost German slave girl: the extraordinary true story of the slave Sally Miller and her fight for freedom / John Bailey.

p. cm.

Includes bibliographical references (p.).

ISBN 0-8021-4229-X (pbk.)

1. Mèller, Salomâ, b. ca. 1809. 2. Mèller, Salomâ, b. ca. 1809—Trials, litigation, etc. 3. Slaves—Louisiana—New Orleans—Biography. 4. Women, White—Louisiana—New Orleans—Biography. 5. German Americans—Louisiana—New Orleans—Biography. 6. Trials—Louisiana—New Orleans. 7. Slaves—Emancipation—Louisiana—New Orleans. 8. Slavery—Social aspects—Louisiana—New Orleans—History—19th century. 9. New Orleans (La.)—Race relations. 10. New Orleans (La.)—Biography. I. Title. F379.N553M553 2004

F379.N553M553 2004 305.8'9687295'076335—dc22

2004050264

Front cover image: *The Match Girl*, 1834 (oil on canvas) by George Whiting Flagg (1816–97). Reproduced with the permission of The New York Historical Society and The Bridgeman Art Library.

Grove Press an imprint of Grove/Atlantic, Inc. 841 Broadway New York, NY 10003

06 07 08 09 10 10 9 8 7 6 5 4 3 2 1

CONTENTS

Author's Note		ix
1	Mary Miller	1
2	The Children of Slaves	11
3	The Year Without Summer	20
4	New Orleans	48
5	Sally Miller	68
6	John Fitz Miller	81
7	Bridget Wilson	92
8	Salomé Müller	111
9	The First District Judicial Court of New Orleans	128
10	The Defense	154
11	Judgment	184
12	The Appeal	196
13	A Presumption in Favor of Liberty	213
14	The Children of Salomé Müller	218
15	Polly Moore	223
16	Nullity	237
17	The Woman Who Remembered Nothing	253
Endnotes		258

... the slave is bound to risk his safety in the service of his master, cannot decline any service, still less leave the service, but is wholly absolutely, and unreservedly under the absolute control, nay caprice of his master.

Judge Albert Duffel of Louisiana, 18601

very book has its moment of conception. For this book, it occurred in the quiet corner of a law library on a university campus in Louisiana. I was undertaking research on the laws of American slavery. My plan was to write a modest volume explaining in nonlegalistic terms the petty regulations and day-to-day controls on slaves in the days before the Civil War (1861-65). I hoped to answer the question of whether slaves were without rights or legal protections. For example, were there any limits to the ferocity of discipline? Could slaves be murdered at will by their masters? Could slave men be castrated to make them more docile? Could women be raped with impunity? Did masters have an untrammeled right to sell children apart from their mother? Were slaves allowed to marry whomever they liked? In fact, did slave marriage exist at all? Could slaves save money and buy themselves into freedom? If a white overseer fathered a child by a slave woman, did that child belong to the mother, the father, or the plantation owner? Was it a crime to teach slaves to read and write?

To a citizen of the twenty-first century these sound like bizarre

questions, but not to the citizens of the slave-owning South. They were issues of constant and critical concern to ordinary people as they went about their daily business of owning other human beings. To my surprise I discovered that there were hundreds of laws and rules about slavery in the statute books. Legislators, lawyers, judges, and priests gave the regulation of slave life and the responsibilities of ownership close and detailed attention. I was even more surprised to discover that there were thousands of cases on slavery in the volumes of America's law reports. I found judgments touching upon almost every conceivable aspect of slavery. Even litigation concerning a mortgage reveals much when the mortgaged property is a tenyear-old girl. The judgments told of blood-curdling brutality, iron discipline, and a judicial hardness of heart. But they also told of compassion, clemency, and a high regard for justice. It was a checkerboard of darkness and light. I read the decisions of judges who flexed the law to free slaves, and of those who bent the law to ensure that slaves could never be free. I read of cases where judges speedily dispatched slaves to the hanging tree, but I also read of judges who went to uncommon lengths to ensure that slaves received a fair trial—even in emotionally charged cases such as the rape of a white woman or the murder of a master.

My plan to write a book on slave law unraveled when, one day, as I struggled to bring some semblance of order to my unruly and ever-expanding manuscript, I opened a volume of the Louisiana law reports for 1845.² On page 339 I met Sally Miller, the Lost German Slave Girl. I was immediately enthralled by her story. By the end of the day I had shoved my notes on lawyers, judges and politicians into my bag and, opening a fresh page in my diary, had begun to jot down ideas for an entirely different project—this one, on the saga of Sally Miller's bid for freedom.

The story of the Lost German Slave Girl was undoubtedly one of the most extraordinary cases in slave litigation. When she was discovered in 1843 she was working in a squalid cabaret near the New Orleans waterfront, the property of one Louis Belmonti. A succession of German immigrants living in the city came forward to say that they knew her as Salomé Müller, a white child, born in the village of Langensoultzbach in the lower Rhine. They swore in court that her

father was a shoemaker and recalled the time he had migrated with his family to the United States twenty-five years earlier. They told the judge that the last time Salomé had been seen, it was as darkness gathered on a day in April 1818 when she stood on a jetty on the edge of a swampy wilderness in St. Mary's Parish, Louisiana.

Litigation about the identity of Sally Miller ran in the Louisiana courts for years. What commenced as a petition for freedom developed into a trial about the honor of a wealthy Southern gentleman accused of the heinous misdeed of enslaving a helpless white girl. As claims and counterclaims were made, and mutual accusations of fraud, lies, and simpleminded gullibility were leveled, Sally Miller's fate became a cause célèbre and was discussed at length by river men in the taverns, traders in the markets, idlers in the coffeehouses, and matrons in the parlors of the highborn. People strained for a glimpse of her whenever she walked abroad so that they too could pass judgment on whether African or German blood flowed in her yeins.

For me, the appeal of writing about Sally Miller was that I could use her story to illustrate many of the issues I had been attempting to cover in my book on slave law—in particular, how judges decided issues according to principles of property when that property was human, and how it was possible for white-looking people to be regarded as slaves.

One difficulty of relating the tale of the Lost German Slave Girl is that controversy and dispute attended it from beginning to end. The warring sides disagreed about almost everything. Ultimately, the telling of any story depends on the storyteller: it is the writer who makes the choice about what to select, what to reject, and what to emphasize. The balance between truth and rhetoric is in his or her hands. The approach I have taken is to let both sides speak for themselves, as they did, vehemently and emotionally, a century and a half ago. In some instances I have created conversations and scenes, and have woven a sense of the times and the reality of slavery into the narrative. Where the court records are incomplete I have made assumptions about the progress of the litigation and the tactics of the parties; however, the story I relate is true in all its basic elements and the law is as accurate as I can make it.

Occasionally I use specialist or archaic terms. The meaning of most of these terms is obvious but some, like chameleons, take their sense from their uniquely Creole surroundings.

The term Creole itself is an example—it hasn't only altered its meaning over time, it has branched into submeanings that fight with the original. Initially it meant a person of European parentage born in a Spanish or French colony, and in Louisiana, it generally came to mean the French living there prior to its acquisition by the United States in 1803. Over the years, the term extended to the slaves owned by the Creoles, to their music, their cooking, their dialect, and so on. Nowadays it means anything derived from that unique medley of French, Spanish, and African American cultures that today makes a visit to Louisiana such a heady experience. During the period I am writing about (1818-50), the group most likely to rejoice in being called Creole were members of the French slavocracy, and, in a pinch, they might have tolerated the word being used (as an adjective) to describe their mulatto children, or the horses they raced, or the cattle they raised, or the food they ate. Creoles at that time were mostly wealthy, cultured, and (according to the Americans) exceedingly arrogant.

There was no love lost between the Americans and the Creoles. According to the Creoles, the *Américains* were typically slick, grasping merchants or Yankee bankers interested in nothing more than money. In return, the Americans called the Creoles, *Johnny Crapaud*. Both looked down upon the noisy, drunken, quarrelsome keelboat and flatboat men who sailed down the Mississippi River—these were called *Kaintocks*, although they were just as likely to come from Tennessee, Mississippi, or Ohio, as Kentucky.

The uninitiated sometimes use the word *Creole*, when they really mean *Cajun*. Cajuns are also of French origin. The British hounded them out of Nova Scotia (then called Acadie) in the 1750s because of their unreliable loyalty to the Crown—they were, after all, French, and Catholic to boot. Many eventually settled in Louisiana along a stretch of the Mississippi afterward called the Acadian Coast and in the bayou country of the western parishes. They became famous for their spicy food and toe-tapping music.

The French influence remains strong in New Orleans, despite the

passing of the years. Faubourg, the French word for "suburb," is still used, and the most famous faubourg in New Orleans is the Vieux Carré, literally "Old Square." It is now known as the French Quarter, although most of the much-admired colonial architecture is in fact Spanish. During the decades of my story the area was sometimes known as the Vieux Carré and sometimes as the French Quarter, and I use both terms interchangeably.

A bayou (the Choctaw Indian word for "creek") is a watercourse linking a river, lake, or swamp. There are thousands of bayous in low-lying Louisiana, and many fit the popular image of eerie, slow-moving, dark waters, hemmed in by overhanging trees and infested with alligators. Some bayous in the northern parishes of Louisiana lack the *Spanish moss* (a trailing, gray-colored plant of the pineapple family) and actually flow quite quickly.

A tignon is a bandana-like headscarf of brightly colored cotton. The story goes that a Spanish governor, dismayed at the unsettling allure of the free ladies of color, ordered that they keep their hair covered at all times. Taking his edict as a compliment, the ladies continued to wear the tignon, long after the law had lapsed.

A picayune was a small Spanish coin. One New Orleans newspaper

was called the Daily Picayune, as a reminder of its price.

In writing this book, the following people gave me technical assistance, advice, and succor (but only my partner, Anne, all three): Dunya Bouchi, Marie E. Windell, Jim Hart, Geraldine Moore, Garry Moore, Horst Thiele, Elizabeth Maddox, Heinrich Thiele, Matthias Schwerendt, Katrin Dahme, David Allan, Elaine Lindsay, Marele Day, Karen Penning, Robyn Flemming, Noelene Tabart, and Anne Mullin. Thank you, and especially Tom Gilliatt of Pan Macmillan, whose editorial assistance and calm advice guided me through many a crisis.

John Bailey Mullumbimby, 2003

가 있는 것이 있다. 취임 사람이 가장하는 것이 되었다. 그 사람이 되었다는 것이 되었다. 1. 기계 : 기계 : 1. 기계 : 1

A white person of unmixed blood cannot be a slave.... [But] a person apparently white may, nevertheless, have some African taint... sufficient to doom to slavery.

Chief Justice Robinson of Kentucky, 1835³

OND

MARY MILLER

The elevation of the white race, and the happiness of the slave, vitally depend upon maintaining the ascendancy of one and the submission of the other.

Chief Justice Watkins of the Arkansas Supreme Court, 1854⁴

Madame Carl Rouff left her timber-framed house in Lafayette to travel across New Orleans to visit a friend who lived in the Faubourg Marigny. It was a distance of four miles, following the bend of the Mississippi as it turned abruptly on itself in its winding course to the Gulf. She caught the mule-driven omnibus along Tchoupitoulas Street to the city, a journey of an hour and a quarter, swaying gently as she watched the unloading of the keelboats, skiffs, and packets anchored alongside the levee. She had allowed herself plenty of time, so it was without urgency that she alighted and crossed the expanse of Canal Street to enter the Vieux Carré. She had only a vague idea of how the streets fit together in the narrow grid at the back of the Place d'Armes, so doggedly she followed Bourbon Street, hoping eventually to run into Esplanade Avenue, which would guide her to her destination.

She entered an area of narrow streets and alleys where a jumbled variety of wooden tenements leaned against one another for support. For decades, poor Spanish-speaking families had lived there, but increasingly their homes were being bought up by Américain speculators who had converted them into flophouses, gambling dens, and bawdy houses for the boatmen who poured in from the riverfront

each evening. It was an area of New Orleans where no respectable woman should venture, even in daylight. Set incongruously in its midst, enclosed by a high wall on three sides, was the Ursuline Convent.

As Madame Carl crossed the street, she felt the heat of the sun reflecting off the surface of the road. She hadn't been feeling well for some months, so it was no surprise to her when she suddenly felt light-headed. She placed a hand on the front rail of one of the houses and took a moment to recover her breath. In front of the nunnery was a small marble statue of a tormented Jesus, a showy display of Catholic idolatry of which she disapproved. Running down to the levee was a terrace of narrow buildings of weather-bleached clapboards. On the front doorstep of one, sat a woman bathed in sunlight, her legs drawn to her chest, her head resting on her knees.

Madame Carl waited, hoping she would soon feel better. She watched a black man push a barrow of watermelon from the waterfront; some urchins, naked to the waist, scrambled to kick a rag ball along the gutter. After a minute or two, she felt strong enough to continue. She pushed herself off the rail. She was no more than three paces from the sidewalk on the other side of the street when the woman sitting on the step sighed deeply and, with her eyes closed, faced into the sun. Madame Carl stopped and took a sharp intake of air. She knew her. It was Dorothea Müller.

Madame Carl held still, fearful that if she moved, the marvel would end. The same high cheekbones, the same smooth, olive skin, the same full mouth. Dorothea Müller. On that stinking, foul ship, tossing endlessly on the Atlantic, she had watched Dorothea's husband carry her body onto the deck, wrap it in a canvas sheet, and slide the bundle into the sea.

Dorothea, whispered Madame Carl to herself. She was looking at the death mask of someone who had died over a quarter of a century ago. Dorothea! Her dearest friend, her school companion in a village half a world away.

The woman opened her eyes and Madame Carl stared intently into her face. She was as Madame Carl remembered her, seated just like that, on the front step of Frau Hillsler's house.

How are you, Dorothea? asked Madame Carl, her voice quavering

MARY MILLER

with emotion. The woman didn't answer. Gently Madame Carl repeated the question. She took a few steps closer and bent over her. Where have you been, Dorothea? It's been so long. The woman, discomfited by Madame Carl'ss gaze, shook her head.

But, of course, this couldn't be Dorothea. Madame Carl recoiled at her own stupidity. Then it struck her with a clear and abiding certainty. It was Dorothea's lost daughter, Salomé. Madame Carl stood spellbound. Salomé, she whispered. Is that you, Salomé?

My name is Mary Miller, missus.

Madame Carl looked at the woman in bewilderment. You are Salomé, the child who was lost.

The woman shook her head once more. Madame Carl flinched in disappointment. She didn't know what to say. She began to feel ill again and leaned against the wall of the building for support. She studied the figure beneath her. The woman wore a tignon of brightly colored madras cotton and a dark kersey shawl over a long dress of coarse linen. They were slave's clothes. Her face was tanned and her hands were engrained with dirt. Unsettled by the attention of Madame Carl, the woman stooped her shoulders in submission. At that gesture of huddled servility, it occurred to Madame Carl that the woman might be a slave. It was an appalling thought that hit her in the pit of her stomach. How could this be? Madame Carl's thoughts tangled in confusion. Was her mind unraveling in the heat?

Please, whispered Madame Carl.

The woman looked up. I am a yellow girl. I belong to Mr. Belmonti, she said, inclining her head toward the interior of a shop behind her.

Madame Carl straightened and took a deep breath. Could she be mistaken? The two women glanced fleetingly into each other's eyes, hoping to understand the other's thoughts. Madame Carl asked her to remove her tignon. The woman on the doorstep paused, then reached behind her head, unwrapped the cloth, and shook her head, unfurling long, dark auburn locks. The hair was Dorothea's, but it was the woman's action—the toss of her head, the sensual delight in the display that took Madame Carl's breath away. Again Madame Carl was shaken, but she pressed on. You are not rightly a slave, she said. You are Salomé Müller.

There was a blank expression on the woman's face, then a look of puzzlement, followed by a slow grin as she pondered a joke she didn't get. Then, finding no answer, she bowed her head in deference.

You are of pure German blood, urged Madame Carl, her voice rising. I knew your mother. I know you. We came together to this country—on the same ship—twenty-five years ago. You are German.

As she waited for a response, Madame Carl's attention was snagged by a shadow moving in a room of the house behind the woman. Madame Carl turned and caught a glimpse of a moon-faced man with a bushy mustache who was leaning forward to listen to their conversation. He stepped back out of view. Salomé's owner, she supposed. A Frenchman. She looked around, noticing for the first time that she was standing outside a barroom of some sort—inside the front parlor were tables and chairs, and a bench containing bottles of colored liqueurs and a cabinet of cigars. She turned back to the woman on the doorstep. Please don't be afraid. I can help you. You are German.

No, I am Mary Miller and I belong to Mr. Belmonti. You ask him. Her eyes begged to be left alone.

Please listen to me. You are not a slave. You are from the Müller family.

There was no response. It was hopeless. Madame Carl wondered if she should speak to the woman's owner, but that would take more strength than she felt she could muster. She could take no more. Abruptly she turned and walked away. At the corner she stopped and looked back. The doorway was empty. It was as if the woman had never existed. In her place stood her master, a tall, plump man smoking a cigar.

Over a century ago, two Louisiana writers, J. Hanno Deiler (a professor at Tulane University in New Orleans) and George W. Cable, working independently of each other, told the story of the Lost German Slave Girl. Deiler's article appeared as a pamphlet in a German-language newspaper in New Orleans in 1888. Cable's version appeared in *The Century Magazine* of 1889 and was later included as a chapter in his *Strange True Tales of Louisiana*. Since neither spoke to either Madame Carl or Mary Miller, their reports of

MARY MILLER

the conversation between the two women were clearly imaginative creations, derived from hand-me-down renditions supplied by relatives. The version presented here is adapted from both these sources and from the notes of evidence of the trial when Salomé Müller sought her freedom in the First District Court of Louisiana in 1844.⁵

In Cable's version, on the very day Madame Carl discovered Mary Miller, she enticed her away for a few hours so that she could show her to members of the German community in New Orleans. However, according to the lawyer who represented Salomé Müller in her quest for freedom, this didn't happen until "the following day, or shortly after". Whenever it was, soon after the initial meeting Madame Carl managed to convince Mary Miller to accompany her across New Orleans to the house of Francis and Eva Schuber in Lafayette. Eva Schuber was Salomé Müller's cousin and godmother, and had accompanied the Müller family on the voyage to America. If anyone could confirm to Madame Carl that she had found the lost girl, it would be Eva.

The journey to Eva Schuber's house took Madame Carl and Mary Miller through the market of the Vieux Carré. Madame Carl was surprised, then disconcerted, to see that her companion was known to many of the black labourers in the market. Madame Carl had to wait as Mary stopped to talk to a half-naked man carrying chickens tied by the legs to a pole balanced across his shoulders, then to some slaves loading boxes of vegetables on to a dray. A Negro butcher wearing an apron spotted with blood called out to her. Madame Carl waited patiently while Mary chattered for a few moments, and then together they walked to Canal Street. From there they caught the omnibus to Lafayette.

Nowadays, Lafayette is part of the urban sprawl of New Orleans, but in the 1840s the area near the river was given over to market gardens, slaughterhouses, bone grinders, and tanners. Eva Schuber and her husband lived in a narrow timber house of two stories on the corner of Jersey and Jackson streets.

Eva Schuber later gave evidence to the First District Court about what occurred on the day her goddaughter was returned to her. She

said she was standing on the front steps of her house when she saw Madame Carl opening the front gate. She hadn't seen Madame Carl for some time and it wasn't her friend's habit to make an unannounced visit.

What happened then? her lawyer had asked.

Eva paused, her eyes half-shut, as if visualizing the scene.

I noticed a woman standing behind her, and I said, Is that a German woman?

What did she say?

She said yes, and I said, I know her.

And then?

Madame Carl said to me, Well, if you know her, who is she?

And what did you say?

I then replied, My God, the long-lost Salomé Müller!

Eva took her visitors inside— into a house so small that one of her sons slept in the parlor directly off the street. He sat on his bed as the three women entered. Then, recognizing Madame Carl, he stood and bowed to her. He looked at the other woman, but his mother made no introduction and instead, in an excited voice, told him to run down the street and get Mistress Schultzeheimer and Mrs. Fleikener. He was to tell them that one of the lost daughters of Shoemaker Müller had returned. They must come immediately and see for themselves. He must tell them to hurry. The boy put on his boots and scrambled down the steps.

Eva pushed her son's bed against the wall and placed three chairs in the centre of the room. She indicated to Mary Miller that she should take a seat, and she and Madame Carl took chairs facing her. For a full minute, Eva sat opposite Mary Miller and examined every feature of her face. It was amazing. She was the image of her mother. The same full, rounded face with small dimples in each cheek, the deep, dark eyes, the olive complexion, and long auburn hair. Eva took it all in, and the more she looked, the more certain she became that her goddaughter had returned. Not a day had passed in the last twenty-five years when she hadn't thought of her. There wasn't a day when

MARY MILLER

she hadn't prayed for her return. At last, at last, she was lost no more.

She is a slave, whispered Madame Carl.

Eva stared at her friend in disbelief. How could she be a slave? she asked. Madame Carl didn't know. She explained how she had found her outside a low-class barroom in the Spanish part of the city. The two women exchanged glances.

Does she remember her mother?

She remembers nothing.

Oh, but she must. Her beautiful mother.

Madame Carl shook her head.

Does she remember her father?

Again Madame Carl shook her head.

Eva returned her gaze to the woman who would be Salomé Müller. He made shoes, Eva insisted, pointing to her own shoes.

There was an awkward silence.

What happened to your sister? asked Eva.

I remember no sister, replied Mary Miller.

Her master's name is Louis Belmonti, said Madame Carl. A Frenchman.

Now both women avoided the eyes of the woman seated in front of them. A feeling of dread enveloped Eva. How could she be a slave? It wasn't supposed to be like this. For years she had rehearsed the joyful reunion in her mind—the tears of emotion, the laughter, the rejoicing as all her German friends gathered to welcome home the Müller sisters. She looked in sad dismay at Mary Miller. This couldn't be Salomé.

There was a clumping up the steps and Mrs. Fleikener burst into the room. Her husband, her son, her daughter, and her daughter's husband followed. Eva and Madame Carl rose to greet them. More people entered: Mistress Schultzeheimer, along with Eva's son who had been sent to collect her. They stood in a circle staring at Mary Miller, still seated in her chair in the middle of the room. Madame Carl made the introductions. Mary Miller looked blankly into their faces.

The news spread quickly from house to house. The woman who lived next door crept into the Schubers' front room to have a look, followed by her five children. Outside, on the front steps, there were

whispered conversations as the history of Daniel Müller and his children was explained to neighbors. Questions were asked and the astounding news conveyed: two of Daniel's daughters had been lost for twenty-five years, but now one was found. Eva's husband, Francis, returned from work to find a crowd spilling out into the street. People rushed to tell him what had happened, and then he was ushered into the house to stare at the woman sitting on a chair in his front parlor. Is that one of the two girls who was lost? he asked.

Then occurred an incident that would be as hotly contested as any other during the court battles that followed. According to the testimony of Eva and Francis Schuber, they took the slave woman into their bedroom and shut the door. Eva sat her on the bed and told her that there was one certain way of identifying her as Salomé Müller. The real Salomé had moles, the size of coffee beans, on the inside of each thigh just below her groin. They were Salomé's identification and positive proof of who she was. Did she have such marks? Mary Miller said that she did. Eva insisted on seeing them. As her husband stood guard with his back to the door, she pushed the passive Mary back on the bed, pushed her legs apart, and gathered up the folds of her dress. She examined her right leg. The mole was there. In mounting excitement she rummaged along the other leg, then raised herself from the bed, her face beaming in exultation. She was Salomé Müller. Her goddaughter had returned. She rushed out of the room and into the front parlor. There could be no doubt. Truly, Salomé Müller had returned. There was a great cheer, followed by clapping. Jubilant voices repeated the news to those in the street. Eva had bathed Salomé when she was a child and had seen the moles on her legs. And now she had seen them again. The lost girl had been found. She was back with those who loved her. At last her troubles were over.

In Eva and Francis Schuber's bedroom, the woman who had been identified as Salomé Müller lay spread-eagled on the bed, staring with glazed eyes at the ceiling.

Mary Miller didn't remain with her rescuers that night. She slipped away from the celebrations and hurried across the city to the house of her owner, a journey that took her several hours on foot.

MARY MILLER

A few days later, Eva Schuber set off in pursuit. She had hoped that Madame Carl would accompany her, but when she called to collect her friend, she was too ill to rise from her bed. Madame Carl gave detailed instructions on how to find Belmonti's cabaret. It was located in a street close by the convent, she said. In Madame Carl's stead, Eva took along her neighbor, Mrs. White, for moral support.

Belmonti's establishment was described by Cable as "a small-drinking house, a mere cabaret." Cabarets in New Orleans (and there were scores of them) weren't grand affairs—a few chairs for customers to sit on while being served spirits and coffee. They were usually run in single-fronted dwellings; the owners lived upstairs, and often a prostitute conducted her business in the back room. Some cabarets sold groceries, bread, and vegetables, while others were fronts for gambling dens. The better class of cabarets might serve meals and have a man playing a fiddle in the evenings. Belmonti's cabaret wasn't of the better class. His only assistant was Mary Miller, who carried drinks to the tables, went to the market each day to purchase food, and attended to the cleaning and dishwashing.

When Eva Schuber and Mrs. White arrived, Mary was setting up chairs in the street. She took a step backward as she saw the two women striding toward her. However, it wasn't part of Eva's plan to speak to Mary; instead, she swept inside looking for Belmonti, leaving Mrs. White to detain Mary outside. Eva found him seated at a low table in one of the rooms with a small cup of coffee in his hand. He looked up in surprise, but then observing the woman's dress of German respectability, seemed to guess who she was and stood up to bow to her. He spoke to her in French, a language Eva understood imperfectly, but she took in enough to grasp that he had been expecting her. With elaborate courtesy, he beckoned for her to sit down. He offered her a drink and pushed a plate of beignets in her direction. She refused both, instead asking him if he spoke English. Little, little, he replied, showing a thin gap between his thumb and forefinger.

Eva came straight to the point. He must release Mary. Her real name was Salomé Müller and she was a white woman. She told him of the tragedy of the family's journey to America and the death of Salomé's mother, and of how no one knew what had happened to Salomé and her sister, Dorothea. She told him about the moles.

Couldn't he see that there could be no doubt about it? Salomé was rightly German and must be freed.

Belmonti smiled. Mary had never said anything to him about being freed, he replied in broken English. He had paid a lot of money for her. She had been with him for over five years.

Mary is pure German, Eva responded. Her real name is Salomé.

He shook his head. No, no, she is Mary, the slave. That is her name.

Eva, her voice rising in anger, retorted that the woman was Salomé. And she was free. Belmonti appeared to be enjoying himself. He again offered Eva coffee; again she refused. No, she didn't want biscuits either. He shrugged, then explained at length why it was best for Mary to remain where she was. Her life was nice with him, he said. When he had purchased her from Mr. Miller, he had said that since she looked as white as anyone, she could easily run away. He might have freed her, but Miller had told him that it was the law that she would have to leave the country, so he couldn't. Mary was happy with him. She bought the meat and vegetables, she cooked, and she served in the cabaret. Why should she want to be German?

TWO

THE CHILDREN OF SLAVES

One man—who to my inexperienced eyes seemed as white as myself ... —got up from his seat as I passed, and asked me to buy him; "I am a good gardener, your honor," he said, with an unmistakable brogue. "I am also a bit of a carpenter, and can look after the horses, and do any sort of odd job about the house."

"But you are joking," said I; "you are an Irishman?"

"My father was an Irishman," he said.

At this moment the slave-dealer and owner of the depôt came up.

"Is there not a mistake here?" I inquired. "This is a white man."

"His mother was a nigger," he replied. "We have sometimes much whiter men for sale than he is. Look at his hair and lips. There is no mistake about him."

Charles Mackay, describing his visit to a slave depôt in New Orleans, 1857⁷

y the 1840s, slavery had existed in America for over 200 years and, through interbreeding, there were a significant number of slaves who weren't pure African. Newspaper advertisements seeking the return of runaways described them in an array of colors ranging from deep black, through brown, tan, olive, bronze, and yellow, to pink and white. These were slaves born of liaisons between Europeans, American Indians, and Africans—but there was no equality about this; in almost every case, they were children born as a result of white men forcing themselves on subjected women.

The abolitionist writer L. Maria Child made white-looking slaves

her particular field of study, and in 1860 she shocked her Northern readers by revealing a number of instances where persons with white skins were held as slaves. Over many years she had painstakingly collected items from the newspapers of the South, and published them under the censorious heading: Southern Proofs that Slavery is a Parental Relation. From the many examples she found, three are reproduced here:

Ranaway from me, a negro woman, named Fanny. She is as white as most white women; with straight light hair, and blue eyes, and can pass herself for a white woman. She is very intelligent; can read and write, and so forge passes for herself. She is very pious, prays a great deal, and was, as supposed, contented and happy. I will give \$500 for her delivery to me.—JOHN BALCH, Tuscaloosa, Alabama, May 29, 1845.

\$25 REWARD. Ranaway from the plantation of Madame Duplantier, a bright mulatto, named Ned, about thirty-five years old; speaks French and English. He may try to pass himself for a white man, as he is of a very clear color, and has sandy hair. From the *New Orleans Picayune*, Sept. 2, 1846.

A steamer, on her way from this place to Natchez, had, on her last trip, forty-seven slaves on board. Our informant states that among these was a beautiful young girl of thirteen, who, he learned with astonishment and pity, was a slave; as hopelessly in slavery as the blackest of her companions, all of whom were in charge of traders, on their way to New Orleans. The girl was nearly white, with straight hair, blooming complexion, attractive shape, and gentle bearing. She is the daughter of a merchant on the Missouri river, whose well-known intention was to emancipate her. But he died, and his executors, or heirs, thought it would not do any longer to bring her up together with the merchant's other daughter, her white sister; therefore she has been sold away into the South.—The *St. Louis Democrat*, Mo., Feb. 1860.8

THE CHILDREN OF SLAVES

A cruel sort of unnatural selection was taking place—if, over many generations, masters tended to choose white-looking women for their sexual encounters, the offspring would be even whiter, with the result that people one-eighth African, or even one-sixteenth, one thirty-second, or one sixty-fourth, remained in bondage. In Georgia, Chief Justice Lumpkin of the Supreme Court, in the course of writing one of his opinions, mused about how easily one could be embarrassed by assuming that a white-skinned person was freeborn:

A mistress and her maid recently received Episcopal confirmation together, kneeling side by side at the same altar, boarding at the same hotel, where the latter was received and treated as a white woman by the inn-keeper and his female guests, when the latter turned out to be a mulatto, and was promptly hurled from her position of social equality. A man, at the beginning of this war, dropped into a village of one of our counties in Middle Georgia, and becoming rather famous for his pugilism, he was chosen an officer in one of the volunteer companies enlisting for the military service. His status was never questioned, until, accosted rather familiarly by his fellow-servant, who had known him long and intimately, an investigation was had, and Sambo was returned to his owner. Which of us has not narrowly escaped petting one of the pretty little mulattos belonging to our neighbors as one of the family?⁹

To most Southerners the presence of people with pale skins in slave gangs was accepted as a matter of course. In Louisiana the Creole slavocracy created an extensive vocabulary for the grades of miscegenation: a *mulatto* came from the paring of a white and an African, a *quadroon* from a white and a mulatto, a *griffe* from a mulatto and an African, a *metif* from a white and a quadroon, a *marabon* from a mulatto and a griffe, a *sacatra* from a griffe and an African, a *meamelouc* from a white and a metif, and a *sang-melee* from a white and a meamelouc.¹⁰

The universal rule of the South was that if the mother was a slave, so was her child. The law was contained in the Latin tag of partus

sequitur ventrem. Literally, it meant: "that which is brought forth follows the womb." If the mother was a slave, then the child was a slave. This wasn't the ancient common law of England where the status of the child followed the father, and confined partus sequitur ventrem to contests about the ownership of animals. Maryland in the seventeenth century, assuming that slaves weren't animals, briefly followed the common law, but quickly abandoned it. A moment's consideration suggests why. If it wasn't for partus sequitur ventrem, a slave woman who became pregnant to a white man could demand freedom for her child. Masters who raped their female slaves would soon find themselves surrounded by bastards claiming to be free. A slaveowner would be at risk of losing the harvest of his female slaves' children to the white overseer he had hired, or to any passing white man who seduced one of his female slaves.

Partus sequitur ventrem was a rule calculated to perpetuate slavery through generations—bondage was transmitted like a birth defect, from mother to daughter, then to her daughter, and to her daughter,

in perpetuity. Two cases show how it worked in practice.

In 1824 the Virginian Court of Appeals decided the case of *Maria v Surbaugh*. Such was the stature of the Virginian court that judges in most of the slave states subsequently followed its reasoning. The facts were simple enough. Mary's owner wrote a will freeing her on her thirty-first birthday. Unfortunately for Mary, she had a long wait—she was only three when her owner died. By the time she was thirty-one, she had been sold several times and had given birth to four children. Under Virginian law Mary was free, but what of her children? Mary's owner argued that the children were his property, because when they were born she was still a slave. The court agreed, saying: "The sole inquiry then, is, whether, at the time of the birth of the children the mother be in fact slave or free, without regard to what may be her future state. . . . "11

In another case, a court in Kentucky considered the will of Job Johnson, which read: "I give unto Margaret Johnson, my beloved wife, the negro girl Lytha, to wait upon her as long as she lives, . . . and then she shall be free." Margaret Johnson lived for many years, and while Lytha waited upon her, she gave birth to seven children. Eventually, on Margaret's death, Lytha became free, but her seven children did not. Said the court: "The children having been born

THE CHILDREN OF SLAVES

when their mother was a slave, are themselves slaves, according to the maxim partus sequitur ventrem."¹²

Partus sequitur ventrem also served to solve the tricky legal problem of ownership of a child when the mother belonged to one master and the father to another. The rule produced the fair result (at least between slaveowners) that, since the master of the mother had to bear the cost of feeding her during pregnancy, he should reap the benefits. Or as Thomas R.R. Cobb, in his influential An Inquiry into the Law of Negro Slavery in the United States of America, put it: "From principles of justice, the offspring, the increase of the womb, belongs to the master of the womb." 13

Another consequence of *partus sequitur ventrem* was to gut the role of fathers. It mattered not whether the father was a slave or free man, white or black—the offspring of slaves belonged to the owner of the mother. Children could be sold, hired, or sent out of the state without their fathers' knowledge. A free man who married a slave woman had to live with the possibility that their children could be taken from them at any time. As a judge in Kentucky once dryly observed, "The father of a slave is unknown to our law." ¹⁴

Even if a free father was prepared to acknowledge his children, it made no difference. Lewis Young, a free man of color, owned several tenements, a substantial farm, and a number of slaves, including his own wife. When his two children came forward to claim their inheritance, they found that William F. Cleaveland, described in the judgment as "the friend of Lewis Young" who "frequently advised him in matters of business," had seized all of their father's property. The court ruled there was nothing Lewis's children could do about it. Since their father had neglected to free their mother, they were slaves and were incapable of inheriting anything. "A slave can have no standing in a court of chancery in this State," said Judge Ligon.

He cannot hold property, and consequently cannot litigate the title to it.... His person, his labor, and his earnings belong to his master, and are held or enjoyed by the slave only by permission of the master...[The children of Lewis Young] come here under a false title, claiming to be free persons, when in fact they

are slaves, and by this suppression of their status, they seek to litigate in this court in fraud of its jurisdiction.¹⁵

In another case, this time in South Carolina, a white man, John Fable, was described as a foreigner who "settled in Charleston some years ago" and "had two [illegitimate] colored children by a female slave." Unfortunately, the mother of his children was held in servitude by another, with the result that Fable's children were not his. By his will, Fable directed that his executor should purchase one of them, if practical, out of the funds of the estate.* This his executor was willing to do, and the child's owner was willing to sell. The problem was that Fable's brother and sister, whom he hadn't seen for years, arrived from Philadelphia, determined to upset the will. They succeeded. Freeing slaves was forbidden, said the court, and a father's dying wish made no difference. 16

The obverse of partus sequitur ventrem was that a free woman could not give birth to a slave child. In 1788, John Fitzgerald of Virginia wrote a deed liberating Mary Shaw, but "reserving to myself, my heirs, etc, nevertheless, an absolute right and claim to all such children or children, which the said Mary Shaw may hereafter bring, or may have born of her body." Thirty-nine years later, Fitzgerald's daughter, acting on the authority of this deed, seized one of Mary Shaw's children. The Virginian Court of Appeals ruled that she couldn't do this:

When a female slave is given to one, and her future increase to another, such disposition is valid, because it is permitted to a man to exercise control over the increase and issue of his property, within certain limits. But when she is made free, her condition is wholly changed. She becomes a new creature; receives a new existence; all property in her is utterly extinguished; her rights and conditions are just the same as if she had been born free. . . . A *free* mother cannot have children who are *slaves*. Such a birth would be monstrous both in the eye of reason and of law.¹⁷

^{*} Emancipation was prohibited in South Carolina at that time (1835) and it seems that Fable's intention was to get around the law by arranging that his executor, after purchasing his son, should give him a large degree of liberty (called "quasi-freedom" in the law report). The report doesn't say why Fable directed that only one of his children should be purchased by the executor. Perhaps there wasn't enough money in the estate to buy both of them.

THE CHILDREN OF SLAVES

The rule that a free woman couldn't give birth to a slave applied even if the father was a slave. Her children were free, but the father's role as a parent was stillborn—or, as was pithily expressed by a judge in 1822, "the free mother...shall have the exclusive custody and control of them, as though their father were dead." 18

One of the more pernicious consequences of *partus sequitur ventrem* was its ability to reach out, years after a woman was emancipated, to drag her offspring back into slavery. It even had the power to skip generations and enslave the grandchildren of freed slaves. This is what happened to the grandson of a slave named Polly.

In 1805, John Moring signed a deed freeing Polly—not immediately, but after she had served him for nine years. During those nine years, Polly had a daughter. Eventually the day of deliverance arrived and John Moring released Polly, who took her daughter with her in the walk to freedom. In 1830, Polly's daughter had a son. Then, in 1838—that is, fourteen years after Polly was freed—John Moring returned to seize Polly's grandson and immediately sell him into slavery. The child was eight years old. What possible grounds could Moring have had for thinking that he could take an eight-year-old boy from the home of his mother and grandmother, both living free in North Carolina?

Moring's claim was based on the *partus sequitur ventrem* rule, but with a sting in its tail. His argument was that when Polly's daughter was born, Polly was still his slave; thus, Polly's daughter became his. Polly was later freed, but that made no difference to the status of Polly's daughter. And because Polly's daughter was his slave, her child was his slave as well.

Chief Justice Ruffin of the North Carolina Supreme Court heard the appeal. In the years prior to the Civil War, Ruffin was regarded as one of the true intellectuals of the Southern bench and his views carried weight far beyond his own state. He was charming, well read and religious. He was also logical and unflinchingly in support of slavery. As Ruffin approached the task of deciding the fate of Polly's grandson, he was seemingly well aware of the difficulties of balancing compassion and jurisprudence:

There is a natural inclination in the bosom of every judge to favor the side of freedom, and [to have] a strong sympathy with ... persons ... who have been allowed to think themselves free and act for so long a time as if they were; and, if we were permitted to decide this controversy according to our feelings, we should with promptness and pleasure announce our judgment for the plaintiff [Polly's grandson]. But the court is to be governed by a different rule, the impartial and unyielding rule of the law.

And what was the impartial and unyielding rule of the law that was forcing the hand of the chief justice? It was *partus sequitur ventrem*—which meant that:

... the plaintiff's mother was born a slave, and so, consequently, was he. With this conviction it becomes our duty to affirm the judgment; consoling ourselves that the sentence is not ours but that of the law, whose ministers only we are.¹⁹

So an eight-year-old boy was sold to a slave trader, Moring became a little richer, and Chief Justice Ruffin concluded that he was power-less to intervene.

Although partus sequitur ventrem was followed in most slave states, increasingly judges and the legislators felt uncomfortable with its ability to pluck children from the families of free blacks and turn them into slaves.* Louisiana moved to lessen the rule's more obnoxious effects by enacting in 1838 that a child "becomes free at the time fixed for her [the mother's] enfranchisement." A few other states followed, but only in a halfhearted way. Laws in Virginia (1849), Kentucky (1852), and North Carolina (1854) said, in effect, that children born during a mother's wait for liberty were free—but if the owner wanted to clearly write that the children should remain as slaves, that direction would be upheld.

^{*} It was always open to masters, contemplating the future emancipation of their female slaves, to specify that children should be freed along with their mothers, but many neglected to do so.

THE CHILDREN OF SLAVES

A few weeks after Belmonti's refusal to release Mary Miller, Eva Schuber was awoken one morning by the sound of feet scraping on the front steps of her house. She lay in bed listening intently, then she heard a tentative knock. She rose and hurried along the corridor and slid open the latch. There stood Mary Miller clutching a canvas bag. The two women looked at each other.

Can you make me free? asked the slave.

Eva stared at her in surprise, then, in a wave of emotion, pulled her into a tight embrace. Oh yes, yes, Salomé. You shall be free.

As tears of joy tumbled down Eva Schuber's face, she nuzzled into the sweetness of her goddaughter's neck and vowed that she would never rest until she had fulfilled that promise.

THRIDID

THE YEAR WITHOUT SUMMER

What a wonderful country! What a future is still in store for you! How everything ferments and boils and germinates and sprouts and blossoms and ripens into fruit!

Friedrich Gerstäcker, describing America to those in Germany, 1850s²¹

They would rather live like slaves in America than citizens of Weinsberg; even if they were facing death they would not change their decision, because they can not live under the present conditions.

A report to the King of Württemberg, conveying the views of immigrants, 1817 ²²

or five seasons the winters came early, the summers seemed cooler, and the harvest was brought in later. Snow that should have melted by May lingered on the hilltops, ponds retained a sheen of ice until June, and frozen drifts remained wedged on the dark side of gullies, to be made deeper by the first snows of autumn. In July, ice storms shriveled the buds on trees. In August, when the oats, rye, and wheat should have been ripening, piercing winds rippled across the fields. And in September, farmers standing in their blackened gardens found themselves peppered with sleet.

Today, climatologists attribute the cold weather that ravaged the Northern Hemisphere in the years following 1813 to a series of volcanic eruptions half a world away. The first was the destruction of the entire cone of La Soufrière on St. Vincent Island in the West

Indies in April 1812. Just as this was clearing, Mount Mayon in the Philippines exploded in 1814, pushing an ash-laden vent seven miles into the atmosphere. Then the biggest of them all—Tambora, on Sumbawa in Indonesia, exploded in April 1815. With one blast the height of the mountain was reduced by 4,200 feet, leaving a caldera four miles wide. The explosion at Tambora was heard 800 miles away. Sir Thomas Stamford Raffles, commanding a British military force, reported that on Java, 300 miles distant, officers, believing they were under artillery attack, sent the navy to repel pirates. Five hundred miles to the northwest the island of Madura was enveloped in darkness for three days. In the initial explosion, 10,000 people were killed. Over the following months a fine dust circled the globe, filtering the sun's rays and reflecting light back into the skies. An estimated 82,000 people died of starvation. Crops failed in China, and in Bengal ferocious storms flooded huge areas of the countryside.²³

Nowhere in Europe was the weather as bad as in the middle and lower Rhine. It was the worst of times. After a decade of ravaging wars, reserves of food were thin. Potato, beets, and pumpkins, carefully stored in straw beds for the winter, had been seized by the army. Then, after the harvest of the following summer, the new stores had been seized as well. A generation of young men had been conscripted into the service of kings and emperors, never to return, leaving old men, widows, and children to work the fields as best they could. For three seasons the crops had failed and the people in Alsace, Württemberg, and Baden feared that, unless the summer of 1816 brought a bountiful harvest, there wouldn't be enough food to see them through the winter.

As spring approached, they had reason to hope. Napoleon was confined to the rocky island of St. Helena in the South Atlantic and their kings were at peace. For the first time in several years there was warmth to the sun. They watched buds appear on the fruit trees and vines, and took it as a sign that the natural order of the seasons had returned, and it was time to plant. Then, one afternoon in May, thick, black clouds rolled down the valleys. They remained for a month, and every day it rained, sometimes in torrents, sometimes in a soft drizzle, and at times accompanied by hail and sleet, but never letting up. Fields on the side of hills turned to mud and slid down to the farmlands

below. Rivers burst their banks and flooded across towns and villages to a height that had never been known before. When finally, in June, the clouds lifted, a peculiar haze hung in the air and each evening an orange-red sunset lit the horizon. The sun was pale, and in the evenings the temperature dropped below freezing point. On cold mornings the villagers looked in horror at the apricot, pear and peach trees, which should have been bearing fruit, shimmering with icicles. Dismayed farmers stood in soggy fields looking at the stalks of their spring plantings, shriveled to black as though they had been charred by fire. Wearily they cut the stalks, now only of use as animal fodder, and replanted, but hopes of a late harvest were dashed when, in the third week of August, swirling winds brought weather colder and more tempestuous than the oldest inhabitants could remember. Potatoes, parsnips, and carrots became rotten in the ground, and beans were nipped away by the frosts.

Winter approached and a desperate search for food began. On the hillsides, grapes, still green and as small as fingernails, were picked while frozen on the vine. Peasants walking across their fields at midday felt the crackle of frost beneath their feet as they searched for beets that might have survived. Gathering enough to eat became a battle with nature. Snails, mice, moss, thistles, and cats were placed in the stew pot. Children were sent into the forest to search for nuts and berries. Bakers without flour made loaves from oats and potatoes. When even that ran out, they saw no reason to light their ovens at all.

One bitterly cold evening in late 1816, Daniel Müller, a shoemaker from the village of Langensoultzbach in Alsace, in the lower Rhine, fell into conversation with a stranger who was setting up camp for his family in a field behind the churchyard. They were going to America, the man told Daniel. It had taken them a week to come this far, and as soon as they reached the Rhine they would sell their horse and wagon and buy passage down the river to the sea. From there they would take a sailing ship across the Atlantic. Never would they return to this wretched country.

The next morning, Daniel returned as the stranger was packing up. He offered the man half a loaf of potato bread and a bowl of cabbage

and sorrel soup. The man passed the food to his wife. As he tucked his children between tea chests and pots and pans, on a wagon pulled by a horse with legs so spindly it seemed unlikely it could stand, he said he was sorry he couldn't give Daniel something in return. Yet, after a moment's hesitation, he said he did have something—something so valuable that it would provide for Daniel and his family for life. He pulled a crumpled sheet of paper from his pocket and pressed it into the shoemaker's hand.

That evening, Daniel visited the house of his brother, Henry. The Müller brothers had married two sisters. Daniel had four children and his brother three, and all of them gathered in Henry's kitchen and sat around the heat of the stove. Henry, aged thirty-eight, was two years older than his brother, and Daniel was anxious to ask him about the piece of paper the stranger had given him. Henry unfolded it and saw that it was an article torn from an illustrated magazine. He held up the page for everyone to see. A lithograph showed a man, his wife, and two children standing in ascending order beside a log cabin built on the plains of Missouri. There were flowers in the front garden, geese in a side yard, and cattle dotted on the pastures beyond. The caption underneath said the family was from Württemberg and that the blooms in the garden had been grown from seeds they had carried from their homeland. Henry then read out how the homesteaders had tamed the savage Indians and had brought them into Christianity, and now traded with them in peace. He read how black people worked the fields and how they were given much better food than any servant in Württemberg. The crops were always abundant and no one ever went to bed hungry. In America there was so much land that everyone could have some of their own.

The Müller brothers and their wives talked about America for hours while their children fell asleep at their feet. Could there really be a place where no person went hungry? A place where there was enough land for whoever wanted it? Where ordinary people could vote for their own leaders and there were no kings or princes, popes or emperors? Where a man could work at whatever he chose, without seeking the say-so of the guilds? Where armies did not march through the country taking whatever they wanted?

Although they had lived for generations under French rule, the

Müllers regarded themselves as Alsatian, rather than French or German. They spoke their own form of Germanic dialect, incomprehensible to most beyond both sides of the border. They cherished their own culture and traditions. They may have been foreigners in France, but Napoleon, hungry for troops, was unconcerned about where they came from—"Who cares if they don't speak French? Their swords do," he was reported as saying. The Emperor took his crop of young men into Egypt, then came back for a fresh harvest for the Russian campaign, and then another, young and ready to die for him at Waterloo.

Daniel was known as Schuster (or Shoemaker) Müller in the village and Henry as Schlosser (or Locksmith) Müller. They lived above their shops near each other in the village and their children were constantly in each other's houses. It was never doubted that if a decision were made to migrate to the United States, both families would travel together.

In the following days, as they considered the idea of abandoning the village and their homes, they began to realize the difficulties they faced. To take such a journey would mean they would never return. To their relatives who remained behind, it would be an absence as permanent as death. The journey could never be made in winter, so they would have to leave at the first sign of spring, in just a few months' time, and Daniel's wife, Dorothea, had just given birth to a boy. After her fourth child in eight years, Dorothea remained sickly and she wasn't sure she was up to such a strenuous journey. She sought the advice of another of her sisters, Eva Kropp, who in turn spoke to her own husband. The Kropps had a fifteen-year-old daughter, also called Eva, and the three of them called around one afternoon and joined a long discussion with the Müller brothers and their wives. Toward the end of the meeting the Kropp family announced that they wanted to emigrate as well. Dorothea's concerns were brushed aside. They could all travel together, they said, and care for her and her new son until she recovered her strength.

When the families met a week later at Henry's house, also present was another of Dorothea's sisters, Margaret, and her husband. There were now four families considering plans to emigrate and individual doubts dissolved in the enthusiasm of numbers. Everyone would look

after one another's children and share the cooking of their food. In America they would farm land next to one another; they would help to build one another's houses and bring in one another's crops, and the women would carry lunch to the men as they worked in the fields.

Word that the Müllers were emigrating to the New World spread quickly through the village and beyond. Mr. Koelhoffer, who lived an hour's walk from Langensoultzbach, said that he would quit his farm tomorrow if the Müller brothers would let his family accompany them to America. Christoph Kirchner and his wife Salomé (a sister of the Müller brothers) asked to join in. Mistress Schultzeheimer, the midwife to the village, said she must come, because after everyone had left, there would be no children to deliver. A big meeting was held—they all would leave together: brothers, sisters, cousins, uncles, friends, and neighbors.

Across Germany whole villages fell under the spell of an emigration fever (*Auswanderungsfieber*, as it was dubbed). Possessing little more than the clothes they stood in, they abandoned their shops, farms, and factories and began the long journey to America. A fantasy paradise awaited them, where fertile, watered pastures teemed with deer and buffalo, the forest trees were straight and strong, the rivers jumped with fish, and the lagoons were alive with all manner of fowl.

The villagers of Langensoultzbach were better off than many of the landless peasants making the journey. After they had sold all they owned, they had enough money for the fare to Holland, then for the crossing of the Atlantic, and a little to spare. They had every reason to be optimistic. They were skilled workers with much to offer the new world. The men were farmers, locksmiths, shoemakers, and store-keepers. The women were cooks, milliners, and midwives. They carried Bibles, food, precious musical instruments, and the tools of their trades.

At the first sign of spring, seven families, over forty souls, walked from Langensoultzbach to the Rhine, where a barge awaited them. Pushed along by a river in flood, they arrived in Holland in twenty-five days. From there, it was but a short distance on foot to Amsterdam.

No sooner had they set out than they became aware that they were walking the same roads as thousands of ragged, starving people. They

had joined a torrent of refugees from half a dozen countries. Some had come from as far away as Switzerland and Saxony, all making toward a Dutch port and hopeful, somehow, of getting on a ship to America. A German nobleman, Baron von Fürstenwärther, taking the same route as the immigrants, wrote:

I have found the misery of the greatest part of the emigrants greater, and the condition of all of them more perplexing and helpless than I could imagine. Already on my journey to this place on all roads I met hordes of people who, destitute of everything begged their way. Indescribably large were the multitudes of these unfortunates....²⁴

After walking for two days, the people from Langensoultzbach entered Amsterdam. By the end of the Napoleonic war, Amsterdam's glory days as a center of world trade were well behind it, and many of its population of 200,000 were living in deep poverty. The City Fathers, barely coping with the distress of their own citizens, were suddenly confronted by an influx of thousands of immigrants camping wherever they could in the city. It was a tragedy in the making, compounded by the shortage of vessels offering passage to America. Transporting impoverished immigrants was a business of low profitability and almost any other cargo would bring in more money. Over the years it had gained a reputation of attracting only the most brutal of captains and crew. Respectable shipowners wouldn't even consider dealing in the trade. The only way to make it pay was to cram hundreds of passengers into an ill-prepared ship and then skimp on rations during the voyage.

For several days, Daniel Müller called on the warehouses of the canals of Amsterdam asking for news of a vessel which might be sailing to America. Finally, he met a man who told him of a ship preparing to sail. He returned to the camp where the people of his village were staying and told the head of each family to follow him at once. They must purchase their tickets this very day before they were sold to others. Hurriedly they followed him to a warehouse overlooking the Nieuwezijds Voorburgwal canal, where in an upstairs room they found the owner of a ship bound for Philadelphia. Gratefully

they handed over the last of their savings and he wrote them a receipt and issued them with tickets. They were fortunate, he told them. He had just purchased a man-of-war from the Russian Navy. She was the *Rudolph* and would be sailing from Helder as soon as he filled her with passengers, and judging from the number of immigrants walking the streets, that shouldn't take long.

The next day the people from Langensoultzbach packed up their belongings and sailed across the Zuiderzee to the deepwater port of Helder where, in a quiet backwater, their boat halted alongside the *Rudolph*. They looked at her in horror. She was a lumpy, antiquated hulk, badly in need of paint, with her sails stained with rot. If she had ever been in the service of the Russian Navy, it must have been many years ago. After climbing aboard they stood on a deck of splintered wood and smelled the foul air rising up from stairs leading to the hold. There was no crew to meet them. Instead, thirty or so immigrant families, who had taken over the best cabins, stared at them in open hostility.

The Müller families searched for space below to claim as their own. Of course, those who had arrived first would have to squeeze up, but there wasn't anyone in charge to whom they could complain. No one on the vessel knew where the crew was. A caretaker came around every few days—an unshaven scarecrow of a man who slept in a shed on the wharf and was usually drunk—but he knew little, and grumbled that he hadn't been paid for weeks.

A few days later a keelboat pulled alongside the *Rudolph*, and the passengers leaning over the bulwark watched more people clamber aboard. They told of how they had given the last of their money to a man in Amsterdam on a promise that the *Rudolph* would sail in just a few days. The newcomers were as poor and as weary as those already on the vessel, but where would they fit? In the bowels of the vessel was a space rank with fetid air and moist underfoot, which had so far been avoided by everyone who had seen it. Men and women with gray skins and dressed in rags descended below, and then returned to the upper deck and looked helplessly around.

Days passed, and still no preparations were made to sail. Then one morning they awoke to find that another fifty people had come aboard overnight. A meeting of the heads of families was held. Over

900 people were now crammed on the vessel and the fear was that the *Rudolph*'s owner intended to sell even more tickets. Surely he had collected enough money by now to hire a crew and have the vessel depart? The meeting elected Daniel and Henry Müller to go back to Amsterdam and demand that the vessel sail at once.

Sick with worry, the two brothers set off for the city. When they reached the canal, they strode up the stairs of the warehouse, only to find that the door to the office was bolted. After rattling the lock in frustration they went downstairs to speak to a man who ran a chandler's shop at street level. Yes, he said with a wry smile, he also would like to know where the fellow had gone. He hadn't paid the rent.

The brothers returned to Helder. They carried news that could have hardly been worse. The master of the *Rudolph* had disappeared. Everyone's money had gone with him. He hadn't paid for the vessel, and the original owners were in the courts claiming ownership. Their ship wasn't going anywhere.

A quarter of a century later, Madame Hemm told the First District Court of New Orleans of the time she spent on the *Rudolph*. Nine hundred people remained on the ship, rocking backwards and forwards against the wharf. They hadn't the means either to continue their journey or to return home, and as a bitter winter descended upon them they were reduced to begging in the streets of Helder.

Madame Hemm was forty-five when she gave this evidence, which made her eighteen when she was on board the *Rudolph*. She told the court that although her family was from Württemberg, she had become friendly with Daniel Müller's children. She had played with all of them, but it was with Salomé Müller, a dark, black-eyed child, that she had played the most—insisting to the judge that this explained why she instantly recognized Salomé when she walked through the door of the courtroom.

They waited in enforced idleness, hoping that somehow, by a godsend, the voyage to America could commence. Men who had worked all their lives—farmers, blacksmiths, coopers—were forced to spend

their days in idleness as they watched, every few weeks, an immigrant ship, her decks crowded with passengers, slip past them, bound for America. It was cold and wet, and there wasn't enough food. Several of the passengers died—of hunger, helplessness, disease? Who could tell? Every few weeks a representative of the unpaid owners came to make sure that the *Rudolph* hadn't moved. He told them the matter was now before the courts. They showed him their tickets giving them passage to Philadelphia. He shrugged his shoulders. It had nothing to do with him.

Five months passed. Then a port official came aboard one day and told them that a court had ruled that the owners had a right to have their ship returned to them. They must leave the *Rudolph* immediately. The 900 were to be ferried back to Amsterdam, where they would be looked after, so it was promised, by charities and the city

authorities.

There were so many refugees in Amsterdam during those desperate days of 1817 that a quarter of the population was in need of assistance. Charities provided bread, peat for fuel and, occasionally, clothes, blankets, and Bibles. The municipality distributed some food and ran a workhouse. Charities attached to the Catholic Church spoke of their assistance as naked alms, frankly admitting that it was "never so much as to cover half of the elementary needs."25 To survive, the homeless (which now included the people from Langensoultzbach) did what the homeless always do to survive. They rummaged through garbage, they thieved, they begged, and they went on foraging expeditions to the countryside. But mainly they walked; a shambling, endless journey through the streets of the city and beyond, searching for something to eat. And when the rains came, they began to die. One or two each night, and the municipal authorities came to view the bodies, to satisfy themselves that it wasn't the plague.

The presence of so many ragged immigrants on the streets of Amsterdam eventually forced the government to announce that it would pay thirty thousand guilders to any ship's master who would transport them to America. Given the number of passengers involved, thirty thousand guilders was hardly a generous offer and for a time no one came forward. Eventually, however, the immigrants, including the

villagers from Langensoultzbach, were told to return to Helder, for a ship was now ready. When they saw her, their hearts sank, for she was another former Russian man-of-war and in even worse condition than the *Rudolph*. In a cruel irony, the owners had renamed her *The New Sea Air*.

Crammed into every available space on board a lumbering, rotten ship, the immigrants entered the North Sea at the time of the winter gales. Shortly after they left port, a violent storm fell upon them. The mainmast, rotten to the core, snapped and tumbled in a tangle of rigging and sails to the deck. During a night and a day of dreadful terror, the ship wallowed in mountainous seas. But then, when finally calm seas returned, they "saw the western sun set clear . . . astern of the ship. Her captain had put her about and was steering for Amsterdam." 26

Dispirited and weary, the passengers waited for what next might befall them. But few peoples are so impoverished that there isn't some means of taking advantage of them. Mr. Krahnstover, a merchant of Amsterdam, announced that he had three ships at his disposal to take the unfortunate Germans to America. These were no old, converted hulks he was offering, but full-rigged sailing ships: the *Emanuel*, the brig *Juffer Johanna*, and a brigantine, *Johanna Maria*. He knew the immigrants had no money to pay for their passage, but there was a way around this. America was truly a land of opportunities. They do things differently there. He gave the head of each family a document and asked him to sign it.

It was a redemption agreement. Its terms allowed the immigrants to travel to America without paying their fares, but when they got there, a frightful cost would be exacted—Krahnstover could sell them and their families into servitude.

Baron von Fürstenwärther, who traveled to America by way of Amsterdam in 1817, obtained a copy of a redemption agreement, similar to, if not the very one, the Müller brothers were required to sign.²⁷

An Amsterdam Ship Contract for Passage to America

We, the undersigned, . . . hereby assume and obligate ourselves as people of honor.

In the first place, we passengers accept with the above mentioned Captain . . . (insert name) . . . our journey from here to . . . (insert destination) . . . North America, to behave ourselves quietly during the journey, as good passengers are bound to do, and to be satisfied perfectly with the food specified below and agreed upon by the captain and us, and as regards water and other provisions, if necessity should demand it on account of contrary wind or long journey, to submit to the measures which the captain shall deem necessary.

There followed a schedule of the food to be provided and the cost of passage. For those who could pay in Amsterdam, the price was one hundred and seventy guilders for an adult and eighty-five guilders for a child. For those who couldn't pay, the adult fare was one hundred and ninety guilders and ninety-five guilders for a child. Then this paragraph:

No passenger shall be permitted without the knowledge of the captain to leave the ship in America, and especially those who have not paid their fare. Should any of the passengers depart in death during the journey the family of such, if he dies beyond half of the way from here shall be required to pay his fare; if he dies this side of half of the way, the loss shall go to the account of the captain.

Just above where the immigrants were required to sign, appeared the words:

We promise to abide by all the above and to this end pledge our persons and our goods, as per right.

This was the essence of a redemption agreement—the power given to the shipowner to sell the immigrants' persons at journey's end for a term of years or, if no purchaser could be found, to rifle through their possessions in the search for items of value.

Still a further disappointment awaited the immigrants. Krahnstover's ships weren't going to Philadelphia. They were bound for

the port of New Orleans in Louisiana. It was a much longer journey, and half a continent away for those who had relatives on the east coast—but it made sense to Krahnstover: in New Orleans, his vessels were assured of an immediate and lucrative return cargo of cotton and sugar.

The immigrants had little choice but to sign. They were refugees trapped in a city weary of their presence, and in the months since leaving home, they had been stripped of their dignity and worn down by defeat and hardship. The few doubters among them were hushed. What did it matter if they were no longer going to Philadelphia? They looked at maps and saw that they were heading further west—to the mouth of the Mississippi fed by a network of inland waterways, deep in the heart of their beloved destination. There they could choose all the land they wanted in an area the size of Europe. And Krahnstover had promised them three ships, instead of one.

But there were more passengers. With new arrivals, their numbers had now swollen to 200 families, 1100 people in all. To accommodate so many, Krahnstover hired workmen to build wooden floors between the upper deck and the hold. He then announced that his ships wouldn't be sailing together, but one after another, as the carpentry was completed. It took endless discussion and argument among the immigrants to decide who would sail on the first departing ship. The members of the extended Müller clan insisted on remaining together, which meant they would be on the last ship, the *Juffer Johanna*.

The first to leave was the brigantine Johanna Maria, her deck black with over 250 passengers. Mrs. Fleikener and Madame Hemm were on board. They were young women at the time. Years later, in court, they would recall their sadness at leaving the people they had met on the Rudolph. They had helped each other through sickness, shared their food, and consoled each other during periods of hopelessness and loss.

The next to leave, a week later, was the *Emanuel*, a fully rigged ship of 300 tons with 350 passengers. Mr. Wagner from Württemberg, then a youngster, and another witness at the trial of Salomé Müller, was on this ship.

Several weeks later, the Juffer Johanna was ready to sail. She was a

brig of 370 tons with 500 passengers. On board were the families of Daniel and Henry Müller, the Kropp family, Francis Schuber, the Koelhoffer family, Christoph Kirchner and his wife and daughter, and Madame Carl with her parents. Although emaciated, most were in good health. If anyone was cause for concern, it was Shoemaker Müller's wife. Dorothea had been ill when she left her home in Alsace, and had been weakened further by the months of worry and hunger. To her, this seemed to be a journey without end, when all she sought was a place where she could rest.

Krahnstover traveled on the Juffer Johanna. Captain Bleeker skippered her, although from the outset it was clear that the man in charge was Krahnstover. Within a day of leaving port he ordered the crew to conduct a search of the immigrants' luggage, removing firearms and anything else that might conceivably be used as a weapon. No sooner was that done than the crew appeared wearing guns and cudgels. His next announcement was that all food was to be placed in a central store and private stocks wouldn't be tolerated. He stood on the bridge and watched as his men broke open trunks and upended bags. Little was found—a few sacks of cereal and strips of dried meats—but it was taken just the same.

Bleeker appointed Francis Schuber, a young butcher from Strasburg, as a trustee to dole out the rations to the head of each family. Once a day they lined up and received flour, rice, dried peas, and salted bacon. It was less than had been promised and of the poorest quality, but complaints were brushed aside. The passengers were told that if anyone wanted extra food, it could be purchased from the ship's store. The same applied to water, which was also in short supply.

Within a week the passengers settled into a routine of daily life. In fine weather, a milling crowd of several hundred shuffled across the decks, avoiding, as best they could, cooking pots, scampering children, and lines of tattered washing. At night, families bedded down in their allotted space below decks, packed so closely together that fleas could jump easily from one body to the next. Ventilation came from an occasional wind gust down the stairs. There was no privacy for the sexes or places of isolation for the sick. During storms the hatches were dropped, and the passengers lay in darkness listenening to the waves pounding on the hull and the oak beams groaning.

Some of the drinking water turned foul and had to be tipped overboard. The remaining water, sitting in kegs in the sun, became tainted, but still the passengers thought of little else than the small scoop poured into their cup each morning and in the evenings. Once again it seemed that God was cursing them. Floods and lashing storms had driven them from their lands, and now they were tormented by thirst.

The youngest child of Daniel Müller died two weeks out of Helder, and the very next day Dorothea died—of nothing in particular, it seemed: melancholy, exhaustion, hopelessness. Daniel tucked his son into the crook of his wife's arm and carried them both onto the deck. He stood there, stone-faced with anger, as the others, fearful of catching whatever mysterious disease had killed his wife and child, peered from behind the mast and only dared to creep closer after he had wrapped them in a canvas sheet. He draped the bundle over his shoulder and, with tears pouring down his cheeks, staggered over to the bulwark and slid it into the sea.

The days turned to weeks, and a second month passed by. Then the third. Water reserves began to run out and rations of food were cut. Little by little the crew extracted the few coins held by the immigrants in exchange for extra supplies. They counted the days. Forty, fifty, sixty. To people who had never seen the sea before, much less ventured to cross it, it seemed endless. Many were weak when they came aboard and their bodies lacked reserves of strength. The ill and the weak began to die, and once the deaths commenced, they continued at the rate of one or two each day. Several passengers, crazed by thirst and despair, jumped overboard. Henry Müller's wife died.

Children grew up on that voyage. They comforted men and women twice their age. They saw their fathers in tears, as they bellowed out their rage at life, at God, at themselves for taking their families on this journey. Eva Schuber told how, after the death of Dorothea Müller, she, at the age of fifteen, bathed and dressed Dorothea's three children. Koroline Thomas, who was aged eight, later told the story of how she saved the life of her father, who was dying of thirst, when she discovered that at the back of one of the water casks a drop of water fell every few hours. She placed a small vial under it and twice a day took it to him.²⁸ Husbands nursed

mothers whose milk had dried up, and mothers nursed children who became languid in the morning and were dead by nightfall. Even as the hymns were being sung for one, another was preparing to die.

A lawyer, much involved with the welfare of the German community, spoke in court of the horrors faced by the people on that voyage:

I see them now, scantily supplied with provisions, crowded almost to suffocation in their ill-stored prison, delayed by calms, pursuing a circuitous route, and now driven in fury before the raging tempest on the high and giddy waves. I see her people in the solemn burial service, day by day, one after another, committing the worn and wasted forms of their companions to the ocean's deep, until one half their number is all that is left. There was the burial of a mother, and she left young and helpless orphans.²⁹

It was the might of the Mississippi they saw first, miles out to the sea, advancing like a tawny-colored canal through the blue-green of the ocean. The *Juffer Johanna* headed toward it, while overhead, gulls, terns, and skimmers circled and swooped. Away in the distance, they saw a line of gray as the cry of "Land, land, America!" came from aloft. If it was America, it was as flat as the Friesland coast. They had expected something grander—a serrated mountain range, perhaps, or a cliff acting as a battlement against invaders. But it was America, they were told. This was *America*! Their ship, buffeted by the churning foam of the river, headed upstream, following a twisting course marked by buoys through islands of mud and sandbars. At last—they had arrived. They had survived.

Then, after not sighting any other vessels for weeks, those on board the *Juffer Johanna* were suddenly surrounded by half a dozen ships, all in full sail, making their way to the mouth of the Mississippi. A call went up from some of the passengers that the ship alongside was the *Johanna Maria*. Mrs. Fleikener and Madame Hemm were on the deck, so close it was possible to shout to them. In joy, they called to each other. Then, in a quite miraculous coincidence, the *Emanuel* hove into view. The immigrants shouted one to another, across the muddy waters, inquiring how each had fared. The answers cried back were dreadfully

similar. They had been becalmed and run out of food and water. Many, many had died. All afternoon, as they passed by vast swamps of shoulder-high grasses, teeming with flocks of geese, more and more names were added to the list of the dead.

Writers give wildly differing estimates of the numbers who died aboard Krahnstover's vessels. Wheelock S. Upton, writing in 1845, said that there were 800 passengers on the three ships and of them, 450 died. Cable put the total number of passengers at 1,800, of whom 1,200 died. Deiler estimated that 1,100 passengers left Helder and, after consulting maritime records in Louisiana, concluded that 597 arrived in New Orleans, the survivors being: on the *Emanuel* 200, on the *Juffer Johanna* 250, and on the *Johanna Maria* 147.³⁰ It was a rare family who hadn't experienced death; many had lost several members. Daniel Müller had lost his wife and his youngest child; his brother Henry had lost his wife—an existence so anonymous that no record was kept of her name.

The cause of the tragedy was obvious enough. Given favorable winds the passage from Helder to New Orleans should have taken fifty to sixty days. Krahnstover had hired the dregs of the Amsterdam waterfront as crew and incompetents as captains, and when the wind fell out of the sails, they didn't know what to do. According to Upton, the "voyage was of the extraordinary duration of four months." Deiler wrote that the journey took five months. Madame Hemm, a passenger on the *Johanna Maria*, recalled that it took ninety days. The apparent discrepancy arises because three vessels were involved. Krahnstover's ships barely had provisions for sixty days, and when they ran out of food and water, the immigrants, already in a weakened state when they came aboard, began to die.

It took the three vessels sixteen days to sail the 100 miles up the winding Mississippi to New Orleans. The passengers watched keelboats and steamers making their way downstream to the Gulf of Mexico. They saw whole trees, roots, and branches float past in the muddy waters. At times the ships moved so close to the levee of the river, they could have jumped ashore. They passed through lush meadows, dotted with neat red-roofed cottages. They saw orange and peach trees in blossom and cattle grazing in green pastures. Here was

America, just as they imagined it to be. They sailed by large plantation houses set amid fields of sugarcane and saw for the first time people with black skins—a line of them working in a cane field, while a man sitting on a horse watched over them.

They awoke on the morning of March 6, 1818, to see a dusky smear hovering in the sky to the north, and were told it was caused by wood fires burning in the kitchens of New Orleans. An hour later, the three ships rounded a bend and there before them was a grand city sitting flush on the banks of the river, the buildings pinked in the warmth of the morning sun. They saw warehouses, smoking factory chimneys, a line of brick terraces and a tiered cathedral with three spires pointing to the heavens. Tied up alongside the banks of the levee, as far as they could see, were hundreds of ships, while busy little ferries crossed backward and forward to a village on the opposite bank.

From the mouth of the Mississippi, Krahnstover had mailed news of his ships' expected arrival in New Orleans, and for several days an item ran in the *Louisiana Gazette* advertising the cargo he carried:

Mr. Krahnstover, supercargo of the ship Juffer Johanna, lately arrived from Amsterdam, begs leave to inform the inhabitants of Louisiana who may want Servants of different ages and sexes, laborers, farmers, gardeners, mechanics, etc., that he has brought several Swiss and German passengers who wished to emigrate to the country, which may prove to be very serviceable in their respective capacities. For particulars apply on board or at the store of Mr. T. W. Am Ende, Toulouse St.³²

It had been the dream of those accompanying Daniel and Henry Müller that everyone from Langensoultzbach would own adjoining farms and assist each other as neighbors, but now the awful reality struck home: they would be scattered like leaves in the wind to wherever their new masters took them. They would own nothing. They would be servants. Daniel and Henry now prayed for something far less ambitious—only that they would be able to stay together, two widowers with six children between them. A wealthy farmer, perhaps someone with a large estate, might take them as a whole.

When the *Emanuel*, the *Juffer Johanna*, and the *Johanna Maria* docked in New Orleans, Krahnstover didn't allow his passengers to disembark. Fearful that some might run away, he posted guards near the gangplanks. For hours the immigrants stood on deck watching ships and steamers pass by. Evening came and they could hear the noise and activity of the city across the apron of the wharf, while on the other side of the river, too wide for anyone to swim, they could see the lights of Algiers. Surely it would be their last night on board? In apprehension and hope they waited for the morning, when Americans were to come to bid for them.

The next day a noisy throng of farmers, merchants and commercial gentlemen and their wives gathered on the levee to visit each of the three vessels in turn. Some wanted families to take into rural Louisiana. Others wanted men to act as overseers of slave gangs on cotton plantations while their wives worked as cooks and maids in the big house. Engineers were looking for strong men to help build the wharves and canals being constructed in the city. Merchants sought skilled tradesmen in printing and tailoring.

The bargaining, such as it was, was conducted through the captain of each ship. His interest in the welfare of the immigrant families was quite limited—he hardly cared how many years of servitude were settled upon, so long as the purchaser paid enough to cover any amount owing on the fare. The immigrants were at a disadvantage at every turn. They had no idea of their own value, or what their masters intended for them after they were sold. The negotiations were conducted in a tongue they didn't understand and, when they were concluded, the newcomers were taken before a notary or a parish judge and asked to sign an indenture in a language they couldn't read.

History hasn't left a description of the sale of the people from Krahnstover's vessels in New Orleans in 1818; however, an idea of what happened to them may be gauged from the experiences of the shiploads of redemptioners from Amsterdam who arrived in Baltimore and Philadelphia in the same year. A German writer, Johannes Ulrich Buechler, wrote of his visit to a redemptioners' market aboard the *Hope*, in Baltimore:

... many ladies and gentlemen came to inspect the new arrivals and to confer with the ship owner who had with him an exact list of all families and persons who had not paid and also those who had paid in Amsterdam. I noticed that these ladies and gentlemen had in view especially small children and young people and I believe if there had been thousands of boys and girls on this ship, they would all have found desirable places. . . .

At first boys and daughters from 9 to 20 years were selected, also small children. As soon as they had agreed about the price, the purchasers departed with the young people they had bought. Then came a selection from the rest—farmers, artisans, etc.—so

that I thought the ship would be empty in two days.

On the following day, a Sunday and a beautiful day, ladies and gentlemen as well as farmers and many other persons came to visit the parents and the remaining immigrants and brought bread, apples, tidbits and other things for the little children. Some of the girls who had left the ship only the day before, on Saturday, came back dressed in French clothing so that I would not have recognized them, had they not made themselves known....

Now let me explain how these people were traded off for their debt. Mechanics had to serve from one and a half to two and two and a half years, according to their abilities; peasant families three to three and a half years; girls of 16 to 20 years of age, up to four years; children from 2 to 12 and 15 years of age must remain till their 20th year or more, some of them even for life. During this time they forget their mother tongue as well as their parents, for in such houses nothing but English is spoken. Children from 2 to 15 years of age have been separated from their parents. Some parties have paid off their whole debt for the trip in this way, by surrendering their children. Separated from their parents, these children often never find each other again...³³

Henry Bradshaw Fearon, an Englishman, "in company with a boot-maker of this city," visited the brig Bubona, docked at the wharves of the Delaware River in Philadelphia:

As we ascended the side of this hulk, a most revolting scene of want and misery presented itself. The eye involuntarily turned for some relief from the horrible picture of human suffering....[The boot-maker] enquired if there were any shoemakers on board. The captain advanced: ... He called in the Dutch language for shoemakers, and never can I forget the scene which followed. The poor fellows came running up with unspeakable delight, no doubt anticipating a relief from their loathsome dungeon. Their clothes, if rags deserve that denomination, actually perfumed the air. Some were without shirts, others had this article of dress, but of a quality as coarse as the worst packing cloth. I enquired of several if they could speak English. They smiled, and gabbled. "No Engly, no Engly,—one Engly 'talk ship." The deck was filthy. The cooking, washing, and necessary departments were close together. Such is the mercenary barbarity of the Americans who are engaged in this trade, that they crammed into one of those vessels 500 passengers, 80 of whom died on the passage. The price for women is about 70 dollars, men 80 dollars, boys 60 dollars. When they saw at our departures that we had not purchased, their countenances fell to that standard of stupid gloom which seemed to place them a link below rational beings.³⁴

In the Southern states, redemptioners were in competition with slaves, and as the price of slaves steadily increased over the years, redemptioners were seen by many to be the better bargain. Redemptioners were cheaper—as a rule of thumb, five or six could be purchased for the price of one slave, although it should be kept in mind that the buyer was only getting servitude for a term of years, rather than labor for life. An added advantage was that when redemptioners became ill, or unproductive through injury, they could be released to fend for themselves, while a master was morally and legally obliged to provide for his slaves until their death.*

^{*} As section 4 of Louisiana's Black Code stated: "The slaves disabled through old age, sickness, or any other cause, whether their diseases be incurable or not, shall be fed and maintained by their owners ... under the penalty of a fine of five and twenty dollars for every offense."

Louisiana law specifically provided that the redemptioner's contract of servitude was "equivalent to a sale" and a master could "correct [that is, whip] his indentured servant for negligence or other misbehavior, provided he did so with moderation." The master, for his part, was obliged to provide the redemptioner with "good and sufficient food, meat, drink, washing, and lodgings." 35

Just as slaves ran away, so did redemptioners, and it was common to see, side by side, newspaper advertisements for their recovery. The following notices, all relating to Germans (very probably brought to New Orleans in Krahnstover's ships), appeared in the *Louisiana Gazette*.³⁶

Redemptioners Escaped!

A German family, consisting of a father, whose name is Andreas Thomas, and of a mother and four children, have gone off without serving the time stipulated in their engagements. Notice is hereby given that those who may harbor any individual of the family aforesaid or give them employ, will be prosecuted according to law. A reward will be paid for placing the said Thomas in the hands of the sheriff who has an order to arrest him.

Sixty Dollars Reward

Absconded from the subscriber's employ on the 6th inst., Four German Redemptioners—they are all young men, well made, and of middle size, and were dressed in Russian sheeting pantaloons, and shirts, red waist-coats and boots.

Ten Dollars reward and all reasonable charges will be paid for their apprehension and also 20 Dollars for John Miller, a sailor who enticed them away. Miller speaks Dutch and broken English, has an impediment in his speech, wears a blue cloth jacket, yellow vest and duck pantaloons, has been in the army and is much addicted to drink.

Captains of vessels and others are cautioned against harboring the above named runaways.

H.W. Palfry

Ten Dollars Reward

Ran away last evening from the subscriber, Two German Redemptioners, namely:

George Stroule, about 28 years of age, 5 feet, 7 inches high, dark complexion and slender make; had on a blue jacket and gray pantaloons with other clothes of the fashion of his country.

Marion Mowry, wife of the said Stroule, about 30 years of age, nearly as tall as her husband, a little pock marked and dressed in the manner of her country.

The above reward will be paid for securing these redemptioners in jail or bringing them to

Lewis Mageonie, On the Canal, suburb Marigny

By the end of that first day, the services of more than half of the passengers on Krahnstover's ships had been sold. Madame Hemm was engaged by a family in Baton Rouge. Mrs. Fleikener, then in her teens, was taken to work as a domestic at the plantation of Maunsell White, one of the capitalist giants of Louisiana and founder of the Improvement Bank. Mistress Schultzeheimer went to look after the master's children on the Hopkins plantation, just outside New Orleans. Madame Carl became a domestic for a wealthy Creole family in the French Quarter. Dorothy Kirchner, the teenage daughter of Christoph and Salomé Kirchner, went to a plantation three miles downriver from the city.

Those staying on board watched enviously as the people who had been sold readied themselves to depart. There was barely time for farewells—their new masters awaited. As those leaving packed their bags they whispered to their friends the names of the men who had bought them and where they were going—places with strange names: St. Charles, Iberville, Pointe Coupée, New Iberia, Rapides. A few were being taken to states upriver: Mississippi, Arkansas, Missouri. Somehow, they would keep in contact, they promised. Somehow.

Both the Müller brothers were left behind. In a society where blacks

did the manual work, shoemakers and locksmiths weren't in high demand. The future Eva Schuber, then a fifteen-year-old member of the Kropp family, also remained. An open-faced girl with the sturdy stature of a strong worker, she could have been sold ten times over, but her parents refused. They had set their hopes on a purchaser taking the whole family.

The next day, sales weren't so brisk. The pick of the passengers had been taken, and Krahnstover feared that with so many redemptioners on offer, he had oversupplied the market. Still, purchasers came, and as the days passed, his ships slowly emptied. Each morning the Müller brothers waited with their children on the main deck, and each afternoon they remained unsold. It was an experience of bewildering humiliation. In Langensoultzbach they were valued as skilled tradesmen, yet here in America they were unwanted. They began to wonder how long they would have to remain on board. Under the terms of their redemption contract, the cost of keeping them alive while in port was added to their price, so they were becoming more expensive as each day passed.

At the end of the week, Eva Kropp's parents, worn down by the prospect of being imprisoned indefinitely, agreed to sell their daughter separately, but at least they were all to remain in New Orleans. Eva was engaged as a domestic to a Creole woman, Madame Borgnette, who ran a boarding school for young ladies in Chartres Street, while her parents took positions in a house in the Faubourg Marigny.

Meanwhile, the immigrants already released into the city complained bitterly to their new masters about the deaths and deprivations aboard Krahnstover's ships, and the brutality of the crews. As news of their ill-treatment spread, several gentlemen in the German community of New Orleans were so outraged by what had occurred that they engaged counsel to pursue Krahnstover in court. One of those hired was a young lawyer in the city named John Randolph Grymes. In the telling of the story of the Lost German Slave Girl, Grymes reappeared a quarter of a century later to represent the slave owners opposed to Salomé Müller's bid for freedom. The papers associated with the lawsuit against Krahnstover have been lost and it is difficult to know what happened. However, one thing is clear:

Grymes wasn't able to achieve anything for his clients.* It isn't apparent why the action fizzled—one would have thought that since half of Krahnstover's passengers had died during the voyage, there would have been a good chance of successfully suing him for something—but then again, these were more robust times, as this report in the *Louisiana Gazette*, published a week after the immigrants' arrival, demonstrates:

German Redemptioners

The public attention has been much occupied the last few days with this description of emigrants that have lately arrived from Amsterdam. The novelty of the circumstance has excited feelings of much interest, and many reports, it is believed, have gone abroad, calculated to make a very unfavorable impression as to the usage of those people on the passage, & their introduction here to servitude. It is always gratifying to see public sympathy enlisted on the side of humanity; & it is the glory of our country that the oppressed and the poor of all nations find in our Land an asylum of protecting justice: but we ought, at the same time guard against any impressions which arise only from our feelings, and are not supported either by the existence of facts, or the intrinsic welfare of the objects of our commiseration. These emigrants have come here under special engagement to redeem the expense of their passage hither by voluntary servitude.... That there are many privations and sufferings incidental to a voyage of this nature, is undeniable; but from the appearance of those people now in our city, we should not conclude that their case has been more than ordinarily so. The servitude they have to submit to here, is not of a grievous kind, and probably will leave them more vitally free than the political institutions of their own country...³⁷

^{*} Two witnesses in the trial to free Salomé Müller, J.C. Wagner and F. Schuber, refer to this litigation but don't explain why it produced nothing for them (Docket 5623). Most likely it never went to trial. See also Cable, p. 157.

The deaths of hundreds of immigrants may not have unduly disturbed the citizens of New Orleans, but then it was discovered that Krahnstover had sold several German families to free blacks. This was something to be concerned about. One of the most sacred taboos of the South had been broken—white people had become the servants of those with colored skin. The Louisiana legislature was in session at the time, and so strong was the sense of outrage that within two days of being advised of what had occurred, it had passed legislation undoing the sales. It was declared to be "the duty of the attorney general" to notify the people of color who had engaged white people that such an engagement was contrary to the true intent and meaning of the law. The Act went on: If "free people of color shall refuse or neglect to comply with the said notice, the attorney general shall immediately commence an action against them to have the contract rescinded...."

The legislature also took the opportunity to make some minor amendments to the law relating to redemptioners. There was no general attack on the system; quite the contrary, the revisions confirmed the right to hold immigrants as prisoners until they were sold. It was declared:

That it shall be lawful for the master, owner, or consignee of any vessel importing redemptioners into this state... to keep and detain said redemptioners on board the vessel wherein they were imported, until the price of their passage be paid, or until they be bound to service pursuant to the provisions of this act.

Some remedial provisions were also passed. The legislature gave notice that twelve months after the passing of the act, if any ship arrived in the state with more than "two persons for every three tons of the burthen of such vessels," or if the passengers had not been "well supplied with good and sufficient meat and drink, particularly fresh water," the shipowners would forfeit their right to sell the passengers as redemptioners. Another law provided "That when any white persons are imported into this state as redemptioners, it shall be the duty of the Governor... to appoint two or more discreet and suitable persons, well acquainted with the language of such redemptioners to

be guardians." It was the duty of the guardians to board every vessel importing redemptioners and inquire into the contracts they may have made, and whether they had been cruelly treated during the voyage.³⁸

These reforms, having effect only for the future, were of no assistance to the Müller brothers. Every day for two weeks Henry and Daniel stood on the deck of the *Juffer Johanna* with their children, waiting in vain for someone to purchase them. Every night for two weeks, after the children had gone to sleep, the brothers anxiously discussed their fate. Surely, said Henry, his brother must realize that it was unlikely that they would ever be sold complete as two families. Couldn't he see that the buyers coming on board were interested only in their children? It had to be faced that the best they could hope for now was that each of them would be able to keep their children with them.

One day, at the beginning of the third week, Henry returned to the cabin to announce to Daniel that he had had enough. He couldn't bear the thought of remaining another day on the ship that had taken the lives of his wife and so many of the people from his village. There was a farmer on the deck who would keep the family together, and he was going upstairs to agree to his terms. He begged his brother not to judge him too harshly. There was no other way. He thrust a copy of his new master's address into his brother's hands. He was going to Bayou Sara. The farmer had said it wasn't too distant, just four days sailing up the Mississippi. Henry promised to write as soon as he arrived. They would only be apart for a few years. He took Daniel into a quick embrace and departed.

Carrying everything they possessed, Henry and his three children followed their new master down the gangplank and stepped onto American soil. After all the sacrifices, heartache, and death, they had arrived. This was America, but they were no longer free. Their passage to America had been paid three times—once by themselves, once by the Dutch government, and, finally, by their own servitude.

A week later a man dressed in rags, and clearly ill, rang the bell at the entrance of Madame Borgnette's school for young ladies in the French

Quarter. Peering shyly from behind his legs was a boy and two young girls. The door was opened by the *femme de chambre*, who, after ascertaining their business, directed them to the scullery, via a lane at the side of the house. There Daniel Müller found Eva Kropp, her sleeves rolled up, scrubbing a large blackened pot. She looked at him in alarm. He was dreadfully thin and black shadows circled his eyes. His shoes were held together with string, the cuffs of his shirt were frayed, and his children were dressed in ill-fitting garments, obviously the gift of some charity. He had good news, he told Eva. They had somewhere to go. He had bound himself and Jacob, Dorothea, and Salomé to work for a wealthy landowner in Attakapas. They were to set sail that afternoon in a keelboat.

Eva Kropp drew the children to her waist. She asked how he could possibly look after three young children. She pleaded with him to at least let her take the youngest. It would only be until he called for her and then he could have her back. Daniel shook his head. Salomé would be staying with him. He was her father and he would never give her up. He began to cry. Ashamed of earning the pity of a fifteen-year-old girl, he then turned away and, taking Salomé's hand, walked off while his other two children followed behind.

FOUR

NEW ORLEANS

Have you ever been in New Orleans? If not, you'd better go; It's a nation of a queer place; day and night a show! Frenchman, Spaniards, West Indians, Creoles, Mustees, Yankees, Kentuckians, Tennesseeans, lawyers and trustees. Clergymen, priests, friars, nuns, women of all stains; Negroes in purple and fine linen, and slaves in rags and chains. White men with black wives, et vice-versa too. A progeny of all colors— An infernal motley crew! James R. Creecy, 1829

ew Orleans was, and still is, the most un-American of cities. Its founder, the Frenchman Sieur de Bienville, looking for a place to site a village in 1718, chose swampland on the banks of the Mississippi some thirty leagues (about one hundred miles) from the sea. In this humid wilderness, infested with snakes, alligators, and mosquitoes, he set his reluctant workforce of convicts and settlers to clear trees and dig ditches. He named the village La Nouvelle Orléans, a name intended to curry favor with the extravagant and self-centered Regent

NEW ORLEANS

of France, the Duke of Orléans—a man, his distracted mother once said, who had been given every gift excepting that of making use of them.

Bienville's choice of such an unpromising site for his royal colony was dictated by geography. He well understood that those who controlled passage up and down the Mississippi could aspire to rule the great valley it drained. Command of the Mississippi required a trading post within the protection of a fort close by where the river entered the sea. But where? Ideally, a trading village should be sited on land high enough to be safe from floods and storms, close to the sea, and on the banks of a river narrow enough to be spanned by a bridge. The lower Mississippi met none of these requirements. From Baton Rouge, about two hundred miles upstream, to its entry into the Gulf of Mexico, the river is uniformly wide (almost half a mile); held in by natural levees, much of its water is actually higher than the surrounding land.

On a voyage of exploration some years earlier, Bienville had seen a small area rising above swamp water on the banks of a crescent-shaped twist of the river. He carefully calculated the advantages of such a site. It was halfway between the French colonies at Natchez and Mobile. An alternative access to the Gulf of Mexico lay through Lake Pontchartrain, located only several miles along an old Indian trail. It was far enough inland to be safe from hurricanes and storms. And when enemy ships slowed down to navigate the curve in the river, they could be fired upon from both shores. This was where he commenced to build a fort.

For the next forty-five years, La Nouvelle Orléans was run either by a succession of military officers appointed as governors, who saw their office as a source of personal income, or by chartered companies more interested in fleecing shareholders than in economic development. Dreams of picking gold and diamonds up off the ground, and of farming lands so fertile they only had to be tickled to yield their abundance, evaporated like marshland fogs. Convinced it was abandoning nothing of value, France transferred the colony to Spain in 1762. The Spanish did no better in extracting wealth from swamps, and in 1800, transferred it back to France. Seemingly in no great hurry to reclaim this problem colony, three years were to pass before

the French flag was raised, and by then Napoleon had passed it on again—this time to the United States.

The Louisiana Purchase of April 1803 was the biggest land sale in history. The whole of the Mississippi Valley up to the Rocky Mountains and beyond, an area of 828,000 square miles, was sold by Napoleon to President Jefferson for fifteen million dollars. With this one transaction, the size of the United States was doubled and from its lands a dozen states would eventually be carved. A fledgling nation, barely two decades old, now possessed an empire straddling an entire continent.

The new territories of the South grew with astonishing speed. Almost anything a man wished to grow—cotton, tobacco, wheat or livestock—seemed to thrive. However it was one crop, cotton, which was the economic powerhouse carrying all the others with it. Whereas under Spanish rule Louisiana had exported the modestly profitable indigo, corn, tobacco and flax, after its acquisition by America, its main exports became sugar—and cotton, cotton and more cotton. Two inventions—one in the Old World, the other in the New—provided the spur to cotton's dominance. The wire teeth in Whitney's cotton gin deftly freed the fiber from the pods and allowed planters to adopt the hardy short-staple plant that was ideally suited to the land in the South. Meanwhile, in England, Watt's steam engine provided the power to spin, weave, and print cloth in the dark mills of Lancashire.

The lower Mississippi Valley became a vast, efficient, cotton-growing machine. Plantation production of cotton with slave labor became so widespread and so profitable that the wealth and culture of the South came to depend on it. Plantations without slaves couldn't compete. An antislave moralist attempting to produce cotton with white labor would go broke. With cotton (and later sugar) commanding the Southern economy, subjected blacks were required in the thousands.

"No, you dare not make war on cotton. No power on earth dares to make war upon it. Cotton is king." This was the roar from James Henry Hammond of South Carolina in a speech to the U.S. Senate. Hammond was saying what he believed everyone in the nation knew, if only they cared to admit it: that cotton was an unstoppable

NEW ORLEANS

economic force that had entrenched slavery into the way of the South. David Christy, a Cincinnati journalist, expressed it even more strikingly:

HIS MAJESTY, KING COTTON, therefore, is forced to continue the employment of his slaves; and, by their toil, is riding on, conquering and to conquer! He receives no check from the cries of the oppressed, while the citizens of the world are dragging forward his chariot, and shouting aloud his praise! KING COTTON is a profound statesman, and knows what measures will best sustain his throne. He is an acute mental philosopher, acquainted with the secret springs of human action, and accurately perceives who will best promote his aims. He has no evidence that colored men can grow his cotton, but in the capacity of slaves. It is his policy, therefore to defeat all schemes of emancipation.³⁹

Nowhere was the dominance of the kingdom of cotton more evident than on the waterfront of New Orleans. Lines of cotton bales, stacked three high, formed broad avenues leading to ships waiting to carry them to the four corners of the earth. Cotton was the ideal cargo—almost indestructible, valuable, and easy to handle. Within two decades of the Louisiana Purchase in 1803, the Mississippi River became one of the great trade routes of the world, in the process making New Orleans the largest city on the western frontier and the third largest in the nation.

Journalists from eastern newspapers, sent to describe the new state of Louisiana, were apt to report that the wharves of New Orleans were the most exotic place in the United States. It was an ant's nest where things were packed and unpacked, sold or auctioned, and then sent elsewhere—either up the Mississippi to the heartland of America, or downriver to the great cities of Europe. They wrote of cargo garnered from every port from Maine to the Gulf being stacked on the levee, ready to be taken to a thousand towns and cities on the vast western plains. There were kegs of nails from Boston, bolts of cloth from New York, and sacks of coffee beans from Cuba. They wrote of near-naked slaves, shiny with sweat, unloading tea chests

from India, crates of fine crockery from England, boxes of wine from Bordeaux, and oak chests of dueling pistols from France. They described teams of horses pulling drays piled high with bales of cotton and slaves rolling hogsheads of sugar up the gangplanks of ships bearing the flags of a score of nations. They marveled at the medlev of tongues to be heard among the milling throng on the wharves. Iewish traders from Russia wearing beaver-skin hats and frock coats examined crates of tobacco. French and Spanish merchants of the city supervised the dispatch of their produce to agents in states upriver. Flatboat men dressed in the furs of animals from the hills of Kentucky walked side by side with bearded sailors from South America. Elegant men and women disembarked from steamers to be immediately harried by pedlars. Black men in ragged pantaloons sold roasted peanuts; women offered sugary biscuits for sale, while black youths danced slapfoot in front of their begging bowls. All this, while the whistle of the steamboat, getting ready to embark for St. Louis, sounded in the background.

The city manufactured practically nothing itself. New Orleans grew, and became rich, by taking a cut of whatever was being carried across its docks. Wharfingers charged for cartage, storage and insurance. Bankers skimmed both ends of the market by providing planters with credit at the beginning of each year, reaping the harvest with interest when the crops were sold, and then financing the exporters who bought it. Attracted by the wealth moving through the city, Yankee traders, Philadelphia lawyers and New York bankers came from the east. Within a few years, Louisianan brokers were boasting that they had more money at their disposal than their counterparts in New York City.

In the years following the Louisiana Purchase the population of New Orleans increased dramatically. Adding a heady spice to the ethnic mix of the city were the 10,000 refugees who arrived in New Orleans from Saint-Domingue (modern-day Haiti). Some were white, but many (about 3,000) were *gens de couleur*. These were no humble children of freed blacks—many had been masters themselves in that decadent mountain paradise that had been run as a French sugar colony until half a million slaves, goaded by intolerably cruel treatment, revolted against their white and mulatto owners. The

refugees were French-speaking, Catholic, and educated, and many brought their slaves with them, including their sang-melee mistresses, called Les Sirènes because of their great beauty. At the Café de Refugies, the refugees drank *le petit Gouave* and regaled listeners with their tragic tales of lost wealth and power. These gracious, licentious people with their fine clothes and luxurious morals had an immediate impact on the fashion and culture of the city.

Many of the refugees from Saint-Domingue believed in voodoo, which has remained a secretive and mysterious cult in New Orleans ever since. Like the city itself, voodoo was a mix of cultures and religions. It twisted Christian saints and liturgies to its cause. From Catholicism it derived a preoccupation with sex, sin, and sacrifice. Symbols of dread, such as bats, black cats, and serpents, were procured from the medieval lore of Europe. To this were added West African mysticism, devil worship, and zombies. The city's most famous voodoo queen was Marie Laveau, a mulatto of African, Amerindian, and white descent, who told fortunes and dispensed hexes and love charms. In ritualistic ceremonies, she led performers in dances with twisting snakes, while her adherents drank rum and blood from the severed necks of roosters, and simulated sexual congress before the weeping statutes of saints. Voodoo had adherents (and curious spectators) among all classes and colors, although its main hold was on the colored and Creole communities.

During the boom years following 1820, almost half a million immigrants from Europe poured into New Orleans. The majority came from Ireland and Germany. Attracted by cheap land and the availability of work on the waterfront and in nearby factories, they settled upriver of the city. The area around Adele Street became known as the Irish Channel, while a few streets away, on Sixth Street, the Germans lived in an area dubbed Little Saxony.

New Orleans was fondly called Sin City by the river men. Notoriously decadent, irreligious, Catholic in name, but not in church attendance, the only Roman tradition followed with any conviction was the Continental Sunday. Entertainment varied from high opera and performances of the latest plays from London and Paris, to the artless and grotesque. As an example of the latter, a handbill circulating

in the city in 1817 announced an "extraordinary fight of Furious Animals":

1st Fight—A strong Attakapas Bull, attacked and subdued by six of the strongest dogs of the country.

2nd Fight—Six Bull-dogs against a Canadian Bear.

3rd Fight—A beautiful Tiger against a Black Bear.

4th Fight—Twelve dogs against a strong and furious Opelousas Bull.

If the Tiger is not vanquished in his fight with the Bear, he will be sent alone against the last Bull; and if the latter conquers all his enemies, several pieces of fire-works will be placed on his back, which will produce a very entertaining amusement.

The doors will be opened at three and the Exhibition begins at four o'clock precisely.

Admittance, one dollar for grown persons, 50 cents for children.

A military band will perform during the Exhibition.⁴¹

Down the Mississippi, like a gutter in flood, were washed gamblers, prostitutes, vagabonds, and thieves from six states. The Kaintocks, after spending weeks guiding their flatboats of massive planks downstream, found an array of bawdy houses, billiard halls, clip joints, and gambling dens awaiting their pleasure. They had the reputation of being the roughest, toughest, and dirtiest fighters in the whole of the South. The red-light districts were located along the waterfront and on Girod Street. The most notorious of all, The Swamp, was an area of flimsy shanties in marshlands behind the city, where drunkenness, knifings, and sordid sex were on nightly offer.

Those defending New Orleans's reputation of having the highest crime rate of any city in the United States, and a murder rate higher even than Kansas City, pointed out that almost all the criminal activity was confined to the riverboat men, sailors, and the Irish and German laborers. This sort of thing happened in all port cities, and after all, New Orleans was one of the greatest port cities in the world. The Creoles, in their fine houses in the Vieux Carré, and the

Americans, living a life of gracious wealth in the Second Municipality, found little reason to be concerned about the nightly mayhem in the gambling dens and brothels of the backswamps.

Opposed to this perpetual and unchecked crime wave was not so much a police force as a small detachment of city guards armed with half pikes and sabers. Soundly and repeatedly defeated whenever they ventured forth to take on the riverfront ruffians, they were usually to be found in the safety of the guardhouse, or walking the beat in the respectable areas of town. No one expected them to visit The Swamp or Girod Street, particularly at night. It wasn't so much that criminals in those areas escaped detection, but rather that detection wasn't even attempted.

Most men in New Orleans carried concealed weapons of various types: stilettos, switchblades, sword canes, slugshots, and pocket-sized revolvers. The Englishman Edward Sullivan in his book, *Rambles and Scrambles in North and South America*, describes what happened to him when he attended one of New Orleans's famous quadroon balls:

These balls take place in a large saloon: at the entrance, where you pay half a dollar, you are requested to leave your *implements*, by which is meant your bowie-knives and revolvers; and you leave them as you would your overcoat on going into the opera, and get a ticket with their number, and on your way out they are returned to you. You hear the pistol and bowie-knife keeper in the arms-room call out, "No. 46—a six-barreled repeater." "No. 100—one eight-barreled revolver, and bowie-knife with a death's head and crossbones cut on the handle." "No. 95—a brace of double barrels." All this is done as naturally as possible, and you see fellows fasten on their knives and pistols as coolly as if they were tying on a comforter [woolen scarf] or putting on a coat.

As I was going upstairs, after getting my ticket, and replying to the quiet request, "whether I would leave my arms," that I had none to leave, I was stopped and searched from head to foot by a policeman, who, I suppose, fancied it impossible that I should be altogether without arms. Notwithstanding all this care murders and duels are of weekly occurrence at these balls, and during my stay at New Orleans they were three. . . .

If liberty consists in a man being allowed to shoot and stab his neighbor on the smallest provocation, and to swagger drunk about the streets, then certainly the Crescent City is the place in which to seek for it, for they have enough and to spare.⁴²

The Creoles, swamped by the number of foreigners settling in their city, retreated to the elegant terraces of the Vieux Carré, with their upstairs galleries of Spanish wrought iron, lush enclosed courtyards, and stone cellars lined with Bordeaux wines. There they tenaciously clung to an exaggerated mimicry of the social value of the ancien régime of prerevolutionary France. They were emphatically Catholic in name, if not in morals, they despised Protestantism, and the excesses following the French Revolution had taught them to be wary of democracy. Few, in fact, were descendants of aristocrats—their forebears in colonial Louisiana had been soldiers, traders, and farmers, and even in a few cases had been sent from the house of correction in Paris. Slaves had made them wealthy. Thirty-five years of Spanish rule hadn't caused them to believe that the old ties with France had been snapped, and most were determined to treat the acquisition of Louisiana by the United States in the same way. They regarded the Américains as ill-mannered money-grubbers, without taste or nobility, and their women as brash and lacking femininity. The Americans' response was to create a stereotype of the Creoles that was just as negative. The author Charles Sealsfield wrote that "the drawbacks from their character are, an overruling passion for frivolous amusements, and impatience of habit, a tendency for the luxurious enjoyment of the other sex, without being very scrupulous in their choice of either the black or white race."43

Although Creole males revered the ideal of the virtuous wife, they saw no inconsistency in indulging in a highly formalized and uniquely Louisianan system of concubinage. Called *plaçage*, the institution saw white men of wealth place young colored women (called the *placée*) in a semipermanent relationship as their exclusive mistress. The arrangements were often made at the quadroon balls under the supervision of the placée's mother, usually an ex-courtesan herself. Dressed in exquisite finery, the women were put on display with the intention of catching a man of quality, by coquettish conversation and

dainty dancing. According to James Silk Buckingham, an Englishman on a grand tour of America in 1842:

[The quadroon balls] furnish some of the most beautiful women that can be seen, resembling in many respects, the higher order of women among the Hindoos, with lovely countenances, full, dark, liquid eyes, lips of coral and teeth of pearl, long raven locks of soft and glossy hair, sylph-like figures, and such beautifully rounded limbs and exquisite gait and manner, that they might furnish models for a Venus or a Hebe to the chisel of a sculptor.⁴⁴

Only light-skinned colored women were admitted to the quadroon balls; pure Africans of both sexes were excluded, and the presence of white women was unthinkable. The price of admission was fixed so high that only men of means could afford to attend. If a man was entranced by what he saw, negotiations began. To the young woman's mother a desirable catch was a gentleman with sufficient wealth to provide her daughter with a house (customarily, one of the neat white houses set in a row along the Ramparts), attendant slaves, money and, if she was particularly beautiful or he excessively rich, a cabriolet.

The arrangement was described as a left-handed marriage. According to the singular mores of New Orleans, a placée was considered virtuous if she was faithful to her provider, never, ever approached his wife, home, or children, and was decorous in her declining years as his ardor waned. She could never expect to be taken by her gentleman into polite society, nor could she dare risk arousing his jealousy by cavorting in public. The permanency of the relationship depended on the honor of the gentleman (always an unreliable commodity), although if he abandoned the relationship without just cause, he was expected to maintain her, or set her up in some modest business such as millinery or dressmaking. No one expected him to take responsibility for her children. Her daughters, yet another shade lighter, were available for a similar arrangement when they grew up, while her sons were left to fend for themselves. Not surprisingly, plaçage was one of the few Creole customs adopted by American males of wealth.

The Creoles and the Americans resolved their mutual dislike by living in different parts of the city. The Americans found green fields upriver of Canal Street where they built mansions in spacious gardens. They created a square in Lafayette, not overlooked by a cathedral, a governor's residence, and a priest's house as in the French Quarter, but with banks, a Masonic lodge, and nonconformist churches. By the 1820s the Americans had installed gas lighting to guide patrons to the fabulous American Theater on Camp Street built by James H. Caldwell, actor, impresario, and property developer. In 1837 he built the even grander St. Charles Hotel, taking up an entire block. It was one of the great hotels of its era and its landmark white dome was an unmistakable navigation beacon for miles up and down the river. Five blocks away in the Vieux Carré, the French built the equally grand St. Louis Hotel. The two nationalities then proceeded to build separate markets, canals, docks, and railway lines. The broad thoroughfare of Canal Street (the canal was never built) served as the neutral ground between the feuding sides.

By the late 1830s the breakdown in relations between the Creoles and Americans was so complete that divorce, rather than separation, became necessary. Put aside was the fact that a little over two decades earlier they had stood together to rout the British in the Battle of New Orleans. The Crescent City was cut into three areas of governance. The result, looking very much like wedges of a pie, created the First Municipality, centered on the Vieux Carré (primarily French); the Second Municipality upriver (primarily American, but with Irish and German migrants on the riverfront); and downriver the Third Municipality, inhabited by the poor of all nationalities. To add to this troika of overgovernance, a mayor and a general council from the three municipalities sat once a year in the Cabildo to discuss matters of overall concern to the city. New Orleans was always ripe for the picking and, with three municipalities, the opportunities for graft, kickbacks, and bribery tripled. Only propertied white men could vote (thus disenfranchising over two-thirds of the population), on the grounds that only they had the requisite good sense, a doubtful proposition since they consistently voted into office the most corrupt band of robber barons in all of America. Politicians of all persuasions created a complex system of patronage, so that government officials,

the police, and contractors owed their appointment to a particular political party. On election days, gangs of ruffians roamed the streets, carrying billyclubs and intimidating voters into supporting their particular candidate.

Kept apart by culture, religion, and politics, the Creoles and the Américains mingled for food, sex, and amusement. They rubbed shoulders in the elegant coffeehouses, in the plush bordellos, at the quadroon balls, and in the tiered cockfighting pits of the French Quarter. They met over the green felt of the gambling tables, and on the horse track at Metairie. They were also likely to meet on the dueling field.

Nowhere was the Code of the Duello held in greater veneration than in New Orleans. Pride, passion, and honor hung in the air whenever gentlemen met, and the least slur upon a person's character, or the merest slight on a woman's reputation, whether intended or not, could lead to an invitation to settle the matter on the dueling fields. No man, if he wished to be considered a gentleman of character, could refuse. Duels were sometimes fought merely as an expression of courtly behavior. The historian Charles Gayarré relates the story of how six young men returning from a ball, upon observing the moon lighting an expanse of grass, remarked what a beautiful night it would be for a joust. They paired off, drew their swords, and after a fine display of skill with the blade, two of the youths lay dying.

Duels were held in the gardens behind St. Louis Cathedral, under the trees on Metairie Road or beside the Dueling Oak in Louis Allard's plantation. In colonial times, duels were fought with the colichemarde, the rapier, and the broadsword, and only occasionally with pistols. Honor was satisfied when blood was drawn (the merest scratch would suffice) and deaths were few. All this changed when the Americans entered the scene armed with pistols or shotguns, and a serious intention to kill. The city's golden age of dueling was in the decades following 1830. It is said that on one Sunday morning in 1837 under Louis Allard's oaks, ten sets of opponents, with their seconds and supporters in watchful attendance, lined up for ten duels, fought one after the other, resulting in the deaths of three men.

In 1818, when Salomé Müller arrived in New Orleans, the city's population was predominantly black. About a third of the population were slaves, a quarter were free persons of color, with whites making up the remainder.⁴⁵

They may have been counted in the census, but the state of Louisiana didn't regard free persons of color (called *gens de couleur libres* by the French) as its citizens. They couldn't vote or stand for public office. They couldn't serve on juries. Prejudice and practice meant that they were excluded from the professions and government positions, and the only schools available to their children were a few run by the nuns or organized by black communities. A myriad of petty affronts emphasized their subordinate status: they were segregated in theaters and on omnibus lines, they were banned from most hotels and restaurants, they couldn't carry a firearm without official approval, and intermarriage with whites was forbidden. A provision in the Louisiana Black Code stamped their social inferiority into law:

Free people of color ought never to insult or strike white people, nor presume to conceive themselves equal to the white; but, on the contrary, they ought to yield to them in every occasion, and never speak or answer to them but with respect, under the penalty of imprisonment, according to the nature of the offence.⁴⁶

Yet Louisiana accorded free persons of color many rights denied black people in the slave-free North: they could leave property by wills, they could sue in court, even where the defendant was a white person, and they could be witnesses in court cases against whites. There was no prohibition on free blacks owning slaves, and many did so.* A thriving middle class of free black people lived in the Faubourg Tremé (located in the First Municipality), which lays claim to being the oldest black urban neighborhood in the United States. They ran small businesses, the men working as tailors, bricklayers, day laborers,

^{*} In 1830, one in every seven slaves in New Orleans was owned by a free black: see Lawrence Kotlikoff and Anton J. Rupert, "The Manumission of Slaves in New Orleans," *Southern Studies*, vol. 19, summer 1980, p. 177. Some of the black slaveowners included in this figure may have been plantation managers for absentee owners.

gardeners, carpenters; the women as seamstresses, laundresses, and tavern proprietors. A few became wealthy enough to send their children to schools in France and to build large houses for themselves.

And there were slaves.

In no state was the chattel nature of slavery expressed in more forthright terms than in Louisiana:

A slave is one who is in the power of a master to whom he belongs. The master may sell him, dispose of his person, his industry and his labor: he can do nothing, possess nothing, nor acquire anything but what must belong to the master.⁴⁷

This definition could equally apply to a horse.

Southern law regarded slaves as property, and just about every transaction involving property could be accomplished with slaves. They were hired out. They were given as security for loans. They were left to relatives in wills. They were seized by creditors. They were given as wedding presents. A "Negro girl, thirteen years of age, of good size" was once bartered away for twenty-nine dollars in pork. 48 "With us, nothing is so usual as to advance children by gifts of slaves. They stand with us instead of money," said a judge in old Virginia. 49

Governments provided slaves to the widows of heroes who died in wars.⁵⁰ They were donated to charities. They were stolen. Like all valuable property, they were insured. They were squabbled over in divorce proceedings. Masters were taxed for owning slaves; traders were taxed for selling them; freed slaves were taxed for the privilege of being free.

In 1819 a man announced in the *Louisiana Courier* that he was holding a lottery of only fifty tickets at twenty dollars each, the prize being Amelia, his thirteen-year-old Negro girl.⁵¹ In 1843 a man named Thomas took a boy to the races at the Metairie track in New Orleans and bet him on Lady Dashwood. The charger won Thomas five hundred dollars. The affair ended up before the courts because Thomas had promised one of his backers a half share of the winnings. The judge made no particular comment about wagering boys, but

Thomas (a cad for not honoring his word as a Southern gentleman) was ordered to share his winnings.⁵²

Several people might jointly own a slave. For example, Ann Williams of North Carolina once owned one-third of a slave. ⁵³ Miss Hamilton of Kentucky held a quarter share of over 100 slaves. ⁵⁴ A slave in Kentucky, named Fleming Thompson, once had five owners. They argued among themselves because three wanted to free him, while the other two didn't. Could Thompson be three-fifths free?*

Slave babies were given to little white girls as pets to be brought up. In the traditional ceremony, the hand of the slave was placed in the white child's hand and the black child was told she now belonged to the other, and it was the duty of one to obey and serve, and the other to command and care. Even yet-to-be-born children could be sold, with consignment delayed until the birth. The Supreme Court of North Carolina upheld such a provision in 1833. Clement Arnold owned a female slave who had produced six children for him. While she was pregnant with a seventh, he bargained her away with four of her children, "including the unborn one... at a price of \$1,000." Under the agreement, he was "allowed to select, at his choice, three of the children to be kept by himself"; delivery "was to be made as soon as the mother should recover after the birth of the next child." Louisiana was unique among the American slave states in prohibiting the sale of children aged under ten apart from their mothers.

Unborn children were also left by wills, especially where a man with no great range of assets wanted to treat his children equally—typically the deceased left a female slave to one child, and the slave's progeny (including those yet to be conceived) to another.⁵⁷ A person named Nelson wrote such a will, which was upheld by a court in North Carolina in 1843. He had three daughters. He left his slave, Leah, to one, and wrote: "And if there should be any increase from my negro woman Leah, I want that equally divided, between my

^{*} In a case that was described by the court as being "by no means free of difficulty," the judge declared Thompson free *pro tanto*, which is a Latin tag tending to camouflage the rather awkward result that Thompson was free to the extent of three-fifths. The judge then suggested that since most of the work of emancipation had been accomplished, it would be a good idea if the other owners entered into an arrangement to make Thompson entirely free. *Thompson v. Thompson* (1844 Ky) 4 B. Mon. 502.

three daughters Jane Magee, Elizabeth, and Aley Amanda; some to buy and pay the others as I would not wish any sold out of the family."58

The law may have designated slaves as property, but legislation has never been able to change human nature. No property was more rational and intelligent. None was more devious and emotional. Slaves became the confidants of family members. Slave women acted as wet nurses and read to white children at bedtime. They nursed the elderly. Slaves became the agents of their master in business dealings. They accumulated wealth. They committed crimes at the behest of their owners.* They got into bed at night with their masters and had the master's children and were named in divorce proceedings. A few, away from prying eyes, committed the illegal act of behaving as if they were married to their master or mistress.

It was the slaves' very humanity that made them such desirable property. The most expensive slaves were young, tractable males of obvious African appearance, who well understood the need to demean themselves before whites. Uncle Toms were especially valuable. Slaves who were uppity, runaways, or violent were marked down in value. The old, diseased, or very young were worth even less. In 1821, at the Virginian markets, a crippled slave was sold for a shilling. White colored slaves were of reduced value because they were unlikely to be questioned if they ran away. Albert, a slave who fled to Canada (or was it Ohio?—there were multiple sightings), "could not be distinguished from a white man." Witnesses said that "they did not consider him to be worth more than half as much as other slaves of the ordinary color and capacities." 60

Generally, women were worth less than men. An exception was pretty, honey-colored females. Life could be a lottery for them—some were purchased to look after children in grand homes, while others were sold to masters looking for a concubine. The value of slaves might stall during a general economic downturn, but the market never fell as hard as other holdings, and always bounced back higher. In 1820, at the slave auction in New Orleans, a good, medium-sized

^{*} Cynthia Simmons got a male slave to murder her husband: State v. Cynthia Simmons and Laurence Kitchen (1794 SC) 1 Brevard 6. John Skinner had two of his slave women put arsenic in the soup of a relative, Samuel Skinner, killing him: State v. Poll and Lavinia (1821 NC) 1 Hawks 442.

slave aged fifteen could be bought for three hundred dollars. A decade later, the same slave would fetch between four hundred and six hundred dollars. In 1837, at the height of an economic boom in New Orleans, a girl, "remarkable for her beauty and intelligence" sold for seven thousand dollars.⁶¹ A white laborer would have to toil for a lifetime to earn as much.

In an admirable mixed metaphor, a commentator once described New Orleans as a melting pot of humanity in a dismal swamp. Or as Colonel Creecy put it, in the poem that heads this chapter:

"A progeny of all colors— An infernal motley crew!"

When the German redemptioners arrived in 1818, New Orleans was little bigger than the original grid planned by Bienville a century earlier. Over the next two decades it more than tripled in size. From a city entirely within the call of the bullfrog, it became a metropolis, and it would take a man more than half a day to walk it from end to end.

The first steamboat had come down the river in 1812; by 1835, over one thousand steamers docked each year. Vessels with double smoke-stacks, three stories in height, and huge paddle wheels could churn their way from the falls of the Ohio River at Louisville to New Orleans in an astonishing five days. Some were pleasure palaces, filigreed with fretwork, cupolas, and wrought-iron lace, carpeted with Belgium weave and lit by sparkling crystal gasoliers, and carrying musicians, barbers, chefs, Southern belles, and fancily dressed riverboat gamblers.

New Orleans reveled in its newfound wealth. Day and night it was a show town. Theaters produced plays in English, French, and German. Rival opera houses were established in the French and American quarters. Dancing was the passion, enlivened by spicy food, wine, and low bodices. There were costumed balls and gaiety. Ice was brought downriver from the frozen North and sold for five dollars a ton. On sunny afternoons the levee provided the city with a promenade where men and women of fashion could stroll and be seen. Fortunes were being made, and great houses were being built. Real estate values rock-

eted, and river land that ten years earlier had been sugar plantations was subdivided for housing and sold for three times its price.

But for all its affluence, apart from a few streets in the American Quarter, the roads of New Orleans were still unpaved in 1830. Depending on the weather, they were either gluey with black mud or dust beds cut with deep ruts. Drainage was still a problem, and in wet weather city blocks were marooned by ditches of gamy water into which, each morning, householders deposited their sewage and food scraps. In the more established areas, pedestrians could walk on raised paths of thick planks, called banquettes—the wood obtained by breaking up flatboats, those huge, lumbering vessels that carried cargo downriver on a onceonly journey. Because the Mississippi was higher than much of the metropolis, gardeners digging in their backyard usually found a puddle of brown water a few feet down. Flash floods, and not prayer, could raise the dead in New Orleans, and holes had to be bored in coffins, and black men employed to stand on them, to make sure they stayed sunk during burials. Those determined to keep their relatives dry in the afterlife built vaults (called ovens) into six-foot-thick cemetery walls.

Given its lack of proper sanitation, and its location in a swamp, it's not surprising that New Orleans had the deserved reputation of being the unhealthiest city of any state in the Union. Periodic cholera, yellow fever, and smallpox plagues carried off hundreds. Although in most years the death rate of New Orleans exceeded its birthrate, the city continued to grow, all through immigration.

Madame Hemm spent four years in the service of a family in Baton Rouge. One day she met Henry Müller in the streets of the city. He told her that he was serving a master in the nearby village of Bayou Sara. He asked her if she had heard anything of Daniel or his children. She hadn't. Henry said he couldn't understand what had happened to them. Daniel hadn't written. No one seemed to know where they were. Madame Hemm asked Henry about his own children, and he proudly told her that they had grown so much she wouldn't recognize them. They were no longer starved for food as they had been in Germany. They had shot up. He reckoned they were bound to be taller than he was.

Years later Henry's son Daniel gave evidence in the trial to free Salomé Müller. He said that his father, right up until his death in 1824, talked continually of finding his brother. If ever he met strangers, he would ask them if they knew anything of a German immigrant with a young boy and two girls. In 1820, or perhaps 1821 (Henry's son wasn't sure of the date), a man told his father that he had heard of two German orphan girls going by the name of Miller living up Natchez way. Although the man was vague about where they lived, Henry had bought a horse and wagon and set off north. He lost the horse attempting to cross the Homochitto River but walked on to Natchez. When he arrived he had asked people endlessly about the two orphan children, but no one knew anything of them.

After serving as a domestic in Madame Borgnette's school for young ladies for two years, Eva Kropp earned her right to freedom. At eighteen years, she married a fellow redemptioner, Francis Schuber, who had plans to open a butcher shop in the market of the Faubourg Marigny.

Mrs. Fleikener spent a year and a half on Colonel White's Deer Range Plantation in the southwest of the state. She returned to New Orleans in the early 1820s. Mistress Schultzeheimer, after completing her service on the Hopkins plantation, returned to New Orleans where she rented rooms near Beekman's cotton and tobacco yard, and resumed her practice as a midwife. The Wagner brothers came out of service and set up a dry goods store on Chartres Street. Dorothy Kirchner married a man named Brown and went to live with him on a farm in Mississippi.

Francis Schuber's butcher shop opened, and customers came. The Wagner brothers' dry goods store flourished, and there were plenty of babies for Mistress Schultzeheimer to deliver. The immigrants all learned English, and even more important, they learned how things were done in America. They shared in the growing fortunes of the city, and told themselves that if they were prepared to work hard, wealth would be sure to come their way.

These were the ones who prospered. Many did not. Charles Sealsfield, writing in 1828, told what happened to them:

There are a great number of Germans in New Orleans. These people, without being possessed of the smallest resources, em-

barked 8 or 10 years ago, and after having lost one-half, or three-parts of their comrades during the passage, they were sold as white slaves, or as they are called, Redemptioners, the moment of their arrival. Thus mixed with the Negroes in the same kind of labor, they experienced no more consideration than the latter; and their conduct certainly deserves no better treatment. Those who did not escape, were driven away by their masters for their immoderate drinking; and all, with few exceptions were glad to get rid of such dregs. The watchmen and lamp lighters are Germans, and hundreds of these people fell victim to the fever, between the years 1814 and 1822.⁶²

FIVE

SALLY MILLER

You are hereby commanded to bring before me the body of one negro man, supposed to be forty or forty-five years old, with one leg off, rather dark complexioned, name unknown; also one negro man, supposed to be twenty-five or thirty years old, with one short leg, supposed to be occasioned by the white swelling, dark complexioned, name unknown; also one negro boy, supposed to be nine or ten years old, copper color, name unknown; also one negro woman, supposed to be forty or forty-five years old, copper color, name unknown; and also one negro girl, about five or six years old, copper color, name unknown; as it appears from an affidavit made before me that the above described persons are runaway slaves, and believed to be without free papers, and placed in the jail of the said county. Given under my hand and seal, this 16th day of January, A.D. 1850.

A writ issued by a justice of the peace in Illinois, 1850, for the apprehension of two men, one boy, one woman, and one girl, runaways from Missouri⁶³

ouis Belmonti was in no doubt where his slave had gone—she had fled to the house of that German butcher's wife in Lafayette. He arrived there early one morning and began pounding on the door. Francis Schuber had already left for work, and Eva and Salomé Müller huddled inside as Belmonti shouted at them through the mail flap. Mary was his and he wanted her back, he yelled. He rattled the door and stamped his feet. She was his property. He kicked the door, and became even angrier when Eva Schuber told him to go away. He would have them both imprisoned, he yelled. The longer Mary defied him, the more he would make her suffer.

SALLY MILLER

After half an hour of shouting at a closed door Belmonti left, but not before threatening them that when he got his hands on Mary he would take her in chains to the public auctions and get rid of her for good. The episode badly shook the two women, especially the vow to auction her. They knew that if Belmonti reclaimed Mary Miller, he could sell her within hours and she would be on her way to some remote plantation, or out of the state, never to be heard of again.

There was no squeamishness in New Orleans about slave auctions—they were conducted under the colonnades in front of the Supreme Court, in the garden behind St. Louis Cathedral and under the lofty rotunda of the St. Louis Hotel. According to the City Directory of 1842, there were 185 slave dealers operating in the city. The most famous of all the auctions was held in the opulent St. Charles Hotel in the American Quarter, where, after dining on the exquisite cuisine the hotel had to offer, men would bid for black men and women standing on blocks at each end of the bar. Over twenty slave pens were located within several streets of the hotel, and one, owned by Theophilus Freeman, was directly opposite. Solomon Northup was sold there in 1841. He described what happened:

With an occasional kick of the older men and women, and many a sharp crack of the whip about the ears of the younger slaves, it was not long before they were all astir, and wide awake. Mr. Theophilus Freeman bustled about in a very industrious manner, getting his property ready for the sales-room, intending, no doubt, to do that day a rousing business.

In the first place we were required to wash thoroughly, and those with beards, to shave. We were then furnished with a new suit each, cheap, but clean. The men had hat, coat, shirt, pants and shoes; the women frocks of calico, and handkerchiefs to bind about their heads. We were now conducted into a large room in the front part of the building to which the yard was attached, in order to be properly trained before the admission of customers. The men were arranged on one side of the room, the women on the other. The tallest was placed at the head of the row, then the next tallest, and so on in the order of their respective heights. . . . Freeman charged us to remember our places; exhorted us to

appear smart and lively—sometimes threatening, and again, holding out various inducements. During the day he exercised us in the art of "looking smart," and of moving to our places with exact precision. . . .

Next day many customers called to examine Freeman's "new lot." The latter gentleman was very loquacious, dwelling at much length upon our several good points and qualities. He would make us hold up our heads, walk briskly back and forth, while customers would feel of our hands and arms and bodies, turn us about, ask us what we could do, make us open our mouths and show our teeth, precisely as a jockey examines a horse which he is about to barter for or purchase. Sometimes a man or woman was taken back to the small house in the yard, stripped, and inspected more minutely. Scars upon a slave's back were considered evidence of a rebellious or unruly spirit, and hurt his sale.⁶⁴

Now the Schuber family took precautions. Salomé was never let out of the house by herself, the front door was always catched, the back gate was padlocked, and Francis Schuber arranged for some young men in the street to have billy clubs ready in their hallway. So constant was the fear that Salomé might be taken that plans of her working as a domestic in one of the mansions along St. Charles Avenue had to be abandoned.

These sorts of arrangements couldn't be tolerated for long. Salomé paced the house like a caged animal, complaining that she had more freedom when Belmonti owned her. Eva and Francis sympathized and the three of them sought counsel from several elders in the German community. What was needed, they advised, was a declaration from a high-ranking official, a court, the legislature, some such body, the governor perhaps, saying that Salomé Müller was a free German woman. Only then could they rest in peace.

The next day, Eva hurried off to consult an attorney who had been recommended to her. He was Mr. L. J. Sigur, principal of the firm of Sigur, Caperton & Bonford, which had its offices in Customhouse Street in the First Municipality. Mr. Sigur listened patiently as Eva described how her goddaughter had been discovered after being held

SALLY MILLER

in bondage for twenty-five years. It is truly a strange story, he said, when Eva had finished. She then told him how her owner had been threatening to seize Salomé and auction her. His face clouded in concern. But Madame Schuber, you and your husband are harboring an escaped slave. I must tell you, it is a most serious offense. The courts treat offenders most harshly.

A few days later, Sigur journeyed to Eva Schuber's house to interview Salomé Müller. He was admitted to the front parlor, where waiting for him was an olive-skinned woman, dressed in the clothing of a German frau. This is Miss Müller, said Eva. Salomé gave him a welcoming smile. While Eva busied herself in the kitchen, they exchanged pleasantries. With an easy grace Salomé thanked Sigur for handling her case. He noticed immediately that she had no trace of a German accent. He said he was pleased to be of service. She said that she hoped her freedom could be quickly settled. Nor was there any slave's deference in her demeanor. Eva returned from the kitchen carrying a tray of coffee and oatmeal biscuits. Sigur dipped his pen in the silver inkwell he had brought with him and opened a fresh page in his journal. And where have you been for the past twenty-five years? he asked.

And so Sigur learned of John Fitz Miller's involvement in the story of Salomé Müller.

He knew Miller. Everyone in New Orleans knew Miller. He had a number of business interests in the city and several plantations across the state. He used to own a stable of horses. Sigur remembered seeing him riding along the levee in the mornings with important men in politics and in the military. Sigur also knew Miller as a man with an irascible temper. He was not someone to be lightly crossed.

Mr. Belmonti had only owned her for five years, Salomé told him. Before that, Miller had held her as a slave for as long as she could remember. He had a sugar plantation in Attakapas. She had been there once. He had his own racecourse and a large house.

It was there that Miller took her, said Eva.

Sigur asked her what she meant. Eva told him that the last time she had seen Salomé she was a little girl. Her father, Daniel Müller, had brought Salomé and her brother and sister to where she was working as a domestic in Madame Borgnette's boarding school. Daniel had

said that he was going to Attakapas where the family had been engaged by a landowner. After that, they were never seen again. It was there, on his plantation in Attakapas, that Miller had made Salomé into his slave.

The vehemence of her words took Sigur's breath away. Was she suggesting, he asked, that Miller had knowingly enslaved a young white girl? She was. But it was an extraordinary thing to say. He could think of few accusations against a Southern gentleman as foul. But that is what happened, insisted Eva. He urged caution. They would have to petition the court to seek Salomé's freedom, and Miller would be bound to fight such a charge. No one could say what would happen.

This wasn't what Eva wanted to hear. Salomé was white, she insisted. The judge must see that. Sigur interrupted to say that she must be realistic. Why would someone as wealthy as Miller need to take a white girl as a slave? He had many slaves already.

But not a pure, white one, retorted Eva. Not a German girl.

Sigur looked at her in astonishment. But where did he keep this German girl?

At his plantation in Attakapas, of course, replied Eva.

Sigur paused for a moment. It would be a difficult case, he warned. Eva Schuber and her husband could well be found guilty of enticing Salomé Müller from her owner and be ordered to pay damages. The legal expenses would be substantial. Who would pay?

Eva didn't hear his question; instead, in a tumble of words, she told how she had recognized Salomé the moment she saw her on her doorstep. So had others. People who had been on the same ship with her. There was Mrs. Fleikener, Madame Hemm, Madame Koelhoffer, and Mistress Schultzeheimer. All of them had recognized her. So had Madame Carl. They had all known Salomé's mother. Mistress Schultzeheimer had been at Salomé's birth. They had all come from the same village. They knew her. They couldn't be mistaken. How could there be any doubt?

Sigur shrugged his shoulders. He was willing to take on the case, he said, so long as Madame Schuber understood that he would be looking to her to pay his legal fees, not the woman to be freed from slavery.

SALLY MILLER

So, money would be needed. Eva Schuber started to collect it.

When, many months later, Eva told her story to the court, she said she hadn't left New Orleans since her arrival twenty-five years earlier and had never been into the Third Municipality until the day she asked Belmonti to return her goddaughter. Yet now, in her search for contributions to Salomé's legal expenses, she traveled the length and breadth of the city, seeking out Germans in Carrollton, the Faubourg Marigny, and across the river in Algiers and Gretna. She knocked on the door of all the German businesses she could find, starting at Jackson Avenue and moving toward the city, then downriver and beyond. She pleaded with German bakers with flour on their hands, impatient to be away, as she explained to them the story of the lost German slave. She spoke to laborers on the wharves, and carpenters at their turning machines. She waited outside the Kaiser Dance Hall on a Saturday night and the Clio Street German Church on Sunday mornings, cajoling, pressing, and shaming. The story was too fanciful for some, but if they attempted to walk off they found Eva at their side, chattering into their ears, imploring them for help. A pure German woman had been taken by an American. Her fate depended on them.

Sigur completed drafting the petition in the last few weeks of January 1844 and arranged for Salomé to come to his office to sign it. Because the terms of the petition had such an important influence on the course of the subsequent trial, the substantive parts are reproduced below:

Sally Miller vs. Louis Belmonti

To the Hon. the First Judicial District Court of the State of Louisiana.

The petition of Sally Miller, a free white woman, residing in the City of Lafayette, respectfully represents:

That she was born of Bavarian parents, who emigrated to this country some time about the year 1817, that her mother having died on the passage, her father, brother, sister and herself, she then being not much above the age of three years, were sold or

bound to service as Redemptioners to one John Miller, who took them into the Parish of Attakapas, and that her father died before they arrived at their place of destination, all of which Petitioner having among other things since learned, she being then of too early an age to have them deeply impressed on her memory.

She further represents that being deprived then of her parents and entirely in the power and under the control of said Miller, he, in violation of all law human and divine, converted Petitioner into his slave, and as such, did for a long series of years, compel her to perform all the work, labor and services which slaves are required to perform, reducing her in all things to the level and condition of that degraded class.

She further represents, that in the year—she was sold by said Miller to Louis Belmonti, the defendant in this suit, residing within the jurisdiction of this Court, to wit: in the City of New Orleans, who has retained her in the bonds of slavery up to a very late period, she having but a short time since left the service of said Belmonti and gone to live with her relations who reside in the City of Lafayette, and she expressly charges that at the time she was sold to said Belmonti as aforesaid, he well knew she was free, it being then a matter of common notoriety that she had been illegally reduced to slavery.

She further represents, that since the time when she manifested her intention of pursuing her rights judicially, said Belmonti has adopted a cruel system of persecution against her, threatening to throw her into prison, to force her to work in the Chain Gang, and even to expose her for sale at public auction, said Belmonti having had ample means of ascertaining that she is a white person, and having devised these means of torturing her from the most malignant motives, and for the purpose of throwing every possible obstacle in the way of her recovery of her rights, and she has good reason to believe that said Belmonti intends to remove her out of the jurisdiction of this Court during the pendency of this suit.

In the closing paragraph, Sigur, with the customary flourish of the times, prayed that Belmonti be cited to appear "and condemned to

SALLY MILLER

pay one thousand dollars damages on account of the illegal and vexatious treatment of the Petitioner."

Oddly, there wasn't one word in the petition about the moles on her inner thighs. Perhaps Sigur wasn't told about them. Perhaps he was, but decided that the petition was no place to reveal all his evidence. Instead, what was included was a vitriolic attack on Miller and Belmonti. The charge against Miller was vicious—he "in violation of all law human and divine, converted [the] Petitioner into his slave, and as such, did for a long series of years, compel her to perform all the work, labor and services which slaves are required to perform, reducing her in all things to the level and condition of that degraded class." These words set the scene for the bitterness that characterized the litigation that followed. They made it inevitable that Miller would join the action to defend his character—he would be shunned in Southern society unless he did so. Compromise became impossible in the face of such allegations.

The damning of Miller wasn't an essential step in Sally Miller gaining her freedom. Sigur could have merely outlined the evidence in support of her German heritage, explained that Belmonti had purchased her from Miller, and left it at that. If Sigur had felt the necessity of explaining how Miller obtained her, he could have left open the possibility that Miller held Sally without realising she was freeborn, or that he had purchased her in good faith from another. Perhaps, behind it all, was the determination of Eva Schuber to blacken Miller's name. To punish and humiliate him for stealing the childhood of her goddaughter. Or it may be that the tactic, the hope, was that Miller and Belmonti, horrified by the possibility of a public airing of their misdeeds, would settle out of court and acknowledge that she was a free white woman. It is possible that Belmonti may have been so cowered, but anyone who knew John Fitz Miller would have known he had never retreated from a fight in his life.

Sigur's petition had given her a new name. When Madame Carl rescued her she was Mary Miller. The Germans remembered her as Salomé Müller. Now she was Sally Miller. Why the change? It was, of course, the Americanization of "Salomé Müller." Perhaps Salomé and her advisers, as they approached an American court, may have wanted to demonstrate loyalty to their adopted country by jettisoning

a name so obviously foreign. Historians have frequently observed that of all the immigrant groups settling in the United States, the Germans were the least likely to remain sentimentally attached to the old country. They tended to avoid enclaves, they neglected national days, rarely held parades like the Irish and the Italians, and unlike the French and the Spanish had no hesitation in anglicizing their names. So she became Sally Miller—and the fact that she had the same surname as the man accused of taking her into slavery was dismissed as being of nothing more than an absurd coincidence.

Though it would have been a large expense for an immigrant family, Francis and Eva Schuber could have attempted to buy Sally Miller from Belmonti. A slave in her late twenties, trained as a servant, healthy and capable of bearing children—she would have been worth five hundred dollars or more. Belmonti might well have thought he could have demanded extra from desperate relatives. Perhaps Eva could have raised the money by subscription among the German community, but would Belmonti have sold? Possibly not. Cable described Belmonti as the "wifeless keeper of a dram-shop," and there are more than a few hints to suggest that Sally was Belmonti's concubine. His behavior in harassing Eva Schuber for Sally's return was suggestive of a jilted lover; however, something more substantial emerged when, during the trial to free Sally Miller, a slave broker, Mr. A. Piernas, gave testimony. Belmonti had become acquainted with Sally while she was Miller's slave. According to Piernas, Belmonti engaged him to ask Miller if he was thinking of selling her. Sally then assisted in the negotiations by telling Miller's mother that she knew a person who would be willing to purchase her. This was Belmonti, and the deal was then done. 65

But there was another, more cogent, reason why purchasing Sally Miller was no solution for Eva Schuber: the transfer of ownership wouldn't have made Sally free. The result would simply have been that Eva would own her own goddaughter and, under the laws of Louisiana, it wouldn't have been easy for Eva to release her.

When Spain and France ruled Louisiana, there were few restrictions on manumission. The colonial administrators believed that if a master could promise his slaves eventual freedom as a reward for fidelity and service, they would be easier to control and less likely to

SALLY MILLER

rise in revolt. The very word "manumission" is derived from a ceremony that goes back to ancient Rome. A Roman wishing to free his slaves would hold them by the hand (manus) then release his grip, touch them with a rod on the cheek, and turn them in a circle, thus demonstrating to all those witnessing the event that his slaves were now free to go wherever they wanted. In Spanish and French Louisiana, men and women were liberated in this way to mark weddings or anniversaries in the master's family. It was also a ceremony followed during religious services by dying masters who desired to make peace with God for the sin of owning slaves, and by men freeing their own children.

In Spanish Louisiana, slaves could also purchase their own freedom. Remarkably, if a fair price couldn't be agreed upon, slaves could ask the governor's tribunal to have their price declared, and then work toward that amount by hiring themselves out at times when their owner didn't require labor from them.

This was the system the Americans inherited when they purchased Louisiana in 1803.66 It wasn't to last. In a series of crimping amendments, legislators set their hearts against freeing slaves. In 1807 the right of slaves to petition for self-purchase was abolished. Under the new regime, if a master wanted to free his slaves, he had to demonstrate to a judge of the parish that they had behaved well over the preceding four years. Running away or any criminal act disentitled a slave for life. Further amendments followed. In 1830 all newly emancipated slaves had to leave the state within thirty days, and masters had to post a bond of one thousand dollars to make sure they did. Provisions intending to limit the number of young slaves being freed into the community were also passed. At one stage, no slave aged under thirty could be freed, except where they "had saved the life of his master or the master's wife or one of his children." Later this was amended so those slaves under thirty could be liberated if a court of the parish agreed.

Driving this constant tinkering with the manumission laws was the fear of a color war, with blacks, free and slave, joining in a bloody massacre of the whites. To many white people in the South, the ideal society only had two racial categories: the master race and their slaves. The existence of a third class, freed persons of color, was seen as a bad

example to slaves and contrary to nature, which intended all black people to be subordinate. If slavery was a positive good, as many believed, and black people were better off as slaves, those who feared a servile insurrection led by freed blacks asked why manumission was allowed. Surely it would be better to entirely stop masters from freeing their slaves. This view won out, and in March 1857, Louisiana, following a trend sweeping right across the South, passed a law totally prohibiting manumission. The ban operated retrospectively, sometimes with heartless results. A slave named Julienne and her children instituted their suit for freedom in April 1857; no matter that Julienne was relying on a promise of freedom made by her mistress in 1837, her petition was a month too late. An apologetic judge noted in his decision: "If it should hereafter become possible, the plaintiff will have a remedy. At the present she has none. The time for her to acquire freedom has not arrived."67 Her time was to come five years later, when, in 1862, Union gunboats took New Orleans and Abraham Lincoln freed all slaves held in the Confederate states.

In 1844, when Eva Schuber consulted Sigur, the state of the law was that if she purchased Sally Miller, and then wanted to free her, she would have to file a petition with a judge of the parish. He would then post her petition on the courthouse door for forty days. If someone objected, there would be a hearing to ensure that Sally had "behaved well at least for four years" and she could earn sufficient income to support herself. Even after satisfying the controlling examination of the state, there was more—she had to leave Louisiana forever, unless a police jury of the parish, by at least a three-fourths vote, decided that she had been well behaved for at least four years or had been involved in some exceptionally meritorious service for her master.

This was hardly a satisfactory solution in Sally Miller's case. Apart from the humiliation of being named on a notice posted on the courthouse door, there was no guarantee that she would be successful—after all, she was a runaway. All sorts of gawkers and opponents might turn up, John Fitz Miller included, arguing that she shouldn't be freed, or if she was, that she shouldn't be allowed to remain in the state.

And then, after running that judicial gauntlet, if finally she was freed and allowed to remain in Louisiana, she wouldn't become a white person or a citizen of the state. Her status would be that of a

SALLY MILLER

free woman of color, with all the discriminatory accoutrements that entailed. Sigur's petition was crafted to achieve something that could never be achieved by manumission: a judicial ruling that Sally Miller was white. By suing Belmonti for damages, Sigur hoped that the court would be forced to decide that she wasn't a slave, was never a slave, and her detention was illegal. By such means, not only would Sally Miller be free, she would have been ruled by a court to be white.

Next to her new name, Sally Miller marked the petition with a large, firm cross. It was a crime in Louisiana to teach slaves to read or write, so it would have been surprising if she had written her name in full. Indeed, so patchy was the state's education system that more than half of the population was illiterate, whites included.

It would be months before a court could rule on the petition and Sigur remained concerned about what might happen to Sally in the meantime. With Miller's name about to be linked to the action, Sigur had no doubt that Miller, with his influence in the city, could easily pressure the police into seizing her, and even perhaps charging Francis and Eva Schuber with the crime of harboring a runaway slave. But Sigur had a solution and after watching Sally make her mark on the petition, he outlined it to her and Eva. On the same day that the petition was filed at the courthouse, Sally would present herself at the prison door, a hundred yards away. Sigur would then make an application with the sheriff for Sally to be released on a five-hundred-dollar bond, pending trial. Once the bond was set, Sally would no longer be a fugitive slave, a criminal charge would be unlikely, and anyone seizing her would be in breach of a court order.

On January 24, 1844, Sigur's not-so-simple plan was put into effect. Sally Miller, accompanied by Eva and Francis Schuber, presented herself at the calaboose, a gloomy, dank prison tucked at the side of the Cabildo on the Place d'Armes. At the same time, Sigur filed his petition for Sally's freedom with Deputy Sheriff Lewis at the First District Court, located in the Presbytere. Sigur placed the bond documents on the counter. Sheriff Lewis left the bond where it was and picked up the petition. His eyebrows rose as he read the document.

And what have Mr. Belmonti and Mr. Miller to say about this? he inquired.

By the end of the day, Sally Miller hadn't been released. Nor was she released the next day, or the day after that. Sigur was apologetic. He told Eva Schuber, who harassed him in his office each morning, that he couldn't really say when she would be released. Things had become complicated.

SIX

JOHN FITZ MILLER

The master may also use every art, device or stratagem to decoy the slave into his power...

Justice Baldwin, United States Circuit Justice, 1833 68

ohn Fitz Miller described the petition to free his ex-slave as the "darkest crisis of my life, coming unsought and unexpected."

It was unexpected because, although the amazing story of the German slave girl had been a topic of gossip in the city for weeks, no one was prepared to risk Miller's legendary ill temper by mentioning the matter to him. Miller lived much of his time on his sugar plantation on the banks of Bayou Teche in Attakapas.* On his periodic visits to New Orleans he had failed to notice that there was a pause in the conversation when he joined his friends in the main bar at the St. Charles Hotel and that some of his old acquaintances seemed reserved when he spoke to them. In the end, it was left to his mother to tell him what seemingly everyone else knew. She had heard it from his ex-business partner, William Turner. A shocked Miller immediately confronted Turner and angrily accused him of spreading rumors about him. Turner shook his head sadly. Didn't he know? How could he not know? There had even been a paragraph in the German-language newspaper, naming him. Only a day or two ago a petition for her freedom had been filed at court, and at this very moment she was under lock and key in the calaboose.

^{*} Attakapas was one of the counties created by the governor and the Legislative Council in 1805 as a judicial and administrative district. It was in the southwest of the state and included New Iberia.

The petition hadn't been served on Miller because it was Belmonti, and not he, who was named as the defendant. Miller strode to the courthouse and demanded to be shown the petition. When at last the clerk of courts placed a copy in his hands, he trembled as he read what it said about him. The accusations made against him, so clearly and precisely set out, were even more appalling than anyone had dared to hint to him. "I am unwilling," he was later to write to his supporters, "that the *finger of scorn* should be pointed at me as a man capable of holding in bondage a white child of tender years entitled to her freedom, for the sake of the trifling value her services could ever be to me. . . . I will expose to the best of my abilities, the tissue of perjury, folly and corruption of which this case was made up, and in which I was made the victim."

From then on Miller regarded himself as the *real* defendant and Belmonti as nothing more than a name attached to *his* court action. He consulted his attorneys, Lockett & Micou, and demanded the right to defend himself. This could be easily done, they advised. Louisiana law allowed a buyer to sue the seller if there had been a false declaration about the quality of the thing sold. All it required was for Belmonti to join Miller as a party on the basis that when Miller had sold him Mary Miller, he had warranted that she was his property, but now it was being asserted that she was a free person and incapable of being owned by anyone.

"For the value of the slave I care nothing," declared Miller.⁷⁰ His motivation, he claimed, was to defend not only his own honor as a gentleman, but the honor of his mother as well. Miller, a lifelong bachelor, was in his mid-sixties. He had rarely lived apart from his mother, and he realized that if people supposed he had reduced a German child to a slave, they would also suppose that his mother must have known about it. "What is far dearer to me than reputation or even life itself," he wrote, is "to remove suspicion from a beloved mother now near ninety years of age, still in full possession of all her faculties, though sorely grieved that her long life of charity, benevolent feelings, and beneficial deeds, were not a security against the shafts of falsehood and of slander."⁷¹

JOHN FITZ MILLER

John Fitz Miller was born into old wealth in Philadelphia in 1780, the son of John and Sarah Fitz Miller. In the period following the Louisiana Purchase, Miller, then in his twenties, left his parents' home. He arrived in New Orleans with a chain of six healthy slaves and a determination to make his fortune. He was in the city for less than two years when his mother joined him. His father had died, and his mother, after a short, second marriage to Joseph Canby of South Carolina, had become a widow again. Both Miller and his mother, now Mrs. Sarah Canby, were independently wealthy, and Miller, latching onto the economic boom in New Orleans in those years, proceeded to make himself even wealthier.

Massive docks were being built in the Navy Yards and Miller contracted to supply labor and lumber to the government. He then opened a block-making shop on the levee, and sometime around 1818, he purchased Withers' sawmill and the surrounding land downriver. It was an astute investment. The city had an inexhaustible demand for timber. Wharves were being constructed for miles on both sides of the river. Hundreds of dwellings were being built, all requiring wood—for the storied mansions being erected in the American sector, for the timber-framed houses being built for the Irish and German immigrants near the waterfront, and for the shotgun houses* being built for the free coloreds in Faubourg Tremé and across the river in Algiers. Down the Mississippi came rafts of hickory, oak, willow, cherrywood, and walnut to be hauled over the levee into Miller's sawmill. From the bayous of southern Louisiana he obtained the indestructible swamp cypress, with its fine grain that turned red as it dried. Schooners brought logs from mills scattered along the Gulf coast. He purchased rough sawn lumber from plantation owners along the Red River and dressed it with his newly purchased steam engine.

By 1823, Miller had thirty slaves living in the grounds of his yard and working as sawyers, axmen, and wagoners. He was widely

^{*} A shotgun house is a narrow structure with connecting doors in a line, giving rise to the notion that you could fire a shotgun from the front gate and hit someone standing in the back room. It is thought that the design came to Louisiana with Haitian refugees in the first two decades of the nineteenth century.

regarded as a good master, and it was a matter of pride to him that any slaves he owned were always well looked after. Down by the levee he built a dozen cabins in rows facing each other across a muddy track. Each cabin had a wooden floor, a proper griddle for cooking and window flaps that opened on poles. He believed it was economic lunacy for a master to ill-treat his slaves and he was contemptuous of his neighbors who let theirs live in filth, or were stingy with food and clothing. He got his work out of them though, believing he could achieve that without being a zealot with the whip. Strict supervision was the answer. He ran his mill from first light to dark every day, save Sunday. He hired Mr. Struve as his overseer and gave him firm instructions about how many feet of wood he expected to be cut each week. If there was a shortfall, everyone from Mr. Struve downward knew about it.

At the back of the mill, on a slight rise to catch the breeze, he built a house for himself and his mother, with elaborate stables for his horses in the rear. In 1833 he purchased a second house; this time upriver of the city, but still he hadn't exhausted his credit with the banks, so, as an investment, he built eight two-story brick buildings in a square at Faubourg St. Mary. With property values doubling each year, what did it matter if he was paying 20 percent interest? He was rich. He was respected as an astute businessman. He entertained lavishly and drove one of the finest equipages in New Orleans.

There was an orgy of financial speculation in the United States in the 1830s and nowhere were the excesses as startling as in Louisiana. Banks built large gothic palaces, borrowed heavily from a compliant state government, and lent to anyone who had a scheme to foist on the market. Loans were secured by mortgages on swamps, or on crops yet to be grown, or on town lots alongside railway tracks yet to be laid. Ordinary people placed their money and their trust in companies that promised to double their investment every two years.

Miller wasn't a man to miss out. There was an old saying in Louisiana that "it took a rich cotton planter to make a poor sugar planter." He purchased three adjoining properties in Attakapas, each one of them running down to the banks of Bayou Teche, and in their rich, deep soils he planted acres of sugarcane. He worked eighty slaves and operated a sugar mill and a rum distillery. He purchased an

JOHN FITZ MILLER

island, cleared its woodlands, and planted six thousand orange trees, so that thereafter it became known as Orange Island. There, on one of its bluffs, he built a house with a view overlooking the silvery surface of Lake Peigneur.

Miller laid out a racecourse on Orange Island, and with a number of local gentlemen, formed the Attakapas Jockey Club. With his mother by his side, he hosted frequent dinners and parties. He entered into the political life of his community and for a period represented the southern ward of St. Martin's Parish.

But for all his generosity and public spirit, Miller was never a popular man, and certainly never a man of the people. He didn't wear his wealth graciously. His hospitality was showy, and the price of eating at his table was to accept his prickly nature. He took offense easily and wasn't averse to threatening his neighbors with legal action. Once he got into an argument with the owner of adjoining lands and sued him for two thousand dollars, alleging that the man had pulled down fences and turned livestock onto his pastures. In response his neighbor said that Miller had ordered his slaves to use dogs to kill twenty head of his cattle. The jury found for Miller, but then to show its disdain at his behavior awarded him a contemptuous one dollar in damages.⁷²

The Panic of 1837 was one of those cyclical catastrophes that occur every few decades to remind the citizens of the United States that wealth isn't created by mass investment in paper promises. The end came quickly, although the signs had been there for a good year beforehand. National imports far outreached exports, and nervous financial houses in England began to tighten credit. For several seasons while bidders were scrambling to buy cotton on the New Orleans Exchange, its value was toppling in Europe. Late in 1836, prices on all commodity goods began to fall, and the slide continued in the New Year. Then, almost overnight, the value of bonds collapsed, and the bottom fell out of the New Orleans real estate market. In May 1837, every bank in New Orleans, save one, suspended payment. There was a brief recovery, but in 1839 the economy plunged into a deeper depression, and this time all banks in the city

halted specie payments. The railway edging toward Nashville stopped dead in its tracks. The speculator who built the Banks Arcade in Gravier Street went bankrupt, and the City Exchange Building, with its planned French interiors, was hurriedly downscaled to half its original size. Finally, the state of Louisiana itself repudiated on its debts.

With a rapidity that stunned him, Miller went down with the market. For the first time in his experience, unsold lumber piled up in the grounds of his sawmill. He clutched a sheaf of worthless bonds. He owed more to the banks than he could possibly pay. Not that his guests on Orange Island noticed any difference. He still boasted the best table in the parish, and his thoroughbreds continued to triumph at meetings of the Attakapas Jockey Club.

For the next three years, Miller devoted his life to staving off bankruptcy. He moved money from one account to another, he borrowed from friends, he begged at bankers' doors, and he juggled amounts due on promissory notes. Creditors wearied of getting money out of Miller. His first, and last, response was to take offense, and if pressed further, to litigate. He regarded letters of demand as a personal attack on his honor and every refusal to give him more time to pay, as an insult. He hired expensive lawyers to raise flimsy defenses and to take every technical point they could think of. Gradually the persistence of his creditors wore him down. He was forced to sell his houses in Lafayette and move back to the sawmill—but still he kept his properties in Attakapas. He transferred assets to his mother. Eventually, however, the day of reckoning came. In February 1841, he was summoned to appear at the Fifth District Court of New Orleans, where, in grim silence, he suffered the ignominy of being declared a bankrupt.73

However, to the amazement of his friends and the dismay of his creditors, Miller seemed as wealthy as ever, and his mother even richer. He continued to entertain and to run his horses, and he built a fine town house for himself and his mother in New Iberia, just a few miles away from his plantations. Then, in October 1842, in a miracle of financial manipulation, he was discharged from bankruptcy. Not that his creditors accepted this. They suspected chicanery, writs were issued, and a second round of legal action began.

JOHN FITZ MILLER

Sally Miller remained imprisoned. Eva Schuber came with food and fresh clothes every day. Sigur, who accompanied Eva on one visit, peered at Sally through the bars and told her how hard he was working for her release and that it shouldn't be much longer. The problem was that Miller had become involved and he was proving difficult. Sally sat bolt upright on a wooden bed and scowled at them both, but said little. The only illumination came from a single barred window, the size of a handkerchief, located high on the wall. Several other prisoners who lodged in the cell with Sally listened with interest to what was being said. It would only be for a few more days, Sigur promised, as he left.

The wardens practiced no racial or social discrimination in storing the human misery in the calaboose of the Cabildo. Runaway slaves, debtors, those awaiting execution, petty criminals, prostitutes, and lunatics were all lodged together in cells described by the *Louisiana Courier* in the early 1800s as "a series of very low, humid, and infectious vaults."⁷⁴

For the prisoners, it was a time of sitting and waiting, the only diversion being when a black person was brought in, placed in the stocks, given a flogging by the wardens, and then released. The wardens' task arose because citizens of the city who were squeamish about whipping their slaves could send them along to the calaboose with a note saying how many lashes they deserved, and an envelope containing the twenty-five-cent whipping fee.

Sigur continued to wrangle with Miller's attorneys. As far as Miller was concerned, Sally deserved to be locked up—if for no other reason than to demonstrate to the people of New Orleans that she rightfully belonged in a cell for runaways. His attorneys contemptuously dismissed the suggestion that a bond of five hundred dollars was sufficient. She was worth much more than that, and now that Mrs. Schuber had corrupted her into thinking she was white, why wouldn't she flee to the North at the first opportunity? How easy it would be for her, with her pale skin, to catch a steamer to freedom. The bond would have to be substantial indeed.

After hearing their demands, Sigur took the journey to the Schubers' house. They want someone to go surety for a thousand dollars, he told

Francis and Eva. They looked at him in astonishment. How could they ever get someone to risk so much? It was more than Francis would earn in three years. She can't be worth a thousand dollars, he said. Sigur wasn't sure. He could ask a judge to set a lower amount, but that would bring all sorts of uncertainties. Miller's lawyers might ask for two thousand; they might argue that she shouldn't be released at all.

Eva set off again to do the rounds of the German business houses. Mr. Wagner listened as she told him how a German woman was now in a damp prison with mad people, criminals, and slaves. He remembered the Müller family, didn't he? The five months they spent together on that ship in Helder? He would help, wouldn't he? He reached under the counter, pulled out his cash box, and dropped a stream of gold coins into her hand. She visited Mr. Eimer, then Mr. DeLarue and Mr. Frendenthal. They all said they would assist. Theodore Grabau, an apothecary in the city, gave her several notes, then said that if she needed further help, she should come back. Eventually, she had a thousand dollars in money and pledges. Francis Schuber went to the sheriff's office with Sigur and was entered on the court file as the bondsman.

On February 1, 1844, after a week in the calaboose, Sally Miller was released.

In the following days, a number of German businessmen who had donated to Eva's cause were called to a meeting in Mr. Eimer's house. It was time to stand together, he told them. One of their own had fallen into the hands of a slaver and she had to be rescued. It would be to the eternal shame of the German community if she didn't have their support. By the end of the evening they formed a committee to ensure that the lawsuit received the financial backing it required. As well as Mr. Eimer, the gentlemen participating were Messrs Grabau, DeLarue, Miesegaes, Rodewald, Curtius, Serda, Fischer, and Frendenthal, all of them owning businesses in the city. The involvement of these men in the affairs of Sally Miller marked the end of Sigur's association with the case. There was nothing in the court documents explaining why Sigur ceased to act, but no doubt the German gentlemen thought there was reason enough after Sigur had allowed Sally to be held in one of the foulest dungeons imaginable for a week. This

JOHN FITZ MILLER

was in addition to his disturbing habit of asking quibbling questions about why she could remember nothing of her parents. As far as Sally Miller's backers were concerned, any lawyer representing her must have total faith. A new attorney with constant certitude had to be found.

The man they approached was Wheelock Samuel Upton. He was an unusual choice. He wasn't of the first rank of lawyers in the state, nor of German descent. Upton was born into a distinguished New England family that could trace its ancestry back to a John Upton who arrived in Massachusetts in 1638. Wheelock Upton's father, Samuel Upton, pursued interests in shipping, originally in Salem, and later in Bangor and Boston. Of Samuel Upton's five children, one became a politician, three became lawyers, and his daughter became an expert in foreign languages. Wheelock Upton, the oldest of Samuel's children, was born in 1811. He graduated from Harvard in 1832 and upon becoming aware that in New Orleans a young attorney might have clients, he headed there determined to make a name for himself. He cowrote a commentary on the Civil Code of the State of Louisiana in 1838, which he expected would establish him as a topnotch attorney, but it didn't seem to have the desired effect. But then, Upton did little to endear himself to his Southern clients. Ever regarded as a Northerner, he had an abrasive personality, and was apt to embroider his addresses to the court with passages from Shakespeare and Sir Walter Scott. It was an approach that rarely moved New Orleans's juries. He was fond of saying that his family had a long tradition of defending liberty and freedom of speech, quoting in support the instance of his ancestor, John Upton, who had stood against the hysteria of the Salem witchcraft trials of 1692. From this, Southerners suspected that he was a secret abolitionist.

The gentlemen from the German community attended at Upton's rooms and, after handing him a folder of papers, asked him to acquaint himself with the facts of the case and prepare a report for them. Later that day, Upton examined what the men had left for him. He looked at the petition of freedom and the bond papers, then picked up the twenty or so pages of notes taken by Sigur of his conferences with Sally Miller and Eva Schuber. After reading for half an hour, with the papers still in his hands, he leaned back in his chair.

Slowly the potential of what he held began to dawn on him. A man could spend a lifetime in the law and never come across a case like this. This, he decided, would be the trial to make his career.

In the following weeks Upton interviewed Sally Miller at length. both in his office and during several visits to Eva Schuber's house. Although he had no reason to doubt her truthfulness, his questions produced no resolution of the puzzling blanks in her life. She remembered nothing about her life in Germany, or her parents, or her sister and brothers, or any of the people who now swore they recognized her. She knew nothing of her family's journey to America. The horrors on board the Juffer Johanna, when half the passengers died, meant nothing to her. Her earliest recollections were of being owned by Miller at his sawmill. Upton asked her how old she was when Miller bought her. She didn't know. He asked her about her earliest memories, but they were always of Miller. He had treated her kindly, she said, but always as a slave. His questions, modestly phrased, about her relationship with Belmonti were deftly misunderstood. She told him she was Mrs. Canby's maid for several years, and when she was very young, she had almost died from yellow fever. She appeared anxious to help, yet nothing of substance ever emerged from his questions. She remembered no German words. When Upton closed his eyes and listened to her, she sounded like any other black servant.

Brash and ambitious Upton may have been, but he was astute enough to know when he was getting out of his depth. He had heard that Miller had engaged John Randolph Grymes and there was no more formidable opponent at the Louisiana bar. It was bound to be a difficult and lengthy case. Upton realized that he needed to be led by a more senior attorney.

With his satchel of papers, Upton walked to Christian Roselius's office in Customhouse Street. Roselius had only recently retired as the state's attorney general and he was building up his practice again. Upton had chosen Roselius not only because he was one of the state's most experienced lawyers, but also because he was German by birth. Roselius received Upton in a room heavy with learning. Books were shelved from floor to ceiling and more were heaped in piles on the carpet. Yellowing papers sat on the window shelf, obscuring the light. A musty smell filled the air. Roselius motioned for Upton to be seated,

JOHN FITZ MILLER

then putting down a law report he had been reading, looked enquiringly at his visitor. Upton asked if he might assume that he had heard of Salomé Müller. Yes, of course, how could he not? There had been nothing else spoken of in the German community for weeks. Upton explained that she was now his client. He placed the petition in Roselius's hands. Roselius read it quickly, then placed it on his desk. He picked up Sigur's notes and flicked through them. He then sat quietly for a moment, nodding in time with his thoughts. It is a sad day, isn't it, when the South can no longer tell the difference between a white person and a slave? He sighed, then pushed the papers back across the desk toward Upton. Don't you agree? Upton said he did.

It's bound to be a nasty little case, with Miller involved, added Roselius. Upton made no comment. Roselius grunted. You know, I wonder if our colleague Mr. Sigur has missed the point in all this. Surely before a court the most important thing will be whether she looks like a white woman or a slave? Is there any sign of the black in her? That's the real question, isn't it?

SEVEN

BRIDGET WILSON

Suppose three persons . . . were brought together before a judge upon a writ of habeas corpus on the grounds of false imprisonment and detention in slavery. . . . How must a judge act in such a case? I answer he must judge from his own view. He must discharge the white person and the Indian out of custody . . . and he must redeliver the black or mulatto person, with the flat nose and wooly hair to the person claiming to hold him or her as a slave. . . .

Judge Tucker of Virginia, 1806⁷⁵

here are no photographs, drawings, or paintings of Sally Miller. A report in the *Daily Picayune* at the time of the court case described her as a "woman of some 33 years of age or thereabouts; has a dark olive complexion, and when young must have been pretty good looking." The New Orleans *Daily Tropic* thought her "somewhat of a brunette." John Randolph Grymes, appearing for John Fitz Miller at court, offered this disparaging view: she had "Indian hair, large black eyes, and that dirty, whitish-yellow complexion, characteristic of the Quadroon."

Her defender, Wheelock S. Upton, wrote of her as a beauty:

Upon a careful examination of her form, her figure, her features, her complexion, no trace of African descent can be perceived in her. She has long, straight black hair, hazel eyes, Roman nose and thin lips. The complexion of her face and neck is dark, but the German witnesses testified that both her father and mother were of very dark complexion; and it appeared that

from her earliest days she had been exposed to the sun's rays in this tropical clime, laboring in the cotton fields, and enduring all the privations, and subject to all the labors and exposures of the African slave. But those parts of her person which have been shielded from the Sun are of that peculiar whiteness which is never found in the African descendant.

"Roman nose! Yes, an Upton Roman nose," scoffed Miller when he heard of this description, adding that he could find ten quadroons in New Orleans who would fit Upton's description. "In truth," said Miller, 'she had Indian blood" and her real name was Bridget Wilson.⁷⁶

The first time I ever saw this imposter, who now assumes the name of Sally Müller, was when she came to my house in N. Orleans, in the winter of 1823 and said she belonged to me. I having previously requested my son to purchase a house servant for me...

These words were written by Mrs. Sarah Canby in a pamphlet in defense of her honor and the honor of her son. Mrs. Canby wrote that she looked at the dejected, light-skinned child and reckoned she was twelve or thirteen; however, she was so thin it was hard to tell. She asked the girl her name and she replied, Bridget Wilson. Mrs. Canby then asked her about her mother, and "she answered, pointing to my housekeeper, a mulatress, 'about the color of that woman."

Mrs. Canby continued: "I then asked her, her master's name—she said, that it was Wilson, that he was her father and had always been very kind to her." Mrs. Canby inquired why Wilson had sold her, and the girl said "he was not the cause of her being sold." She explained that Wilson had given her to his married daughter as a nurse for her children, but the family had got into debt so she was sold at a sheriff's sale and bought by a man named Anthony Williams.⁷⁷

The attempt by Miller to explain how he obtained Bridget Wilson was one of the great controversies of the story of the Lost German Slave Girl. Miller's version (and his mother supported him in every

detail) was that he obtained Bridget Wilson in the summer of 1822 in New Orleans, and not in 1818 in Attakapas.

According to Miller, a slave trader named Anthony Williams arrived in the city by ship from Mobile, Alabama, with a number of slaves to sell. No sooner had Williams brought his coffle of slaves ashore than he discovered that the city was in the grip of a yellow fever epidemic. Upward of two hundred of the city's population were dying each day, business was at a standstill and even the slave auctions had been canceled. Immediately Williams decided to flee the city, intending to take his slaves with him. Then, to his alarm, he discovered that his youngest slave, a pale-skinned girl, was showing signs of fever. No captain would accept her aboard his ship so he would have to get rid of her. Not that this was the extent of Williams's problems—he was also broke. He had thousands of dollars of value in human flesh in his possession, but no ready cash to pay for the passage of himself and his slaves back to Mobile. Then, across the levee, he saw Miller's sawmill.

Taking the girl with him, Williams went into the sawmill and offered to sell her to Miller, who, after inspecting her, concluded it was likely that she had yellow fever—but he also knew that if she survived she would be worth three or four hundred dollars. He wasn't interested in buying her; it was too risky an investment, but he told Williams that he was prepared to lend him one hundred dollars, but only if he left the girl as security. Williams agreed. It was also agreed that if she survived, Miller would sell her, and so recover his hundred dollars. When Williams next returned to New Orleans, Miller would hand over to Williams the balance of the purchase price, after retaining his expenses and profit on the sale.

Sally Miller's supporters never accepted that such a person as Anthony Williams existed. To them, Miller's explanation of how he obtained "Bridget Wilson" was nothing more than a pack of lies, told by a man desperate to cover the truth that he and his mother had seized Salomé Müller in 1818 and held her on his plantation in Attakapas, gradually breaking down her resistance until she believed she was a slave and all memories of her German past were gone. However, one aspect of Miller's story did measure up: there was a plague of yellow fever in New Orleans in 1822 that killed thousands.

If there was a slave trader named Anthony Williams in the city, it was perfectly understandable that he would be desperate to escape.

Yellow fever was well known in New Orleans. Between 1796 and 1850, it afflicted the city twenty times, peaking in 1853 when nine thousand people died. It was called "the saffron scourge" by the Americans, "fievre jaune" by the French, and "the black vomit" by the Spanish. It began in summer and ended with the first frost of winter. It lurked in the miasma of decay and rot surrounding the city, and when the weather became humid, it drifted in with the mist, entering through the cracks in walls to attack those inside. Doctors prescribed leeches, cupping, bleeding, and purging, accompanied by massive drafts of mercury and opium, but cures seldom worked. Victims' skin turned a soft vellow and their eyes creamy. They felt as if their bones were being crunched; their temperatures rose, they shook in cold sweats, and finally, as they began to vomit dark phlegm, it was known that death was near. Prevention was directed toward getting rid of the pestilence that lurked in the atmosphere—by firing cannonballs to puncture the air, burning tar barrels to fumigate the low-lying mist hovering overnight, and, failing that, praying to God for mercy on a sinful city.

With a cruel efficiency, it particularly carried off children and new-comers to the city, earning it yet another nickname, "strangers' disease." Eight thousand Irish and German immigrants died of yellow fever while digging the New Basin canal in the American sector (for which they were blamed for disturbing the soil and releasing the miasma). Long-established residents of the city, and those of African and Indian descent, appeared to have an immunity from the disease.*

Miller called in Dr. Alexander, the man who regularly attended to the maladies of his slaves, to examine Bridget Wilson. The doctor confirmed that she was indeed suffering from yellow fever and it was

^{*} It wasn't until 1900 that it was discovered that the bite of the *Aedes aegypti* mosquito carried yellow fever to humans. New Orleans was superbly sited to be a breeding ground for mosquitoes. Stagnant water pooled within the city boundaries, it was surrounded by swamps, and during the summer it rained every few days.

well advanced. It was too late for him to prescribe a cure. Her only chance, he said, was to be given rest while the fever took its course. Miller placed her under the care of Daphne Crawford, a colored nurse the doctor recommended to him. This woman subsequently gave evidence in the case to free Sally Miller about the care she gave to the sick slave child. Crawford said she lived in a house on the corner of Rampart and Customhouse streets. The girl was her only patient, so she "received all my attention." She described her as "slender, sickly, and not very tall" and, because of the yellow fever, she looked "sunburned." It took her a month to restore the child to health, and when the child was well, she walked her to the sawmill and gave her back to Miller.

Miller decided to surprise his mother with a gift of the child. He pointed Bridget toward the house where his mother lived, and told her to knock on the door and tell the lady who answered that she now belonged to her.

Mrs. Canby was well pleased with the pretty, pale-skinned girl her son had provided for her, and in a very short time the two became inseparable. A number of witnesses recalled how Mrs. Canby would take her along when she visited friends in the city, showing her off as if she were her grandchild. Bridget would also accompany her on shopping expeditions to the French boutiques on Royal Street and walk be her side, carrying the purchases her mistress had made. When Mrs. Canby was at home, Bridget was required to be in constant attendance, ready to fetch things. Bridget would serve her breakfast in bed, help her dress, and during the day follow her, collecting her books and reading glasses, as she moved from room to room. She would adjust her pillows when she retired at night, and be there, within call, when she awoke in the morning.

After several months Mrs. Canby approached her son, and after indicating her satisfaction with the girl, asked if she could buy her. She explained that she was fearful that Williams might return to reclaim his slave, so she wanted Bridget to be hers—and she wanted to pay the full value. Miller, ever ready to indulge his mother, agreed, and on February 24, 1824, mother and son went before two notaries and, under seal, the transfer was formalized. Mrs. Canby gave her son three hundred and fifty dollars for Bridget Wilson.⁷⁸

Following the formalities of the purchase, Mrs. Canby returned to her home and called Bridget into her bedroom. She sat the girl down and said there were some important things she wanted to tell her. First she told her the good news, that the old woman was now properly and officially her owner. However, she couldn't be "Bridget" anymore. Mrs. Canby explained that her cook's name was Bridget and she found it too confusing. Bridget must get a new name. According to Mrs. Canby, her new slave said that Bridget was only a nickname that she never liked, and she selected for herself the name of Mary. So she became Mary Wilson.

Mrs. Canby ran a busy household. In addition to Bridget the cook, and Mary Wilson, her servant, she owned a black waiter named Jim Brigger and a quardroon boy, Yellow Jim, who tended the garden and did anything else his mistress required. The work of these four was far more than just looking after an elderly widow and her son. A wide circle of friends continually dropped in at the house. Mrs. Canby hosted dinners for her son and held meetings for her charities in the drawing room. She also took in orphaned white girls from the Ursuline Convent and gave them a home until they could be placed elsewhere.

These were days of grand parties and extravagant living for Mrs. Canby and her son. All sorts of important people came. General Lewis, the commander of the state militia, was a constant visitor, as was Charles F. Daunoy, attorney at law, and Emile Johns, Louisiana's foremost composer and concert pianist. Gentlemen in full-dress coats and ladies in long, elegant gowns of silk would walk up the stairs to be met by Mary Wilson. Dressed in a black frock and a lace apron, she stood ready to take the gentlemen's hats and cloaks and the women's shawls, and to escort them inside. Guests would ask Mrs. Canby who the girl was, and be surprised to learn that she was a slave. Some would ask Mary herself, Is it true you are a slave? And she would say Yes, and smile when they exclaimed, But you are so white.

Among the slaves in the yard, Mary was envied because she was a house servant. The work was easier, the food was better, and she wore the cast-off clothes of her mistress and not the rags they wore. With her white skin and fine dresses they saw her as different. She was educated in the way of white people and able to mimic their genteel ways.

In these early years, Mary Wilson served Mrs. Canby with fond devotion and the old woman was pleased with her. However, as Mary began to grow into womanhood, Mrs. Canby began to observe things that disturbed her. She noticed that Mary went out of her way to engage visitors in conversation, especially the gentlemen, who in turn, intrigued by her beauty, seemed quite happy to spend time with her. She was a particular favorite of several of her son's friends, who often dropped in on a Sunday afternoon to chat on the veranda after a ride along the levee. Mary hovered on the edge of conversations, listening to things that a young girl should never hear, ever ready to carry the decanter from the sideboard or to bring an ember from the stove to light their cigars. Mrs. Canby told Mary several times she was too bold with company, but it made no difference, particularly when her son undermined her authority by asking her to fetch for him and his friends. Mary, she concluded, was far too precocious for her age.

Not long after, as Mary delivered Mrs. Canby's breakfast to her bedroom one morning, she asked if she could marry Yellow Jim. Mrs. Canby could hardly believe her ears. Was she serious? It seemed she was. Mrs. Canby was stunned. She had raised Yellow Jim from birth, and had regarded him as a favorite. "I refused my consent," she wrote, "because I did not think her worthy of him, as even at that early age she was an abandoned character, and gave me a great deal of trouble." Abandoned Mary proved to be, for Yellow Jim, got up in a tattered straw hat on his head, and with his shirt unbuttoned to reveal a honeybrown skin, proved to be too much for her. A few months later, Mrs. Canby noticed that Mary Wilson was rapidly gaining weight, and a confronting investigation revealed that she was pregnant.

Both Mary and Yellow Jim were expelled from the house and made to live in one of the huts for the yard slaves. However, they were retained as domestic servants, and right up to the birth of her child, Mary would rise every morning to be at Mrs. Canby's side when she awoke.

In the entire South, slave marriages were no more than cohabitation by the permission of masters, and they meant nothing under the law. In Louisiana, an article in the Civil Code confirmed this: "Slaves

cannot marry without the consent of their masters, and their marriages do not produce any of the civil effects which result from such contracts."⁷⁹

At first blush it seems strange that that most fundamental of Christian concepts, the joining of a man and a woman for life, wasn't given protection in any of the slave states. The South was deeply religious, and by the 1800s the African population, most into their second or third generation of bondage, was firmly under control. Southern legislators over the years gave constant attention to the details of slave regulation—tinkering with almost every aspect, reforming, clarifying, increasing penalties—but the family continued to be violated. Marriage meant nothing, "husbands" were split from their "wives," and children were taken from their parents.

It didn't have to be so. In Spanish and Portuguese slave colonies it was never doubted that the African had a soul that needed saving. Slave marriages were protected by the church as a Christian institution, and any master who split a man from his wife by sale was not only breaking the law, but also committing a grievous sin. This was never the attitude in America. Perhaps the explanation lies in the strongly capitalistic nature of slavery in the United States. If a master wanted to sell a woman apart from her husband, the bonds of marriage had to give way to rights of ownership. This view of slaves as disposable chattels was buttressed by an unholy alliance of racism and fear. Racism encouraged the belief that black people's inherent immorality made it impossible for them to adhere to marriage vows. Fear meant that masters didn't want to lose their power to sell an unruly slave—a threat no longer possible if the law required them to keep families together. It would "make the holding of slaves a curse," declared Thomas Cobb in his book on slave law, if marriage were to "fasten upon the master of a female slave, a vicious, corrupting negro, sowing discord, and dissatisfaction among all his slaves; or else a thief, or a cut throat. . . . "80

The failure to recognize slave marriages produced far-reaching consequences. One was that all slave children were bastards. Yet another was that children from a slave marriage couldn't inherit property—even if they were subsequently freed. Consider the case of the children of an ex-slave named Miles Howard. When Howard was a slave, he "married" Matilda, another slave, who bore him several

children. Howard was then emancipated by his owner, and as a free man worked until he had enough money to purchase Matilda out of slavery. They had more children. Matilda died, and after a period Howard took a second wife. The marriage was celebrated with due religious ceremony. Further children were born from the second marriage. Howard died a wealthy man-with enough property to make it worthwhile for his children from the second marriage to fight about his assets all the way to the Supreme Court. These children argued that only the legitimate offspring of their father were entitled to inherit—and since the first marriage was a slave marriage, then all the children born of that union were illegitimate. Judge Pearson of the North Carolina Supreme Court agreed. "The relation between slaves is essentially different from that of man and wife joined in lawful wedlock," he said. "[W]ith slaves it may be dissolved at the pleasure of either party, or by the sale of one or both, dependent on the caprice or necessity of the owners." When Matilda and Miles became free persons, they "were guilty of a misdemeanor in living together as man and wife without being married, as the law required; so that there is nothing to save them [their children] from the imputation of being 'bastards.'"81

Another consequence of the failure of the law to recognize slave marriages was that a "wife" could be forced to testify against her "husband." During a murder trial in North Carolina in 1836, a slave named Mima was compelled to give evidence against her "husband" of ten years, with whom she had had five children. Her testimony convicted him and he was hanged. Eror similar reasons the defense of provocation wasn't available when a slave found his "wife" in an adulterous embrace. As Thomas Cobb rather brutally observed, "A slave had no honor to defend."

Although it lacked legal endorsement, the institution of marriage proved resilient in slave society. Social historians, after examining plantation records of the old South, report that the rate of marriages among slaves was as high as among white people. Wise masters encouraged marriages. The advantages were obvious enough: they made for a happier, more docile workforce, each child born was an asset in the master's hands, and the presence of children reduced the chances of their parents running away. Marriage also enriched the life

of the slaves. It afforded comfort, security, and sexuality; late at night, men and women could whisper to each other of their suffering. For a people who owned nothing, they could feel they owned each other.

There was considerable diversity in the form of the marriage ceremony. Sometimes the master dressed up in his best suit, pulled out the family Bible, and conducted a marriage ritual he made up himself on the lawns of his home before a congregation of the assembled slaves. He might speak about the seriousness of the commitment, the sanctity of joining a man and a woman for life, and a determination to whip anyone who fooled around with the bride. On other occasions a traveling parson might be invited to conduct the service, or the wedding party would parade to a log church in a clearing where a black preacher would officiate. Sometimes there would be dancing and a feast around an open fire and the obeah man* would give his blessing. In slave narratives there is frequent mention of the ceremony of jumping over the broom. The couple would jump three times over a broom laid on the ground, repeating, "I marry you, I marry you, I marry you." It was said that the one who jumped the highest was destined to be the boss of the relationship. Or perhaps there was no ceremony and all that would happen was that the master would give temporary approval for a man and woman to live as a couple.

In Mary Wilson's case, in asking Mrs. Canby's permission to marry, she was doing no more than asking to be allowed to move in with Yellow Jim and that they be recognized as man and wife. By getting herself pregnant, she in effect forced Mrs. Canby's hand.

Mary Wilson gave birth to a son. She named him Lafayette, after the Marquis de Lafayette, the French aristocrat who had fought beside Washington in the war for American independence.

"About four years after the birth of this child," wrote Mrs. Canby "she had another son, whose father was a white man in our employ named Struve." Mrs. Canby provided no further information and moved on to other matters. It is difficult to know what to make of this. Was this proof of her "abandoned character," as Mrs. Canby

^{*} The obeah was a priest-like figure, skilled in the use of charms and potions, and often possessing the authority to wield spiritual and community leadership over his fellow slaves.

implied? Was Mary Wilson a willing harlot, or had Struve forced himself on her?

In a slave society, it was difficult to tell the difference between rape and seduction. Power in penile form sprouted from the customary rights of ownership, and compliance was overhung with the threat of violence. Brutal rape was rarely necessary—and even if it was, the few cents left on the table turned it into prostitution. Some slave women may have been flattered by the attention of the master; others realized that with acquiescence came gifts, better clothes, and food. But for most, the intimation of violence was enough. As one slave woman was recorded as saying in 1839, "we do anything to get our poor flesh some rest from de whip; when he made me follow him into de bush, what use me tell him no? he have strength to make me." It was only a small perversion for white masters to believe that submission was a sign of the natural lust of black women for white men.

Black women had no protectors. Their husbands and fathers were emasculated by a regime of white control. As Thomas Jefferson, a principal drafter of the Declaration of Independence and the third U.S. president, confessed: a "man must be a prodigy who can retain his manners and morals undepraved by such circumstances." Famously, Jefferson didn't.

White women who became aware that their fathers, husbands, or brothers were visiting the slave quarters at night usually blamed the black temptresses for luring their men away. This wasn't a time of sister solidarity, and instances where white women acted on a sense of sympathy with female slaves were difficult to find. And if a white man was ever indicted for the rape of a slave, historians haven't found a record of it. Helen Catterall, in her five-volume study that summarised thousands of cases on slave law, didn't find a single report of a white man being convicted of the rape of a slave.⁸⁵

Nor did it make any difference if the victim was a child. No white man was ever charged with the rape of a slave child. George, a slave, was. He was accused of the rape of a female slave under ten years of age. If the girl had been white, George would have hanged, but his lawyer argued that the laws on "sexual intercourse, do not and cannot, for obvious reasons, apply to slaves; their intercourse is promiscuous. . . ." In a celebrated decision that provided leadership to jurists in

the entire South, Judge Harris of Mississippi ruled that George had committed no offense known to the law. According to Harris, rape of a slave of any age wasn't a crime. Harris, aware of some earlier cases which had ruled that natural or common law applied to slaves, dismissed these as being "founded mainly upon the unmeaning twaddle, in which some humane judges and law writers have indulged." A year later, the Mississippi legislature responded to this decision by making it a crime for a black man to rape a black child under twelve years of age. The glaring inadequacy of this supposed reform was that it still wasn't a crime for a white man to rape a black child, and there was no protection for black women over twelve from rapists of any skin color.

The Louisiana Civil Code left the legal position in no doubt: only white women could be the victims of rape. "It is true, the female slave is peculiarly exposed," admitted Judge Preston of Louisiana in a judgment he wrote in 1851. "That is a misfortune; but it is so rare in the case of concubinage that seduction and temptation are not mutual. . . . "87

This was an agreed-upon fiction formulated by male judges. The real point was that if the rape of a slave by a white man was made a crime, some of the finest and best in the land would have to face the court. To alter the law would have placed a restraining hand on white men's lust, and this the South wasn't prepared to do. There was nothing to stop a master from breeding children in his own image, or turning a blind eye to an employee who regarded slave wenching as a pleasant diversion on warm evenings. If racism gave birth to slavery, sexism was its handmaiden. It was a world of entrenched double standards. In all the Southern states, slaves were habitually hanged for assault or rape of white women, yet it wasn't a common crime. White men's assault and rape of slaves was so frequent as to be common, but criminal convictions were unknown.

Mary Wilson named her second son Madison, after the president of the United States. He was as white as any baby could be. Mr. Struve was the father, but the child was Mrs. Canby's property.

Soon after the birth of Madison, Yellow Jim died. What of, doesn't appear in the records. It could have been yellow fever, smallpox,

cholera—all deadly diseases that flourished in New Orleans. It might have been an accident in the sawmill.

Mrs. Canby recorded that Mary's next child was a girl, who was named Adeline. Before the birth of that child, Mary had told her mistress that the father was also Mr. Struve, but "on my remarking for the first time, when it was about five weeks old, that it was very dark, she acknowledged it to be the child of my colored waiter, a dark griffe, by the name of Jim Brigger."

Mary now became Mary Brigger, and moved in with him. The relationship with Brigger was neither happy nor stable—caused, according to Mrs. Canby, by Mary's flirtatious behavior.

At the beginning of 1834, after holding her for eleven years, Mrs. Canby sold Mary Brigger and her three children, Lafayette, Madison, and Adeline, back to her son. The transfer was recorded in a formal way before a notary and a witness. The change of ownership made no immediate difference to where Mary and the children lived or the domestic duties Mary performed, and possibly she was unaware it had occurred. The price was three hundred and fifty dollars, a real bargain considering that Miller had sold Mary (then a child called Bridget Wilson) to his mother for exactly that amount, and he was now getting three children as well. The four of them would be worth more like two thousand dollars. Clearly, Mrs. Canby was shifting some of her wealth to her son—probably to provide security for his investment borrowings.

Within weeks of regaining ownership of Mary and her family, Miller sent Lafayette to Cincinnati, Ohio, to work on his sister's farm. Her husband, Nathan W. Wheeler, was in financial difficulties, and from time to time Miller had sent them money; this time he despatched Mary's eldest child.

Children were the only valuable property slave parents could retain—but then never permanently, never with certainty. As their children became older, productive, and more valuable, it became more likely the master would want them for himself—either to work, hire, or sell. Mary Brigger was better off than most slave mothers who had a child taken away—she at least knew where her son had gone, and she periodically received news of him when Miller's sister wrote to her brother. She could even hope that eventually he would be returned to her.

There was widespread acceptance in the South that a humane master would, as far as it was possible, avoid splitting a slave mother from her child. Ten years was regarded as the age at which children could be decently taken from their mother; however, where debts arose, or a master's estate had to be distributed on his death, it was accepted that separation may have to occur at a younger age. In such cases, Southern opinion held that, unfortunate as separation was, a slave mother's affection for her child was impulsive and not strongly developed, so any feeling of loss would quickly pass. A slave father's bonds with his children were thought to hardly exist and warranted no consideration at all. Only in one slave state was there legislation against selling infants apart from their mother (prohibited under the age of ten) and that was Louisiana.* Never was a law more frequently breached. Technically, at least, Miller hadn't broken this law, because he hadn't sold Lafayette, only lent him-although to his mother, the effect was much the same.

Then the slaves working at Miller's sawmill began to hear stories that the master was in trouble with his money and he might have to sell everything. They still had to get up when the sun rose and stand at the mill until sunset, but for much of the time the saws were idle and it didn't seem to matter if they worked or not. One day a man in a stovepipe hat with a notebook in his hand walked through the yard with Miller at his side. The stranger stood staring at the slaves and wrote continuously in his book. Miller held a hand over his mouth when he spoke to the man, so they couldn't hear what their master was saying, but they knew what was happening. Then the two men walked through the huts and looked at the women and children. Miller took the man back to the house and shut the door.

The single men went first. It was always without warning. Mr. Struve would come calling early in the morning and read out the names of those who were sold. He would follow them into their huts and watch as they placed their clothing in a bag. That done, he would

^{*} This being section 9 of the state's 1828 Black Code. In 1854, Georgia passed a law of weasel words that said that children under five shouldn't be sold separately from their mothers—but this only applied to deceased estates and then only if the distribution wasn't otherwise affected. Alabama had a similar law.

usher them into a buggy and drive them away. It was over in minutes, and they were never seen again.

Then, by an unexpected turn of events, Mary Brigger was reunited with her son. Nathan Wheeler had deserted Miller's sister and she had packed up her possessions, left Cincinnati, and come to live in New Orleans. Having no further need of Lafayette, she had returned him to her brother. Now that the mill was rarely operating, Miller had no particular use for the boy, and while he worked out if he should sell him, Lafayette moved into the hut with his mother and her husband, Jim Brigger. Mary hadn't seen Lafayette in two years and she was amazed how he had grown. He was tall and wiry from laboring in the fields and as thin as a hickory stick. After two weeks, Miller announced his plans for Lafayette. It was harvesttime on the plantations in Attakapas and the cane needed cutting. Lafayette would be sent there.

Changes were also planned for those serving Mrs. Canby. She called a meeting of her domestics—Bridget (the cook) and Jim and Mary Brigger—and told them that the house in New Orleans was being shut down. She and Mr. Miller would be moving to Orange Island and she required her servants to come with her, Mary's children included. But then the surprising news. Mary wouldn't be coming. She was needed to stay behind and look after the house at the sawmill.

Soon after, they all departed. Although Mary remained in New Orleans, she wasn't allowed to live in Miller's house, or even in one of the huts in his yard. Instead, she would be lodging with a free colored woman, Madame Bertrand, in her house in Rue Des Grands Hommes. Mary knew Madame Bertrand well—she was the midwife who had delivered Lafayette. Mary was not to be left idle. Mrs. Canby gave firm instructions to her slave that she was to go to the house at the sawmill every day without fail and ensure it remained cleaned and well aired.

While in New Orleans, Mary became pregnant again. Obviously, Jim Brigger couldn't be the father. Mrs. Canby later conducted yet another investigation into the identity of the father of one of Mary's children. She learned that he "was a Frenchman, a shop keeper who resided near us." This could well have been Belmonti. In fact, it probably was. The child was a boy, and Mary named him Charles.

Mrs. Canby wrote: Mary "proved so troublesome that she [Madame Bertrand] would not allow her to remain. I then sent her colored husband down for her with whom she came to the Attakapas, for the first time in her life in January 1839." The italics are Mrs. Canby's, intended, no doubt, to nail as a lie the assertion that it was in 1818 that she and Miller had converted Salomé Müller into their slave.

Under the escort of Jim Brigger, Mary was collected from New Orleans and taken to Miller's plantation on the banks of Bayou Teche. When she arrived she was met with the news that Lafayette had died a day or two earlier. Mrs. Canby wrote that Mary "went over to a funeral service on [Orange Island] she had requested to be performed for him, in my own carriage, with several of her fellow servants and returned the same day with them." Judging from Mrs. Canby's words, it seems to have been a slave funeral and neither she nor Miller attended. It wouldn't have been normal to provide a coffin for the burial of a slave. Mary Reynolds, who was a slave herself in Louisiana, once described how "when a nigger died . . . they buried him the same day, take a big plank and bust it with an ax in the middle 'nough to bend it back, and put the dead nigger betwixt it."

Mrs. Canby didn't explain how Lafayette died and, although the fact of his death was mentioned several times during the court case, nothing further was revealed. The work of slaves on sugar plantations was a deadly business and it wasn't likely that the death of a child would be thought of as notable, or records kept of the cause. The Agricultural Society of Baton Rouge calculated in 1829 that on even a wellconducted sugar plantation the incidence of death among slaves was two-and-a-half percent greater than the birth rate. "The cultivation of sugar in Louisiana," wrote Thomas Hamilton, a British traveler in 1833, "is carried on at an enormous expense of human life. At the season when the cane is cut... the fatigue is so great that nothing but the severest application of the lash can stimulate the human frame to endure it, and the sugar season is uniformly followed by a great increase of mortality among the slaves."90 In addition to the scourge of yellow fever and other tropical diseases, the hoeing and harvesting of the cane was a dangerous business and accidents were common. The cane was cut with a sharp knife about fifteen inches long and three inches wide, and in the humid, dank climate an accidental cut to the flesh could

easily turn septic. After gathering the cane, it was the job of the children to feed the stalks by hand between two giant iron rollers kept turning by a steam engine fired by cane trash. During harvesttimes the grinding of the sugar continued day and night. In the whole of the South, only on the rice plantations of Georgia, where slaves were required to stand knee deep in water for several hours each day, was the fatality rate higher.

Mrs. Canby described Mary's conduct while in Attakapas:

... she behaved so badly and proved such a nuisance to the neighborhood; exciting her husband's jealousy, by her abandoned conduct; they lived so unhappily, fighting and quarrelling together, that I resolved to part with both of them. Accordingly, I expressed my determination to my son, who sent her immediately down to New Orleans, where she said she wished to go, and where she knew a person who would purchase her.

This person was none other than Louis Belmonti. Mary, under threat of sale by Mrs. Canby, likely saw Belmonti as a convenient solution to her problems.

Seemingly Mrs. Canby's decree that Mary should return to New Orleans was the equivalent of a divorce from Jim Brigger, because by the time she arrived back in the city, she no longer called herself Mary Brigger. She was now Mary Miller.

Belmonti engaged a slave broker named Piernas to act on his behalf. Belmonti was no Creole gentleman with the money to keep a concubine in one of the houses along Rampart Street, so he did the next best thing by attempting to purchase both a worker for his cabaret and a sexual slave who had probably borne his child. The negotiations proved difficult between Piernas and Miller. Although it was common knowledge that Miller was desperate for money, and perhaps in normal circumstances he would have sold the unruly Mary for a bargain price, he was aware that Belmonti wasn't after *any* slave—it had to be *her*. Eventually Piernas and Miller set the price at one thousand dollars, ten times what Miller claimed to have given Williams for her. With that amount of money, a modest house could be built; a white laborer would have to work five years to earn as much.

Belmonti had his woman, and Charles came with her. Madison and Adeline remained behind on Miller's sugar plantation. The contract of conveyance of Charles and Mary Miller was made part of the court proceedings. It was written in the French language. In a rather unusual clause it specified that Charles was "to stay and remain the property" of Miller but would be "in the supervision and the care of his mother until he had reached the age of ten years, or more if there was no necessity of taking him." Miller was made responsible for Charles's medical care, otherwise the "costs and expenses of maintenance were at the charge of Belmonti." Mary's age was stated as being twenty-two.⁹¹

Mary Miller proved to be as troublesome for Belmonti as she had been for Jim Brigger. A few weeks after purchasing her, she and Belmonti had a tremendous argument. Deciding he could no longer put up with her bad temper, he called on Miller and asked him to take her back. According to an affidavit, filed as part of the litigation: "Miller informed him that [Mary Miller] was in fact a white woman, who had all the rights of a free white person, and was only to be kept a slave by kindness and coaxing. . . . Belmonti was extremely dissatisfied with this conversation, and declared . . . that if he had a pistol at the time he would have shot Miller."92

Belmonti didn't shoot Miller; instead, he tried kindness and coaxing.

Meanwhile, Mrs. Canby didn't go through with her threat to sell Jim Brigger. Perhaps she felt that a man of gray-haired loyalty, who had the misfortune to marry a harridan, shouldn't be penalized on that account. In any case, when she looked more closely into the matter of ownership, it seemed that Jim belonged to her son, and not to her. Fortune smiled on Jim Brigger, because when it became clear to Miller that he could no longer avoid insolvency, he gave several of his slaves their freedom, Jim included.

Mary Miller remained with Louis Belmonti for the next five years. After being the companion of an old woman behind the fence of a sawmill for as long as she could remember, she was now owned by the patrone of a small cabaret on the edge of the Vieux Carré and free to wander more or less wherever she wanted. Most mornings she went to the market to do the shopping. Everyone there knew her. Then she

returned with her string bag of meat, eggs, and vegetables, and brought out the chairs for the day's trading.

Then, one bright day in 1843, as she sat on the front steps of Belmonti's cabaret with her eyes closed and the morning sun streaming onto her face, she heard a woman's voice, whispering to her in a German accent that by rights she should be free.

EIGHT SALOMÉ MÜLLER

 \dots a perpetual and impassable barrier was intended to be erected between the white race and the one which they had reduced to slavery. Chief Justice Roger Taney of the Supreme Court of the United States, 1856^{93}

heelock S. Upton's legal opinion greatly pleased the gentlemen backing Sally Miller. He had expressed his entire belief in the truth of the main elements of the petition. She was, to his mind, of pure German blood and everything possible must be done to free her. He and Christian Roselius stood ready to prosecute her case with all the energy and skill they could muster.

The news that Roselius would be involved was greeted with delight by Sally Miller's supporters. He was regarded as the most learned man in the German community and someone the American courts must listen to. It is said by some Louisiana historians that Roselius was a redemptioner, but others say this wasn't so, citing as proof that a biographical note published during his lifetime makes no such claim, and almost certainly the author would have checked his facts with Roselius. Whatever the truth, Roselius's rise from humble immigrant beginnings to become attorney general of the state remains an extraordinary achievement. When he landed in New Orleans in 1820, after a sea journey from Bremen, Roselius was seventeen years old, spoke little English, and possessed only a rudimentary education. Soon after his arrival, he was employed as an apprentice to a printer who published the *Louisiana Advertiser*, and his first home in America was a bed under his master's composition

stand. Roselius was a restless genius. He soon recognized that if he was to succeed in America he had to become proficient in English, so he purchased volumes of Shakespeare and Milton and studied them at night. Within six months he had become so accomplished in English, and so adept at typesetting, that he could simultaneously read the copy and lay the characters by touch. In 1824 Roselius began to read law and marveled at the simple beauty of Louisiana's civil law. In 1825 he persuaded his master to allow him to use the printing press to publish his own magazine, the Halcyon, covering the literary and artistic scene in New Orleans in a style similar to the English Spectator. Roselius was the editor, chief writer, and typesetter. Louisiana was a difficult market for a magazine of culture and after eighteen months the Halcyon folded. Roselius began to teach part-time at a girls' school. There he courted the directress of the school and married her. He continued his studies of the law, and in 1828 was admitted to the bar.

Carving out a career for himself as an advocate in the Louisiana courts couldn't have been easy for a German immigrant with few contacts. As he waited in his office for clients, he toiled to rid his English of any trace of an accent by listening to himself address an imaginary jury. Because the civil law of Louisiana was ultimately derived from Roman law, he learned Latin so that he could read the *Justinian Institutes* as originally written; because the Civil Code was based on the *Code Napoléon*, he mastered French. In later years he became renowned for his ability, in addressing juries, to easily and fluently explain his point in French to the Creoles and then in English to the Americans.

Gradually work began to come his way. No one was more industrious in preparation, or more dogged in exploiting weaknesses in his opponent's case. He was blunt and fearless, and had a profound knowledge of the law. His reputation spread and within a few years, he had a steady stream of clients anxious to find an advocate who would give his utmost to their cause. He was one of those rare attorneys who could not only mould a jury to his making, but also persuade judges by quoting from the ancient treasures of Roman and French jurisprudence. In 1840 he was elected to the state legislature, and the following year he was appointed attorney general. However, the

SALOMÉ MÜLLER

elegant duplicity of Louisiana politics wasn't to his liking, and after a term in office, he didn't seek reelection; instead, he hastened back to his constant mistress, the law.

On April 27, 1844, the *Answer of John F. Miller* to the petition of Sally Miller was filed in the First District Court of New Orleans.⁹⁴ The next day the clerk of courts delivered a copy to the office of Christian Roselius. He read it through and, after a moment's reflection, called in a messenger and told him to go to Upton's office and ask for his attendance as soon as possible.

Upton arrived within the hour. After reading the document, Upton handed it to his younger brother, Frank, who had come with him. Frank was another Harvard graduate, and with the encouragement of his elder brother had recently arrived in New Orleans to make a career in the law. It seemed that when one hired Wheelock S. Upton, one hired his younger brother as well. There was yet another Upton in the office they shared rooms in Exchange Place—Rufus, a cousin and a student at law—but the elder Upton thought he would be pushing Roselius's patience if he had brought him as well.

In the opening paragraph of the answer, Miller had denied every allegation contained in the petition, save that he had sold Sally Miller to Louis Belmonti. He explained where he had obtained the girl: "That on the 13th August 1822, one Anthony Williams, then of Mobile, left with the Respondent for sale a certain mulatress girl, then named Bridget, about 12 years of age, said Williams claiming said girl as his slave, and representing her to be a mulatress and slave for life."

His answer then told of selling Bridget to his mother, and eleven years later, repurchasing her, along with the three children she had borne in the meantime. In 1838, he had sold her to Belmonti. Never had he "received the plaintiff or her parents or any others as Redemptioners." He declared that "he then believed and still believes her to be a mulatress of African descent."

But it was the things that Miller had left unsaid that had caught Roselius's attention and had caused him to summon Upton. Apart from Miller's declaration that he believed Sally was of African descent (for what that was worth), there was nothing in the answer that

contradicted the fundamental claim of the petition that she was German. Roselius had feared that Miller might have located a slave woman who claimed to be Sally's mother, or a master who would swear that he had raised her from birth. There was nothing like that. Miller's defense started in 1822, on the day she was deposited with him by Anthony Williams. The most important questions of all remained unanswered: Where had she been before that? Where did Williams get her? And who was Williams? Apart from saying he was "then of Mobile," there was nothing more said about him. Upton said he knew a lawyer named Breden who had lived in Mobile for the last twenty-five years and had conducted the census there. He would write to him and ask what he knew of this Anthony Williams.

Miller's failure to account for his slave's whereabouts in the years before 1822 was encouraging. However, as Roselius and the Upton brothers discussed the case further, they realized that it was just as much a problem for them as it was for Miller. It meant there was no firm link between Miller and the disappearance of Salomé Müller in 1818. They couldn't prove that Miller had taken her as his slave. About the only thing Miller had said with any authority was that he hadn't engaged Daniel Müller and his children as redemptioners. He could, of course, be lying, but it would be a dangerous thing for him to do and would be easily checked by asking his neighbors. If he wasn't lying, and he hadn't taken Daniel Müller and the children as redemptioners, who had? Where had Salomé gone to in 1818? And where was the rest of the family?

It's the missing four years, harped Upton to Sally Miller and Eva and Francis Schuber when they met in his office for a conference a few days later. They had to be able to explain to the court where she had been between 1818 and 1822. Sally shook her head. She couldn't help. Her first memories were of recovering from yellow fever in Nurse Crawford's house. She could recall nothing before that.

Upton turned to Eva Schuber.

The last time she had seen Daniel Müller and the three children was the day they had called in on her at Madame Borgnette's school to say farewell. She remembered how worried she had been as she

SALOMÉ MÜLLER

watched them walk away. Daniel had promised to write as soon as he settled in with his new master, but the weeks passed and she heard nothing. Friends explained to her that the mail service in Louisiana was good if it was between towns on the Mississippi, but if it had to cross from the inland parishes it could take weeks. But the weeks turned to months, and still there was nothing. She became convinced that something dreadful had happened.

Did you ever hear of them? Upton asked.

Francis Schuber then told what he knew. In his butchery business in the French Quarter he regularly bought meat from German farmers who herded their cattle from Attakapas to the city markets. About a year after Daniel Müller was last seen by anyone, Francis had gotten into conversation with one of the cattlemen who told him the story of what had happened on a keelboat making the run from New Orleans along the Atchafalaya River to Attakapas. A passenger, a man who couldn't speak English—a German, the cattleman thought—was going upstream with his young son and two daughters. One evening, just as everyone was settling down to eat, the passenger let out a gasp, stood up, clutched at his chest, and toppled over. He was dead even before he hit the timbers. Where was he buried? Francis Schuber had asked. Well, they were halfway along a windy, tea-brown river moving through swampland. What else could they do? They waited until his children were asleep, weighted his body down, and toppled him into the water.

So, now there were three children on the keelboat, said Upton. Three young children.

Not for long, replied Francis. Not for long. When the crew awoke the next morning, the boy had gone. It took no time to search the keelboat. He had gone. No one had heard anything. No splash, no footsteps across the deck. It seems the boy had slipped himself over the side. By this time the crew was in a blue funk. It was difficult enough to explain that one of their passengers had died, but they at least had had his ten-year-old son to explain what had happened; now all they had was two small girls looking at them in horror. They searched the man's luggage and found a ticket naming the family's intended destination, so they delivered the two girls there. There was no one to meet them, so they tied a label around their necks and

shoved off, leaving the girls standing on a wharf on a misty river, hemmed in by giant cypress trees.

There was a long silence as they imagined what might have happened next.

Eva Schuber had no doubts. The two little girls, stunned by the death of their father and the suicide of their brother, alone in the world, without speaking a word of the language, were collected by Miller.

Sally Miller continued to live with the Schubers in Lafayette during the months they waited for the trial to commence. Both she and Eva were strong-willed women and conflict between the two was inevitable, especially as Eva saw it as her role to take the black ways out of her goddaughter. Everything, beginning at the most elementary, had to be relearned. Eva gave instructions to Sally on how to sit demurely, with her feet placed just so, with her back straight and her hands folded in her lap. Never should her legs be open—only blacks and men sat like that. Eating was no longer a straightforward affair. There were special knives, forks and spoons for this and that, and a particular way to eat mashed potato, and another way to eat peas and never by squashing them together on a spoon. Her husband didn't always follow these rules, but that, Eva explained, was because he was a man. Sally was no longer allowed to wear red; red was a black woman's color. Her tignon was confiscated. Her hair was cut at shoulder length. Eva decreed that the sun must never touch her flesh. The judge must see a white-skinned woman. She had to wear gloves and hold a parasol aloft whenever she went abroad. And never again would she sign her name with a cross. Eva sat with her for hours at the kitchen table and guided her hand across a slate in a thousand repetitions of the name the litigation had given her. Sally Miller would pout. She would shout and scream her resistance, but Eva's will prevailed.

The weeks passed and Sally began to complain that life in Lafayette was dull. Eva encouraged her to make friends with the German women who visited, but Sally was reluctant to meet them, saying that she had nothing to say to them. She complained that they peered at her as if she were a circus animal. She grumbled that the clothes Eva

SALOMÉ MÜLLER

chose for her were too hot. She longed for her cotton smock that allowed the breeze to flow up her legs. She missed the excitement of the waterfront, the smells of the market, the cries of the traders, the ribald calls from the sailors. She wanted to mix with black men carrying meat that dribbled blood down their shoulders, and with women selling mangoes from large flat baskets balanced on their heads.

Sally escaped into the city whenever she could. She had a ready excuse. Upton had stressed to her how important it was to find witnesses who could say how she came into Miller's possession. Who were the very first people she recalled meeting in her life? Who were the visitors who called for afternoon tea at Mrs. Canby's house? Did she remember any of the men who worked for Miller or collected timber from his yard? She must speak to them all and ask if they knew how Miller had obtained her.

Three people came to Sally's mind and she went searching for them. One was a white man, an engineer, by the name of Fribee, who kept the machines running at the sawmill. He had befriended her when she was a youngster, and sometimes he would take her to look at the huge steam engine that drove the blades backward and forward through the timber. Another was an old Creole woman, Madame Poigneau, who used to come and chat with some of the women in the slave huts. Then there was Daphne Crawford, the woman who had nursed her when she had yellow fever.

Sally searched first for Fribee. She asked for him in saloons, billiard halls, and waterfront inns. She asked boatmen sleeping it off on the levee. A few remembered him, although they hadn't seen him in months. Some thought he had gone upriver.

She then went to the house on Rampart Street where Daphne Crawford lived. When the old nurse came to the door she recognized Sally immediately. Sally told her how she wanted to be free because she was white. Daphne listened, but showed no emotion and didn't ask her inside. Sally began to ask if Miller had ever said where she had come from, but Daphne interrupted, saying she didn't want to help. She didn't believe that Sally was white. She was a mulatto, just like her, and her advice to Sally was to accept who she was. Her own daughter was fairer than Sally and still she wasn't a white person.

Sally then went looking for Madame Poigneau. She had lived in a tumbled-down house with her ne'er-do-well husband and a brood of children a few streets back from Miller's mill, but when Sally knocked on the door she was met by a stranger who said he had never heard of her. Despondently, Sally walked away. It was more than twenty years since she had seen Madame Poigneau. Perhaps she had died. Sally asked one of the traders at the market. As far as he could recall she had moved years ago to one of the streets at the back of the Vieux Carré. He thought for a moment, but no, he couldn't remember where. He hadn't seen her lately. Not for months, a year probably. She asked several more traders. They all knew Madame Poigneau, but they hadn't seen her for some time. One trader gave Sally an address where he thought the old woman might be. Sally walked there and knocked at the entrance of a small clapboard house. The door opened and it was Madame Poigneau. She looked at Sally and, with a broad smile on her face, pulled her into a hug. Sally told her why she had come. But I had always thought you were white, replied the woman. She took her into her house, saying in a mixture of Spanish and English that she had been such a small, lost child. She could never understand what she was doing with Mrs. Canby, especially since she spoke with a German accent. Sally Miller took a sudden breath, and then asked her if she was sure about what she was saying. Yes, yes, said Madame Poigneau. I remember you. You were Bridget Wilson, and you spoke like a German.

Eva Schuber also walked the streets of New Orleans looking for witnesses. She was seeking people who remembered Salomé Müller in Amsterdam and would identify her as Daniel Müller's daughter. She had expected to find twenty or thirty easily—after all, hundreds of them had arrived in 1818—yet, as she began to knock on doors and ask among the German community, she was surprised at how few of them there were. They had spread across the length and breadth of America. Some had moved upriver to states farther north. A few had gone to California; many more had journeyed east to Philadelphia or New York, where they had relatives and had originally planned to go before Krahnstover had taken them south. Many had died, seemingly within a few

SALOMÉ MÜLLER

years of arriving. Eva heard stories of cholera, drowning, vague illness, hard drinking, childbirth, madness, yellow fever. Even within her own family there weren't many left—her mother-in-law and her sister Margaret were both dead; the other Salomé, the sister of the Müller brothers and wife of Christoph Kirchner, had completely disappeared. Christoph and Salomé's daughter, Dorothy, had lived in New Orleans for a couple of years, married, and moved somewhere upriver, but Eva didn't know where. Henry Müller was dead, and while she knew his children were in Mississippi, she hadn't seen them in a long time.

But there were also those who prospered and frequented the German Club, boasting of how easy it was to succeed in America. Eva spoke to them. Surely they remembered Daniel Müller and his wife Dorothea and their four children? There was Locksmith Müller and Shoesmith Müller. They both had children, but there was one particular child, Daniel's daughter, a pretty, dark-haired girl—this was the one who had been held as a slave for twenty-five years and had now returned. Some asked if it was true that she'd had black men for husbands. And had children by them as well? Questions that insinuated that she was undeserving of their help, or that if she was truly German, this wouldn't have happened. Eva would reply that it was all behind Sally now. Or, whatever had occurred, she wasn't in any position to resist.

Others, although sympathising, would shake their heads and say they couldn't remember that far back. There were so many children on the boats. There was so much distress, so many starving, sick people. It was hard to remember. Some didn't *want* to remember. It had taken them years to put their nightmares to rest. Sometimes Eva would persuade one or two to visit her house and look at Sally who, with sullen resentment, would pose for her visitors. It was so difficult after all these years, they would say. Eva would nod, and say she understood, and make them tea and offer raisin cake, and then escort them to the door.

Mr. Wagner was one of these visitors to Eva's house. Although he was from Württemberg, he had gotten to know the Müller family on board the *Rudolph* in the port of Helder in 1817. He drank coffee with Sally and asked her about her childhood in Germany and was surprised to learn that she didn't remember anything. He took Eva aside

and said he couldn't in all conscience swear on a Bible that he recognized her. But Eva mustn't think that he was withdrawing his support. He still believed in her and he would be quite willing to come to court and tell the judge about the mistreatment on the voyage to America and how all of them, including Daniel Müller and his children, were sold as redemptioners.

When Eva totted up her list of witnesses there were only seven, and that included herself and her husband. It was such a disappointment after all the effort she had put into it. She spoke to Mr. Eimer in his shop in Bienville Street. He was one of the most generous contributors to the fund to free Sally Miller, and was always ready to lend a sympathetic ear. He asked if the seven included Madame Carl, because he had heard that she was seriously ill. She had some sort of mysterious lump in her stomach, and the doctors didn't know what to do about it.

Eva called on Madame Carl on her way home. She was in bed and seemed smaller than Eva had remembered her. Her skin was as gray as a winter's dawn and there were deep circles under her eyes. Madame Carl smiled at her friend. Yes, of course, she would still give evidence. She inquired when the hearing was to be held. It was six weeks away. Ah yes, she said, she should still be around for that.

John Fitz Miller called on people who in years past had drunk his wine, dined at his house, and ridden out with him on early morning gallops. He hadn't seen most of them for years, not since the disgrace of his bankruptcy, but an even greater disgrace threatened him now. It had to be done; he had to ask for help. To each he made the same request: Would they come to court to swear that they had never seen a little German girl among the domestic servants at his and his mother's house?

A pure white person couldn't be a slave. This wasn't a presumptive rule that could be rebutted by an owner bringing evidence to the contrary. Quite simply, no white person could be a slave—and no

SALOMÉ MÜLLER

number of contracts of sale, court records, or memories of mothers in bondage could make it otherwise. At the core, the issue in Sally Miller's case was whether she was of pure German descent. If she was, it didn't matter how Miller obtained her, she must be free.

Sally Miller's petition would be heard according to the unique laws of Louisiana. In 1803, when Thomas Jefferson purchased Louisiana from Napoleon Bonaparte, the territory was governed by the laws of the Spanish and French colonial administrators. Acting on the assumption that such laws must be barbarous, one of the first things the new American governor of the territory, William Claiborne, did was to attempt to impose America's version of the English common law on the state. Much to his surprise, the citizens resisted. They liked their civil laws. They regarded their laws as morally superior to, and certainly more understandable than, the common law. Bowing to the storm of protests, Claiborne confined himself to reforming the criminal law and the law of evidence, and left the civil law of Louisiana to its Roman traditions. It was subsequently codified in 1808. Its sources were mainly French, but some Spanish, Roman and English elements were included in one harmonious mass. It was revised from time to time, most notably in 1825, but its fundamentals remained the same.

With biblical simplicity (and anticipating by 150 years the push for plain English), the code set out complex concepts in terms the ordinary man could understand. Here is an example:

Article 449. Common things may not be owned by anyone. They are such as the air and the high seas that may be used by everyone conformable with the use for which nature intended them.

Article 450. Public things are owned by the state or its political subdivisions in their capacity as public persons.

Article 453. Private things are owned by individuals, other private persons, and by the state or its political subdivisions in their capacity as private persons.

With such elegant brevity, is it any wonder the people of Louisiana fell in love with their civil code? Behind its apparent simplicity lay 2,000 years of wisdom, distilled and refined by the *Justinian Institutes*,

the ancient writings of the Spanish partidas, and the works of Montesquieu. At every turn there was a religious and moral basis to the code. Whereas the common law was about the preservation of landed estates and the sanctity of a bargain between merchants, the code was devoted to the protection of the family and honest practices in business. For example, contracts were regarded as creating mutual obligations that involved concepts of fair dealing quite unknown to the common law. There was the astounding belief that merchants should act morally and that an agreement could be set aside if there was a defect that made the thing useless. In family law, acquisitions of property became, not the exclusive possession of the husband, but the joint possession of the spouses. A father in composing his will was compelled to reserve a portion of his estate for his widow and children. Bastards were legitimized by marriage and could inherit property along with the legitimate children. Parents were responsible for the damage caused by their children.

The Code was the source of the law, and it mattered not what an earlier generation of judges might have said about it. The dead hand of precedent was shunned. By way of contrast, the common law was jammed together by judge-made rulings stretching back centuries, to be ascertained not in one volume, but in hundreds of law reports that only the very rich could possibly possess.

However, at Governor Claiborne's insistence, the rules relating to evidence at trials were determined according to the common law, and its contribution to Sally Miller v. Louis Belmonti and John F. Miller was to rule that neither Sally Miller, nor Louis Belmonti, nor John Fitz Miller could appear as witnesses. This was because, under the arcane laws that applied in the common law world at that time, a person with an interest in the outcome of a legal action could not appear as a witness in his own cause. The law reasoned that people couldn't be trusted to tell the truth if the outcome might impact on their own pocket. Sally Miller, as well as being excluded under this rule, was doubly silenced because she was a slave. In Southern courts, the only time a slave was permitted to speak was to confess to a crime or to condemn another slave. The rule against an interested person giving evidence also applied to Francis Schuber, on the technical reasoning that he might lie to the court to save the thousand-dollar bond he had

SALOMÉ MÜLLER

posted against Sally Miller's promise to appear at court. Upton, anxious that Francis should give evidence, realized this problem in time, and a few weeks before the trial was due to commence, another person in the German community, a Mr. Boman, became the bondsman in his place.

Sally Miller left the Schuber household a fortnight before the trial began, and moved to a boarding house in Lafayette. Why the change? Only one insubstantial clue exists: during the cross-examination of Francis Schuber some weeks later, the attorney for Miller asked him if he had "expressed great partiality" for the plaintiff. Evidently, Francis was prepared for the question, because he ignored its sexual overtones and replied that he had taken "the part of the plaintiff because he knew her to be in the right."

It was a nasty, underhanded question that had nothing to do with the merits of the case, but was damaging just the same—as Miller's attorney had intended. Nothing more about the relationship between Francis Schuber and Sally Miller appears in the documents. Did the questions suggest that Francis Schuber was infatuated with Sally Miller? It is difficult to think what else the attorney was getting at. If it was the case, did Eva Schuber order her out of the house? Perhaps. In any event, although Sally left the Schubers' home, there was no faltering in Eva's dedication to the cause of freeing her goddaughter. Eva had devoted her very being to making Sally free, and she was determined to see it through, come what may.

Two days before the trial was due to commence, Eva Schuber's son arrived at Upton's office and handed him an envelope. He waited in case there was a reply. Inside was a brief, handwritten message. It said that Madame Carl had died during the night. Then a P.S.: I thought it important that you should know as soon as possible. Eva Schuber.

Upton thanked the boy. No, there wasn't a reply.

As he shut the door behind the departing messenger, Upton felt a great weight settle on his shoulders. He cursed the bad luck of it. He had planned to make Madame Carl his first witness. He had lost the dramatic opening of her discovery of Sally Miller at Belmonti's cabaret. He then had planned to lead her through the story of the

journey from Germany, the deaths during the voyage, and how they were sold as redemptioners when they arrived. She had impressed him as a resolute woman, not likely to be flustered by his opponent's cross-examination. She was to be the one to dispel any thought that this was a case brought by excited immigrants hoping to bring a lost relative back from the dead. Heaven knows the case had enough difficulties as it was. There was still no solution to the baffling puzzle of the unaccounted-for years between 1818 and 1822, which had swallowed Salomé Müller and spawned forth Bridget Wilson. Nor had anyone given him proof that Miller had engaged Daniel Müller and his children as redemptioners, much less that Miller had kept Dorothea and Sally at one of his plantations in Attakapas. And what had happened to Dorothea? No one knew that, either. According to Miller's answer, Sally Miller was about twelve in 1822. Eva Schuber was now saying she was much younger. It was Eva's recollection that the girl was a little over three when they left Alsace in 1817. She may have been vounger, she may have been older, but whatever age, you would think she would remember something of her parents and the sea journey to the United States.

If this wasn't enough, at the last moment Roselius had bowed out, giving as his excuse that he was obligated to appear in the Supreme Court for the churchwardens of the St. Louis Cathedral who were arguing that the building belonged not to Bishop Blanc, nor even Pope Leo XII, but to them. With only a perfunctory apology to Upton, Roselius had said that the most he could do was to appear to make the opening address, but thereafter Upton would be on his own.

Upton had learned that John Randolph Grymes would oppose him, and he had reason to be overawed at the prospect. Grymes was the elder statesman of the New Orleans bar and its most famous practitioner. He was the first choice of wealthy clients, and other counsel could only marvel at the fees that he could command. In one case, the infamous batture case,* he earned a reported one hundred thousand dollars for rescuing a strip of waterfront land for the City of New

^{*} Over decades, the Mississippi River deposited a considerable tract of land adjacent to the New Orleans waterfront—called a "batture"—and the dispute about who owned the resulting real estate was the subject of wrangling in the courts for years.

SALOMÉ MÜLLER

Orleans from the claims of a fellow lawyer, Edward Livingston. In another case, he and the same Edward Livingston were paid twenty thousand dollars each by the gentleman buccaneer Jean Lafitte to defend his brother, Pierre, on a charge of piracy. At the time when this engagement came his way, Grymes was the district attorney for the parish of Orleans, but the prestige of public office wasn't enough to hold him and he resigned to appear for Lafitte. The team of Grymes and Livingston failed to obtain Pierre's release, so the pirates organized a jailbreak and freed Pierre anyway. Jean Lafitte, ever the honorable man, acknowledged his debt and invited Grymes and Livingston to his island hideaway in Barataria Bay to collect their fee. What happened next is the stuff of legend, one version of which was recounted by Herbert Asbury in his book *The French Quarter*:

Grymes, who was notorious in New Orleans as a gambler and a playboy, accepted eagerly, but Livingston declined, and deputized Grymes to collect his fee at a commission of ten per cent. Grymes received the money the day he arrived at the pirate's establishment, but he lingered on the island, charmed by Lafitte's hospitality, and nightly gambled with the pirate chieftain. At the end of a few days the twenty thousand dollars Grymes had collected for himself was back in Lafitte's strong-box, together with the two-thousand-dollar commission from Livingston. 95

Such stories only added to Grymes's reputation for absurd adventures and high living. The strict hearsay around New Orleans was that everything he earned through the law, he let slip through his fingers in high living, careless generosity, and discreet affairs of the heart. He frequented the cockfighting pits in the French Quarter, the horse track at Metairie, and the card table at the St. Charles Hotel. An invitation to dine at his table, with its magnificent food and fine wines, was to be savored for months afterward. During his lifetime he was involved in several duels, one as an upshot of his involvement with Jean Lafitte. A man imprudently accused him of being 'seduced by the blood-stained gold of pirates'; Grymes was the steadier shot, and his bullet hit his accuser in the hip and left him a permanent

cripple. On another occasion, while he was briefly a member of the state legislature, he attacked a fellow legislator.

The distinguished historian of Louisiana, Charles Gayarré, wrote:

There is nothing of the scholar in Grymes; his collegiate education has been imperfect; his reading is not extensive as to legal lore, nor anything else. But there is infinite charm in his natural eloquence and his powerful native intellect knows how to make the most skilful use of the materials which it gathers at random outside of any regular course of study and research. He has the reputation of never preparing himself for the trial even of important cases, and he seems pleased to favor the spreading of that impression. He affects to come into court after a night of dissipation, and to take at once all his points and all the information which he needs from his associates in the case, and even from what he can elicit from his opponents during the trial. It is when he pretends to be least prepared, and has apparently to rely only on intuition and the inspiration of the moment, that his brightest and most successful efforts are made. Many have some doubts about the genuine reality of this phenomenon, and believe that Grymes works more in secret that he wants the public to know.

No man was ever more urbanely sarcastic in words or pantomime. If the Court disagrees with him on any vital point, and lays down the law adversely to his views, he has a way of gracefully and submissively bowing to the decision with a half-suppressed smile of derision, and with an expression of the face which clearly says to the bystanders: I respect the magistrate, as you see, but what a goose that fellow is!⁹⁶

A case with little law and few witnesses to sizzle was Grymes's meat. Those burned by his cross-examination remembered his piercing eyes that mesmerized concessions that they never intended to make. In addressing juries he was witty, elegant, and cynical. He cajoled them with folksy humor and peppered them with shrewd observation about society, the fond silliness of women, the grandness of Southern culture, the bumbling ways of public officials and the inherent stupidity of dark-skinned people. He always spoke softly,

SALOMÉ MÜLLER

with a lilt to his speech and a smile on his lips. His voice was easy to listen to and had a cadence that persuaded.

Upton spent the rest of the day fussing about his office, tidying his papers and going through his notes of examination of witnesses for the hundredth time. He made sure that the petition and the answer, the summons to appear and the bond papers were neatly indexed in a folder. That done, he leaned back in his chair. He wondered what would happen to Sally Miller if he lost the case. He supposed she would have to be returned to Belmonti. What then? Belmonti would be free to inflict any punishment upon her he felt she deserved. Still, on the couple of occasions he had met Belmonti, he didn't seem a bad sort of fellow. Perhaps he wouldn't be too harsh. But who would know? And there was always Miller in the background, who might want to borrow her for a while so that he could inflict some punishment of his own.

Upton's mind wandered through the various aspects of the case. It seemed to him that Grymes had the much easier task. Miller's explanation of how he obtained Sally at least had the advantage of simplicity—over twenty years ago, Williams came to his sawmill and left him a slave girl to sell. Williams didn't return, so Miller sold her to his mother. Later he bought her back from his mother and sold her to Belmonti. And that was it. Logical, simple, and believable. Whereas his own case depended upon a court believing that a miracle had occurred when a German woman missing for a quarter of a century had been found in a New Orleans cabaret—and in Upton's experience, courts didn't like miracles. His witnesses were a succession of immigrants who could recognize a little girl after twenty-five years on the strength of two moles and because she looked like her dead mother. Upton took a deep sigh, willing himself to believe.

NIND

THE FIRST DISTRICT JUDICIAL COURT OF NEW ORLEANS

The slave . . . cannot be a party in any civil action, either as a plaintiff or a defendant, except when he has to claim or prove his freedom.

Article 177 of the Civil Code of the State of Louisiana

n May 23, 1844, the Upton brothers, each carrying a black leather case, walked through the streets of the Vieux Carré toward the First District Court. Following closely behind were Eva Schuber and her husband, holding bundles of papers, and directly behind them was the plaintiff herself. She was wearing a slate-gray dress that fell to her ankles. A frilled lace collar, held in place by a large brooch, pressed high on her neck. Her hair was parted in the middle and pinned in a knot at the back of her head. Walking behind her came Madame Koelhoffer, Mistress Schultzeheimer, and Mrs. Fleikener, dressed in church-going black. Then came Messrs. Frendenthal, Grabau, and DeLarue dressed in business suits, all of whom Eva had earlier introduced to Wheelock Upton, telling him that these were some of the men who were meeting his legal expenses. Then at the rear, hobbling along with the aid of a walking stick, was Madame Poigneau, who would tell the court that she had heard Bridget Wilson speak like a German.

In Toulouse Street they met up with Christian Roselius. No man was more respected by the German community, and Sally's supporters surrounded him and thanked him profusely for taking on the case. But he was a lawyer in a hurry, and he extracted himself from the well-wishers and strode off toward the court, one arm swinging, the other holding a battered buckskin satchel containing documents he had examined overnight. The others, like participants in a medieval religious procession, followed along behind, instinctively ranking themselves according to their importance to the case.

The First District Court was housed in the Presbytere. It was originally the priest's house to the St. Louis Cathedral next door. On the other side of the cathedral stood the Cabildo, where the Spanish governor had ruled, while his soldiers had paraded in the Place d'Armes directly out in front. These three buildings represented the trinity of ecclesiastic, divine, and military authority in the colony. When Louisiana became American, the symbols of power changed. The Cabildo became the City Hall and later housed the Supreme Court, the Presbytere was turned into the district court, and the Place d'Armes became a public park. Nowadays the Place d'Armes is designated Jackson Square, but in 1844 the splendid statute of Old Hickory riding a prancing horse hadn't been erected, and the Pontalba buildings with their guillotine windows opening onto graceful balconies had yet to be built. The square was then an old marching ground with a set of stocks in the middle where black people convicted of crimes by the nearby courts were whipped each afternoon.

A correspondent in 1847 wrote of "the curious scenes" he saw in and around the Presbytere courthouse:

Apple-women take possession of its lobbies. Beggars besiege its vault-like offices. The rains from Heaven sport among its rafters. It has everywhere a fatty, ancient smell, which speaks disparagingly of the odor in which justice is held. And yet in this building (which the poorest Eastern village would blow up before sundown should it appear within its precincts) are held from November until July, six courts, whose officers brave damp and steam enthusiastically and perseveringly. You turn...into a narrow alley and brushing past a greasy crowd are soon within the criminal court, where a judge, perched in a high box, wrangles

hourly with half-crazed witnesses;—here you behold jurymen, who of themselves constitute a congress of nations; zealous, full-lunged lawyers; and audacious criminals ranged in boxes, very much to the satisfaction of a mustached district attorney and the merry-looking keeper of the Parish jail.⁹⁷

It was into this bedlam that Roselius and the Upton brothers led Sally Miller and her backers. They elbowed through the crowds and climbed the stairs to enter one of the courtrooms. Already it was half full. A hush fell on the audience as they turned to stare at Sally Miller, judging her white or black, according to their preconceptions. The lawyers took their seats at the bar table, and Roselius indicated directly behind them, to where Sally, as the plaintiff, should sit.

Grymes arrived a few minutes before court was due to commence. He was a tall, elegant man, in his late fifties, with graying hair and a thin face. He wore a paisley waistcoat and a shiny black coat. A dandy gambler on a steamboat wouldn't have been better turned out. He came at the head of a team of attorneys and assistants, who waited respectfully until he had chosen his seat, then took their place either side of him. John Fitz Miller, his head held high, and mortified that it had come to this, sat behind them. Grymes nodded to Roselius. They knew each other well, respected each other as formidable opponents and disliked each other immensely. With those curt courtesies over, both men concentrated on the documents placed before them by their more junior associates.

The respective followers of Sally Miller and John Fitz Miller moved to sit directly behind each side's legal team. Louis Belmonti wasn't there. He had decided that the litigation was no longer of concern to him, and was well satisfied to leave it to his counsel. The *Daily Picayune*, in reporting the case, was kind to him, making it clear that he had acted in good faith and that if damages were to be awarded, Miller, and not he, would sustain them. ⁹⁸ As the trial progressed, the press, presumably in the interest of making things simple for their readers, ceased mentioning Belmonti's name at all.

Precisely at eleven o'clock there was a tapping at a door set in the paneling along the front wall. All rise, called Deputy Sheriff Lewis, in a clear and booming voice, and in obedience there was the scrape of a

hundred chairs. The door swung open and with his black robes swishing behind him, Judge Buchanan strode to his judicial upland on which sat a large upholstered chair. He looked around, nodded briefly to Grymes, then to Roselius, and, ignoring the other counsel, threw his robe behind him so that it enveloped his chair, and sat down.

Oyez! Oyez! The Honorable First Judicial District Court of the State of Louisiana is in session, cried the sheriff. All those who have business in the case of the petition of one Sally Miller against Louis Belmonti and John F. Miller come forward and they shall be heard.

Both sides, for quite different reasons, had requested that a judge sitting without a jury should decide the petition. Roselius and Upton had been concerned that if they insisted on a jury, it was likely that most of its members would be slaveowners and disinclined to take away another fellow's property. Nor might the typical juryman readily accept that a Southern gentleman would be capable of enslaving a young white girl. Grymes, for his part, had been worried about the jury's reaction to the sight of a white woman seeking her freedom. He had expected (and a quick glance at Sally Miller confirmed this) that she would appear in court groomed in the most respectable of clothing and with a pale skin indicating she hadn't seen the sun for weeks. To his mind, the defendants' cause would be best served by drawing a crusty old judge who wouldn't be swayed by the emotional foolishness of the German witnesses or the charming pretences of the plaintiff.

Grymes couldn't have wished for anyone better than the judge now facing them. Alexander M. Buchanan was an ex-soldier who frequently used the bench to lecture the citizens of New Orleans on the need for rules and discipline in society. He wasn't admired for his knowledge of the law, but Grymes saw no disadvantage in that. Here at least was a judge who would decide the case without flourish or adventure and stick to the facts. If Buchanan was known for anything in lawyerly circles, it was for his quick temper and his overconcern for the dignity of his office.

The lawyers stood in turn to announce their appearance: Mr. Roselius with Messrs F. W. Upton and W. S. Upton for the plaintiff; Mr. Grymes, with Mr. Micou and Mr. Lockett, for Mr. Miller; and Mr. Canon for Belmonti.

Roselius waited to catch the judge's eye so that he could commence his opening address. Behind him, every seat had been taken and some of the overflow spectators were lined against the side walls. There was a witness stand on Roselius's left; to the right was a small desk for Deputy Sheriff Lewis. In the well of the court, directly in front of the lawyer's bench, was a rail enclosure capped in brass knobs, where Mr. Gilmore, the clerk of the courts, waited, ready to write notes of the proceedings. Shorthand wasn't a skill he possessed, so he wrote his notes in an abbreviated, narrative form, by omitting the questions and only recording the answers.*

Roselius spoke for most of the morning, reordering the elements of an intricate drama into a simple sequence of events. He spoke quietly. There was no stage thunder, no arm waving, no appeals to emotion. His tone was of a plain fellow, come to tell of an awful wrong, and seeking the court's help in putting things right. He told of the journey of German immigrants to the United States, how one such family—a widower, Daniel Müller, and his children—upon their arrival in New Orleans had become redemptioners in Attakapas, and how Attakapas was where Miller had several plantations. He explained how Sally Miller had arrived on the doorstep of the Schuber house a year ago and how the people who gathered there had instantly recognized her. He read the petition and Miller's answer, pausing to list the witnesses he would call and what evidence they would present.

^{*} In writing this book, I have relied heavily on the notes kept by the clerk of courts, particularly in portraying the events of the trial. The notes, however, have their limitations: they are only a précis of what was said, and are usually in the third person. Mr. Gilmore did not record counsels" addresses on the facts, or submissions on the law, although the judge's rulings were sometimes inscribed in bills of exception, in the judge's own handwriting. Gilmore's notes also contain an occasional error (for example, mixing up the plaintiff and the defendants), but I must not be too critical—given that his words were written at speed, with quill and ink, they are remarkably comprehensive. The approach I have taken is to reconstitute the evidence into what I think counsel asked, and the witnesses replied. I have omitted much that is repetitious, and placed examinations about the same topic together. Where obvious gaps appear I have relied on sources such as newspaper reports, the pamphlets written about the case, and what I think it was likely counsel would have said. The notes of the case before Buchanan were made part of the Supreme Court Collection, now housed at the University of New Orleans, Docket 5623.

He pointed out to Buchanan the unusual features of the lawsuit now before the court. He said that almost always the petitioners in freedom cases were people with some African blood in their veins, offering this explanation or that as to why they should no longer be held in chains. However, in this case the petitioner was saying that she had nothing of Africa in her. She was incapable of being made a slave. She should never have had her childhood stolen from her or have been forced to labor for others. Why not? Because she was always a free white woman.

Roselius turned to face Sally Miller. Everyone in the courtroom followed his gaze. This woman, he declared, is of pure German descent. She is pure white. In the name of justice, she must be freed. He turned back to Buchanan. This is the unique issue at the core of this case. This is the important matter you have to decide.

When Roselius was done, Grymes, without rising from his chair, announced that the defendants would make their opening address after the plaintiff's case had concluded.

It was time for Roselius to make his apologies. After inclining his head in respect to the bench, he explained that he had a case at the Supreme Court he must attend to. His esteemed colleague, Mr. Wheelock Upton, ably assisted by his brother, Mr. Frank Upton, would take over from here.

Even before Roselius had packed up his belongings, Wheelock Upton was standing in his place. In a nervously loud voice, he asked the sheriff to call his first witness.

A woman of many years, dressed in clothes that spoke of poverty, made her way slowly through the crowd into the body of the court. Sheriff Lewis motioned her forward and then, offering his arm, aided her into the witness stand. After she had settled herself, the clerk of court placed a Bible in her hand. She spoke very little English, she said. Spanish was her tongue. An interpreter was summoned and with great solemnity Mr. Gilmore took her through the oath of truthfulness.

Upton approached and bowed low. He asked her name and where she lived. Her answers came through the interpreter: Madame Poigneau, and she lived in the Third Municipality.

Did she know the woman seated behind him? Yes, she did. She had known her since she was eleven or twelve. She had seen her at Miller's

sawmill. Then, without any further prompting, she added that the girl had the color of a white person, so she remembered her from that. She had the appearance, the mien, the eyes, and the color of a white person.

And what accent had she when she talked? asked Upton. Was it French, Spanish, whatever?

She had a German accent, said Madame Poigneau.

Upton glanced toward Buchanan, confirming that he understood the significance of her words.

Are you sure that this is the same person? pressed Upton. He directed Madame Poigneau's gaze toward Sally Miller. Are you sure this is the same person you saw as an eleven- or twelve-year-old girl, speaking like a German in the yards of Miller's mill?

Madame Poigneau nodded. Yes, she was sure.

Upton sat down. His examination of Madame Poigneau had taken only a few minutes, but he had planned it that way. The essential point was so important, he didn't want it lost in other evidence. He could hear a buzz of excitement from the German people sitting behind him. He glanced behind him and saw the smile on Eva Schuber's face and her certainty that now they must be believed.

Grymes rose slowly to his feet, began to ask a question, then stopped himself. He glanced at the clock. Buchanan took the hint. They would resume at two o'clock, he announced.

As Upton left the courtroom, a jubilant crowd of Sally Miller's supporters surrounded him as if he had done something wondrous. So, she spoke with a German accent! It was all they needed, wasn't it? Then, with the proof of the moles on her thighs to come, victory must be theirs. Never had there been such a clear-cut case.

After lunch, the crowd in the courtroom was greatly reduced. Many from the German side, well pleased at how the morning had gone, hardly saw the need to continue to show their support. The business of the day awaited. Miller had lost some of his supporters as well, but he had gained one. A tall, balding man in his mid-forties sat next to him. He was dressed in a snuff-colored frock coat and nursed a crisp Panama hat on his knee. Upton didn't know who he was, but he was clearly someone, because Grymes got out of his seat to welcome him. Upton asked his brother to find out about the

THE FIRST DISTRICT JUDICIAL COURT OF NEW ORLEANS

newcomer. He returned with the news that the man was General Lewis, the commander of the state militia. He was, it seemed, to be called as a witness for Miller.

Grymes began his cross-examination of Madame Poigneau gently enough. When had she first seen Sally Miller? She appeared unsettled by his question. She couldn't exactly remember. It was at least twenty years ago.

Well then, asked Grymes, what street were you living in then?

Again his question caused her difficulty. She didn't know the name of the street. You can't remember? asked Grymes solicitously. She said she couldn't, but then added that she had always lived in the lower part of the city.

Did she know the name of the faubourg? She didn't know that either. Grymes smiled sympathetically. She gave the names of some of the people she knew in her street.

How does that help the court? said Grymes, with the slightest of sneers. Do you expect the judge to know these people?

The woman made no response.

So, you don't know where you were living?

It was about half a square from Mr. Miller's mill.

It's difficult after such a long time, isn't it? said Grymes.

Madame Poigneau agreed.

Grymes turned to a different topic. Had she ever visited Miller in his house?

No, she hadn't.

Had she ever visited his mother, Mrs. Canby?

No.

Well, then, why were you on Miller's land?

I went to the yard to visit among the old Negresses.

These would be slave women you were visiting, Madame Poigneau?

The witness mumbled a reply. He repeated the question.

Yes, she said more loudly.

Suddenly there was a hardness in Grymes's voice. So, you heard Sally Miller speaking with a German accent, while you were visiting old slave women?

Yes. She always spoke German.

But you were visiting slave women?

Yes.

Because they were your friends, these slave women? That was why you visited them?

Yes. Bridget always spoke German.

You are now saying that this woman spoke German, are you? Not just had a German accent, but spoke German?

She always spoke German.

She spoke German to you?

Yes, she always spoke German.

Ahh, said Grymes. Could you speak a little German for us?

She looked at him in confusion. Grymes sighed in mock empathy. Gone, has it?

I used to be able to speak German back then, but it's forgotten. It's because I only speak Spanish now. But Bridget spoke German then. I heard her.

And what did you talk about.

I never had a conversation with her. I just heard her talking.

Well, what was that?

I once said: Well young girl, you are running about with your feet naked and your calico robe on.

I see, said Grymes. How old are you, Madame Poigneau?

I don't know. We Creoles don't count our ages.

No, I suppose not.

I was born in New Orleans, though, added Madame Poigneau, and grew up during the rule of Governor Galvez.

Grymes's face beamed. Governor Galvez, the Spanish governor? You remember him? The witness did.

Bernardo De Galvez's rule in Louisiana had ended sixty-five years earlier. Grymes looked at Judge Buchanan and shook his head in a knowing way, implying that Madame Poigneau's mind had long since departed her. Oh dear, said the lawyer in a stage whisper as he sat down.

Somewhat shaken after watching Grymes maul his first witness, Upton next called Madame Hemm. She was a middle-aged German woman of dour respectability, whom he felt sure would have no difficulty in remembering where she lived. Nor was there any possibility that she would have spent her time visiting elderly slave women.

Madame Hemm went through the story of how she had accompanied her parents from Württemberg to Holland, and how, once they had arrived in Amsterdam, her father had used the last of their savings to pay for the family's passage to Philadelphia. Later they heard that the man who had taken their money had become bankrupt. They had been cheated and they had nowhere to go. They had spent five months in Helder and it was there that she had met Salomé Müller. She guessed that Salomé's age was then three or four. Eventually the Dutch government made them return to Amsterdam, where they waited until they came to America. Many, many of them had died.

And that child you saw in Holland, do you see her now in the court? asked Upton.

Oh, yes, said Madame Hemm in a clear voice, pointing to Sally Miller. I recognized her as belonging to the same family. She is the person I saw in Amsterdam.

How did you recognize her as the same person? he asked.

There was the family likeness in her face, which I saw as soon as she came in the door.

The lawyers packed up their books and papers, and walked back to their office. The first day in court had ended, and Madame Hemm would continue to give her testimony in the morning. The German supporters of Sally Miller accompanied the Upton brothers part of the way. There was none of the excitement that had accompanied the parade to the Presbytere that morning. Would it go for much longer? they asked. Weeks yet, they were told. They nodded; they had thought as much.

Before he let Sally Miller go, Wheelock Upton asked her about General Lewis. He had visited Miller's household a lot, she told him. That was many years ago. He had spoken to her plenty of times. What had they talked about? Nothing, really. Nothing important. Nothing that she could remember. She had waited on his table and carried coffee to him and Miller while they chatted on the veranda.

He was always friendly to her. He was always polite. Sometimes he asked her about her children. That was all. But what did she say to him? Nothing, replied Sally. She couldn't imagine what he was coming to give evidence about.

The Upton brothers continued on their way. It had been a day of mixed fortune. Madame Poigneau hadn't been the savior they had hoped for, but Madame Hemm had done well. Still, there was Grymes's cross-examination to come.

The next morning Upton asked Madame Hemm a few questions about the dispersion of the immigrants once they had arrived in New Orleans. Madame Hemm said that she never knew where Shoemaker Müller's children had gone and it was only lately that she had learned that Sally Miller was alive. Upton asked her again to explain how she recognized Sally after all those years. She gave the same answer: she immediately saw the family likeness.

It was Grymes's turn. He had listened carefully to Madame Hemm's evidence and concluded that she had made only one substantial point—that she could recognize Sally Miller after a gap of twenty-five years. His cross-examination concentrated on the improbability of this. There had been hundreds of German children in Helder, hadn't there? How many were there? Two hundred families? Nine hundred people? How could she remember one little girl? Madame Hemm insisted that she could.

Really?

He asked Madame Hemm her age—forty-six next fall—so she would have been eighteen or nineteen when she last saw Sally Miller? Yes. And how old was Sally? About three or four. Madame Hemm's family wasn't from Alsace, but from Württemberg? Now, that was miles away across the Rhine. And the first time she had met Sally was on board the *Rudolph* in Helder? And she hadn't seen the plaintiff since they left Amsterdam? They hadn't come over on the same boat, and she hadn't seen her in New Orleans? All this, Madame Hemm conceded, but stressed that Grymes couldn't possibly realize what things were like at Helder. They were there for five months, worried sick about what would happen after they lost their money. Everyone

helped one another. They looked after one another's children, they nursed the sick, they shared what little food they had. Everyone knew everyone else, and she knew Salomé Müller.

By the time Grymes had finished with Madame Hemm, it was mid-morning on the second day. Upton announced that his next witness would be Eva Schuber, the godmother to the plaintiff.

Eva had convinced herself that Sally Miller's freedom depended on her evidence and as she took the oath her voice trembled with anxiety. Upton asked her what year she had arrived in America. It was the sixth day of March 1818, she responded with singsong certainty. She couldn't remember the name of the ship, but she remembered the name of the captain, all right. He was Captain Krahnstover.⁹⁹

She seemed a little calmer now. Did she know the plaintiff? Yes, she did. Upton let her tell the story in her own way. The words tumbled out. Yes, she knew her. She had cared for her after the girl's mother died. She was her godmother. Eva patiently went through the tangled relationships by marriage and blood of the families who had left Langensoultzbach. She was fifteen years old and Salomé Müller was two years and three months. Eva told of the heartbreak of being cheated out of their fares, of how they had begged in the streets of Amsterdam, then of the voyage across the seas—all recounted in a flat, quiet voice, not so much remembering, but reliving events that would remain with her for the rest of her life—a teenager watching silently as around her people died, day after day, week after week, on that doomed voyage. She told of the death of Salomé's mother, and how she had then nursed Dorothea and Salomé when they were ill and comforted them when they were frightened. She had put them to bed and slept with them at night, and had dressed them in the morning. She had seen marks on Salomé's body. Moles, brown moles, on the inside of each thigh. She had seen them often. And she had seen them again when Madame Carl brought Sally Miller to her house a year ago, and they were the same.

Upton asked her about her first sighting of Sally Miller after all those years. She said that she had seen a woman standing behind Madame Carl when she came to her house, and had asked, Is that a German woman? Madame Carl had said, Yes, and she had said, My

God, the long lost Salomé Müller! She had instantly recognized her. She needed nothing more to convince her that it was Sally Miller. She would recognized her among a hundred thousand persons.

And did you attempt to have her owner free her?

I spoke to Mr. Belmonti about Sally Miller.

What did he say? inquired Upton.

He blamed Mr. Miller. He said he wanted to set her free, but Mr. Miller had told him that if he did that, she would have to leave the country. That it was the law. Mr. Belmonti then told me that Mr. Miller had said to him that he didn't sell her as a slave. Miller had said she was a white woman, as white as anyone, and neither of them could hold her if she chose to go away.

Grymes opened his cross-examination by asking her about the last time she had seen Daniel Müller and his three children. She hadn't seen them leave New Orleans, had she? No. She hadn't seen them on board any keelboat, either? No. Nor did Daniel tell her who their new master was? No, he hadn't. It could have been anyone, couldn't it? Reluctantly she agreed.

He asked her how old she was when she arrived in New Orleans. Fifteen, going on sixteen. She was now forty-three.

And you say Sally Miller was about three?

Yes.

And she spoke German plainly?

Yes.

And no other language?

No.

The other little girl, Sally Miller's sister, how old was she?

She was four years and two months.

Is she alive?

I don't know. I haven't heard anything.

So, you can't say if she is dead or alive?

No.

You didn't see Sally Miller again until last year?

That's right.

And you say you recognized her after all those years because she looked like some of your relatives.

I recognized her.

THE FIRST DISTRICT JUDICIAL COURT OF NEW ORLEANS

But you have no other reason to believe that this woman was the daughter of Daniel Müller than the supposed resemblance she bore to the family and the marks you mentioned. That is it, isn't it?

Eva agreed.

So it went on for the rest of the morning. Grymes hounded her, ridiculing her claim to see the likeness of Sally Miller in her faded recollection of a three-year-old child. She suffered his attacks with a tired resolve. He scoffed at her answers, he rolled his eyes, he sighed in exasperation, but she wouldn't be moved. Stubbornly, she maintained that she could recognize Sally Miller. She had found the moles on her legs. She was sure she was her goddaughter.

If you believed that Sally Miller had gone to Attakapas, why didn't you search for her there?

How could I? I was bound to work for Madame Borgnette. I was tied to her. How could I go anywhere?

What year did you leave Madame Borgnette?

I can't remember.

You can't remember?

No.

Well, did you search for Dorothea or Sally after you left Madame Borgnette?

No, I was married. I mentioned about Daniel Müller to my husband. I asked him to make enquiries.

But he didn't?

He told me that he had heard that when a keelboat returned from Attakapas, Daniel Müller and the boy had fallen out of the boat and were drowned. We asked the other Germans who came out on the same ships if they had heard of Daniel Müller's children, but they hadn't heard anything either.

And how long have you been married?

Twenty-four years.

Yet, for most of this time Sally Miller was at Mr. Miller's mill, in this very city?

I didn't ever go to Miller's mill. I had never gone that far down-river, until about ten months ago.

Thank you, Mrs. Schuber, said Grymes. And with that Eva Schuber's evidence ended.

Upton's next witness was a thin man with a face made craggy from the sun and drink. Sally Miller had found him that morning in the Bayou Hotel in St. John's and had shepherded him through the streets and up the stairs to the courtroom. He had been diffident about coming, but once there he seemed to delight in the attention. He was an old soldier, he told the court, come from the North with Jackson's army and had fought in the Battle of New Orleans. That was nearly thirty years ago and he had stayed in the South ever since. He gave his name as Mr. A. M. Wood and he was a carpenter. He knew Sally Miller from over twenty years ago. He had first met her when he was employed by Mr. Miller to work at his mill.

When was that? asked Upton.

Would have been in 1821 and 1822. She was a domestic, serving at the table and the like.

Upton then asked the vital question: Did you ever hear her speak?

He screwed up his face. Yes, I did. She talked German.

That must have made you curious?

It sure did, replied Wood. So, I asked.

Who?

The lady who owned her.

Mrs. Canby?

That was her name. I asked where she had come from, and she told me the girl's mother was dead and she was an orphan, and she had taken her on as charity.

I see, said Upton. Have you seen her since then?

I have, off and on around New Orleans.

And is she the same person you saw?

I know her. I know her to be the same girl.

How old was she, when you first met her? Grymes asked Wood in cross-examination.

She looked to be five, perhaps older, seven.

That was in 1821 or 1822, you say?

Yes.

And then you left Miller's employment and went working over the lake?

Yes, that's right.

THE FIRST DISTRICT JUDICIAL COURT OF NEW ORLEANS

But you came back to New Orleans in about 1824? You were no longer working for Miller by then?

No.

But you went to his mill from time to time?

Wood agreed. Why wouldn't I go to Miller's to buy timber? I'm a carpenter.

But you went there for more than that, didn't you?

Wood didn't answer. He began to look uncomfortable—he could see where this was heading.

You remember being told that they didn't want you to come to the sawmill anymore?

Again Wood didn't answer.

Go on, tell the court why they didn't want you there anymore.

Wood looked around helplessly.

Yes, Mr. Wood? insisted Grymes.

They said it was because I was overfamiliar with the girl.

Ah-huh. Grymes stood with a slight smile on his face, his hands tucked out of sight behind his coat, his shoulders slightly stooped.

And who told you that?

It was Mr. Struve, the sawyer at the mill.

And what did he say?

He told me I was getting too familiar with that Dutch girl and had better keep away.

Grymes was too wily to ask what "too familiar" meant. He pretended to examine his notes while everyone wondered. Then, after waiting a few moments and without raising his head from his notes, he asked Wood what work this "Dutch" girl performed.

She waited in the house, sometimes she nursed visitors' children, sweeping, looking after Mrs. Canby . . . things like that.

How old was she then?

She might have been nine.

Nine. Or perhaps five or seven, mused Grymes. That's what you said earlier. Wood squirmed.

The first time you met this girl, she was waiting at the tables? Yes, that's right.

Although you never had your meals with Mrs. Canby and Mr. Miller? There was a second table, wasn't there?

Yes. I ate at the second table.

With the blacks?

Yes.

And with this little girl you were overfamiliar with who might have been five or seven or nine?

She ate with us sometimes.

And the cook and the butler?

Yes, and some of the other white tradesmen.

And what was this girl called?

I think they called her Sally.

She was Mary, wasn't she?

I knew her as Mary. They called her Sally, as well.

When did Mr. Struve say you were too familiar with this girl?

It might have been in 1825.

It was 1824 a moment ago.

It was the latter part of 1826 or 1827.

You're not sure, are you?

Wood didn't answer.

Grymes turned to Upton, challenging him to examine the witness further. Upton thought for a moment. Asking more questions would probably only make matters worse. No, he replied, he had nothing more for Mr. Wood.

The irony is that if Wood's last recollection was correct, and he was warned off by Struve for being over-familiar with Sally Miller in 1827 or 1828, a little over a year later Struve himself got her pregnant. However, both Upton and Grymes avoided this topic. Grymes understood that the code of the South forbade asking questions about the identity of the white father of a slave child, and it couldn't have helped Sally Miller's cause for Upton to have raised side issues that reflected on the morality of his client.

Upton's next witness was married to John Fitz Miller's sister, and Miller was outraged that family should testify against him. "It is Nathan W. Wheeler to whom I have the misfortune, I may almost say, the disgrace, of standing in the relation of brother-in-law," Miller was later to write. This "perjured villain . . . had been the recipient of my bounty for years. He and his family had long lived on my charity, and when it was no longer in my power, owing to my loss of fortune, to contribute

THE FIRST DISTRICT JUDICIAL COURT OF NEW ORLEANS

to their support as liberally as in former days, he basely deserted his wife and child, who are thus thrown on me for their daily bread."¹⁰⁰

Miller might not have been so furious if Wheeler's evidence had been inconsequential. However, it wasn't. After telling the court that he had been living in New Orleans off and on since the spring of 1813, Wheeler then said that he had seen Sally in Miller's possession in 1819 or 1820. This was quite contrary to Miller's contention that he had never laid eyes on Bridget Wilson until Anthony Williams walked into his sawmill with her in August 1822.

Wheeler said his first sight of the plaintiff had been in Miller's yard. He had asked Miller if she was white and Miller had told him she wasn't. She had been left with other Negroes for him to sell. Although he had sold the others, Miller had said she was too white to be sold.

Did you see her after that? Upton asked.

Oh, yes. She was raised in the family.

Did Mr. Miller say who had left her with him?

I never meddle in family matters, so I don't know anything else about her. I concluded from what Miller said that she was a quadroon.

But even now you think of her as white?

I may have expressed myself on the subject of her being white, when I heard of this affair. Her color rather surprised me at the time.

Did you ever hear her speak?

Wheeler shook his head. He hadn't. He never paid much attention to that sort of thing.

Grymes began by asking how old this slave girl was when Wheeler first saw her. Wheeler though she was about seven or eight. What work did she do? The same as the others, replied Wheeler, common work, cleaning knives and forks, waiting on the table. She was called Mary, wasn't she? Yes, he hadn't heard her called anything else.

And Mary had a child who is now dead, didn't she?

Wheeler agreed that she did.

He was named Lafayette?

Wheeler agreed with that as well.

You took this child to work on your property in Cincinnati?

I did. Mr. Miller lent him to us for a while.

Quite so. And how old was the child when you took him to Cincinnati?

Wheeler thought for a moment. About five or six. Yes, that would be correct. The child was named after General Lafayette, so he must have been born soon after the celebrations when Lafayette visited New Orleans in 1825.

Quite so, said Grymes again. He had no further questions.

Upton glanced across at his opponent. He wondered why Grymes had gone out of his way to establish Lafayette's age. What relevance had that to the case? Upton couldn't work it out and it worried him. He doubted if Grymes ever asked needless questions.

Upton had one more witness to round off the day. Mrs. Fleikener took the Bible and swore that she knew the infant Sally Miller. She was positive the plaintiff was the same person and she should know—she was family. Her first husband's mother and the plaintiff's father were brother and sister. She had lived about three miles from the Müller family, and when they began the journey to Amsterdam, they had all started together. In Holland she had seen Salomé every day for six months.

Grymes took her back to their time in Holland. Sally Miller was two years and two months, she said. They had traveled on different ships to America, and she had not seen Sally Miller when they arrived. Although she had lived in New Orleans for two decades, she had never heard of her. Yet, when she saw her at Eva Schuber's house a year ago, she had instantly recognized her. Grymes smiled his encouragement at her powers of recall. It was because of her resemblance to her mother, she firmly declared. Sally had the chin of her mother.

With that the proceedings ended for the day. It was a Friday. Judge Buchanan's court took a leisurely pace. He normally sat on only three, occasionally four, days a week. He announced that the case would resume the following Tuesday.

Back in their office the Upton brothers unpacked their bags and closed the door behind them. It had been an arduous two days. With any other judge they might have felt more confident. Buchanan hadn't said much, but they both worried about what he might be thinking. They only had a few more witnesses to present. Three or four, and then finally Francis Schuber. That was it. Would it be enough? They weren't sure.

THE FIRST DISTRICT JUDICIAL COURT OF NEW ORLEANS

There was some good news from Mobile. Mr. Breden had written to say that despite a conscientious search of records in the city, he had found no trace of an Anthony Williams. Nor had his name appeared in any census. Breden had also taken the trouble of speaking to a Mr. Davis, known around Mobile as "the original George Davis," who was one of the oldest citizens in Mobile and knew everyone and whom everyone knew, and Davis was quite sure that no such person as Anthony Williams had ever lived in Mobile.

On Tuesday morning, Upton introduced yet another middle-aged German woman who recognized Sally Miller from twenty-five-year-old memories. She was Mistress Schultzeheimer, who explained that she was Salomé's aunt by her first marriage. In Germany she had known the plaintiff's mother, Dorothea, because they had attended the same school. She also knew about the moles on Salomé Müller's legs. Once when they lived in Alsace, Dorothea had shown her the marks on her baby's thighs. Mistress Schultzeheimer was a midwife and able to assure her that they were nothing to worry about.

How old was the child when you saw the moles on her legs? asked Upton.

About six months. Just a baby.

Have you seen those marks again recently?

Yes, I saw them again this morning—on the body of Sally Miller. They look like beans of coffee and they were the same today as when first I saw them.

This was one witness Grymes couldn't shake. He challenged her claim that she had known Dorothea Müller, and even that she had come to America on the same ship. He asked her how many ships there were and who else was on board. He asked her about Dorothea's sisters. He asked her where she lived when she first came to America. Mistress Schultzeheimer granted him nothing. He then suggested that she had spoken to Madame Hemm about the case. Or Mrs. Schuber. What about Mrs. Fleikener? No, she hadn't seen any of them for a long time. Well, who brought her to court today? It was Sally Miller. She had collected her from her home and taken her to Mr. Upton's rooms. She had asked Sally to show her the moles, but

she had refused, saying that she could only look at them in her lawyer's office. So it was in Upton's office where she had seen them. Sally had lifted her dress. They were exactly as Sally's mother had shown them to her all those years ago.

Grymes ran through his range of sighs and snorts, but Mistress Schultzeheimer stuck to her guns. They were the same moles. She recognized them. She had also recognized Sally Miller because of her looks. She knew her.

The next witness was less certain. All that Madame Koelhoffer could say was that Sally Miller looked like one of Daniel Müller's children. Both Daniel Müller and his wife had that sort of dark complexion. Madame Koelhoffer also thought she looked like others in the family, especially Daniel Müller's sister, Salomé Kirchner.

Mr. J. C. Wagner, who had spent six months on the *Rudolph* with the Müller family, told of traveling from Germany to America. About the only sting in his evidence was to mention that Grymes, in 1818, had represented the immigrants in their attempt to avoid having to serve time as redemptioners. Grymes had failed and they had been sold anyway.

Grymes made no attempt to defend himself. In fact, he saw no need to ask Wagner any questions. The immigrants may have suffered grievously on the journey to America, but that had nothing to do with Miller and Belmonti.

In the closing minutes of the third day, Francis Schuber took the stand. Upton took him through the now familiar tale of the horrors of the journey from Germany. Then Upton asked him if he remembered when Madame Carl had brought Sally Miller to his house. He certainly did. He had recognized her the moment he saw her. I said to my wife, Is that one of the two girls who was lost? My wife said she was.

At that, Buchanan called a halt for the day. The remainder of Francis Schuber's evidence would have to wait.

The next morning, Schuber continued from where he had left off. Upton asked him about the day that Madame Carl had brought the plaintiff to his house.

THE FIRST DISTRICT JUDICIAL COURT OF NEW ORLEANS

We inspected her legs to see if the marks were there.

And were they?

Yes, they were.

What do you know about these marks?

They were often spoken of in my family. I heard my mother-inlaw, who is now dead these twelve years, say that if ever the lost child was found, even if it was a hundred years, she could be identified by the marks on her body. The marks had been made by burns the child had received when she was five or six months old.

The last part of this answer stunned Upton. He asked Francis if he was talking about Sally Miller. He was. His mother-in-law had said that the girl had been held before a fire to keep her warm and sparks had burned her on her legs.

Upton quickly moved on. He asked Francis if he had seen the marks on Sally on the day Madame Carl had brought her to his house. No, he hadn't, not personally. It was his wife who did the examination. He was in the bedroom, but they weren't shown to him. But his wife had found them, all right.

In cross-examination, Grymes asked nothing about the marks on Sally's legs. He was quite content to have them described as burns and he certainly didn't want to give Francis the opportunity of changing his mind. Instead, he put it to Francis that he had no reason to believe that Sally was the child of Daniel Müller other than his recollection of her in Holland. Francis agreed. He also agreed that although he believed that Daniel Müller went to Attakapas, he didn't know who had engaged him.

Grymes then asked a question as gentle as the slice of a knife through liver: Had he not expressed a great partiality toward one of the parties?

Francis replied that he took the part of the plaintiff because he knew her and he knew her to be in the right.

Well, pressed Grymes, when you heard of the death of Daniel Müller, with all your partiality for his children, why didn't you go searching for them?

I didn't know where to look. After us immigrants were sold, we were scattered like young birds leaving a nest, without knowing anything of each other. Most of us never kept in contact. There were

so many people I never saw again. People who helped each other at Helder and on the boat—good, kind people who I never saw again. We talked a lot about what had happened to the children of Daniel Müller, but they had disappeared, along with the rest.

Upton had planned to call no further witnesses—that was until Francis Schuber had blurted out that his mother-in-law had said that the marks on Sally Miller's legs were caused by sparks from a fire. The case certainly didn't need that complication. Francis's wife, Eva, had already been in the witness box and described them as brown moles and she had been backed up by Mistress Schultzeheimer, who had said they were moles the size of coffee beans-not likely to be confused with burn scars. If the nature of the marks was left in doubt, inevitably Grymes would suggest that they were burns, recently scorched into Sally's skin in a desperate attempt to mimic those on the real Salomé Müller. Upton had seen the marks only briefly. In his office, Sally had sat on his desk and cautiously lifted her dress to let him examine her thighs. They looked like moles to him, but he couldn't be sure. He wondered if he should take the risk of having Sally examined by Judge Buchanan; even going further and asking him to conduct a formal inspection of her whole body so that he could see for himself that there was no sign of African blood in her.

There were many cases in the law books of the South describing courtroom inspections of people claiming to be white. The usual procedure was for the claimant to stand in the well of the court under the gaze of the judge while their lawyer pointed out that their nose was thin and angular, or that their eyes were blue. He would ask them to bow their heads to display the straightness of their hair. Sometimes they would disrobe to show how pale their skin was. Next, physicians would come forward and provide opinions about the identifying features of the various races, and advise on what side of the line the claimant stood. It was a sideshow run by judges that drew idle people in as amused spectators.

Many who suffered this humiliation were free persons, and the issue was whether they could vote, or send their children to school, or carry a gun without a license, or be a witness in a court case against a

white man. The court had to decide between those who were truly white, and those who merely looked white. To designate a person "visibly white" was to damn them. It meant that they wouldn't stand closer scrutiny—there was a frizz to the hair, an unacceptable flatness to the nose, a thickness to the lips—all indicating that surging through the veins was tainted blood.

If you were "visibly white," a reputed master wasn't barred from asserting ownership, transmitted through a slave mother. One case, decided in Arkansas, illustrates the point. Thomas Gary, a sixteen-year-old, looked white. A Dr. Brown examined Thomas and said he could discover no trace of Negro blood in his eyes, nose, mouth, or jaws—his hair was smooth and of a sandy complexion, perfectly straight and flat, with no indications of the Negro curl. Thomas's eyes were blue, his jaw thin, his nose slim and long. Dr. Brown's expert view was that it would take at least twenty generations from black blood to look as white as Thomas Gary. Another physician, Dr. Dibbrell, said he would judge Thomas to possess a small amount of Negro blood, no more than one-sixteenth, perhaps not so much, and wouldn't swear that he had any at all. Admittedly, his upper lip was rather thicker than in the white race, but in the doctor's opinion he made up for that by having a sanguine temperament.

Thomas Gary related a harrowing story to the court of how, after his father had remarried, he was sent away to Louisiana, where he had been taken in slavery and offered for sale. Being white, no one would buy him, so he had been sent back to Arkansas and sold to a man named Stevenson. Initially, both his father and Stevenson were in competition to own him, but under slave law, Thomas's father could have no claim, so he dropped out of the case.

At trial, Stevenson insisted that Thomas had African blood in him and this came from his mother, Susan, who was a slave. Stevenson then produced a series of witnesses who told the jury that they had seen Thomas and Susan together and she had always treated young Thomas as her son and he had gone to her as his mother. The testimony was damning. According to the court, the connection with his slave mother was "sufficient to repel any presumption of freedom" arising from the whiteness of his skin.¹⁰¹

In another case in Arkansas, a woman named Abby Guy and her

four children, in an effort to sway a jury, displayed their feet. Abby looked white and her children looked whiter. Abby's eldest daughter had been accepted into a white boarding school, went to the white church, and was invited to parties where she danced with white boys. Abby lived with a white man named Guy, and passed as Mrs. Guy, but when Guy died, her previous owner seized her and the children.

Abby Guy's attorney called two doctors whose expert evidence was intended to distance her and her family from black people. The note of their opinion in the law report reads:

Dr. Newton—Had read Physiology. There are five races—the negro is the lowest in intellect. Some physiologists are of the opinion that in the head of the mulatto, there is some negro hair, and some white hair, and that the negro hair never runs out. It would not run out before it passed the second generation. It may in the third generation have waves. The color, hair, feet, nose, and form of the skull and bones furnish means of distinguishing negro blood or descent. The hair never becomes straight until after the third descent from the negro, from either the father or mother's side. The flat nose also remains observable for several descents.

Dr. Comer—Heard the last witness, and corroborated his statements. 102

The jury, on this evidence, set Abby Guy and her children free. Their owner took an appeal to the Supreme Court of Arkansas, where on a technicality a retrial was ordered. At the second trial, "the plaintiffs were brought into court for inspection, and were permitted to pull off their shoes and stockings, and exhibit their feet to the jury against the objection of the defendant." Again the jury freed them and again the slaveowner appealed. The Supreme Court recorded that the slaveowner's counsel had argued "with much warmth of expression, that the court committed a gross error in permitting them . . . to exhibit their bare feet." The court disagreed, soberly recording that: "No one, who is familiar with the peculiar formations of the negro foot, can doubt, that an inspection of that member would ordinarily afford some indication of the race." Abby Guy and her children were declared to be free.

THE FIRST DISTRICT JUDICIAL COURT OF NEW ORLEANS

Upton hesitated to put Sally Miller through a similar procedure. It would be a risky business to ask Buchanan to examine her and draw his own conclusion, and even if he agreed to take part, he was hardly qualified to be able to distinguish between a burn and a mole. Moreover, just presenting Sally for inspection would create an adverse impression—to someone like Buchanan, a white woman of repute would never participate in such a demeaning presentation.

Upton dithered. He decided to wait and see how the defense case proceeded. He told the judge that the issue of identification of the marks on Sally Miller was yet to be addressed. He would discuss the issue with Mr. Grymes and, if need be, return with further evidence. With that, he closed his case.

It was now time for Grymes to show that Sally Miller was a slave.

INDIV

THE DEFENSE

The question of freedom should be determined, like every other question made before the courts, solely upon its legal aspects, without partiality to an applicant for freedom, because he may be defenseless, and a member of an inferior race, and certainly without prejudice to his kind and color, and without regard to the sincere convictions that all candid, observing men must entertain, that a change from the condition of servitude and protection, to that of being free negroes, is injurious to the community, and more unfortunate to the emancipated negro than to any one else.

Justice Fairchild, of Arkansas, indulging in mixed messages¹⁰⁴

In Grymes's hands, the trial wasn't about freeing a white woman from slavery; it was about defending the reputation of a Southern gentleman. Not forgetting his mother, now in her nineties, named by implication as an accessory to the charge leveled against her son. Both of them had been brought low by the accusation of their own servant—an olive-colored quadroon, a woman they had cared for and raised from childhood, a slave intent on destroying them both. The injustice of this petition, declared Grymes in his opening address, was that Miller had been placed in the position where a slave was forcing him to explain himself. Make no mistake, that was the practical result of this petition, Grymes told Judge Buchanan.

This woman has made wild allegations that, in effect, said to Mr. Miller: "Now that I have ruined your reputation, it is up to you to clear your name." Mr. Miller, in defending himself, has had to reach back over two decades looking for evidence of his ownership of some-

THE DEFENSE

one who had, without complaint, protest, or opposition, been his servant since 1822.

Grymes then asked Buchanan to set aside any feelings of sympathy he might have for the fond beliefs of people who have managed to see a German woman in a common slave—too much was at stake for that. Nor should His Honor be swayed by compassion for someone who might look white. The petition must be decided according to the tenets of impartial justice. Even His Honor's natural concern that the honor of the South was under attack for enslaving white people should be set aside. It was the facts that should decide this case. And the facts, declared Grymes, were emphatically on the defendant's side.

One of Grymes's junior lawyers handed him a document tied in red tape. Grymes unfolded it and held it in the air. Mr. Miller, declared Grymes, being forced to defend himself, was now in a position to do so. This document was the power of attorney executed by Anthony Williams giving Mr. Miller the right to sell a twelve-year-old slave named Bridget Wilson.

Grymes read several excerpts showing the detail of the transaction. It was dated August 13, 1822, he said, as he handed it to the sheriff to pass up to the judge. Your Honor might see that it is witnessed by two notaries. I now announce that both of these men shall give evidence in support of what that document says.

Grymes held up a second document. It was a receipt for one

hundred dollars, dated the same day, recording that Miller had paid that amount to Anthony Williams. Grymes pointed out that it was signed by both parties, and again witnessed before a well-known notary of the city. The notary would also give evidence. Grymes picked up a third document. It was the bill of sale of slaves whereby Mrs. Canby in 1834 had sold Bridget and her children, Lafayette aged

Mrs. Canby in 1834 had sold Bridget and her children, Lafayette aged five, Madison aged three, and Adeline aged fifteen months, to Mr. Miller for three hundred and fifty dollars. Grymes handed the receipt and the bill of sale to the judge. Over the next few days, said Grymes, His Honor would see the mosaic fall into place, piece by piece, showing how Mr. Miller had obtained the plaintiff. He would see a chain of ownership from Williams to Belmonti, each link beyond reproach. The plaintiff was born a slave. She is a slave, and at the end of this case, Grymes assured the court, she will remain a slave.

He announced his witness list, all people who knew Mr. Miller and were anxious to come and speak on his behalf: Mr. G. Pollock and Mr. C. Pollock, both notaries public; General Lewis; Mr. Emile Johns, the well-known composer of the city; Mr. C. Hurst, notary public; Mr. W. Turner, a respected businessman in the city; Mr. C. F. Daunoy, a well-known attorney; Mr. H. B. Stringer, a commissary of the Third Municipality. This was the calibre of the people who were prepared to speak on behalf of his client.

Grymes began by calling the man who had witnessed the power of attorney of Anthony Williams. He was Mr. George Pollock, port warden of New Orleans. Pollock's evidence was less helpful to Miller's cause than might have been expected. He recognized his signature, all right, but couldn't remember actually signing it. Nor could he remember meeting this Anthony Williams. Grymes showed him the place where a Mr. Cornelius Hurst had also witnessed the document—did he know him? Yes, of course. He was a colleague of his, and yes, that looked like his signature. Grymes handed Pollock the receipt from Anthony Williams for one hundred dollars. Did this jog his memory of Williams? No, not really. Pollock couldn't recall ever seeing that document either.

Pollock was of more assistance to the defense when asked about his recollections of Bridget Wilson. He had seen her on visits to Miller's house for a year or two before 1824, and he had watched her forming into womanhood. She was, he told the court, well developed for a twelve-year-old. He had spoken to her several times, but couldn't detect a foreign accent. He took her to be a quadroon. She would accompany Mrs. Canby wherever she went, and he saw them on occasion shopping together in the city. He and Miller were almost inseparable during those years and they regularly rode together. Miller was thought of as a man of wealth with a great many slaves. He was highly indulgent to them. And for that matter, so was his mother. She was a very kind woman, and he was personally aware that Mrs. Canby raised some orphan white girls. Miller entertained lavishly. There was so much company in the Miller household in those days that it was difficult to keep track of everyone. Pollock recalled that over the years the plaintiff had given birth to several children, the first having been born immediately after the visit of the Marquis de La-

THE DEFENSE

fayette to the city. Up to 1825, he had never heard of Miller having business interests in Attakapas.

Pollock then told the court that he had seen Bridget several times after Louis Belmonti purchased her. This was because he had a daughter at the Ursuline Convent and, when he picked her up after school, he would see Bridget standing in the doorway of Belmonti's cabaret. She was well dressed, and on the couple of times he chatted with her, she seemed content. She had never complained about her treatment, and not once had she said she shouldn't be a slave.

Pollock hadn't been the stellar witness that Upton had feared. Williams remained a ghostly figure. It was more than Upton could have hoped for, and he felt he need ask only a few questions in cross-examination. He again got Pollock to declare that he had no recollection of witnessing the power of attorney—all he could say about it was that it bore his signature. Was the slave girl present when the document was signed? Upton got the answer he was hoping for: Pollock couldn't remember that either.

On reexamination, Grymes asked Pollock if it was his practice to have slaves before him just because they were mentioned in a document. Pollock said it wasn't.

The next witness, Emile Johns, was a seller of sheet music and a book publisher, and it was his firm, E. John & Co. of Stationers Hall, New Orleans, which, in 1838, had brought out Upton's book, *The Civil Code of the State of Louisiana with Annotations.** Johns said that upon his arrival in New Orleans in 1818, Miller had engaged him as the family music master. They became friends and hardly a day passed when he didn't call in on Miller to chat. Miller had since fallen on hard times, but twenty years ago Miller had had many slaves and, in Johns' opinion, was too good a master and spoiled them. Johns first saw Sally Miller around Miller's house in 1822 or perhaps 1823. She appeared to be between ten and twelve. He took her to be a quadroon.

^{*} Johns was an interesting character. Born in Krakow, Poland, and probably educated in Vienna as well as being a printer and law-stationer, he was also an accomplished pianist and composer. He gained international fame in 1833 when several of his works were published in Paris under the title of *Album Louisianais*. He was also the Honorary Consul to Russia.

He hadn't paid much attention to her except to ask her to get a coal to light his cigar but, from what he could hear, she didn't have any sort of accent. In his hearing, she was always called Mary.

Johns also said that the first time he was aware that Miller had an interest in a plantation in Attakapas was six months ago, when Miller invited him to visit. If Miller had owned property in Attakapas between 1818 and 1825, he was sure he would have heard of it.

Upton's cross-examination was brief. He asked him if he didn't consider Sally Miller too white to be a slave.

He disagreed: I considered her a quadroon, because she had the color of a quadroon.

But you said you didn't pay much attention to her?

That's right, I didn't.

So, you didn't think about her color?

I didn't think about her at all.

So, why did you think she was a slave, when she was so white?

Because she was always among the slaves, I never thought of her other than as a slave.

Buchanan took a break for lunch. Upton freed himself from Sally Miller and her backers and hurried away to a small room adjacent to the court reserved for the legal profession. He slipped the latch on the door. He had some thinking to do. The way in which Grymes planned to conduct the defense was now apparent: like a skilled craftsman whittling away, Grymes intended to carve out a victory by calling a string of well-connected friends of Miller to say that they knew Sally when she was Mrs. Canby's servant and that in their view she was a slave. Grymes knew his judge, and he was counting on Buchanan buckling under the weight of consistent opinion from the cream of New Orleans society. Upton struggled with what he could do about this. It seemed to him that a scattergun attack on the credibility of each witness would achieve little. What he needed was a consistent approach that would allow him to ask similar questions of all Grymes's witnesses so that he could emphasize to the court his fundamental and strongest point: that they only thought her a slave because Miller had led them to believe it. After several minutes of thought, he

THE DEFENSE

jotted down a theory of the case. It was this theory that molded his cross-examination of the witnesses to come. To each of them he would put a similar series of questions: Did they agree that Miller and his mother treated Sally Miller as a slave? (Of course, they did.) And the reason they regarded Sally as a slave was because she was treated as such by Miller and his mother? (He expected them to say yes.) Well, then, he would ask, didn't that mean that *if Miller and his mother had treated her as a white person*, they would have seen her as a white person instead. (Here Upton would hold his breath, hoping for agreement.) And the culmination of his theory, which he would put to Buchanan in his final address, was that because everyone treated her as a slave, Sally Miller, a helpless orphan-child, believed it herself. Thus, the circle was complete. This was how Miller had subdued her into bondage.

The next witness, Carlisle Pollock, said he had known Miller and his mother since 1812, and had been employed as their notary. To his knowledge, Miller hadn't acquired property in Attakapas until 1837 or 1838. He also gave evidence of seeing Sally in Miller's family at about the time she was acquired by Mrs. Canby. He hadn't observed any accent in her speech. From her appearance, he thought that she was colored, a mixed blood.

But, insisted Upton, if you had seen her among whites, would you not think she was white?

Pollock paused. I can't really say. The problem is that in New Orleans there are many white people of dark complexion and many colored people with bright complexions.

But what do you say is in the features of the colored persons to denote them as such?

It's hard to put your finger on it. But you can tell the difference. People who live in countries where there are many colored persons acquire an instinctive means of judging that cannot well be explained.

Are you saying that it is instinctive? Is that how you tell?

Well, yes. In some cases, peculiar features stand up when people have black blood.

Did you see any peculiar features in the face of the white girl you

saw at Miller's sawmill that would have induced you to believe her a colored woman?

This was a question that Mr. Pollock was unwilling to answer. He avoided it by saying that he had no cause to impress her features on his recollection.

Grymes felt some repairing had to be done. He asked Pollock whether, in his experience, people who look white were often not.

Pollock readily agreed. He had seen persons whom experienced men would have taken for white, but whom he knew to be colored. There were also many colored persons in New Orleans who looked like those in white families.

With the question of color now well and truly muddied, Grymes left it at that. Pollock was the last witness for the day. Tomorrow, announced Grymes, he would start with General Lewis.

Upton by this time had accepted that it was unlikely that he would be able to show that Miller owned property in Attakapas in 1818. The evidence presented so far suggested strongly that Miller hadn't begun to purchase lands there until at least a decade later. To Upton's mind, this was but a minor blemish. He had convinced himself that ultimately it didn't matter how Miller had obtained Salomé Müller. The essential point was that, through a number of eye identifications by those who knew her, and the presence of the marks on her legs, he had sufficient proof to show that Sally Miller was Daniel Müller's daughter. Added to this was the failure of Grymes to produce Anthony Williams, or even to explain who he was. And when Grymes's own witnesses, who had supposedly signed the power of attorney, failed to remember anything about it, he and the German supporters of Sally Miller took it as an article of faith that Miller, after creating the Williams story, had forged the power of attorney, the receipt for one hundred dollars, and the signatures of the two notaries.

Meanwhile, both legal teams realized that something had to be done about identifying the marks on Sally Miller's legs. Were they burns or natural blemishes? Grymes complained to the judge that Upton's witnesses had spoken about them for days, yet no one from

his side had ever seen them, and they couldn't even be sure they existed. Upton conceded the point. The next day, before General Lewis gave evidence, he announced to Judge Buchanan that, following discussions with his opponents, agreement had been reached on how to ascertain the origin of the marks. It was proposed to have Sally inspected by a doctor and a report prepared stating their cause. Buchanan agreed to the proposed course and signed an order for the medical examination to proceed.

Yes, he was familiar with Mr. Miller, said General Lewis in response to Grymes's first question. He wasn't acquainted with Mr. Belmonti, though. He had known Mr. Miller intimately for twenty-five or twenty-six years. And the plaintiff? He had known her for about twenty years, although he had never heard her called Sally Miller. "Mary" was the only name he knew her by. He had seen her off and on over the years at Mr. Miller's house. When he first saw her she was forming into womanhood, and that was before 1824. He was able to be precise about the dates because he was chosen by the state to carry the votes to Washington for the presidential elections of 1824. When he returned in 1825, Sally was in the family way after she had started living with one of Mr. Miller's colored boys. His name was Yellow Iim, and he looked to be as white as Mary.

What was the reputation of Mr. Miller and Mrs. Canby as to how they treated their slaves? asked Grymes.

At that point, Lewis searched for the woman who was causing all the trouble. After finding her seated next to Eva Schuber, he looked carefully at her for a moment, then frowned. He returned to the question. Miller is a kind and indulgent master, he said. In fact, too much so, in my view. All his slaves were fond of him. And Mrs. Canby is one of the best, most matronly ladies I know. She is very respectable and charitable. She is welcomed in all the respectable families in New Orleans and is forever sending little presents to her friends in the city. She often visited my father. When I knew her she was still living in New Orleans and was always ready with an offer of charity whenever her services were needed. She raised many young ladies in her house; one, I remember in particular, became Mrs. Parmly.

I attended Mrs. Parmly's wedding to Mr. Parmly, a dentist in the city. I am, of course, talking about twenty years ago. Miller was rich, then. He had many slaves and a thriving business. Since then, he has become something of a recluse. His loss of fortune hit him hard.

Did you ever hear the plaintiff speaking?

Yes, frequently. She came to my father's house on errands, delivering things from Mrs. Canby. And when Mrs. Canby visited, she would often come with her. She was Mrs. Canby's companion.

How did she speak? Was there anything unusual in her speech?

Not at all. I have no recollection of her speaking with any accent other than that of a colored American servant. There was nothing unusual about the way she spoke.

But she was treated as a slave?

Well, she was, but she was also treated as a favorite. Because of her light complexion, I suppose. Everyone who came to the house treated her well.

Even you? You treated her as a colored girl?

I hadn't the least suspicion that she was other than a colored girl, until this court action was brought. Just a few days ago, when I called in to observe this hearing, I spoke to the plaintiff and she told me that she had discovered she was white.

What was your reaction to that?

I was surprised; until then, I had also thought her colored. She also said to me that she was sorry she was obliged to bring the suit.

After Grymes had concluded his examination, Judge Buchanan asked several questions of Lewis. When he had seen her in the latter part of 1823, or 1824, could he positively say that she was over ten?

But Lewis wouldn't be led. No, he really couldn't say how old she was. Her breasts were formed, or forming, but the girl might have been precocious for her age. He found it impossible to exactly state her age.

But, I take it you thought her colored?

That's right. As I said, I had no suspicion that she was anything other than a slave. If she had been considered white, it would never have been permitted that she live as the wife of a colored boy. I, for one, wouldn't have countenanced a connection of that kind, either then or now, had I known of it.

It was Upton's turn. Isn't it the case that you had no reason to believe that the girl was a slave other than the fact that she was in Miller's family as a slave, and treated as such?

Lewis considered his answer for some time. Yes, I would agree with

Upton had struck gold. He continued to mine it: And if you look at her now, sir, is there anything in her appearance that would lead you to believe her colored?

For a second time Lewis looked long at the plaintiff. She is as white as most persons, he replied. But then, he added, but then, I have seen slaves as light a color as she.

Lewis appeared dissatisfied with his answer and was about to say something more, but stopped himself. Upton waited for him to continue. Lewis shook his head. No, that was all.

One brick at a time, Grymes attempted to wall Sally Miller in. After Lewis had departed, he called two further witnesses to give weight of numbers to evidence already presented. Charles F. Daunoy, attorney at law, said he rode regularly with Miller in 1822, 1823, and 1824. He had met the plaintiff many times and it had never come into his mind that she was German. She looked a quadroon to him, and she spoke much as did other servants around the house. He never knew the girl by any other name than Mary.

Mrs. Kopman was a friend of Mrs. Canby and for several years had lived with her. She recalled that the first time she had seen Mary Miller was in 1825. Mary had been scrubbing the front steps of Mrs. Canby's house. Mrs. Kopman thought she looked about fifteen or sixteen, and she was pregnant. A few months later she had given birth to a boy. Mrs. Kopman said that she had many conversations with Mary. She had no German accent. Once, Mary had told her she was of the Indian breed and had been brought here by a Negro trader from over the lake.

Mrs. Kopman's evidence that Mary had said that she had come from "over the lake" was later seized upon by both sides as confirming their account of how she came to be in Louisiana. To the Germans, it was a faint memory of the voyage across the Atlantic; to those on Miller's side, it was a recall of sailing through the Gulf islands from Mobile to New Orleans. It was a case of more evidence resolving nothing.

On the other hand, the allegation that Mary had said she was "of the Indian breed" wasn't taken up by either party as being of significance. Indian descent didn't guarantee freedom. The first slaves in Louisiana (as in the rest of colonial America) were Native Americans, not Africans, and although both the Spanish and the American authorities passed laws prohibiting the enslavement of Indians, those already in slavery, and their descendants, weren't released. Descendants of Indian slaves, and Indian-African slaves, continued to be held in Louisiana, right up until the Civil War. ¹⁰⁵

Before proceedings got under way after the luncheon adjournment, General Lewis stood up and announced to Buchanan that he wanted to add to his evidence. Everyone in the courtroom looked at him in surprise, but no one stopped him when he strode to the witness stand. There was a lull of curious expectation as Mr. Gilmore swore him in. Yes, what is it, General? asked Buchanan. All craned forward to hear him speak. What he wanted to add, he said in a soft, clear voice, was that the other day, as Mrs. Schuber was giving evidence, he had been struck by a remarkable resemblance between her and Sally Miller. Then, a little later he had seen another young woman, a member of the Müller family, sitting next to Sally. Again, he was struck by the resemblance. It had caused him to think. Perhaps he was wrong about his earlier evidence. He had always thought the plaintiff had something resembling the colored race in her features, but he might have been induced to that belief by the fact that he had always seen her associating with persons of color.

There was a deep silence in the room as the judge, counsel and spectators took in what Lewis had said. Miller's own witness had turned against him!

That was all I wanted to add, said Lewis.

Grymes half rose from his chair, ready to insist on the right of examination, but then he paused. What would a cross-examination of Lewis achieve? Lewis was not a man to be broken down by artful questions, and Grymes had no doubt that he had wrestled long with his conscience before deciding he must give further evidence. Grymes resumed his seat, and in a showy display of contempt waved his hand

in dismissal of Lewis's evidence. I have no questions for this man, he said.

Judge Buchanan frowned for a moment, then thanked the witness. The general stood up and, carefully avoiding eye contact with anyone, strode through the hushed courtroom and out the door.

Lewis's evidence was a dramatic moment of betrayal of Miller's cause. The man who had been his friend for a quarter century, the man in whose evidence he had set most store, had let him down. Miller sat in the court stunned by what he had heard. He looked across at those supporting Sally Miller and saw them whispering to each other. Some glanced towards him, gauging his reaction. He would give them nothing. He averted his eyes and looked directly ahead.

To Upton, it was the breakthrough he had been praying for and a vindication of his theory of the case. From that moment on, all of his doubts vanished. Even hidebound, conservative, prejudiced Buchanan must now see that Sally was white. Perhaps Grymes might argue that Lewis's opinion of Sally Miller's whiteness carried no more weight than anyone else's, but Lewis wasn't just anyone else, and the lawyers on both sides knew it. General Lewis was one of New Orleans's most distinguished citizens. His father, the late Joshua Lewis, had been a judge for the Superior Court of the Territory of Orleans. Buchanan would have known the family well.

However, Grymes wasn't done yet and his next witness was to be as damaging as any he had previously called.

Mr. Joachim Kohn was a shopkeeper who ran a dry goods store in Chartres Street. He had a clear recollection that almost twenty years ago, one of his regular customers was Mrs. Canby, who would arrive in a carriage accompanied by a slave girl called Bridget.

Grymes asked him how Mrs. Canby treated Bridget. As a servant, he said. She treated the girl kindly, but as a servant. In my view, she was a quadroon.

Kohn said that he had plenty of opportunity to hear Bridget speak, because sometimes she would come by herself carrying messages from Mrs. Canby about what she had to purchase. There was nothing Dutch or German in her appearance, or in her accent; if there had been, he, being German himself, would decidedly have observed it.

And, inquired Grymes, what was her color like, compared to some of Miller's other slaves?

It was a question designed to inject a tincture of black blood into Sally Miller's veins, and shopkeeper Kohn was prepared to assist. Miller had several servants who were whiter than that girl, he replied. One of them Miller owned even up to the present day.

Upton tried the same approach with Kohn as he had with every other defense witness. It was true, wasn't it, that his only reason for believing Sally to be a quadroon was because she was treated as a slave? Amazingly, Kohn agreed. Upton then challenged him on the assertion that Miller was holding another slave even whiter than Sally Miller. It's true, maintained Kohn. I've met him, and his name is John Pickett and he lives with Miller in Attakapas.

So little did each side trust the other that two doctors were required to inspect the marks on Sally Miller's legs. The plaintiff chose Dr. Warren Stone, who was professor of surgery at the University of Louisiana; Miller chose the equally distinguished Dr. Armand Mercier, a graduate of the College of Louis le Grand in France. Both were somewhat overqualified for the simple task they were being asked to perform—in the words of the court order, "to examine the moles or marks upon the thighs of the plaintiff and to report in writing to the court on or before the 11th June on the nature, appearance and cause of the same." The inspection, the parties agreed, would take place in a room above the courtroom on June 4.

Meanwhile, the defense case ground on, Grymes calling witness after witness, each confirming the other: they hadn't seen Mary Miller in Miller's possession earlier than 1822; no one had heard her speak with a German accent; she had never complained about being a slave; as far as they knew, Miller never owned land in Attakapas earlier than 1830.

The other witness to the power of attorney, Cornelius Hurst, gave evidence. He recognized his own signature, but he had no recollection of this particular document. Nor did he recall anything about Anthony Williams. But then, it was over twenty years ago.

William Turner said that he had been Miller's partner for three years, between 1834 and 1837. He now ran a rival sawmill down on

the levee. Turner said he had run into Sally Miller about eight or nine months ago, wandering below the French Quarter, in the Faubourg Marigny, and had asked her what she was doing there. She had told him that she was a free white woman. That had somewhat surprised Mr. Turner, because when he had met her in 1834, she had called herself Mary Brigger, from the name of the colored boy she was living with, and had several slave children underfoot.

Another witness, Mr. H. B. Stringer, a commissary of the Third Municipality, said he had lived for almost two years with Miller, from 1834 to 1836. Seeing that she was so very white, he had once asked Mary where she was from. She had replied that she came to the country young, and believed she came from Georgia, or Mobile in Alabama. Stringer said he had no doubt that she was a slave—he had only asked her the question because her light color had excited his sympathy.

After rejecting Sally Miller's request to be a witness for her, Daphne Crawford appeared in court to give testimony on Miller's side. The laws of Louisiana, although allowing free men and women of color to give evidence, required that on the court record they be designated as f.m.c. or f.w.c.*, the intention being to warn juries and judges not to give their testimony the same weight as the word of a white person. Madame Crawford recounted how, during the summer of 1822, Miller had paid her to nurse a little girl named Bridget who was suffering from yellow fever. Bridget had told her that a man had brought her to New Orleans from Mobile.

Upton asked the witness about Bridget's color.

She was no fairer than me, said Crawford. When she had the yellow fever she looked white, but when she recovered she was darker.

She looked like a white person?

I never thought Bridget was anything but a mulatto.

It wasn't the answer Upton wanted. He persisted. But when you first saw her, what did she look like?

She looked sunburned, but when she recovered from the yellow fever, she looked no clearer than I do. She looked dark.

Opinions of this sort needed rebutting and Upton found, of all people, a slave trader to do it. Mr. A. Piernas had acted as the broker

^{*} That is, free man of color or free woman of color.

for Belmonti in purchasing Mary from Miller in 1838. Although the defense hadn't completed its evidence, Buchanan allowed Upton to interpose Piernas's testimony. Piernas told the court that Belmonti had commissioned him to approach Miller to see if he would sell Mary. He said he had always known that Mary was Miller's slave, but he had an opinion of his own.

And what was that? Upton asked.

She didn't look like a colored person to me. I know my slaves, and I never observed anything in her face which resembled the African race.

To which, Grymes asked only one question: That is a mere opinion of yours, isn't it, and not based on any fact you can bring to this court? Piernas agreed that was the case.

Belatedly, and as his final witness, Grymes produced someone who was able to bring Anthony Williams into the proceedings, although, it must be said, not in a totally convincing way. William Johnson said that he was crippled during the war against the British, but in 1823, when he was still working as a carpenter, he had placed orders for timber at Miller's sawmill. He saw the plaintiff there and he thought she was about twelve or thirteen. She spoke English fluently enough. One day he asked her where she had come from, and she told him Mobile. She had been brought to New Orleans by Mr. Williams, who had sold her to Mr. Miller.

Upton's cross-examination hardly helped his cause. He challenged Johnson on his recall that Sally Miller had ever mentioned Williams to him, only to have Johnson repeat the claim, and then add that she had mentioned it to him many times. Upton asked him if Sally spoke with an accent, only to be told that he never knew Miller to have had a Dutch girl in his family. If he'd had one, he would have known about it, he said. He knew all Miller's house servants. There was another one called Mary—a tall quadroon girl, just as fair as the plaintiff and with hair just as straight.

So, the case drew to a close. Grymes announced that he had no further witnesses. There was only one more piece of evidence, and that was the doctors' report.

On the following Tuesday, Sally Miller, escorted by Eva Schuber, presented herself at the old Presbytere building. The two women followed the sheriff up the stairs, through the crush of lawyers and litigants, past the courtroom that was now so familiar to them, to steps that led to the third floor. They waited nervously on a bench for half an hour until Drs Stone and Mercier arrived. Sally was immediately beckoned inside one of the rooms. Eva was told to stay where she was.

The next day, Upton received a message from the clerk of court that the doctors' report had been filed. Did he want to look at it? Upton hurried to the courthouse. With a broad smile on his face, Mr. Gilmore handed the report to Upton and watched as the lawyer untied the tape around the cover sheet. Upton read it quickly. It couldn't have been better. The doctors had written:

We, the undersigned . . . did, on the 4th June, proceed to a room situate above the court, examine the said Sally Miller and did find:

- 1. On the middle of the internal part of the left thigh, a mark of the size of a lentil, of an irregular form, of a brown color, and presenting on its surface three small nipples of a deeper color, with strong and black hair.
- 2. About the superior third of the right thigh, a mark presenting a slight prominence on the skin, of the size of a coffee bean, of an oval form, being composed entirely of small protuberances of about the same dimensions of a blackish color, in one word, resembling a blackberry.

Conclusion

- 1. These marks ought to be considered as Navi materni.
- 2. They are congenital, or in other words, the person was born with them.
- 3. There is no process by means of which artificial spots bearing all the characters of these marks, can be produced.

New Orleans, 4th June, 1844. Mercier, D.P. W. Stone, M.D.

When Eva Schuber came to Upton's office the next day, he showed her what the doctors had written. It can't be challenged, he assured her. Grymes and Miller had to accept that the moles had been with Sally from birth. It was very good news. The case was almost over. The evidence was all in. He would present his final arguments on Tuesday, Grymes would reply, and then it was finished. They had done their best. Then it would be up to Judge Buchanan.

Not quite. Eva said that she had another witness for him. She went outside and ushered a middle-aged man into the room. She introduced Upton to the son of Locksmith Müller, a cousin of Salomé Müller. A farmer, Upton judged from his appearance. He now lived in Mississippi, she said, but just by chance he was in New Orleans for a few days. His name was Daniel Müller. Eva's two sons had taken Daniel to meet Sally Miller at her lodgings in Lafayette only the previous night and he had recognized his cousin the moment he had set eyes on her. He had to give evidence, she said firmly. He could talk about the moles as well.

Upton explained the difficulties. The testimony part of the case had ended and Grymes would be sure to oppose any attempt to enter further evidence. It would then be up to Buchanan, and he might not allow it. But he could try, couldn't he? Well, it depended on what Daniel had to say. Was his evidence worth the effort?

Upton spent several minutes talking to Daniel Müller. He seemed smart enough and he was convinced that the woman he had seen the previous evening was his cousin. Perhaps his evidence might help if Buchanan was still undecided. Anyway, it couldn't hurt. Upton told Eva to bring Daniel along when the hearing resumed and he would see what he could do.

Upton spent the next few days preparing his final address. As he read over what he had written, he became even more convinced that victory must be theirs. It wouldn't matter if Buchanan refused to hear Daniel Müller. He was sure that they had made their case as it was.

As Buchanan took the bench, Upton readied himself to ask for leave to introduce Daniel Müller's evidence, but in a moment of hesitation,

the opportunity was lost. Grymes was on his feet. Upton was surprised to hear that it was his opponent who wanted to reopen. He had some vital, important, new evidence, which must be heard if justice was to be done. Grymes handed Buchanan a deposition from John Fitz Miller. He explained that it had been composed only that morning as a matter of utmost urgency. Of course, he had a copy for his opponent, and with a gracious bow, he placed it in Upton's fingers. It was half a page in length, written in Miller's hand and in evident haste. Since his counsel had "announced the closing of the evidence," Miller had written, he "had discovered that the first child of the plaintiff was baptised and a record of it exists." Annexed to the affidavit was an extract of the Register of Baptism from the St. Louis Cathedral of New Orleans. 106 It was in French. As Upton struggled to understand what it said, he had his ear cocked, listening to Grymes explain that a Mrs. Labarre, the godmother to the baby, was waiting to give evidence, if His Honor so allowed. Grymes turned to point to an elderly, colored woman sitting on a bench behind him.

Upton looked at the document in confusion. Where was this leading? Grymes guided Buchanan through the contents of the extract. It showed that within the archives of the church could be found a record of the baptism of a boy named Jean, to a mother named Marie, a quadroon enslaved to John Miller. The godmother was, as Grymes had suggested, Rosalie Labarre, and the godfather was someone called Célestin Médecin. The child was born on December 29, 1825, and the baptism took place on May 9, 1826.

Perhaps so, but it still made no sense to Upton. What did it have to do with the case? Who was Marie? Who was Jean? The vital paragraph of the certificate read:

L'an 1826 et le 9 de Mai a été baptisé Jean, né le 29 Décembre 1825, fils naturel de Marie, quarteronne, esclave John Miller, le parrain a été Célestin Médecin et la marraine Rosalie Labarre.

Presumably, Grymes would argue that "Marie, quarteronne, esclave John Miller" was Mary Miller. Her child, according to this, was Jean.

Buchanan was also puzzled. Grymes assured him that Madame Labarre would explain all. It would only take a few minutes, and she

was ready to take the stand. Upton objected, his main point being that evidence coming from a public record, as this obviously was, should have been found by the defendants earlier and presented before they closed their case. Even as he spoke, he could see it was a lost cause. Buchanan wanted to know more about this cryptic new document that Grymes thought was so important.

Madame Labarre was noted in the court record as being a free woman of color. Under Grymes's guidance, she told the court that in 1825 she lived in the area in the front of Miller's sawmill. She knew Mary Miller very well. She was made the godmother of Mary Miller's child during a baptism at the St. Louis Cathedral. The godfather was Célestin Médecin. He now lived in Mexico.

Grymes asked her to explain who Jean was. The explanation was simple. Jean was Lafayette. The *vicaire* of the cathedral had said he couldn't be baptized Lafayette, unless they had the general's permission, and of course they couldn't get that, so he had to be Jean.

This was all Grymes had to ask. He thanked her and turned to Upton for his cross-examination.

Even as he was getting to his feet, Upton began to realize the implication of this woman's evidence and it horrified him. He paused, his mind racing in several directions at once. He needed time to think. Looking up at Buchanan, he asked for a short adjournment. He needed to consider what Grymes had sprung upon him. Buchanan, now beginning to appreciate where Grymes had led the case, agreed.

Upton sat at the bar table, took a deep breath, then counted the years off on his fingers. There was no getting away from it. If Madame Labarre's evidence was allowed to stand, Sally Miller had given birth to Lafayette at around the age of ten.

Upton instantly understood the dreadful problems his case now faced. A succession of his own witnesses had sworn that Salomé Müller was either two or three when she arrived in New Orleans in March 1818. His chief witness, Eva Schuber, had claimed she was aged two years and three months when she left Alsace in the spring of 1817. This made her ten when she had Yellow Jim's child and perhaps nine when he was conceived.

He knew that Grymes would claim that, as a matter of accepted biological knowledge, it was most unlikely that a child of such tender

years would be capable of giving birth—unless she had black blood in her veins; it being a matter of common knowledge in the South that Negro women were much more sexually precocious than white women. Wasn't it everyone's experience that slave girls had babies while they were still children themselves? The heat of Africa had made women fertile at an earlier age.

Grymes would then point out that Miller's witnesses had said that Sally Miller was twelve when Anthony Williams left her with Miller in August 1822, making her fifteen when Lafayette was born. Surely, this was the more likely scenario. The only logical conclusion to draw from the disparities in their ages was that Salomé Müller and Sally Miller were not the same person.

Upton took Sally into the corridor outside the courtroom. Well, was it true? he asked. No, it wasn't, she replied. Lafayette was born much later than 1825. She couldn't say when, but it was much later. He was never called Jean. The midwife at Lafayette's birth was Madame Bertrand and she would confirm what she was saying. She would know when Lafayette was born, because she kept a book of all the births she attended.

Well, what about the baptism? Upton asked. She had never been to any baptism for Lafayette, she replied. She knew nothing about him being baptized. Upton examined his copy of the certificate. There was nothing to suggest that either she or Yellow Jim had been present. He recalled Rosalie Labarre's evidence—she hadn't claimed that the parents had been there. This didn't surprise him. In Louisiana, a master might well arrange for slave children to be baptized without the knowledge of their parents. A baptism, in addition to its religious significance, had the secondary and important purpose of creating a record of ownership on a document of impeccable authority.

When the court resumed, Upton began his cross-examination of Rosalie Labarre. He asked her why she had been chosen as the god-mother of Lafayette. She didn't know; perhaps it was because she lived closest to the sawmill. Upton suggested that she had given evidence against Sally Miller because she bore her ill will. This, she denied. She was a friend and still was. Never had she quarreled with

her. He asked her how old Mary was when she gave birth to Lafayette. Madame Labarre replied that she was about thirteen. How could she be sure? Because she was there when the child was born. And so was Mrs. Canby. Another woman, whose name she didn't know, was also present. Upton asked her if she knew who the father was. It was Jim Miller, she said. Had she seen any marks on the legs of Mary Miller while the baby was being born? No, she hadn't.

Upton sat down. He realized that he hadn't greatly diminished Madame Labarre's evidence but he could think of nothing more to ask her.

Grymes then proposed that the extract of the record of the baptism of Lafayette Miller be accepted into the court record. Upton objected, but Buchanan received it anyway.

Grymes had only one question of Madame Labarre in reexamination. He asked her to look at the woman seated next to Mr. Upton. Could she be sure she was the same person she knew as Mary Miller?

Madame Labarre looked at Sally Miller. Yes, she said, it was the same person.

Miller later wrote in glee of the devastation that Madame Labarre's evidence had inflicted on his opponents:

And how they stood aghast when having closed their evidence, they discovered the testimony I had in store,—testimony they could neither refute nor deny—by which I proved, if Sally Miller was Salomé Müller, the child of the cold and backward climate of Germany, had under the genial sun of Louisiana, ripened into a mother at ten years of age. Here was the horn of a dilemma, and Sally did gore them Yankees, negroes, Dutch and all.¹⁰⁷

Suddenly, the issue of the date when Lafayette was born had become pivotal to the case. If Buchanan believed that Sally Miller had given birth to a child when she was ten, Upton felt sure he would rule against her. It became imperative that he challenge Madame Labarre's evidence. He stood before the court to ask that he be given time to

combat these latest revelations. Judge Buchanan was reluctant. As far as he could see, the case had dragged on too long already. The plaintiff's lawyers should have anticipated that evidence about her age would be important, and prepared on that basis. Upton launched into an emotional protest. This new piece of evidence was produced at the very heel of the hunt. He had been ambushed. He should have been forewarned. How could His Honor make a just decision when doubt remained about who the baptismal certificate related to? How could anyone be sure that the "Marie" in the certificate was the plaintiff? How could it be assumed that the "Jean" in the certificate was her son? When Mrs. Canby sold Bridget and her children to Miller in 1834 the bill of sale stated that Lafayette was five, and so born in 1829. Now Miller wanted to contradict his own documents and say he was born in 1825.

Eva Schuber and Sally Miller, seated next to each other in the body of the court, heard the anxiety in Upton's voice as he struggled to persuade Buchanan to allow him time to bring further evidence. They listened to the arguments go back and forth, barely understanding what was happening. It seemed unthinkable to them that, on the last day of the trial, after everything had been going so well, they were suddenly in danger of losing.

Upton could see that Buchanan was wavering. He told the judge that his client believed that the midwife at Lafayette's birth was Madame Bertrand. This woman lived in the Faubourg Marigny, not far distant. A summons could be issued and she could be in court this very afternoon. She would know when the child was born.

His words wore Buchanan down. The judge prepared a summons directing that Madame Bertrand attend at the court after lunch. Sheriff Lewis was sent off to serve the summons on her. With that small victory accomplished, Upton then pressed Buchanan for another. He wanted to present one final witness. The judge glowered at him.

Daniel Müller told the court that he was ten when he came to America. He was now aged thirty-six, and his father, Henry, was the uncle of Salomé Müller. They all came on the same vessel. Salomé was about three years old.

Do you recognize anyone in the courtroom who traveled to America at the same time? asked Upton.

I recognize several, he replied. I recognize Mrs. Schuber and two others. I recognize Mistress Schultzeheimer and Madame Koelhoffer. He pointed to each of them. And I recognize the woman there. She is Salomé Müller.

Are you sure she is the same person you knew in Germany?

There is no doubt in my mind that she is the same person. My parents' house was only three hundred yards from her parents' house in Langensoultzbach. I knew her from the day she was born and I saw her every day while we lived in Alsace.

Upton asked about the moles. Daniel Müller replied that he had never seen them himself, but he had heard his father, mother, brothers, and sisters all say that she had the marks. They were on the inside of each of her thighs. They were natural marks, and she was born with them. His father had always said that he would find his two lost nieces from the marks on Salomé. His father had often spoken of Dorothea and Salomé, and when Daniel was twelve, his father had spent a month searching for them in Natchez. Even after that, his father continued to ask all the Germans he came across if they had heard about Daniel Müller or his children. In 1824, his father was back in Bayou Sara and he met a man driving cattle who told him that there were two girls named Miller living in Attakapas. His father began to make preparations for a journey there, but he died before he could set off. That was in May 1824.

Grymes asked Daniel why he had formed the opinion that the plaintiff was the same person as Salomé Müller. The witness counted off the reasons. First, because of her resemblance to the family, particularly to her mother. Second, on the say-so of his relations that they believe her to be the same. Third, because of the marks.

Upton couldn't resist a reexamination. Daniel Müller was by far the most impressive of all those he had called.

You saw the plaintiff just a few days ago?

Yes.

How were you able to identify the plaintiff after so many years?

Her features were impressed upon my memory. She looked exactly like my sister, and when I saw Salomé Müller, I recognized her

immediately. Her features were just as they were in 1818. They were distinctly impressed upon my memory. She is Salomé.

It was a dream answer.

When the parties assembled in Buchanan's court after lunch, Madame Bertrand wasn't there. A shamefaced Deputy Sheriff Lewis informed the judge that although he had delivered the summons, she had refused to come with him. She was indisposed, she had said. It was a lady's reason. He hadn't asked for more details. He could hardly force her to attend, could he?

It took all of Upton's persuasive powers to convince Buchanan that he should be given another chance. After all, argued Upton, there was so much doubt about Madame Labarre's testimony. Hadn't she said that although she was present at the birth of Lafayette, she hadn't seen any marks on the mother's legs? This meant it couldn't have been the plaintiff. And hadn't one of Miller's own witnesses, William Johnson, only a few days ago told the court that Miller had another house slave named Mary? The Marie in the baptismal certificate could well have been her. The solution, he urged, was to permit Madame Bertrand's evidence to be taken on commission, at her house, if need be. That way, Madame Bertrand would be able to say conclusively when Lafayette was born.

Buchanan eventually agreed. Not that he intended to take the evidence himself. He appointed the recorder of the court, Mr. Lewis, or if he was unavailable, Associate Judge Bright, to go to Madame Bertrand's house early the following morning. If all went according to plan, a deposition of her testimony would be available when the court resumed at eleven the next day. Buchanan handed a copy of the commission to Upton and told him to make the arrangements.

The court then rose. It was three in the afternoon and Upton, after escaping from the anxious concerns of Sally Miller and Eva Schuber, hastened to the judges' chambers in search of a commissioner. Immediately, he ran into difficulties. Recorder Lewis refused to act, saying that he was otherwise engaged, and Associate Judge Bright was nowhere to be found. Frantically, Upton searched through the courts and offices of the Presbytere, but no one seemed to know where

Bright was. He decided to travel to the judge's house in Faubourg Marigny and wait for him there. It was almost dark when Bright arrived. The judge invited Upton inside and listened carefully as he explained what Buchanan had ordered. Upton showed him the copy of the commission. With little attempt to disguise his irritation, Bright finally agreed to be at Madame Bertrand's house the following morning. Upton then left the judge's house. He still had much to do.

In a document, now held in a Louisiana archive, Upton gave his version of what happened next:

Madame Bertrand was to be notified, and Mr. Grymes, Mr. Canon and Mr. Micou—all this was done by me in person after dark, and certainly some diligence was necessary, and was given, to this part of the proceedings. Madame Bertrand lives far down in the Third Municipality, Mr. Grymes has his office in Exchange Place, Mr. Canon in the lower part of the First Municipality, and Mr. Micou resides in Carondelet Street. The next morning I rose earlier than usual and proceeded at once to the house of Madame Bertrand. I found her awaiting the arrival of the Commissioner [Associate Judge Bright]. I conversed with her for half an hour; I might have arrived there a little before the hour named; I was certainly there at the hour, and for a considerable time after—for so long a time after, as to lead me to the conclusion that some mistake had been made about the hour, and that the Commissioner would not come. Under this belief I left. Neither the Commissioner nor either of the opposite counsel had appeared. On my way to my office I met my colleague, Mr. Roselius, in Royal Street, and stated to him my disappointment in not being able to obtain the testimony of Madame Bertrand, and urged his attendance at Court punctually at eleven o'clock, in order to take such steps as should secure her testimony to the Plaintiff. I repeated to Mr. Roselius the substance of the conversation I had had with Madame Bertrand, and he left me with the remark, "that unquestionably the Judge would order her attendance at Court; at all events we must not think of going to trial without her." I stated in this conversation that Madame Bertrand had told me that the first child of the plaintiff was born, as she believed, in

1827 or 1828. That she (said Madame Bertrand) was, with Mrs. Canby, the only persons present at the birth—that she, Madame Bertrand, acted as the *accoucheuse* at said birth. If indeed Madame Bertrand will state this, it will go far to remove, nay it will, in point of fact, at once wholly and completely remove *the only* shade of doubt that in any way hangs over the Plaintiff's cause. ¹⁰⁸

Upton begged Roselius to return to the case, if only to bring his authority to a plea that Buchanan must allow them another chance to secure Madame Bertrand's evidence. Roselius said he would be there.

When Roselius arrived at the courthouse at eleven o'clock, he found Upton, Grymes, and Micou in the midst of a heated argument in the hallway. They were blaming each other for the failure to obtain Madame Bertrand's testimony. Upton swore that he had arranged with Bright for them to meet at seven o'clock and that was the time he had told everyone. No, no, insisted Grymes and Micou, he had told them to be there at seven-thirty. Grymes and Micou turned to Roselius. It was entirely Upton's fault, they said. He had muddled up the time and had left early.

When Buchanan took the bench, the squabble continued before him. Miller, who had also risen early that morning, hurriedly wrote out an affidavit, stating that Mr. Micou had told him to attend at Madame Bertrand's house at half past seven. He had waited with Mr. Grymes and Mr. Micou until "at least eight o'clock... the time as shown by three watches worn by the gentlemen who were present." Grymes handed Miller's affidavit to the judge. The blame clearly lay on the plaintiff's side, Grymes suggested. The court had already overreached itself in indulging Mr. Upton as he attempted to patch up his case, he said. Grymes urged Buchanan to resist any further attempts to obtain Madame Bertrand's evidence. The legal costs were mounting each time Mr. Upton led the court on a wild goose chase. The case should now proceed to its finality.

Roselius stood to address the court, but Buchanan motioned him to remain silent. Instead, he sent the clerk of courts to Associate Judge Bright's chambers. Buchanan said he expected that the judge would report on the outcome of his commission even if no evidence

had been taken. They would wait to read what he had to say. Buchanan remained on the bench, his head down, moving his quill across a page. Upton watched him, convinced that Buchanan was already writing his judgment. Roselius picked up the notes of a trial in the Supreme Court he was appearing in later that day. Grymes sat with his hands clasped in his lap, his eyes closed in quiet repose. Behind the lawyers the court was almost empty. Sally and Eva, as always, sat together, whispering to each other. Miller paced at the back of the room.

After ten minutes, Mr. Gilmore returned with Bright's report and handed it to Buchanan. The judge scanned it quickly, then read it out to the parties. Bright was in no doubt that he had fixed the time of the commission for seven-thirty. When he had arrived, "within ten minutes of the time fixed," he was "informed by Madame Bertrand that Mr. Upton had been there and left a few minutes before." 110

Did Mr. Roselius want to say anything about the matter? asked Buchanan. Roselius did. It did look as though the fault may lie with his colleague, but given the haste and pressure under which Mr. Upton had labored last night to arrange the commission, the confusion over the time was forgivable. But really, the failings of Mr. Upton weren't the issue. The *real* issue was justice, and its likely miscarriage if this critical piece of evidence wasn't received. The fate of the plaintiff shouldn't be jeopardized by a mistake of her counsel. Too much was at stake for that. The possibility that a white person might be doomed to eternal bondage was more than enough reason for the court to allow more time.

Buchanan gave Roselius's submission little consideration. There would be no continuance. As far as he could see, the negligence was attributable to Mr. Upton in not awaiting the attendance of Associate Judge Bright. It was up to the plaintiff and her legal advisers to have their evidence ready, and if they failed to do so, the court wouldn't wait on their convenience. The record was complete. The court would delay no more. Judge Buchanan ordered the lawyers to proceed immediately to final argument.

Upton went first. He confronted the issue of Sally Miller's supposed immorality head-on. Strictly, it had nothing to do with the case, but no one believed that. A fragment of Upton's address appears among the court archives. "However polluted and degraded her person may have been," he told the court, "her friends seem to be bound to her as it were by very hooks of steel." Her "moral power, and weight, and influence" were as ." . . inconsistent with the nature of an African, as it would be with the nature of a Yahoo" (the italics are Upton's). He continued:

The Quartronne is idle, reckless and extravagant, this woman is industrious, careful and prudent—the Quartronne is fond of dress, or finery and display—this woman is neat in her person, simple in her array, and with no ornament upon her, not even a ring on her fingers. Ask her friends if, since they have discovered her claims to freedom, since she has been made aware of her rights, if in any instance or in any particular she has departed from the strict proprieties which belong to the pure and good of her sex, and they will tell you, No! They will tell you that she has in all ways and in all things comported herself as well become the rights and station she claims.¹¹¹

Upton then listed for Buchanan the points that went to prove that she was a free white woman. There was the firsthand identification by her relatives. No less than seven people had come forward to say they recognized Sally Miller as Salomé Müller, and an eighth, the late Madame Carl Rouff, who, if she hadn't passed away, would have told about discovering her in Louis Belmonti's cabaret and bringing her to the safety of her godmother's house. There could be no uncertainty in the face of such testimony. Then there were the moles. He read out the opinion of Drs. Stone and Mercier, lingering over the words *navi materni* and the conclusion that there was no process by which artificial marks could be produced. Next, Upton pointed out that Miller had plenty of opportunity to take a helpless girl as a slave and hide her in his mill or one of his houses in New Orleans or Attakapas. He gave special emphasis to the evidence of Madame Poigneau and Mr. Wood, who had said they heard Sally Miller speak with a German accent, not

forgetting that Miller's own brother-in-law, Nathan W. Wheeler, had said he had seen Sally in the yard of the mill in 1819 or 1820. Finally, he highlighted the failure of his opponents to produce Anthony Williams—a glaring omission, he said. Even the notaries who were claimed to have witnessed the documents bearing Williams' signature couldn't remember him.

Upton dismissed the fuss about Sally's age as a diversion sprung at the last minute by a defense team knowing it faced defeat and desperate to try any trick to divert the court from the essential fact that Sally was a white woman. Her appearance betrayed no trace of African blood. All Buchanan needed to do was look at her to see that. Even some of Miller's own witnesses had confessed that the only reason they regarded Sally as a slave was because Miller had treated her as one. And the poor, unfortunate girl had believed it herself. This was how Miller had enslaved her.

As Upton concluded his address, he looked up at Buchanan, searching his face for a favorable sign. Had he said enough? He found it impossible to know what the judge was thinking. Even as Buchanan was getting ready to call on Grymes, Upton decided to have one last go. It was such a strong case, he said, that it would be tragic if the absence of Madame Bertrand's evidence should decide the issue. Buchanan smiled and said that the point had been made already. He well remembered what Mr. Roselius had said on that subject. But now it was time to allow Mr. Grymes to speak.

Grymes concentrated on disparaging the evidence of the German witnesses. It was impossible, he told Buchanan, that a court would believe that people could remember an infant after a quarter of a century. Everything pointed to the fact that the plaintiff was using the gullibility of the anxious family of Salomé Müller in an attempt to gain an ill-deserved advantage for herself. There were many examples in literature and history of impostors duping relatives and friends—Perkin Warbeck, the scoundrel who was recognized by Edward IV's sister as a pretender to the throne; Martin Guerre, who fooled a whole village; and the two Dromio brothers, who looked exactly alike and served two identical brothers. Grymes dismissed the German witnesses' memory of the moles as fantastic, and contrasted the quiet respectability of the people who had appeared for his client.

It was their sober recollection that the plaintiff was a slave. He pointed out that it was Mrs. Schuber's evidence that the plaintiff was about three when she arrived in New Orleans in 1818. This meant that the plaintiff had her first child when she was ten. No white woman would have allowed herself to become as degraded as this. Could she truly be, as was claimed, a pure white person? Common sense said no! She had no memory of her childhood and no hint of a foreign language in her speech. She had never claimed her freedom until corrupted by her meddling supporters. On the other hand, a succession of Mr. Miller's witnesses had sworn that the girl they saw at his house in 1822 and 1823 was much older. Twelve or thirteen. There was an obvious mismatch between the ages of the lost German girl and Miller's slave. They could not be one and the same. The evidence abundantly established that the woman now sitting in the court was an impostor. She could not possibly be Salomé Müller.

Buchanan heard him out, then thanked both Mr. Upton and Mr. Grymes for their assistance. He knew that the parties regarded it as an important matter, so he would write his judgment as soon as he could. He stood, everyone in the court rose with him, he bowed to those in the court and left the bench.

Upton remained slumped in his chair at the bar table. His arms hung either side of the chair. He felt too empty to be tired.

BLBVBN

JUDGMENT

In no part of this country, whether North or South, East or West, does the free negro stand erect and on a platform of equality with the white man. He does, and must necessarily feel this degradation. To him there is but little in prospect but a life of poverty, of depression, or ignorance, and of decay. He lives amongst us without motive and without hope. His fancied freedom is all a delusion. All practical men must admit, that the slave who receives the care and protection of a tolerable master is superior in comfort to the free negro.

Judge Lumpkin of the Georgia Supreme Court, 1853¹¹²

ate on Saturday July 22, 1844, Sheriff Lewis descended the stairs from the courts in the Presbytere and pinned a paper on the notice board. Among the usual staple of theft, defamation and debt was Sally Miller v. Louis Belmonti and John F. Miller, listed for judgment on the following Tuesday. A few idlers sauntered over to have a look. Within hours the news had spread through the French Quarter. Mr. Wagner, in his dry goods store in Chartres Street, was told by one of his customers, and after confirming the listing with his own eyes, he hurried to tell Mr. Eimer at his business in Customhouse Street. Together they went to inform Mr. Grabau, standing behind the counter of his apothecary shop, then the three of them walked to Exchange Place to advise Upton. He welcomed them into his office, but said he already knew—Mr. Gilmore from the court had sent a message earlier in the day. It meant that Buchanan had written his opinion in less than two weeks, and as Upton served his guests coffee, they fretted over what it meant. Mr. Wagner, who had sat through the case on more days than

JUDGMENT

most, thought that Buchanan, being convinced that Sally Miller was a white person, had decided that she must be freed as soon as possible. Mr. Eimer wasn't so sure. If only they hadn't been gypped at the last moment by that business with the baptismal certificate. What a pity Madame Bertrand couldn't tell Buchanan what she knew. Upton agreed and apologized for mixing up the time they were to meet to obtain her evidence. It wasn't his fault, they said. They shouldn't have left it all to him. Mr. Grabau asked Upton if he thought they would win. They could only wait, said Upton diplomatically, but then added that he remained hopeful. Upton's visitors shook his hand as they departed and thanked him for his assistance. He had done all that he could—whatever the result might be.

After they left, Upton wrote to Eva Schuber informing her of the news. He said he was leaving it to her to contact all who should know, and in particular to make sure that Sally Miller attended. Although he didn't mention the possibility, he had it at the back of his mind that if they lost, Sally was required to submit to capture to answer the thousand-dollar bond the German community had posted for her.

Like almost every issue that fed the city's imagination, opinions on the outcome of the case were divided, and largely on ethnic grounds. The Americans were stoutly behind Miller. It was a preposterous story—just the sort of thing the ill-educated German immigrants might believe. Many of them knew Miller; true, he was a difficult character, but they couldn't accept that he would enslave a young white girl. And as for the kindly Mrs. Canby being involved, well, that was just impossible. The lower classes of the city, particularly the Germans and the Irish, being of immigrant stock, were natural backers of Sally Miller, while the Creoles were willing to believe that the Americans were capable of anything if there was money in it. Support for Sally Miller among the *gens de couleur libre* was lukewarm—convinced, as they were, that there was only a fuss being made because of her pretensions that she was German.

Buchanan delivered his judgment on Tuesday, June 25, 1844. It was a day of dripping heat, overhung with the certainty of an afternoon thunderstorm. Heat rose in waves from the sidewalks, and the air was

thick to breathe. Horses hitched to carriages beside the Place d'Armes flicked flies with their tails from one to the other, while their drivers retreated under the shade of trees. Men going about their business in the city streets slipped loose their collars but still found themselves drenched with perspiration well before they had reached their destination. Women preparing to brave the heat wore loose-flowing muslin and insisted that their servants walk beside them, angling an umbrella to shield them from the sun.

At the Presbytere, a crowd gathered early, anxious to secure a place by the time Buchanan took the bench. As soon as the doors opened, a sharp-elbowed crowd filed up the stairs and into the courtroom. Shortly before the hour of eleven o'clock, the gentlemen of the press, lawyers, and the litigants arrived. Sally Miller and Eva Schuber took their usual place behind Upton. A year had passed, almost to the day, from when Sally had run away from Belmonti, and she must have wondered if this would be her last day of freedom. At the other end of the table, Grymes, Micou, and Cannon chatted about their next case and the latest doings at the bar. Miller entered the courtroom and sat by himself behind Grymes. He looked fixedly ahead. As usual, Belmonti hadn't bothered to attend. The temperature in the courtroom began to rise. The windows were opened, but it made no difference—there was no breeze to be had.

When, exactly on the hour, Buchanan appeared, he held several sheets of paper scored in his own hand. During the past days he had been through several drafts. He had altered words, crossed out paragraphs, added lines, consulted his notes, and written it out again. But throughout, not once had he wavered in the certainty of what his decision would ultimately be. With head bowed, he commenced to read:

The Plaintiff alleges that she is wrongfully held in slavery by the Defendant; that she is free and white; that she was born of Bavarian parents, who emigrated to this place about the year 1817, the Plaintiff being then about three years of age; that she with the rest of her family, consisting of her father, a brother and a sister, were sold or bound to service as Redemptioners, to one John F. Miller, who took them to Attakapas; that her father

JUDGMENT

having died, Mr. Miller kept the petitioner as his slave, and sold her as such to the Defendant.

Buchanan turned a page. He was, he said, satisfied that a person named Sally or Salomé Müller had arrived in New Orleans in March 1818 with her father and it may be safely assumed, from all the testimony, that she was not more than three years of age.

The evidence goes to show that Daniel Müller and his family went up to Attakapas... within a few weeks after their arrival, in the service of some person: but who that person was, is not shown. One very important fact is however shown to my entire satisfaction by the evidence, which is that it could not have been John F. Miller, the warrantor, who bought the services of the German family in question.

At this Upton felt a sinking feeling in his stomach, but then he consoled himself that all was not lost—yet. It was still open to Buchanan to rule that although it wasn't known how she became a slave, there was sufficient evidence to show that she was Salomé Müller.

Buchanan continued:

At this point, we lost sight of the little German child. . . . She is supposed to have been rediscovered, some twenty-five years afterwards in the person of a slave of the Defendant, living below New Orleans. The supposed identity is based upon two circumstances. First a striking resemblance of the Plaintiff to the child above mentioned, and to the family of that child. Second, two certain marks, or moles, on the insides of the thighs, (one on each thigh,) which marks are similar in the child and the woman. This resemblance and these marks are proved by several Witnesses. Are they sufficient to justify me in declaring the Plaintiff to be identical with the German child in question?

There he paused, but did not look up. "I answer this question in the negative."

A low sigh escaped from the people sitting behind Upton as the significance of Buchanan's words sunk in. Then, multiple soft whispers translated the judge's words into German. Buchanan, in a flat, controlled voice, continued. He listed five reasons why he couldn't accept that the plaintiff was a free German woman. First, there was nothing to show that the child of Daniel Müller wasn't still existing in Attakapas. Second, the ages of the two individuals didn't correspond. Third, Sally Miller had told various witnesses that she had come from Mobile, or across the sea, or from Georgia, or was of Indian parents-all explanations totally at variance with the origin claimed for her. Fourth, there was "no trace in her appearance, or language, of a German origin, as there would have been, if she had arrived here in 1818 of an age to speak plainly, and speaking plainly the German tongue, as proved by Mrs. Schuber." And finally, "the Plaintiff is proved to have been brought to bed of a child in 1825, which is inconsistent with the supposition of her having been only three years of age in 1818."

Judge Buchanan continued to read from his notes:

I must admit that the family of the Redemptioners seem to be firmly convinced of the identity which the Plaintiff claims. Their convictions, however sincere, are no reasons for declaring the Plaintiff free, in the face of many cogent presumptions to the contrary . . . it is quite out of the question to take away a man's property upon grounds of this sort.

Now Buchanan, for the first time, directed his gaze at the German people staring blankly back at him.

I would suggest that the friends of the Plaintiff, if honestly convinced of the justice of her pretensions, should make some effort to settle à l'amiable with Mr. Belmonti who has honestly and fairly paid his money for her. They would doubtless find him well disposed to part on reasonable terms, with a slave from whom he can scarcely expect any service, after what has passed. 113

With that, Buchanan handed counsel copies of what he had just read to them and left the bench.

JUDGMENT

Buchanan's judgment was crushing in its certainty. Miller had won. The suit was dismissed with costs. Sally Miller, the white slave, was still a slave. Upton looked across at her. No flicker of emotion showed on her face. The German people had heard, but they didn't move. Eva Schuber slumped in dismay in her chair.

Miller strode to the bar table and stumbled through a speech of gratitude as he pumped Grymes's hand up and down. Then he turned to congratulate Cannon and Micou. The four of them packed their bags and departed, Grymes pausing for a moment at the door of the court, to wish Upton good morning. They didn't even bother to take their prize with them. She was now Belmonti's property and he wasn't in court to collect her. Sally Miller sat alone, staring into some middle distance of her thoughts, as her supporters crowded around Upton, demanding to know what had gone wrong. How could the judge rule that she was a slave? Why hadn't he believed them? What about the proof of the moles? Hadn't they told him how certain they were that she was Daniel Müller's child?

Upton, shaking with emotion, stood up. Never had there been such an injustice, he declared to those crowding around him. He was just as astounded as they were, but what could you expect from someone like Buchanan? He turned and strode down the stairs and out into the Place d'Armes, Eva Schuber keeping pace with him as best she could, picking up pieces of paper flying from his bag, as if they still mattered.

The next day, Upton called Eva and Sally to his office and told them that the fight wasn't over yet. He would ask for a new trial, and if that failed, he would appeal to the Supreme Court.

The two women told him that Sally had moved back into the Schuber house. She would be safer there. Eva vowed that if Belmonti came looking for her, she and her husband would fight him to the death. Upton said he hadn't heard from Belmonti's lawyers about reclaiming Sally, but he guessed that it would only be a matter of time. Sally asked if Belmonti could take her at any moment. Upton conceded that it was possible. He was sorry, but legally she was Belmonti's property again. Hopefully, not for long. That was why it was important to quickly lodge the paperwork for a new trial. He would do that

tomorrow. Once the motion was filed, the bond would continue, so she would be safe again. But he needed grounds. This is what he wanted to talk to them about. They must search again for someone who knew Sally during those vital few years when she was first made a slave of Miller. They must look for additional witnesses.

After they had departed, Upton began to write out the motion for a new trial. Under Louisiana law, the judge who had heard the case had a judicial discretion to order a new trial if good grounds—cette revision, said the French side of the Code—were shown. The usual cause was that some vital new information had been discovered that could not, with due diligence, have been previously obtained. The emphasis was on the new—a remake of old evidence wouldn't do, nor additional evidence piled on to support a point already made. 114

Upton was now totally convinced of the justice of his client's cause. He may have been prepared to admit to himself that when he first agreed to appear for Sally Miller, he had an eye to furthering his own career by the publicity the case was bound to bring, but he had moved far beyond that. He was now emotionally bound to her fate. Her life so far had been one of perpetual misfortune, and he was determined to do all he could to give her a fresh start. It was all very well for Buchanan to announce that she was a slave because he could find no trace of her German origins, but given the horror of her life why wouldn't her memories be obliterated? Her mother, her father, and her brother had died one after another before her eyes. Then her elder sister had disappeared without a trace. She had been scarified into subjection at the hands of Miller. Given one name after another. Her children taken from her. Had Buchanan no perception of what it must have been like for her?

New trials were hardly ever granted, and there was no reason to think that the motion to be filed on behalf of Sally Miller would be the exception—but that didn't stop Upton. As he sat down to reread Buchanan's judgment, he boiled at the injustice of it. The point the German community regarded as decisive, the moles on Sally Miller's thighs, had been briefly referred to, but then, without any judicial explanation, had been totally ignored. Buchanan hadn't bothered to explain why he had so offhandedly dismissed the claims by Sally

JUDGMENT

Miller's relatives and friends that they could recognize her. Miller's failure to produce Williams wasn't referred to. The admissions made by General Lewis, that he saw a resemblance between Sally Miller and members of her family, wasn't mentioned. Nor was Wheeler's evidence of having seen Sally in Miller's yard in 1819 or 1820.

Upton's greatest irritation, however, was directed at a particular

paragraph that Buchanan had written:

I am guided altogether, by the numerous and respectable witnesses of the defendant, and ... put out of view the evidence of Poigneau and Wood, witnesses of the plaintiff as being entitled to no credit, from the contradictions and absurdities which they contain, and the irreconcilable variances from the evidence of all the witnesses of the defendant.

To this, Upton wrote:

It seems to me that Madame Poigneau would be the very person who would be most apt to know the facts of which she speaks. She was a poor white woman, often in the yard of Miller with his servants, lived in the immediate neighborhood and saw much of the plaintiff. Wood saw much of her also; he was of that class and standing at the time, and in such employ about the house, as to give him far better opportunity of knowing the girl than had the family music master, the seamstress, or the haberdasher.

He added: "The distinction being drawn was that the plaintiff's witnesses were second table, while the defendant's witnesses live in the parlor, and the parlor witnesses were more credible." ¹¹⁵

The new evidence that Upton required was supplied by Nathan W. Wheeler, the impoverished disgruntled brother-in-law of John Fitz Miller, who visitedUpton's office later that day. Since appearing in court, he had remembered something else: Miller had another slave girl, named Bridget. She was about Sally Miller's age, but consider-

ably darker. Miller owned her for several years from about 1822, and then she had died. This second Bridget was in addition to Mrs. Canby's cook, also known as Bridget.

Wheeler and Johnson between them had placed two Marys and three Bridgets in Miller's household. As Upton thought further on the matter, it occurred to him that these slaves, bearing the same name, gave Miller plenty of opportunities to switch Salomé's identity. Was it possible, he wondered, that when one of them had died, Mrs. Canby and Miller, by forcing Salomé to alter her name, had passed her off as the deceased? Then, as the years passed, in order to cover their tracks, they had confirmed her new identity on sale notes and, ultimately, her name and that of her child on the baptismal certificate?

But in this puzzle, nothing fell easily into place. If Miller had captured Salomé Müller soon after the death of her father, how and where had he kept her—and perhaps her elder sister as well—until he subjugated their wills and had them believing they were slaves? He would have required a place isolated from prying eyes. If Miller had property in Attakapas at the time when Sally was lost, none of his friends or business associates knew of it, and investigations by Sally's backers hadn't been able to discover it. The sawmill? It didn't seem feasible. Although it was surrounded by a wooden fence and located at the edge of the city, traders and employees were coming and going all the time. Where else, then? Miller owned several houses, one in the American quarter and, later on, one in the Faubourg Marigny. But witnesses had spoken of constant visitors and grand parties at both of those houses.

But if Miller was capable of swapping Salomé Müller for a dead slave, what else was he capable of? It then occurred to Upton that the explanation of how it had been possible for Miller and his mother to hold a German child without anyone noticing her had been evident for some time—if only he had possessed the wit to see it. He could have kicked himself for not thinking of it earlier. Eva Schuber had led him into the error of believing that Salomé Müller had been held captive in the boggy swamps of Attakapas. But all along, had she been in Mrs. Canby's care in New Orleans? An act of charity had disguised a great evil. A number of the witnesses had praised Mrs. Canby for looking after orphan girls from the Ursuline Convent. No doubt

JUDGMENT

some of the girls were orphans, but was it possible that Daniel Müller's daughters had been concealed among them? Visitors, if they took any notice of her at all, would have assumed that the nuns had left her there. It was the perfect hiding place.

It was a grand theory, the difficulty being that Upton had only fragmentary evidence to sustain it.

The next day, Sally returned to Upton's office with the news that she had another witness for him, not in the flesh, but he could be had with a few days' notice from a sugar estate near Bayou Plaquemine. His name was Fribee. (His first name doesn't appear in any of the court documents.) Fribee had told her that when he was working as an engineer in Miller's sawmill he could recall Sally speaking with a German accent. Jubilantly, Upton wrote down the details. Along with Madame Poigneau and Mr. Wood, Upton now had three witnesses saying they recalled a girl with a German accent in Mrs. Canby's service.

The next day Sally brought him Peter Curran, a tugboat pilot who lived at the Balize, at the very mouth of the Mississippi. His evidence was to the effect that Belmonti had told him that, a few weeks after purchasing Mary Miller, she was so troublesome that he had demanded of Miller that he take her back. Miller had told Belmonti that she was a white woman and was only to be kept a slave by kindness and coaxing. Belmonti was extremely dissatisfied with this conversation and had declared to Curran that if he had a pistol, he would have shot Miller. Upton regarded what Curran had to say as important because it backed up Eva Schuber's testimony.

Then Nathan Wheeler returned to bring Upton something further. He had been thinking about things, and it was now his recollection that the date of Lafayette's birth was 1827 or 1828. This was what Upton wanted to hear. So, quite ignoring Wheeler's sworn evidence during the trial that Lafayette was born in 1825, and the obvious concern that Wheeler hated Miller because of his failed marriage with Miller's sister, Upton included the new information in the motion for a new trial. Upton attributed Wheeler's lapse of memory to "the excitement of his testimony in open court."

Upton wrote the motion for a new trail with the furious speed of an angry man and had it completed by June 27, a mere two days after Buchanan had delivered his judgment. He included the evidence of Fribee and Curran (which wasn't new in the legal sense because it merely confirmed what other witnesses had said) and an affidavit from Wheeler (which was astonishingly new because it contradicted what he had said on oath). He also launched into a long complaint that Madame Bertrand's evidence hadn't been heard, adding that the plaintiff's rights shouldn't be "hazarded upon the ten minutes variance of a town clock." He offered to pay for the costs of a new trial if the "negligence be really attributable" to him. After he had written the accompanying commentary, he had a document of fourteen pages. Much of its ink was spent in being offensive to Buchanan:

The Judge of this Hon. Court does not preside here as if his bench were of no higher dignity than a stand upon the Metairie Race Course, and he but to decide which jockey brought in his horse first to the winning-post by the head or the length . . . The judge here, and in such a case as this, has his own great responsibility to answer—he has his own conscience to satisfy—he has the true justice and merits of the case to pass upon, and give judgment according to his own sense of right and wrong. ¹¹⁷

Judge Buchanan's suggestion that the friends of Sally Miller might purchase her from Belmonti was rebuffed by Upton in contemptuous indignation. It was "a piece of advice, which does infinite credit to that cool indifference to feeling which is so excellent an attributer of the judge. History hands down to us the name of a Roman counsel who was equally successful in throwing aside all human weakness."

This, presumably, was a reference to Pontius Pilate.

So it goes on, trumpeting, repetitive advocacy, peppered with poetry and garnished with insults. Upton quoted from Shakespeare, Byron, and a lengthy passage from Sir Walter Scott's *The Abbott*. In case Buchanan thought there wasn't a lot in common to be found in the adventures of noblemen in the Scottish highlands and a slave in Louisiana, Upton explained:

JUDGMENT

The author makes the Lord of Morton discover this resemblance of a son to his father, and that father not having been seen by Morton for nearly twenty years. And is there anything in this unnatural or improbable? On the contrary, we find it true and truthful—it is strange to be sure, but "truth is strange, and stranger than fiction." I doubt much if Mrs. Hemm ever read Walter Scott, but Walter Scott read such people as Mrs. Hemm.¹¹⁸

He had Sally Miller come to his office to sign the motion—not with her mark, as she had a year earlier, but with a full signature.

Upton then appeared before Judge Buchanan and laboriously read through the fourteen pages of his motion, while the judge fumed. After inflicting romantic novelists upon him and comparing him to Pontius Pilate, Upton asked him to grant a new trial. In reply, Grymes read out an excerpt from a decision of the English Kings Bench deploring the practice of losing parties demanding a second hearing when they hadn't prepared properly in the first place. He trusted there was no necessity for him to spend too much of the court's time on this particular motion, he said, before adding unctuously that His Honor would know what do with it. He then sat down.

Motion denied, growled Buchanan. Upton, following the script, stood up and announced that there would be an appeal to the Supreme Court.

I never doubted that for a moment, replied Buchanan.

THE APPEAL

The slave, to remain a slave, must be made sensible, that there is no appeal from his master; that his power is in no instance, usurped; but is conferred by the laws of man at least, if not by the law of God.

Judge Ruffin of North Carolina, 1829¹¹⁹

Miller was again liable to be taken by Belmonti, so Upton undertook to have the bond renewed to secure her freedom pending the appeal. Upton's abuse of Buchanan might have brought pleasure to himself and joy to Sally's adherents, but seemingly he was unaware that it was Buchanan who would set the amount of the bond to secure Sally's freedom pending the appeal. Roselius went along with Upton to shield his junior from the ire of the judge. Although the bond for the trial was set at one thousand dollars, Buchanan doubled it to two thousand dollars for the appeal, justified on the basis that, now that he had found that she was rightfully a slave, she had a much greater incentive to run away.*

Once again, Eva Schuber knocked on doors seeking sureties. It was harder this time. Hadn't the court ruled that Sally Miller wasn't a German? That was enough for many to lose faith. If she was let free

^{*} The Louisiana Code of Practice gave Buchanan plenty of scope. Article 576, apparently dealing with slaves and fruit in the one paragraph, read: "If the judgment [appealed against] decree the delivery of a slave or some moveable of a perishable nature, the court shall require surety to an amount exceeding by one half the estimate value of such slave or moveable."

on a bond, she would be sure to run away like all slaves do when they are afraid. Once again, Mr. Wagner, Mr. Eimer and Mr. Grabau kept the faith. Mr. Serda, Mr. Fischer, and Mr. Frendenthal remained loyal. Eva collected coins from German people in the timber houses in the streets of lower Lafayette. It took her several days, but eventually she gathered in enough to go to the sheriff's office and install her husband as the bondsman.

A few weeks later, Upton met Mr. Eimer outside his shop. Eimer said he wouldn't be able to support Sally Miller for the next few months. Not that he had lost faith in her—in fact, he was more convinced than ever that she was German. It was just that he had promised his wife that they would return to their homeland at least once in their lifetime. They had been in America for thirty years and it couldn't be put off any longer. But there was one thing he would do for Sally. He would journey to Langensoultzbach and search for the birth certificate of Salomé Müller. He would be back by October. Would that be too late? Upton assured him that it wouldn't. The way cases were backed up in the Supreme Court, it was more likely the appeal wouldn't be heard until the following year.

This proved to be the case, and those involved in the litigation returned to the business of living. Sally left her lodgings with the Schubers and moved across the city to the Faubourg Marigny where, according to Mrs. Canby, she lived with a "person whom she now claims as her husband."120 Whether this is true, or Mrs. Canby intended to create the whiff of scandal, is, from this stretch of time, impossible to say. During the autumn, Roselius, while still attending to his law practice, stood as a Whig candidate to the State Convention and was duly elected. Upton, who had hoped to achieve fame by freeing Sally Miller, had instead achieved notoriety for confirming her as a slave, and there was still no clamor of clients at his door. From time to time, in the courts of the city, he ran into Miller, the perpetual litigant, fending off claims from his creditors. Grymes, appearing in all the great cases of the day, continued to acquire a fortune with every word he uttered, and to lose it with just as much grace at the city's gaming tables.

In October 1844, the Eimers returned from Europe. When their ship docked in New Orleans, Mr. Eimer left his wife to cope with the luggage and, taking a black attaché case with him, hurried through the streets of the city directly to Upton's office. He brushed aside Upton's secretary, and upon opening the office door, found the lawyer at his desk. Without a word, he pulled several sheets of paper from his case and placed them on top of the book Upton had been reading.

Upton picked them up. He was looking at documents written in French. As he picked through the words, Eimer, with a broad smile on his face, watched. Slowly, Upton worked out that he was reading an extract from the register of the births of the parish of Langensoultzbach. In the margin he saw, under the Royal Seal of France, the name of Salomé Müller.

The mystery is solved, whispered Eimer.

Upton continued to make his way through unfamiliar words. The child's name was Salomé Müller; that he could make out. Her father was Daniel Müller, aged thirty-two years, shoemaker. Her mother was Dorothea. There followed a declaration by the recorder of births and deaths that a child of the female sex was born in legitimate wedlock on the tenth day of the month of July 1813 at 10 a.m. The record had been made at 2 p.m. on the very same day, at the mayor's office.

Upton let the paper fall from his hands. He immediately understood what Eimer meant. It was astounding. Every one of the German witnesses had been wrong. She hadn't been two, or even three, when she arrived in New Orleans—she was almost five. This meant that she wasn't nine or ten in 1825, when Lafayette was born, but twelve and a half. His mind raced ahead. Two of the reasons Buchanan gave for rejecting Sally Miller's petition were invalidated. The ages of Bridget and Sally did roughly correspond. It was feasible for her to have given birth to Lafayette in 1825. After all the worry, after all the mistakes they had made, after the disappointment of Buchanan's decision, here at last was the answer. He jumped up and hugged the small man across the table. They did a little jig. They decided to tell Roselius. Eimer placed the precious birth certificate back in his attaché case and the two men hurried down the stairs and

through the Vieux Carré to Roselius's office in Customhouse Street. Suddenly a victory in the appeal seemed possible.

Still, things weren't that straightforward. Even as Upton hastened to Roselius's office, he began to realize that the birth certificate brought with it as many problems as it solved.

Just as Eimer had done to him, he placed the document into Roselius's hands without any introductory words. Roselius read it quickly, then a wry smile played on his lips. We'll have some explaining to do, won't we now? he said.

The birth certificate had turned the plaintiff's case inside out. There was no longer any need to show that Lafayette was several years younger—the birth certificate had made his mother several years older. There was no longer any need to attack Madame Labarre's evidence, or to endeavor to put Madame Bertrand on the witness stand. Wheeler's recollection that Lafayette was born in 1828 no longer mattered. Now "Marie" could be Mary and "Jean" could be Lafayette. Even General Lewis could be right when he said that Mary Miller was forming breasts in 1823.

But even as the birth certificate made the plaintiff's case simpler, it had made the presentation of the appeal more difficult. The doubt about the disparity in the ages between Salomé Müller and Bridget Wilson may well have been resolved, but what would the Appeals Bench think when it emerged that the German witnesses had made Sally Miller younger than she really was? Surely, Salomé Müller's devoted godmother would have known how old she was? Grymes would be on hand to suggest that this was no mistake. On the contrary, it was proof of a well-orchestrated chorus of witnesses, conducted by Eva Schuber, intent on deceiving Buchanan. And the motivation for the lies was obvious enough: making the plaintiff several years younger explained why she remembered nothing of her parents and the voyage to America. But the problems brought by Mr. Eimer's birth certificate went farther than that. If the German witnesses couldn't be trusted to say how old the plaintiff was, what did that make of their claims that they could recognize her after twenty-five years? And if Eva Schuber and the others could be so wrong about her age, why should they be believed when they said that Salomé Müller was born with moles on her thighs?

When Upton met Eva a week or two later, he asked her how she had become so confused about her goddaughter's age. She replied that she hadn't done it deliberately, if that's what he was thinking. She was only eleven when she became Sally's godmother and she had simply remembered the wrong year. It was such a long time ago and so much had happened since. Upton wondered about her answer, but he let the matter rest.

Given the public interest in the outcome of the appeal, all five judges of the Supreme Court of Louisiana sat to hear the arguments. Although the legislation creating the court didn't create a position of chief judge, that title, by convention and courtesy, was bestowed on the most senior appointment, and that person, by at least thirty years, was François-Xavier Martin. He had been a judge for twenty-nine years and chief judge since 1836. He was a jurist of national fame and, despite his advanced years (he was eighty-three), his mind was as sharp as any of the other judges who sat with him. He was also totally blind.

Martin's eyesight began to fail him when he was in his seventies. Most men would have seen this as a reason for retiring, but not so Martin. When he was no longer capable of writing opinions, he dictated them to an amanuensis; or when none was available, he placed guides at the edge of each page so that he would know when to move his hand down to commence writing a fresh line. In 1844 he returned to his native France, hoping to find a cure for his blindness by consulting the best oculists in Paris, but none was prepared to operate on him, save one who promised too much, and Martin distrusted miracles. He returned to New Orleans, resigned to spending the remainder of his life in darkness.

The law was his passion and, according to his contemporaries, he had no other interests. He was a lifelong bachelor and attributed his good health to his abstemious habits. Despite being French, he claimed never to have tasted wine until he was in his sixties, and then "in great moderation." Music, literature, and games were of no interest to him. He was notorious for his unsociability, slovenly dress and closeness with money. His interests were solely intellectual, and his pleasures, such as they were, lay in discussing fine points of law

with colleagues. His scholarly output was prestigious. He created the first set of law reports in the state of Louisiana and edited the first twenty volumes. He compiled several law books in French and English. He wrote the history of Louisiana, followed up by a history of North Carolina.

For all of Martin's industry, the court he presided over was held in derision by most in New Orleans—and with good cause. Following the economic crisis of 1837, claimants flooded to the Supreme Court seeking redress from their financial woes, only to be entangled in a system that was slow, costly, and highly technical. Within months, a large backlog of cases clogged the lists, but Martin ignored the problem. He was derided as conducting a "talking court," and litigants were accustomed to hearing inane points of law argued between judges and attorneys for hours. Without a glimmer of humor, Martin turned proceedings into an intellectual battlefield. He was merciless on counsel and seemed to take delight in making them appear foolish. He sat for only five hours a day, three days a week, claiming it was that essential he have private time for research and the writing of opinions. It wasn't unusual for only one case to be heard in the three allocated days. One disgruntled lawyer calculated that at the rate Martin's court was disposing of matters, newly issued suits wouldn't be heard for thirteen and a half years. 122

Martin saw no reason for change and showed every intention of remaining chief judge while he still had the strength to breathe. He paid great attention to the minutiae of the law but none to procedures. Judges appointed to clear the backlog resigned in frustration at the impossibility of having Martin introduce reform. Matters became farcical when, for a period in 1839, every other judge abandoned their appointment, leaving Martin alone on the bench. Two more were appointed, but within months they also departed. So low was the salary of a Supreme Court judge that few competent lawyers would accept an appointment unless they had independent wealth, and even then they might hesitate to work under Martin's idiosyncratic rule. Eventually, another four were recruited: Henry Adams Bullard, Alonzo Morphy, Edward Simon, and Rice Garland. With the possible exception of Bullard, a native of Massachusetts and a Harvard graduate, they weren't from the top rank of lawyers in the state.

These were the men who sat with Martin in 1845 when the Sally Miller appeal was argued. It had been jumped through a bloated caselist, presumably because of its notoriety and the adverse publicity it was bringing Louisiana.

Upton spent many hours over many days worrying about what he would say to the court. He wrote draft after draft analyzing Buchanan's decision, then listing the multiple errors he thought the judge had made, but he remained disappointed in what he had composed. It was too harping, too ill-tempered. He had identified no overwhelming point that would secure victory. He made further alterations, he changed the order of things, he cut out paragraphs, but still he remained dissatisfied. It was to be the most important speech of his legal career and he had to get it right. He read the notes of the evidence of the trial again and for the first time saw all the mistakes that had been made in presenting the plaintiff's case. Some by him. Some by others. It should never have been alleged that Miller had land in Attakapas in 1818, before it was known for certain that he did. That had been Sigur's mistake. His own mistake had been to bungle the arrangement for the taking of Madame Bertrand's evidence-although, if they could get the Appeals Bench to accept the birth certificate from Langensoultzbach, this would be repaired. His second mistake had been not to realize the significance of Sally Miller's age until it was too late. He could never excuse himself for that. However, Eva Schuber had made the biggest mistake. If, as Upton suspected, in her zeal to make Sally Miller free, she had lied about her goddaughter's age and had convinced others to do the same, it was these falsehoods that had led Buchanan to rule that Salomé Müller and Sally Miller couldn't be the same person.

Upton wondered if there had ever been a case similar to Sally Miller's decided in Louisiana. He had never heard of such an instance. Still, one never knew. He spent the next two days in the library of the Supreme Court sifting through the court's judgments since its creation thirty years earlier. There was nothing there about white people being taken as slaves. He wasn't surprised. Since it was universally accepted that whites couldn't be slaves, there would be no

need to litigate the matter. He then moved to the records of the old Territorial Court, which had existed prior to Louisiana becoming a state in its own right. On the afternoon of the second day, in a room overlit by the westerly sun, he came across the case of *Adelle v. Beauregard*. At first he could see nothing in the report that might assist and was about to set it aside. It didn't concern a white person, but a mulatto slave, a young girl who had run away from her master. It was also decided in 1810, two years before Louisiana became the eighteenth state of the Union, and on that account might be thought to carry little weight. But it was only a few pages long, so he read on, and as he did so an unsteady argument began to form in his mind.

The case concerned Adelle, a young mulatto. Her master, Monsieur Beauregard, a wealthy plantation owner, had brought her with him from the West Indies to New Orleans. Adelle was treated with particular consideration, taught the ways of a lady, and, when she became old enough, was sent to a boarding school in New York. Seemingly a New York education changed Adelle, because upon her return, she was no longer the dutiful servant who had left Beauregard's house several years earlier. After tolerating his rule for just a few months, she fled and immediately brought a suit for freedom in the Territorial Court. At the trial, Adelle's lawyer challenged Beauregard to show that she was his slave. This Beauregard failed to do—possibly because he didn't want to admit that he was her father. Instead, his lawyer relied on the argument that because Adelle was colored, Beauregard wasn't required to provide proof. The color of her skin meant that it could be assumed that she was a slave. If she wanted to be set at liberty, it was up to her to show that she was born free or that at some time in her life she had been emancipated. The Superior Court of the Territory of Orleans decided in Adelle's favor. In the course of its decision, a distinction was made between the status of pure Africans and those of mixed blood:

... negroes brought to this country being generally slave, their descendants may perhaps fairly be presumed to have continued so, till they show the contrary. Persons of color may have descended from Indians on both sides, from a white parent, or mulatto parents in possession of their freedom. Considering how

much probability there is in favor of the liberty of those persons, they ought not to be deprived of it upon mere presumption, more especially as the right of holding them in slavery, if it exists, is in most instances, capable of being satisfactorily proved.¹²³

It was this paragraph that seized Upton's attention. The court had accepted that colored persons, as distinct from full-blood Africans, were free unless those claiming them showed them to be slaves. But Sally Miller wasn't colored. She looked white. How much stronger must be the assumption of freedom for her? Could it be argued, he wondered, that on the basis of *Adelle v. Beauregard*, if the court, after considering all the evidence, remained unsure if Sally Miller was a slave, then it must free her.

But Adelle v. Beauregard had its difficulties. It had been decided in 1810, at a time when judges were still moved by the spirit of freedom enshrined in the Declaration of Independence and ennobled by the sacrifices of the American Revolution. Judges in those times were apt to pick up their pen and, after quoting Jefferson, Franklin, and Adams, declare for the proposition that all men were created equal and that there was a presumption toward freedom regardless of skin color. 124 However, as Upton appreciated, in recent years judges in the South had pulled back from the belief that the presumption of freedom could apply to those held in slavery. If slavery was good for slaves (as many Southerners held), it was illogical for the courts to lean toward freeing them. Instead, judges in many states took their lead from the stream of laws passed by state legislators, increasing the regulation of slaves, facilitating the capture of fugitives, and sanctioning the imprisonment of any blacks unable to prove themselves free laws that were the very antithesis of freedom. 125 The question now troubling Upton was whether the Supreme Court of Louisiana would regard Adelle v. Beauregard as sound law. He wondered which of the territorial judges had written it. The note preceding the report said it was delivered "By the Court," probably meaning that it was a unanimous opinion. Was it possible that Martin was a member of the bench? It was delivered in the fall term of 1810. Surely Martin wasn't a judge then? He flicked to the front of the volume and found an announcement that, following the death of Judge Thompson, Martin

had been commissioned a judge on March 21, 1810. Upton looked at the date in amazement. It meant that almost certainly, thirty-five years earlier, Martin, as a junior judge, had joined in freeing Adelle. Upton felt a quivering in his stomach as he realized the implications of the case he held in his hands. Could he possibly hope that Martin's court would be prepared to hold firm to the view that colored people, like white citizens of the United States, were presumed to be free?

But for the presumption of freedom to be applied, there must be doubt. Upton could see that. This made it even more important that the new evidence of the German birth certificate be proffered to the court.

The appeal to the Supreme Court of Louisiana commenced on May 21, 1845. It was almost a year since Buchanan had made his decision. The fate of Sally Miller had become a talking point in much of the South and was also beginning to be followed by Northern newspapers, which wrote it up as an intriguing case of a poor immigrant attempting to free herself from the horrors of slavery. People in New Orleans reckoned it to be the premier legal battle of the year, particularly since that master of Southern oratory, John Randolph Grymes, was to appear.

On the morning of the appeal, an overflow audience queued early outside the Cabildo. As soon as the doors opened, they rushed inside to gain a seat. Newspaper scribes took their place along the side wall. In the front row of the public gallery, in a place Upton had reserved, sat Sally Miller, defiantly showing her whiteness for all to see, while next to her was Eva Schuber, willing and praying for the judges to make it so.

The same legal team appeared: Christian Roselius, Wheelock S. Upton and Francis H. Upton for the plaintiff; John R. Grymes and W. Micou for Miller; and E. A. Cannon for Belmonti. Despite all of its disadvantages, Upton had convinced Roselius that the birth certificate should be made part of their case. He doubted that they could succeed without it. But there lay another uncertainty. Under Louisiana law, an appeal wasn't an opportunity to run the case for a second

time and new evidence wasn't usually admitted. The normal process was for the judges of the Supreme Court to read the notes of the previous trial and then hear written and oral arguments from opposing counsel on whether a different verdict should be entered. The first obstacle to be faced was in having the Appeals Bench even look at the birth certificate.

The task of inducing the bench to take up the birth certificate fell to Roselius. Although he had none of the persuasive powers of Grymes, he had the advantage of being one of the few counsel at the New Orleans bar who was the intellectual equal of the chief judge, and Martin respected him for that. Roselius was a short, powerfully built man with a rough-hewn face much as you might expect from a Dutch farmer, but there was nothing rustic in the matters he discussed. He was able to pick up a volume of law in Latin and, without hesitation, translate its content into English for the judges, then read a commentary in French on the *Code Napoléon*, all designed to show the subtle shades of meanings inherent in their state's Civil Code.

Roselius started by assuring the court that no one could doubt the authenticity of the document Mr. Eimer had brought back with him. Not only had he obtained the signature and seal of the mayor of Langensoultzbach attesting that it was a true extract taken from the Record of Births and Deaths of the village, but he had also obtained the signature of the president of the Civil Tribunal of Wissembourg, declaring that it was indeed the mayor who had signed the declaration of authenticity, and then the signature of the minister of home affairs stating that it was the truly the president's signature.

Roselius placed the certificate in the hands of the clerk of courts, but that was where it remained. Why should we consider that, Mr. Roselius? Martin asked.

Because, Your Honor, answered Roselius, there is an exception to the rule that new material shouldn't be considered in appeal. He took up a volume of the Louisiana law reports and began to read.

The case was Marie Louise F.W.C. v. Marot, decided a decade earlier by the late Judge Mathews. A slave named Josephine had sought freedom from her wealthy Creole owner, Madame Toussaint Marot. During the course of arguing the appeal at the Supreme Court, it had become apparent that Josephine's lawyer had made a serious blunder

in failing to bring certain evidence in her favor. Madame Marot had sent Josephine to Paris to learn the art of hairdressing, and what her lawyer had failed to realize was that because France didn't tolerate slavery, Josephine had become free, and it wasn't in the power of her mistress to reclaim her when she returned to Louisiana. But could this new evidence of residence in France be taken into account at the appeal? Judge Mathews had decided it could. He wrote that in "an action brought to redeem a helpless female from slavery . . . every thing which may properly be done in *favorem libertatis*, should be done . . . "¹²⁶

As he made this submission, Roselius kept his eye on Martin. He was sure that if he could persuade the chief judge, his seniority and strength of personality would carry the rest of the bench with him. Martin, however, was giving nothing away. He held up his hand for Roselius to stop. The court waited while he composed his thoughts. Is it not strange, he said, that before Judge Buchanan you argued that the plaintiff was younger than the age designated by Mr. Miller, and now on appeal you are trying to have us accept a certificate that says she is older?

Roselius had expected a question along these lines, and after much thought had concluded that no answer would satisfy Martin, save confession. Your Honor is, of course, correct, he replied. Counsel are mortals; some are slower than others, and it took us a little time to realize the obvious.

A slight smile passed Martin's lips. Well, is not there the difference? In Marot's case, there was a failure to raise a vital point, but in your case, Mr. Roselius, there was no such failure. Your side distinctly argued the matter of her age, but now, on appeal, you want to say something different about it?

Roselius responded as best he could. The principle endorsed by *Marot*, he said, was one of liberty of the subject, not one of fine distinction between what the lawyers thought was important when they presented the case at trial and what they wanted to raise on appeal. Marot's case simply said that every opportunity should be given to the petitioner to show that she was free, even when something different had been argued in the district court.

Martin thought about Roselius's answer for a moment. Then he said he would like to hear what Mr. Grymes had to say on the topic.

To Grymes, the admittance of the new material was a mischievous

and costly waste of time. The rule restricting new evidence in appeals was a sensible one, he said. It was in the public interest that there should be an end to litigation. Parties shouldn't be allowed to wear the other side down amid incessant claims of new evidence. The expense was wearing heavily on Mr. Miller and Mr. Belmonti, to say nothing of the damage to their reputations. Anyone reading Judge Buchanan's reasons for dismissing the petition for freedom could see that he thought that it was a very weak case, and it could hardly be that the birth certificate would solve the glaring inadequacies of proof identified by the judge. The only merciful thing for the bench to do was to immediately despatch it.

There was whispering behind hands for several minutes as Martin consulted with his brother judges. That concluded, he announced that the court would take notice of the birth certificate, although what weight it should be accorded remained to be seen. Mr. Grymes had made a valid point—there was much more to this case than the issue of the plaintiff's age.

Roselius bowed in respect of the wisdom of the ruling. He would now hand over to his colleague, Mr. Upton, who would take the court through the detail of the evidence and the points of appeal.

Upton commenced by abandoning many of the claims made in the petition originally drafted by Sigur. It would no longer be asserted that Miller had property in Attakapas in 1818, or that he had engaged Daniel Müller and his children as redemptioners. Nor would it be said that Miller had acted in bad faith. In truth, said Upton, there had only ever been one aim and that was to free the plaintiff from the bonds of slavery. Miller's possession of her, whether rightfully or wrongfully gained, wasn't the issue. The claim for one thousand dollars in damages wasn't being pursued. All that was now being sought was the freedom of a poor German woman.

No comment came from any of the judges on the bench, so Upton, after a sigh of relief, embarked on the task of summarizing the evidence of each witness, thus showing, he hoped, that Buchanan had got the tenor of the evidence hopelessly wrong.

At the end of the day, Upton had still not concluded, and the next morning he resumed from where he had left off.

Just before midday, he turned to the law. He had decided to keep

this, his most tenuous argument, to the last. He announced that he would be relying on the case of *Adelle v. Beauregard*. A slight smile passed Martin's lips, as if acknowledging the return of a long-absent acquaintance. Upton decided to read the case in full. It was only a few pages, he said, so it would not take long. As he turned the first page, he looked up at the bench of elderly white faces. Martin sat with his eyes shut, rocking backward and forward in time with Upton's words, recalling passages he had helped to craft thirty-five years earlier. The others were taking notes or listening intently as he read. Silently and unnoticed, black messengers carried books and documents from the judges' chambers beyond.

When he finished reading, Upton closed the law report and faced the five judges. Adelle v. Beauregard provides a complete answer, he said. Even if at the end of this appeal the court thinks that Sally Miller is a mulatto, rather than a German, this makes no difference—the onus is on Mr. Miller to show that she is a slave. If he cannot prove his title to her, then she must be released. This is what Adelle v. Beauregard stands for. Even if the court entirely believes Mr. Miller when he says that he acquired Sally Miller from Anthony Williams in 1822, this still doesn't prove that she is a slave. No one knows how Williams obtained her, so she must be released. Even if the court harbors doubts about her age or whether she could bear children at a young age, none of this is conclusive. It doesn't prove that she is a slave, so she has to be released. Her lack of a Germanic accent means nothing if Mr. Miller can't prove his ownership of her, she must be released.

Martin leaned forward, listening intently.

When Upton finished, there was a moment of silence. Is that it? demanded Martin.

Upton replied that, yes, he had completed his submissions.

Are you not intending to explain why none of this was put to Judge Buchanan?

Upton squirmed. I didn't know of the case then.

I thought not, growled Martin. I take it that legal research is no longer a requirement at the New Orleans bar.

Upton stood with his mouth open, unable to think of a reply.

Oh, sit down, snapped Martin. The answer is obvious.

The introduction of Adelle v. Beauregard into the debate worried Grymes. It was just the sort of hoary case that Martin might find persuasive. Even lawyers at the Louisiana bar who had known Martin for years and were familiar with the hundreds of opinions he had written, found it difficult to forecast how he would decide a particular issue. His written judgments were terse and unadorned, but for all that, they often contained surprises. His approach to the law was to push first principles to remote, ultimate conclusions, regardless of the consequences. He measured the law as a mathematician might; there was only one right answer to every problem, and his task was to find it. His mind ran on a mechanism of pulleys and belts where logic worked and emotion counted for nothing. He ignored criticism that he was legalistic, remote or inaccessible. It wasn't his task to make the law progressive, or to develop it as a social weapon, or even to make it practical. Nor was it to protect private property or governments. The law, in Martin's hands, remained pure.

Grymes gave Adelle v. Beauregard considerable attention when he began his reply mid-afternoon on the second day. He told the court that there were sound, practical reasons why Adelle v. Beauregard shouldn't be regarded as the law of Louisiana. It couldn't be true in a slave-owning society that masters had to show how they obtained their slaves. Thousands of people held colored slaves with no better title to show than that of Miller—was it going to be suggested that all of these slaves could now flood the courts with petitions of freedom? If the court followed Upton's reasoning, any slaves who weren't pure African could now hope for deliverance if their master couldn't produce a piece of paper showing title to them. The rights of ownership of thousands of slaveowners in the state would be imperiled if Upton was correct. Was the court prepared to let this happen? Was the court to be seen as foolish?

Grymes continued: fortunately for the peace and prosperity of Louisiana, Upton was wrong. He hadn't given the court the full story. Grymes took the court to a much later case, *Mary v. Morris*, ¹²⁷ which, he claimed, had placed a safeguard around *Adelle v. Beauregard*.

Mary v. Morris was decided by the Supreme Court of Louisiana in

1834, although it had its origins two decades earlier. John Marshall of Georgia, upon his death, left a mulatto slave, Mary, to his daughter for a period of five years, after which time, according to the provisions of his will, Mary should have been set free. Unfortunately for Mary, Marshall's daughter neglected to tell her this, and instead took her to Louisiana and held her for twenty-four years, while Mary produced five children. Somehow, eventually, Mary discovered the contents of the will and sued for freedom for herself and her children. The defense was that emancipation was prohibited in Georgia and had been for many years, so John Marshall's will was invalid from the outset. This argument found favor with Judge Mathews of the Louisiana Supreme Court, so Mary and her children remained enslaved. But the significant point of Mary v. Morris, according to Grymes, was that Mathews, in giving his reasons, had said: "Being from color and [in the] actual possession of the defendant, presumed to be a slave, the burden of proving her freedom devolved on her."

Grymes argued that the law emerging from this case displayed the common sense absent from *Adelle v. Beauregard*. This law protected the legitimate rights of ownership. It meant that if a colored slave was in the *actual possession* of a master, the onus of proof remained with the slave to show he was free. This was the guiding principle to be applied. Sally Miller was in the *actual possession* of Belmonti before she became an illegal runaway, so it was up to her to show she was free and not vice versa. This she had failed to do.

Grymes then went on to point out that this view accorded with the ancient and wise provisions of the Spanish partidas. In Spanish law, if a master could produce any title or document to show that he had possession in good faith, it was then incumbent on the slave to prove otherwise. Miller and Belmonti had well satisfied that criterion, argued Grymes. They had possession of Sally Miller for over twenty years, and the power of attorney from Anthony Williams showed good title.

Grymes then put aside his law books for a final attempt at winning over the judges. The court had heard a lot about the fate of this woman, but he now asked that some thought be given to the fate of his client. Mr. Miller's life had all but been destroyed. The bench must not be so blinded by concern for the plaintiff to ignore the effect of

this appeal on Mr. Miller. He was the victim of a well-concocted web of lies. Mr. Upton might say that he was no longer alleging a lack of good faith, but it was far too late for that. The accusations had been made; the malicious gossip had taken its toll. Only through a complete rejection of this appeal would his reputation be restored.

After Grymes had concluded, Martin had one further query for Upton. As you quite rightly say, Mr. Upton, there is a presumption of freedom inherent in *Adelle v. Beauregard*. But a presumption always dissolves in the face of cogent evidence to the contrary, does it not?

Upton said he must agree.

Yes, that is the correct answer, Mr. Upton. That is the issue in this case. Is there proof that she is a slave?

And with that the five judges left the bench.

A PRESUMPTION IN FAVOR OF LIBERTY

It often happened that he would return the next day after a protracted discussion and say, "Well I have consulted my pillow on that question, and after all I believe I was wrong."

Judge Bullard, on Judge Martin¹²⁸

hree weeks later, on Saturday, June 21, 1845, the parties returned to the Cabildo to hear the Supreme Court pronounce judgment. Miller, accompanied by one of his witnesses, Joachim Kohn, sat in straight-backed silence directly behind his lawyers. Men and women from the German community filled the rows of seats in the public gallery, but there was none of the excitement of the day when Buchanan delivered his decision—experience had taught them to be wary of justice.

The room grew still as four judges entered the courtroom. Judge Morphy was absent on account of illness, said Chief Judge Martin, explaining the empty chair. However, His Honor concurred in the court's judgment, which would now be read by Judge Bullard.

All eyes turned to Bullard. In a slow, Yankee accent, he commenced his recitation of the facts:

She sets forth in her petition many things connected with her biography, and that of her father, which are unsupported by evidence, and which we regard as wholly immaterial to the great

question which the pleadings present, to wit, whether the plaintiff be white and free, or a slave.

To Upton's ears it wasn't a promising start. Did this mean that the court intended to ignore Mr. Eimer's birth certificate after all? He listened as Bullard spent the next few minutes summarizing the facts of the case and the evidence of the parties. Then Bullard paused, indicating to his listeners that the preliminaries were over. He went straight to the core of the matter:

Ever since the case of *Adelle v. Beauregard*, in the Superior Court, as early as 1810, it had been the settled doctrine here that persons of color are presumed to be free. Slavery itself is an exception to the conditions of the great mass of mankind, and, except as to Africans in the slave-holding States, the presumption is in favor of freedom, and the burden of proof is upon him who claims the colored person as a slave. . . .

These were the words Upton had prayed to hear. The court intended to follow the reasoning of *Adelle v. Beauregard*. Might they win? He held his breath, struggling to quell the fear that some twist in the court's reasoning might yet deny them victory.

The proof in the record of the complexion of the plaintiff is very strong. Not only is there no evidence of her having descended from a slave mother, or even a mother of the African race; but no witness has ventured a positive opinion, from inspection, that she is of that race. She is evidently a brunette, but Gen. Lewis, one of the most intelligent and candid witnesses on the part of the defendant, who had known her long, says she is as white as most persons; but that he has seen slaves as bright as the plaintiff. He adds, that he always thought she had something resembling the colored race in her features, but this opinion may have been induced by the fact that he had always seen her associating with persons of color. He also testifies to her resemblance to another female then in open court, shown to be a German, and a kinswoman of the lost daughter of Daniel Miller. . . .

Her own statements on the subject, so far as they are of any value, while they show that she did not seek this controversy, and was apparently contented with her condition, make no allusion to her parentage, unless it be to the Indian race: and when she alluded to the fact of having come over the lake, or of being sold by a negro trader, it is impossible to say whether she alludes faintly, as a dim reminiscence, to her voyage over the Atlantic, or to her being brought here from Mobile. . . .

It has been said that the German witnesses are imaginative and enthusiastic, and that their confidence ought to be distrusted. That kind of enthusiasm is, at least, of a quiet sort, evidently the result of profound conviction, and certainly free from any taint of worldly interest, and is by no means incompatible with the most perfect conscientiousness. If they are mistaken as to the identity of the plaintiff; if there be in truth two persons about the same age, bearing a strong resemblance to the family of Miller, and having the same identical marks from their birth, and the plaintiff is not the real lost child, who arrived here with hundreds of others in 1818, it is certainly one of the most extraordinary things in history. If she be not, then nobody has told who she is.¹²⁹

As Bullard read, a murmur rose from the body of the room, rising in intensity, as he approached the end. "After the most mature consideration of the case, we are of the opinion that the plaintiff is free. . . ." The courtroom broke into uproar. "It is, therefore, adjudged and decreed. . . ." The Germans in the court stood as one. Upton felt his back being slapped. Bullard, ignoring the disturbance, continued to read. ". . . that the judgment of the District Court be reversed; and ours is, that the plaintiff be released from the bonds of slavery."

It was over. They had won. People embraced their neighbors. Eva Schuber and her husband hugged each other. Mr. Grabau stood with tears flowing down his face. Mr. Eimer did a dance to the front of the bar table. Upton turned to look at Salomé Müller. She sat slumped in disbelief. He called to her, and she looked up and smiled at him, then she disappeared behind a crowd of well-wishers.

Upton collapsed back into his seat. The case had been won on the strength of *Adelle v. Beauregard*. There wasn't one word in Bullard's

judgment about the birth certificate. Not one word about the plaintiff's age. There was nothing about when Lafayette was born, or whether Sally ever spoke with a German accent. The word "Attakapas" wasn't mentioned. None of this seemed to matter to the Supreme Court. The essential point was that she looked as though she had white blood in her, so it was up to Miller to explain where she came from. This he had failed to do.

Tucked away in mid-paragraph toward the end of the judgment, if anyone cared to hear it, was a crumb thrown to Miller. It was "presumed," said the court, that he had "acted in good faith, and in relation to whom, we are bound to say, that the allegations in the petition tending to his prejudice, are wholly unsupported. . . . "130"

Upton looked around. He hadn't even seen the judges leave the bench. Grymes, the other lawyers, and Miller had gone. The courtroom was theirs.

Within days, a grand celebratory ball was held by the German community in the Kaiser Dance Hall in Lafayette to welcome Sally Miller back into the ranks of white society. The *Daily Tropic* of June 30, 1845, devoted a column on its front page to describing the event. "The friends of Sally Miller, in great numbers were gathered together last Tuesday, at the home of Francis Schuber" and "about nine o'clock the party adjourned to a neighboring hall," where "with music and dancing, a sumptuous feast, and an abundance of rich wines, they enjoyed themselves until a late hour."

If the returned slave was to be accepted without reservation by the German community, it was the women who had to do it. When Sally Miller arrived at the hall, two hundred ladies waited to receive her. The most distinguished German in New Orleans, Christian Roselius, linked arms with Sally and escorted her around the hall. To each of the women lining the walls, Roselius formally introduced her as Sally Miller, a free German woman recently returned to society. Sally bowed and said she was pleased to be back. Some of the women took Sally by the hand and gave it a squeeze, others embraced her and with tears in their eyes told her she was lost no more. Several pressed a calling card into her hand and told her she was always welcome in

their home. "They did greet her," said one newspaper "as bone of their bone, and flesh of their flesh."

After a circuit of the room, which took almost an hour to complete, Roselius accompanied Sally to the stage, where he proposed a toast. "Her liberation is not all," he was quoted as saying. "A new leaf had been turned in the life-book of the freed woman. That leaf is white. See to it that it remains white and unsullied, so that the sorely tried woman who has been lifted up, will sink no more." 131

Upton was called upon to speak. In emotional terms, he paid tribute to Eva Schuber: "One there is to supply, as far as may be, the mother's place—a holy conventional religious obligation has been imposed upon her and faithfully does the god-mother redeem her vows."

He then cast an appeal to the ladies present:

On you I call to save this injured, this unhappy woman from sinking. We have snatched her from the house of bondage; to leave her now unprotected would be a cruelty instead of a kindness. Visit not upon her ignominy of her past life—not to her belongs its shame—not on her should be laid its reproach. Since Saturday last, a new life has opened upon her. The book which she now unfolds has as yet no word upon its pages. Ladies! Will you see that its future record is an honest and a correct one? Take her by the hand, go with her to the house of your God, teach her to worship His name, cheer, comfort, counsel, and aid her.¹³²

The speeches finished, the orchestra led into music, and Roselius, who explained that the pleasures of dancing had little attraction for him, led Sally Miller to the hand of Upton. He escorted her to the floor and together they began a waltz. Others joined in and soon there was a swirling circle of men and women enclosing the two of them.

FOURTEEN

THE CHILDREN OF SALOMÉ MÜLLER

Natural fruits are such as are the spontaneous produce of the earth; the produce and increase of cattle, and the children of slaves are likewise natural fruits.

Article 537 of the Civil Code of the State of Louisiana

ally Miller was free, but her children were not. Her second son, Madison, and her daughter, Adeline, were still held by Miller on his plantations in Attakapas. The youngest of her children, Charles, lived with Belmonti at his cabaret. Since Belmonti was probably Charles's father, Sally wasn't so concerned about him, but Madison and Adeline were a different matter. Within days of the Supreme Court decision, Sally called at Upton's office and asked him how she could get them back. Miller hated her, she said, and he might do anything to her children. He might sell them. Then she would never see them again. Already, Lafayette had died on Miller's sugar plantation and she didn't want that happening to Madison and Adeline.

Upton told her that the legal position was quite clear. Miller had no right to her children and they should be released. The effect of the court's decision was that she had never been a slave; therefore, her children couldn't be slaves either. It was that simple.

However, enforcing the law was quite a different matter, as Upton found out when he wrote a note to Miller's lawyers later that afternoon. They answered that they would find out the attitude of their client and let him know. They replied a few days later. As far as Mr.

THE CHILDREN OF SALOMÉ MÜLLER

Miller was concerned, the decision of the Supreme Court only related to the mother—and she was a fraud. The children were his property and would remain so. If she wanted them back, she would have to sue for them. And he would welcome any legal contest she cared to mount.

Within days of receiving this advice, Upton had taken up the challenge. He called a meeting of Sally Miller, Eva Schuber, and the members of the committee formed to secure Sally's freedom. He recommended that Sally sue both Miller and Mrs. Canby for the deprivation of her liberty and add on a plea for the release of Madison and Adeline. He explained that, although the damages claim against Miller had been withdrawn at the Supreme Court, that didn't mean she couldn't sue him elsewhere. This time, in order to avoid the prejudice of judges such as Buchanan, he suggested she should file with the United States Circuit Court and demand a jury trial.

The meeting attendeesenthusiastically endorsed Upton's plan. Theodore Grabau pledged his apothecary firm, Curtius & Grabau, to cover the legal costs, and Upton promised to immediately draft the petition to the federal court.

In his accusations against Miller and his mother, Upton was as forthright and as vindictive as ever Sigur had been:

The Petition of Salomé Müller respectfully represents [that when she] was yet of tender age and too young either to assert or to be aware of her rights she was illegally and feloniously seized by one John F. Miller and by the mother of John F. Miller, Mrs. Sarah Canby. Your petitioner was converted and raised as a slave—her natural liberty was debarred her, she was made to hold a place with negroes and those born to servitude, severe tasks and burdens were imposed upon her, cruel and harsh and wicked punishments were inflicted, she was ranked with slaves, treated as a slave and taught only the duties of a slave, your petitioner for more than twenty years suffered hardships and privations imposed only upon the African race.

He then sought an order for the release of Sally Miller's children, "Madison and Adeline, now about fourteen or fifteen years of age still

held as slaves by the said John F. Miller and Sarah Canby, who refuses to restore them to the care of your petitioner, but wickedly claims them as their property."

Upton didn't hold back in the amount of damages he was seeking:

That as compensation for more than twenty years of hard labor in the service and the use of John F. Miller and Sarah Canby, they shall ... pay to her the sum of TWENTY THOUSAND DOLLARS. That for the wrongful and felonious deprivation of her liberty, for her cruel and unnatural bondage for all the wrong, and outrages, which during her whole life she had suffered that they shall be decreed to pay her the further sum of FIFTY THOUSAND DOLLARS, and such additional sum as an honest jury shall deem just and right.

That for the services of her two children and for the wrong to them done the said John F. Miller and Sarah Canby jointly and severally be decreed to pay your petitioner the sum of FIVE THOUSAND DOLLARS.¹³³

Upton and the German community were now on a crusade. Release of their kinswoman from bondage was the task only half completed—recovery of her children, and humiliation and punishment for those responsible, remained. Thoughts that the Supreme Court had, in effect, given Sally Miller the benefit of the doubt were glossed over. As far as her supporters were concerned, the judgment had made Sally Miller pure white and Miller a lying wretch.

The name on the petition was Salomé Müller. Sally Miller was no more. Perhaps Sally insisted on the change so that she could free herself from an association with her hated former owner and the publicity the case had brought to her. Perhaps Upton, as he approached the federal court, wanted to emphasize that she was truly German. He may have wanted to underscore that the decision of the Supreme Court of Louisiana had changed his client from a slave into a German woman.

If Salomé Müller hoped to fade into quiet obscurity, there was little chance of this occurring while she had Upton as her champion. Within weeks a pamphlet of twenty-four pages, relating the history of

THE CHILDREN OF SALOMÉ MÜLLER

the Sally Miller affair, appeared on the streets of New Orleans. It bore no publisher's imprint, nor any author's name, yet everyone knew that it was the work of Wheelock S. Upton. It was a shameless piece of self-glorification. Roselius's name wasn't mentioned, his brother only once, his own many times. After describing the horrors of the immigrants' journey from Germany to New Orleans, he told the story of the litigation, culminating in his triumphant appeal to the Louisiana Supreme Court. At every turn, he praised the bravery and determination of the German community, the skill and industry of the plaintiff's counsel, and the deviousness of John Fitz Miller. He disparaged Miller's explanation that he had purchased Sally Miller from Anthony Williams, and recycled the suggestion, made by Wheeler, that Miller had switched the identity of Sally Miller with that of a dead child. If that wasn't enough to torment Miller, Upton used his pamphlet to inform the public of his client's claim for damages against Miller and Mrs. Canby.

A few weeks later, a translation of Upton's pamphlet appeared in the *German Courier* of New Orleans, and a shorter version appeared in the *Daily Tropic*. Upton sent a copy of the speech he made at the German ball in Lafayette to the *National Anti-Slavery Standard* published in New York, where it appeared on the front page. In the following months a number of journals and papers picked up the report and told the story of the Lost German Slave Girl to the nation.

Miller's answer to the suit for damages was just as belligerent as Upton's originating petition.

She "is not Salomé Müller, an alien of German descent," he contended. "[S]he is Mary or Bridget, a slave, born in the State of Georgia or Alabama." Furthermore:

[If she should] rely upon a judgment of the Supreme Court of Louisiana, the defendants plead that the said Mary or Bridget falsely and fraudulently assumed the name of Sally Miller and pretended to be a native of Germany, and she procured false testimony to establish her identity... and only by reason of such fraud and ill practices, on the part of said plaintiff and her

witness, and not otherwise, was the said judgment obtained and procured. . . $.^{134}$

And as for the plaintiff's claim of five thousand dollars for the unjust bondage of Madison and Adeline, Miller retorted that none of her children "were of any service." Besides, the expense of keeping the plaintiff was "fully equal" to all services rendered by her or her children.

Salomé Müller had been delivered from slavery and, as most people understood the Supreme Court decision, she had been declared white. Yet, within days of that victory, she was heading toward a trial, this time before a jury of Southern white gentlemen, seeking the freedom of her children, fame and fortune for her lawyer, and punishment for her captors.

It was to be a long and arduous venture, fraught with more difficulties than either she or Upton could have ever imagined.

POLLY MOORE

I too have claims, I too will seek justice. . . .

John Fitz Miller, 1845 135

he is now free. . . . Free by judgment of the Supreme Court, but not all the rain in "the sweet heaven," can sweeten her into a white woman-no, not even the honor of joining hands in the same dance with her counsel and deliverer Wheelock S. Upton Esqr. at the grand ball given in honor of the triumph—

"Where he was the bravest of the brave,

She the fairest of the fair."

So wrote John Fitz Miller, in white-hot fury, in his pamphlet A Refutation of the Slander and Falsehoods Contained in a Pamphlet Entitled Sally Miller. 136 Not anonymously, but with a byline of his own name, in inch-high gothic type. Hatred beyond rationality brewed in Miller toward the people who had brought him low, and he had decided to fight back by publishing a pamphlet to counter the one written by his adversary, Wheelock S. Upton. Miller wrote of his ex-slave:

She has been metamorphosed by the "Grace of God" and the decision of the Supreme Court, with which Louisiana is now blessed, from Sally Miller, my former Slave, into Salomé Müller, a free white German Redemptioner. . . . I will expose to the best of my ability, the tissue of perjury, folly and corruption, of which this case was made up, and in which I was made the victim. Victim did I say? No, thank God, that was beyond their power.

Counsel, witnesses and client, they were all worthy of each other, and I defy and despise them all.¹³⁷

In a document thick with grandiloquent justification, self-pity, and blustering bravado, Miller lauded the decision of Buchanan (reprinted in full) and ridiculed the decision of the Supreme Court (also reprinted in full). In Miller's eyes, the judges of the Supreme Court were "southern men with northern feelings." The "Plaintiff's witnesses were perjured, her counsel were dupes and asses, and the court was most effectually mystified and humbugged." Upton was a man of "low cunning and a rapacious disposition combined." Mrs. Schuber was a "great romancer" who was part of a "well conducted and unprincipled scheme devised... to defraud me, put money in their own pockets and gratify the bad feelings of a very bad servant." 138

Then, after writing sixteen pages of invective and sarcasm, in the closing paragraphs Miller made an astonishing claim. A claim to confound and confuse his enemies. A claim to turn everything on its head. A claim to restore his reputation and utterly destroy the plaintiff and her counsel.

He announced that he had discovered the real Salomé Müller. She was alive and married with children. She was called Mrs. Polly Moore, and she lived "twelve or fourteen miles, north of Bastrop, in the Parish of Morehouse, on the Chemani creek, near a place called Fort Wedge." ¹³⁹

Miller claimed that it was Upton's passion for publicity that had led him to discover the woman who was the real Salomé Müller:

This is another instance of how the machinations of the wicked draw down punishment on their own heads. Had the plaintiff and her counsel, Wheelock S. Upton Esq., been satisfied with the ordinary publicity which the decisions of the Supreme Court confer, the Truth might not have come to light. Mystery had still hung over these transactions and I might have gone down to my grave, with suspicion on the minds of many to darken my

POLLY MOORE

memory. But no, the plaintiff or her counsel thought it necessary to prepare the mind for another suit and the pamphlet was the result. 140

Immediately after the shattering disappointment of the appeal, Miller had retreated to the sanctity of the house of Joachim Kohn in Bienville Street, New Orleans. Kohn, a commission merchant in the city, had known Miller for many years and had been a witness in the trial held before Buchanan. In times past he had dined on Miller's generosity, and he wasn't prepared to abandon him now, not at the time of Miller's public shaming when he needed him most. Kohn assured his friend that people would soon forget, but Miller didn't believe him—not in the few years he had left in his lifetime.

In the following days, as Miller read newspaper accounts of the case and of the self-seeking activities of Upton, he became even more convinced that the story of the lost German slave wouldn't be allowed to fade away. The *Daily Picayune*, in reporting the outcome of the appeal, reproduced a large section of the judgment. The *Daily Tropic*, after exclaiming: "Truth is stranger than fiction!," declared that it would soon issue "a complete history of this case prepared by an able member of the New Orleans Bar, and we venture to say that few publications have appeared possessing so much of singular and romantic interest as this narrative of events happening in our midst." Soon after, the *Daily Tropic* published a feature on the celebratory ball, including Upton's and Roselius's speeches. Then, if anyone in New Orleans was likely to soon forget Sally Miller, Upton's pamphlet, bearing her name on the title, appeared.

Upton's pamphlet was passed hand to hand the length and breadth of Louisiana, and eventually a copy fell into the hands of a merchant who made frequent visits by keelboat along Bayou Bartholomew in the extreme northeast of the state. He was immediately reminded that years ago he had heard something of two orphan girls of Dutch descent being raised by farmers in Morehouse Parish. Through an intermediary, the merchant passed what little information he had about the girls on to Miller. The area he described was a wild and remote territory with a sparse population of Dutch and French woodsmen. Miller left the next day on a steamer. It was a journey of

many days, up the Mississippi for several hundred miles, and then following twisting tributaries: the Red River, the Black River, the Boeuf River, and finally the Ouachita River, as it headed toward the Arkansas border. In Bastrop he spoke to people who recalled two orphan Dutch girls arriving in the county of Ouachita over twenty years ago. He was given other names. He traveled by horse collecting statements from everyone he could find who had the slightest recollection of what had happened to the girls. He asked about them in taverns, eating houses and produce stores. He was told of a middleaged Dutch woman, the widow of John Parker, who lived near Point Pleasant. Miller journeyed to a small farmhouse on the banks of a creek. The woman, surrounded by several children, greeted him. Miller introduced himself and asked her name. She replied with a strong accent. She had remarried only last winter to David Moore, so she was now called Mrs. Polly Moore. Miller asked about her father. She said his name was Daniel Miller and he came from Germany.

News that Miller claimed to have discovered Salomé Müller, in the form of Mrs. Polly Moore, a farmer's wife of Morehouse Parish in northeast Louisiana, spread quickly throughout New Orleans. It was yet another twist in a saga that had captivated the citizens of the city for the past couple of years. The German community dismissed the claim as more lies from a desperate man; even for Miller's allies, the existence of a second Salomé Müller was hard to believe. Many thought that Miller had topped even his own reputation for eccentricity by inventing people in remote locations.

Miller's claims were unable to be verified by anyone living in New Orleans—his witnesses were about as far north as one could go and still be in Louisiana—nevertheless, his pamphlet with its overblown literary style, heavy sarcasm, and scurrilous attacks on the Supreme Court made entertaining reading. Copies of it were much in demand. There was an expectation that it would be a battle royal when Salomé Müller's damages claim came up for hearing.

The suit against Miller and Mrs. Canby showed every indication of being a mammoth and unwieldy affair. Upton estimated that his client would need to call a dozen witnesses or more, and Miller, not to

POLLY MOORE

be outdone, supplied a list of twenty people whom he wanted to give evidence, adding that this was by no means the entirety of them. Whereas most of Salomé's witnesses lived in New Orleans, many on Miller's list lived in isolated districts where transport was primitive, and several of them resided outside the state.

Miller's lawyers overcame some of the difficulties of distance by arranging for those who knew Polly Moore to be examined by a specially appointed commissioner at a location near their homes. By late November 1845, the process had begun. Copeland S. Hunt was appointed as the commissioner, and Miller's lawyers compiled a list of interrogatories they wanted him to ask each witness. Before Hunt set off on his journey to northeastern Louisiana, he sent Upton a copy of the interrogatories. Upton was invited to add some questions of his own, if he so desired.

Upton examined the interrogatories in his office. Miller had gathered the names of a dozen people who would presumably say that they had known Polly Moore since her arrival in Morehouse twenty-seven years earlier. The interrogatories followed a similar pattern: How had they come to know Polly Moore? What was her age? What language did she speak? What nationality did they suppose her to be? What did she say of her life? What did they know of her history? Did she have a sister and, if so, what did they know of her?

As Upton flicked through the questions he was surprised that Miller had assembled so many witnesses who would assist in his game of saying that Polly Moore was Salomé Müller. He noticed that most were farmers and merchants, but one was a lawyer, Robert McGuire, who practiced in the town of Monroe in Ouachita Parish. Another was Oliver Morgan, a judge of the parish. Upton thought it odd that a lawyer and a parish judge had joined in Miller's foolishness. Perhaps the explanation was that there had been some sort of court proceedings involving Polly Moore that would tend to show who she was.

The last set of interrogatories was for Polly Moore herself. The inquiries of her were more specific: Did she know when and where she was born? Who were her parents? Did she have sisters or brothers? Who were they? What had happened to them? Was her name ever changed? Were her parents dead and, if so, what caused their deaths? Had she or her sister ever had marks on their thighs?

As Upton considered what to do about the interrogatories, he continued to be troubled by the number and range of witnesses Miller had obtained. But surely there was nothing to Polly Moore's claims? There was no reason to worry. Miller's new evidence would be soon exposed for the silliness it was. After some thought, Upton concluded that the best tactic would be to disdain to take partin this farce. He wrote across each of the documents: "No plaintiff's interrogatories" and sent them back to Commissioner Hunt.

During the first two weeks of December 1845, after a long journey upriver, Hunt set himself up in the Monroe courthouse and made arrangements for the witnesses named in the interrogatories to appear before him. After requiring each to swear on the Bible to tell the whole truth and nothing but the truth, Hunt dutifully asked the questions specified for him and recorded the answers. He then read his notes back to the witnesses and had them swear, then sign, to their accuracy. The statements (called depositions) were then sent to the United States Circuit Court in New Orleans.¹⁴²

Meanwhile, Miller had yet another revelation with which to amaze the people of New Orleans. He claimed he could now trace the history of Bridget Wilson from her birth in Georgia to her sale by Anthony Williams to himself in 1822. He now even knew who Anthony Williams was.

Even after the jubilation of discovering the real Salomé Müller in northeast Louisiana, Miller didn't rest. If he could find Salomé Müller, was it possible he could find Anthony Williams? Or a slavemaster named Wilson who had once owned a girl named Bridget? Immediately he set off to Alabama, accompanied by a commission merchant from New Orleans named Thomas B. Lee. The two men traveled by steamer along the inner shore of the Gulf. Once in Mobile, they asked everyone they met if they knew Williams or Wilson. They walked through the streets of the city speaking to traders in the slave markets, farmers in the dry goods stores, clerks in the mayor's office, and sailors along the waterfront. Eventually, someone remembered that there used to be a poor farmer named Wilson, long since departed this earth, who had run a few slaves, years ago, on a property a few miles

POLLY MOORE

out of town. They were directed along a track to Wilson's house where his daughter, Mrs. Coward, now lived. Mrs. Coward welcomed them with the hospitality that had made Alabama famous. Yes, her father had owned some slaves, she said, and she clearly remembered a pale-colored girl who was their servant. Her name was Bridget, and her mother was a mulatto woman named Candice, and her father was a white man.

Miller sat at Mrs. Coward's kitchen table and copied down all she knew. She told him that when Bridget was born in 1809 the family had lived in Tatnall County, Georgia. They had moved to Leaf River, Alabama, in 1810, and Bridget came with them. Mrs. Coward's father, John Wilson, had given Bridget, when she was aged about thirteen, to his daughter, Peggy, as a nurse for her children. Peggy (a sister of Mrs. Coward) lived in Mississippi. Peggy's husband, Enoch Rigdon, had fallen badly into debt and Bridget was exposed to sale at a sheriff's auction held out the front of the Perry courthouse in Mississippi. The successful bidder was Jonathon Thomas—although it was Mrs. Coward's recollection that Thomas didn't keep Bridget for more than a month before he sold her to his son-in-law. His name was Anthony Williams. What happened to the child after that, she didn't know. Nor did she know where Anthony Williams could be found.

Miller wrote down the name of every person Mrs. Coward had mentioned, and in the coming months, with the unerring devotion of a gun dog, he tracked them down. But first he rushed back to New Orleans to add Mrs. Coward's story to the pages of his pamphlet before it went to the printers.

Upton decided it was time for a counterattack. The rumors circulating in the city about Miller's discovery of Polly Moore and the history of Bridget Wilson were taking their toll on the credibility of his damages claim. On December 16, 1845, he filed a writ of habeas corpus in the United States Circuit Court seeking the release of Madison and Adeline. Here, he thought, was an opportunity to put Miller on the back foot and regain the initiative in the battle for public opinion. The supporting petition relied on only one contention: the mother of the two children was "a free white woman—so proved and

decreed by the judgment of the Supreme Court of Louisiana." This was one action Upton was convinced he couldn't lose.

The writ of *habeas corpus* was set down for determination at 10 am the very next day, December 17. The response of Miller's lawyers was as immediate as it was surprising. Overnight, Grymes worked on a petition to the New Orleans District Court asking for a ruling that the judgment freeing Salomé Müller be declared null and void. It was filed early the next morning, prior to the hearing in the United States Circuit Court. Grymes had relied on an article in the Louisiana Code of Practice saying that a judgment "may be annulled in all cases where it appears it has been obtained through fraud, or other ill practices." According to the petition there had been fraud aplenty. Grymes wrote that Sally Miller:

... well knew she was not of free birth and that she was rightfully and lawfully held in slavery by the said Belmonti.... [She had] fraudulently, maliciously and deceitfully, combining with certain persons, more particularly with F. Schuber and E. Schuber, his wife, and Daniel Miller, induced these persons and others to give testimony to the effect that she, the said Sally Miller, was the child of a certain Daniel Müller. ¹⁴³

Other paragraphs alleged that the testimony that the real Sally Miller had moles on her thighs was "wholly false and fictitious," as was the claim that she looked like her deceased mother, or that her relatives and friends could recognize her.

When the parties assembled later that morning at the United States Circuit Court, Grymes produced a copy of his petition. He declared that the sole foundation in support of the writ of habeas corpus had been the Supreme Court judgment, and the filing of the nullity petition intended to cut the ground from under that. The woman was a fraud and this is what his client would show when the nullity proceeding commenced in a few months' time.

The writ of habeas corpus was adjourned off. The attempt to gain the freedom of Madison and Adeline was effectively stymied. The children's fate depended entirely on whether their mother was a slave

POLLY MOORE

or a free white woman, and that issue was now the matter of raging controversy being litigated in both the state and federal courts. The fate of Madison and Adeline would have to wait another day.

The failure to obtain the release of the two children badly shook Upton. He had all but promised Salomé that she would have Madison and Adeline back with her for Christmas. With dismay, he realized that Miller intended to fight them every inch of the way and to take every possible point in every court he could find.

In the days leading up to Christmas, Upton drafted a response to the petition of nullity. It was filed on New Year's Eve. In it he strenuously argued that there had been no fraud. He then added his strongest point: the decision of the Supreme Court was "final and conclusive and cannot be disturbed."

The warring sides couldn't even agree on her name. Grymes in his petition had called her "a person calling herself Sally Miller held in slavery"; while Upton, in his response, described her as "Salomé Müller, an alien, native of the province of Alsace upon the lower Rhine in Germany."

Upton dropped into his office late one afternoon in January. The courts were still closed for the law vacation, and he planned to clear up a few items of paperwork remaining on his desk. When he opened the door he found a bundle of papers waiting for him. During the New Year's break the marshal of the United States Circuit Court had dropped off copies of the depositions that had been compiled by Commissioner Hunt during his visit to Monroe in search of Polly Moore. Upton decided to read them. He sat on a sofa next to his desk, and after adjusting his oil lamp so that it directed light over his shoulder onto the pages, he quickly flicked through them. Hunt had collected twelve depositions. Eleven of them had something to say about the life of Polly Moore, and the twelfth was from Polly Moore herself. He would leave that one until last. He placed it on a small table at his elbow.

The first four depositions he read were from the children of Mr. Thomas Grayson, a merchant, now deceased, of Prairie Boeuf. They said that from time to time their father would go to New Orleans to

pick up supplies for his store. In those days no steamer made the journey up the Ouachita River, so a neighbor, John Thomasson, ran the passage in his keelboat. After one such journey in 1818, their father had returned with five German children. They were all orphans. According to Betsy Stewart (the daughter of Thomas Grayson), the children had cost her father five hundred dollars. Betsy Stewart's brother, Wiley Grayson, said that two of them were girls—aged "about six, seven or eight." Wiley Grayson's sister, Narcissa Garrett, recalled her father saying that the father of the girls was "a very good shoemaker and that he was thought to have died of grief from having lost a child, a little boy." Lucetta Rutland, yet another sister, said that the two girls' names were Dorothy and Sally, and her father had said that "the brother of the girls was drowned coming up from New Orleans and that their father had died suddenly."

All of Grayson's children recalled that their father hadn't kept the two girls for more than a few days. He had sold "their time" to Thomasson, the man who owned the keelboat. Soon afterward, Thomasson had moved to the nearby town of Monroe, where he and his wife opened a tavern. Lucetta Rutland said she had heard of the "cruelty of Mrs. Thomasson to the two girls."

Upton opened the deposition of Robert McGuire. He was a lawyer who had lived in Monroe since 1819. He said he had seen two Dutch girls frequently around Thomasson's tavern "where they were treated as servants." One of them was called Dorothy. Afterward, he "knew the girls by the names of Sally and Polly Miller until they were married." "It was," said McGuire, "commonly reported about town that Mrs. Thomasson treated them very cruelly. In consequence of that, some of the citizens made complaints to Oliver J. Morgan, the Parish Judge, who had the girls brought before him and considerable testimony taken." Mrs. Thomasson had cut one of the girls with a large kitchen knife and stuck the flesh of the other with a fork. McGuire said he had seen the wounds.

Hunt also examined Judge Morgan. He recalled the case, but said he wasn't required to make a ruling because Thomasson agreed to give up the girls. The judge said he had kept the two little girls at his house until he could find someone to take them. The year was 1823 or

POLLY MOORE

1825, and one of the girls was then between ten and twelve, and the other between thirteen and fourteen. Eventually, the girls were given to James Gleason and his wife, Charlotte.

Both James and Charlotte Gleason made statements. Mrs. Gleason said the girls were named Dorothy and Salina, and they spoke Dutch and tolerable English. She changed Dorothea's name to Polly and Salina's name to Sally, because "she thought it was the English name for the Dutch." Mrs. Gleason said, "Polly would speak of her distress in crossing the sea.... Polly used to say that her mother died on the water and that her father died after he had landed, and so did her brother." Their being taken away from Mrs. Thomasson caused them to be much talked of in the county, said Mrs. Gleason.

Her husband said that one of the girls was called Salomé, but he had called her Sally. The other was Polly, and she had told him once that her father's name was Miller.

Upton then picked up the statement of Elisha Thomasson, the son of John Thomasson. He said nothing about his mother's cruelty to the girls, but he did say the two girls lived in the family until 1825. One was called Dorothy. The other was called Saline.

The remaining two depositions added little. Mary Headon, a resident of Franklin Parish, said she "knew two Dutch girls who lived in the family of Mr. Thomasson; they went by the name of Dorothy and Salina." Richard King, an army major, said he saw two small girls at the house of either Mr. Grayson or Mr. Thomasson, but he couldn't recall which.

Upton put the last of the supporting depositions aside. They had been somber reading. He had fully expected the evidence substantiating Miller's claim to have found Salomé Müller to be laughable, but what he had just seen was anything but. He guessed that a jury would find the testimony persuasive, particularly since a parish judge appeared to be affirming the general thrust of what the others had said. Upton tried to think of ways to explain away the depositions. Perhaps it was true that two little girls of Dutch or German origin had arrived in Morehouse Parish in around 1818, but that didn't make them the children of Daniel Müller. Hundreds of redemptioners had arrived in Louisiana at that time—it could be mere coincidence, even to the similarity of the names. Polly and Sally weren't

such unusual names. Yet, the depositions had identified the girls' father as a shoemaker and got the details of his death roughly correct. They had said that their mother had died on the water. He wondered about that. There was also the mention of the death of their brother by drowning.

Reluctantly, Upton reached for the deposition of Polly Moore. He began to have a bad feeling about what it might say.

In his first question, Hunt had asked Polly Moore how old she was. She didn't know exactly, but supposed she would be about thirty-two. Nor did she know where she was born. She said she now lived in the parish of Morehouse, near Point Pleasant, Louisiana.

In the answers that followed (her deposition went to four pages of tight handwriting), Hunt had written down what she had told him of her arrival in Morehouse. She confirmed the statements of the Grayson children that she had only lived a short time with them: "Witness does not recollect how she got to Grayson's house. Mr. Grayson did not wish to keep witness with his family having several children of his own and witness was transferred to the family of Old Mrs. John Thomasson."

Polly told Hunt that she and her sister "did not speak the same language as the family of Mr. Grayson...the Graysons called her Dorothy and her sister Salomé, but this was a mistake." She said she was two years older than her sister. The two small girls then lived with the "family of the Thomasson for several years."

Polly made no accusations of ill treatment by Mrs. Thomasson and gave no explanation as to why she was given to Mr. and Mrs. Gleason. She said Mrs. Gleason had changed their names again. She became Polly and her sister Sally. This continued the mix-up of their names that had commenced at Mr. Grayson's house, because she was really Salomé and her sister, Dorothy. They didn't stay with Mr. and Mrs. Gleason for long. She and her sister lived with James Owen, about two miles away, and then with John Stirling on the Ouachita River. Polly said she had then married John Parker of Ouachita Parish. They had been married for twelve years. After his death, she had married David Moore, only last winter. This was why she was now called Polly Moore.

POLLY MOORE

Hunt had asked about her parents. She had said that "her father was a Dutchman, a shoemaker by trade." His name was Daniel Miller and her mother's name was Salomé.

Hunt had then asked her what she knew about the death of her father and mother. He copied down her reply:

Witness recollects getting on board the ship, getting up a very high place—it seemed to her now like a dream. Witness's mother died on the vessel—her father died coming up the Black River. Witness's mother was seasick and perish[ed] from the want of something to eat—witness does not know what caused the death of her father. He ate a very hearty dinner on board the boat which he cooked for himself. He then laid down on the boat. Witness heard him making a curious noise. She got up, not having finished her dinner at the table, and went to her father but he was then dead.

Polly also told Hunt that she had an older brother, but she had lost him in New Orleans. He "drowned or someone persuaded him off," she said. Her sister had married Alexis Hamilton, who lived on the Ouachita. She had two children. Her sister has been dead for three years. She was known as Sally, but her real name was Dorothy Miller.

Hunt's final question was whether she had any marks on her thighs. She did not. Nor had her sister.

Upton returned Polly Moore's deposition to the pile with the other eleven. He sat in the gathering darkness of his office, thinking about what he had read. Was it possible? He dare not think about what it meant. There had to be some other explanation. Polly Moore had signed her deposition with a cross. So she wasn't an educated person. Not that he thought this would make it any easier to shake her testimony—if it ever came to that. He imagined her to be a believable sort of woman, warding off with her own ordinariness any suggestion that she had composed such a complex set of lies. She had got one or two details wrong, like the name of her mother and her belief that she was older than her sister, but mistakes of this kind were explicable given

that she had no relatives to pass on the stories of her family. She had said her father was a Dutchman, but again Upton saw nothing in that—in Louisiana, anyone of Teutonic stock was regarded as Dutch.

It became dark. He sat in his chair, buried in thought, as deeply rooted certainties began to decay. Perhaps he had misunderstood what he had read. He looked across at the depositions stacked next to him, but he couldn't bring himself to pick them up again. No, he knew what they said all right, and it frightened him.

As rumor of the testimonies given by the witnesses in Morehouse Parish began to circulate in New Orleans, many in the German community who had welcomed Salomé Müller back into their fold began to have second thoughts. It was whispered by some who had met her that she had none of the social graces you might expect of a real German woman and her speech was entirely that of a slave. Admittedly, she was a beauty, but it was the olive-skinned beauty of a quadroon, not of a white person. Those who bothered to read the judgment of the Supreme Court reproduced at the back of Miller's pamphlet saw that there hadn't been a complete endorsement of Salomé Müller's German heritage. In effect, she had been given the benefit of the doubt because she looked white, and no one knew where she came from, but now Miller was saying that he *did* know where she came from—she was born in Georgia, the child of a slave and a white man.

SIDVINDIDA

NULLITY

Oh run, brother, run! Judgment day is comin' Oh run, brother, run! Why don't you come along?

Traditional spiritual

arly in the New Year, Upton received further disquieting news. Miller's lawyers had another two witnesses ready to give evidence. One was Dorothy Kirchner, a German redemptioner and a blood relative of the Müller brothers, and it appeared she had a few things to say about the lies Eva Schuber had told. The other was Mrs. Coward, and she was only too willing to say how Bridget Wilson had been a slave of her father and had eventually come into the possession of Anthony Williams. Both women were in New Orleans on a visit of just a few days, so Miller's lawyers arranged for their evidence to be recorded by a commissioner for use at a later date in defense of the seventy-five thousand dollars damages claim.

Upton, Eva Schuber, and Salomé Müller attended the commissioner's hearing. Eva hadn't seen Dorothy for over twenty years. They had been at school together in Langensoultzbach, sat in the same classroom, attended the same confirmation lessons at the village church, and had traveled to Louisiana on the same ship. Despite this, when the two women met at the courthouse, they failed to recognize each other. They had to be introduced by the clerk of courts. It was an awkward encounter; they had nothing to say to each other—they had been brought together by lawyers on opposing sides in a contest so bitter it forbade cordiality. They said good morning to each other, then sat apart until it was time for Dorothy to give evidence.

Dorothy Kirchner bore the married name of Dorothy Brown. She

told the commissioner that she had wed Brown when she was seventeen and they had moved to Claiborne County in Mississippi. Only recently, she had returned to Louisiana and now lived in Madison Parish. Her father's name was Christoph Kirchner and her mother was Salomé Müller—not the Salomé Müller at the center of this case, but the sister of Henry and Daniel Müller.

The first part of Mrs. Brown's evidence confirmed what the others had said about the terrible voyage to America and the loss of life. Thereafter, however, everything she said contradicted Eva Schuber. She had no recollection of Eva being the godmother of Salomé Müller. She hadn't seen Eva care for Daniel Müller's children on the *Juffer Johanna*, even after Daniel's wife had died. She had never heard of any peculiar marks on either of Daniel's daughters—in fact, she had seen Salomé naked when she was a child and there was nothing at all unusual about her thighs. When told of the claim of Daniel Müller (the son of Henry Müller) that he recognized Salomé Müller as his cousin, she was dismissive. He had been only eight when they arrived in America, so he would know nothing. She, on the other hand, had been fifteen.

Then, for good measure, Dorothy Brown boasted that the Kirchner family had experienced no trouble in finding Daniel Müller's two daughters and one of them was Polly Moore. She told how, in 1832, she had heard that both Sally and Dorothy were living in Monroe in Ouachita Parish, and her own brother, Daniel Kirchner, had visited the two sisters in 1833. He had remained with them for about ten days. Both were then married. Mrs. Brown said she had corresponded with both women after that, although one of them was now dead.

The next day the commissioner took evidence from Mrs. Coward. She repeated the story of Bridget Wilson as she had told it to Miller in her kitchen several months earlier. Bridget was born in 1809 of a slave woman named Candice who belonged to her father. Mrs. Coward's deposition then read:

Bridget was the first child that Candice had. Witness knew the mother of Candice. Her name was Rachel, and belonged to witness's father. Rachel was a black Guinea negro. Bridget was of light color—was only a quadroon—her father being a white man

NULLITY

and her mother a mulatto. Rachel and Candice are both living—the latter lives in Hines County, Mississippi—witness saw Rachel last Sunday morning in Mobile, where she came to visit her grandchildren. Rachel is about one hundred and ten year old, as near as she could guess. She is entirely blind and of no use to any one.¹⁴⁴

Mrs. Coward said that Bridget could be easily identified because she had marks like raspberries on each of her thighs.

Upton's examination concentrated on something that had happened only the night before. Had Mrs. Coward visited the Schuber house? Yes, she had. And had she found what she was looking for? At this question, Mrs. Coward became indignant. She had been three times to Mrs. Schuber's house to see Bridget Wilson for herself, and on the first two occasions she had been told that Bridget wasn't in. On the third occasion her nephew had accompanied her, but Mrs. Schuber refused to let him into her house, so he had to wait outside, while she went in alone. She was taken upstairs to a room without any lights where three women were sitting on chairs. Mrs. Schuber pointed out the one with the fairest skin, and said there is Sally Miller. Mrs. Coward had then said, Is that you, Bridget? You should be ashamed of yourself. At that, Mrs. Schuber and the women had laughed and said, That is Sally over there, pointing to another of the three women—one who had kept her hand over her face all the time. Mrs. Coward said she had asked this woman several questions, but received no reply. Mrs. Coward complained that "although she had done nothing offensive" during the visit, Mrs. Schuber appeared very angry and "did not treat her politely."

A few months later the marshal of the Circuit Court delivered another three depositions to Upton's office. They were from people who knew John Wilson. All three said that Wilson had bred a slave girl named Bridget. Two of them, Griffin H. Holliman and Robert McCarty, said they were present at the sheriff's auction in Mississippi when Jonathon Thomas had successfully bid for her. Holliman thought

that the girl would have been about ten or eleven years of age. McCarty said she was thirteen or fourteen. Both witnesses said there had been some dispute about the title to Bridget. Holliman said that after the auction Thomas had "become alarmed" that he didn't have proper ownership of her, so he got his son-in-law, Anthony Williams, to take her to New Orleans and sell her there.

Upton wondered if here lay the explanation of why no one in Mobile had heard of Anthony Williams. Williams had never lived in Mobile. He wasn't a slave trader, either. He was the son-in-law of a farmer from Perry County, Mississippi. Possibly he told Miller that he lived in Mobile because he was attempting to get rid of a slave he wasn't sure he owned.

In May 1846, Miller heard the surprising news that Polly Moore had come to New Orleans for a brief visit. This was too good an opportunity to miss. He immediately filed an affidavit in the District Court, saying that he wanted her testimony taken before she returned to her home in Morehouse. The court appointed Mr. O. P. Jackson, Associate Judge of the City Court, to record her evidence, which he did on May 27, 1846, in his office in Royal Street in the French Quarter.

No one would have ever confused Polly Moore with a slave. She was a fair-skinned, fair-haired, ample woman who spoke with a heavy accent. Judge Jackson took three pages of closely written notes of her testimony. The first two pages recorded her as giving much the same evidence as she gave to Commissioner Hunt in the previous December. She also confirmed that Daniel Kirchner had visited her and that subsequently she and Mrs. Brown had corresponded, although, as she explained, she had to get someone else to write the replies for her.

On the third page of Jackson's notes appeared a bombshell. She wasn't Salomé Müller at all, but her elder sister, Dorothy. The record of her evidence read:

Thinks she told Mr. Hunt that her name was Salomé, and her sister Dorothy, but upon thinking of it further, she is satisfied that she was mistaken, their names were changed several times, witness being sometimes Salomé & sometimes Dorothy—When I first went up in that Country—could find no body with whom

NULLITY

I could converse in my own language, it was some time before we could make ourselves understood in English—Until we learned English, we found it difficult to make them understand us—If we wanted anything we had to point at it—is certain from her own recollection, without reference to what she has heard that she is older than her sister.

Polly Moore told Jackson that Salomé was "now dead and has been, going on four years." Jackson wrote down:

My sister left two children now living and in my care at present. She died on the Ouachita River—was with her during a part of her sickness—was not with her at the time of her death, being sick myself. Saw her buried in the yard in which deponent then lived.¹⁴⁵

If this was Salomé Müller, her death occurred at about the same time that Madame Carl discovered her sitting on the steps outside Belmonti's cabaret in New Orleans.

Upton was now fighting Miller in both the federal and state jurisdictions in cases that were costly and time-consuming and gave every prospect of being disasters for both him and his client. By mid-1846, this much had become clear to him: it was time to call a halt—at least to the one he had power to stop. He filed papers abandoning the damages suit and the attempt to obtain the freedom of Madison and Adeline. It was an embarrassing back-down, especially after the windy notoriety he had claimed for himself when he announced the action. Distressing as it must have been for Upton, it was even more distressing for Theodore Grabau, the backer of the action, who was left to pay Miller's legal costs.

Even after jettisoning the damages claim, Salomé Müller was still facing the application to have the Supreme Court judgment declared a nullity, and Miller, with vengeance festering in his heart, wasn't about to abandon that. Here was a heaven-sent opportunity to get back at all those who had tormented him. If he could succeed in

having Salomé's freedom declared a nullity, as well as condemning her and her children to a lifetime of slavery, he could have Eva Schuber, her husband, and all the others who had conspired against him, charged with perjury. It would be a delicious requital for all that they had done to him.

Upton was stunned at the speed with which their fortunes had plummeted. A mere twelve months had passed since the victory of the appeal. Twelve months ago, he had danced with Sally Miller at the great celebratory ball in Lafayette to welcome her into white society. It was only twelve months since he had filed the suit for seventy-five thousand dollars in damages against Miller and his mother.

Grymes, showing a mastery of Louisiana's procedural rules, had lodged the nullity petition at the District Judicial Court of New Orleans and not the Supreme Court. His intention was to bypass Martin's court and ask Judge Buchanan to reopen his earlier decision. Grymes relied on an article in the Louisiana Code of Practice that, rather ambiguously, read:

The nullity of a judgment may be demanded from the same court, which has rendered the same, or from the court of appeal before which the appeal from such judgment was taken . . 146

During several sitting days, Upton attempted to persuade Buchanan that the Code couldn't possibly mean that he, sitting as a District Court judge, could hear a petition seeking to overrule a judgment of the Supreme Court that had overruled him in appeal. Grymes urged Buchanan to take the Code as it read—clearly, it clothed him with the authority to investigate if witnesses had lied to him. Lying to a jury was bad enough, but lying to a judge was worse. It had to be stamped out. Buchanan, as the judge who had heard all the evidence in the first place, knew more about what lies the German witnesses had told than did any of the Supreme Court judges.

Grymes won the argument. The nullity petition was seized by Buchanan, and it did little to relieve Upton's sense of foreboding when Buchanan announced that he would sit with a jury, whose decision it ultimately would be, so his views on the matter were unimportant. The trial would commence sometime in the New Year.

NULLITY

A file relating to Miller's nullity petition is now preserved at the University of New Orleans. On its yellowing pages is a note by Deputy Sheriff Lewis that he attempted to serve some documents associated with the case on Upton at his office on November 23, 1846. Upton refused to accept service. Lewis wrote on the document's cover sheet: "say they will have nothing to do with the suit." On November 28, the sheriff made a second attempt at service. The handwritten note reads: "tendered copy of the within Notice of Trial to W. S. Upton Esq. Attorney of Sally Miller who refused accepting service." 147

Upton had withdrawn from the case. The man who had lectured the German ladies of New Orleans about their duty toward the woman who had returned from slavery had grown weary. Litigation that he had hoped would bring him fame was now bringing him ridicule. The tide of public opinion was turning, and an increasing number of people in the city believed that he and the German community had been made the dupes of a cunning and manipulative slave. Salomé Müller's supporters were now harder to find, and Upton was becoming uneasy about who would pay him.

Eva Schuber remained as steadfast as ever. She called in on Upton at his office and begged him to continue. Upton spoke to her about the difficulties the case now faced. He asked her to consider the evidence arrayed against them, but nothing he said to her shook her resolve. Nothing ever shook Eva Schuber's resolve. In the years of litigation, reversals, and emotional and financial cost, she never faltered in her belief that the woman Madame Carl Rouff had discovered sitting on a doorstep was the lost daughter of Daniel Müller. If Upton had to be paid, it was Eva who would foot the bill, even if her husband and her family had to suffer for it.

The court file shows that on December 2, 1846, Upton accepted service. Whether he was being paid again or Eva's pleas had worn him down, it is impossible to say. But Upton was back. The Salomé Müller litigation had become like a tar baby, and the more he struggled to extract himself, the more he became entangled. He would argue the case alone. Roselius was no longer part of his team, and his brother, Frank, had gone to practice law in New York.

It took over a year for the nullity trial to commence. The first day of the hearing was January 3, 1848. Upton stood up to announce his appearance before Buchanan—the judge he had previously compared to Pontius Pilate and a racecourse steward. Upton was opposed by lawyers Micou and Claiborne appearing for Miller, and Cannon appeared for Belmonti. A jury of twelve was sworn in—all men, all property holders, and all white.

This time Miller was the plaintiff, so it was his right to go first. In an attempt to reduce the length of what would otherwise have been an extremely lengthy hearing, Buchanan had ordered that the transcript taken in the original proceedings, and in the now abandoned suit at the United States Circuit Court, could be taken as part of the record. Miller's lawyers took it in turn to read to the jury the many pages of evidence this case had collected. They read the sworn testimony from all those who had said that Bridget Wilson arrived in Miller's sawmill in 1822, and the depositions from those in Morehouse Parish who knew Polly Moore from 1818 onward, and those in Alabama and Mississippi who knew John Wilson and the young mulatto slave he owned—all going to show, lawyer Micou said, the quite separate lives of Bridget Wilson and Salomé Müller.

Micou then placed before the jury several documents new to the case that he felt sure would clinch the matter. The first was a bill of sale dated July 1, 1822, written by the deputy sheriff of Perry County in the state of Mississippi, transferring "a certain mulatto girl named Bridget, to Jonathon Thomas, he being the highest bidder." The next was a sale note of July 11, 1822 from Jonathon Thomas recording that "in consideration of the sum of three hundred and fifty dollars, to me in hand paid" he "bargained and sold unto Anthony Williams . . . a certain negro girl Bridget, aged twelve years, yellow complexion." 148

Finally, Micou held up what he considered the ultimate, absolute proof that Salomé Müller was an imposter. It was the redemption agreement by which Daniel Müller in 1818 had sold himself and his three children in servitude to Thomas Grayson of Morehouse Parish, Louisiana.

A copy appears on the court file. It is a long document, so in the reproduction below, some of the formal parts have been omitted:

NULLITY

United States of America

Be it known that this day before me, John Lynd, Notary Public in and for the State of Louisiana, residing and practising in the City of New Orleans . . . personally came and appeared Daniel Müller aged thirty seven years, his son Jacob Müller aged ten years, his daughters Dorothea Muller aged eight years, Salemia Müller aged four years and Thomas Grayson who mutually covenant and agree...that whereas by articles of agreement entered into and dated Amsterdam the second day of December 1817 between Captain H. H. Bleeker of the ship Lady Joanna and ... in consideration of passage from Amsterdam to a port in the United States of America... And whereas in consideration of the said sum of \$ __ having been for them by the said Thomas Grayson to the said Captain Bleeker paid, ... they do by their presents, with the advice and consent of James Petot Parish Judge and of their own free will and accord, bind and put themselves to the said Thomas Grayson to serve him, his Executors and assigns the date hereof, for and during the full term and time of Daniel Müller, three years, Jacob Müller, eleven years, Dorothea Müller, ten years and Salemia Müller, sixteen years, or until Jacob shall have obtained the age of twenty one, and the two girls, Dorothea and Salemia each the age of eighteen next ensuring—during all of which respective terms the said servants... faithfully shall serve, and that honestly and obediently in all lawful things as a good and dutiful servant ought to do and the said master . . . shall find and provide for the said servants sufficient meat, drink, apparel, washing and lodgings, material and medical attendance. education for the minors according to law, and all other necessities fitting such a servant. 149

There followed the signature of Daniel Müller, and three crosses, being the marks made by his children. The place where the price should appear had been left blank for some reason. According to the evidence of one of Grayson's daughters, her father had paid five hundred dollars for the seven redemptioners he purchased in New Orleans in 1818 (of which, after the death of Daniel Müller and his

son, only five children arrived). Presumably, the amount Grayson had paid to Bleeker for Daniel and his three children was somewhat less than that.

In the earlier proceedings before Buchanan, one of the redemptioners, Mr. Wagner, had said that the passengers on Krahnstover's vessels were sold for "one or two years according to their ages." This may have been generally true, and some of the other witnesses said they had served terms of that order, but not so Daniel Müller and his children. He was bound for three years, while his children were bound for ten, eleven and sixteen years. That Daniel Müller would sign a document selling the childhood of his son and daughters shows how desperate he must have become as he languished on the Juffer Johanna. The agreement binding them to Grayson was signed on April 2, 1818, which meant that Daniel Müller and his children had been kept on board the vessel for twenty-six days after she had docked in New Orleans. Its terms had received the assent of James Petot, a parish judge. This was a requirement of the territorial legislation of 1806 whenever children were bound. It seems that the judge saw nothing in the document to concern him.

However, the length of the terms of servitude wasn't a matter Micou referred to when he placed the indenture in the hands of the jury. His purpose was to show how wrong the German witnesses had been. It was clear proof, he told the jurymen, of what had happened to Salomé Müller. She hadn't been taken southwest to Attakapas, as Eva Schuber had claimed, but in the opposite direction, three counties away, to Morehouse Parish in the northeast.

Upton commenced his case by calling Eva Schuber. She said it had been more than four years since Madame Carl had come to her house with Salomé Müller, and she hadn't the least cause to change her opinion that Salomé was the true and lawful child of Daniel and Dorothea Müller, and her goddaughter. Upton then led her through her account of the time Mrs. Coward had visited her house in search of Bridget Wilson. Eva's version had Mrs. Coward, after identifying one of Eva's neighbors as Bridget, exclaiming that she would swear in court that she was the slave her father had brought up.

Upton then put Eva's neighbor on the witness stand. She confirmed that Mrs. Coward had called her Bridget.

NULLITY

Fooling Mrs. Coward may have gratified Eva Schuber and her neighbor who took part in the charade, but it was hardly a decisive rebuttal of the evidence Miller's side had assembled, and Upton's other witnesses weren't much better. Ezra Hiestand, an attorney in practice in New Orleans, said that he was of German descent, but only remotely so. However, if he met Salomé Müller in the street, without knowing who she was, he would say that she was German. Upton's next witness, William Meyers, said that in 1822 he worked in Miller's mill repairing machinery and recalled seeing a little German girl about the place, between eight and ten years of age, who spoke broken English. He thought she was Salomé Müller, although he might be wrong because there were two or three yellow girls about the house. One of them had called Mrs. Canby her aunt.

Upton read to the jury the evidence of the earlier case before Buchanan, emphasizing the testimony of those who had positively identified Sally Miller as the lost German girl. He took them to the testimony of Wood and Poigneau, who said they had heard a girl speaking German in Miller's sawmill and how General Lewis had said that the only reason he thought she was a slave was because she associated with slaves. And that was it. Four witnesses and a rehash of the earlier case. The other people Upton had promised in his pamphlet, such as Wheeler, Fribee, and Curran, didn't appear. None of the German witnesses who had identified Salomé Müller in the earlier trial gave evidence.

In rebuttal, Miller's side called Mr. L. J. Sigur, the lawyer who, four years earlier, had drafted Sally Miller's petition for freedom. He confirmed that Mrs. Schuber had come to his office several times and that he had interviewed Sally at Mrs. Schuber's house as well. He said that he had looked to Mrs. Schuber for payment of his fees. Micou then put it to him that, during the initial interviews, Eva had said nothing to him about the marks on Sally Miller's legs. Sigur refused to answer the question, saying that the conversations were a matter of professional confidence between a lawyer and his client. Micou then asked Sigur if it wasn't until after he had suggested to her "the necessity of such proof to support Sally Miller's claim for freedom" that Eva mentioned the existence of the moles. Sigur refused to answer this question as well.

After the closing argument, and just as the jury was about to retire, Upton stood up and asked Buchanan to explain to the jurymen the importance of the law in this case. What had emerged from the Supreme Court in the case of *Salome Miller v. Louis Belmonti* still applied. Even though the jury was considering whether the verdict was tainted by fraud, the law was another thing, and no one could say that the principle espoused by the Supreme Court was under challenge. The jury should be reminded that it must follow what the ultimate authority in this state had said.

Upton handed up a statement of what he thought the judgment meant, and although it must have greatly irritated him, Buchanan, to his credit, read it out. The vital paragraph said:

That on the law of slavery in the case of a person visibly appearing to be a white man, or an Indian, the presumption is that he is free, and it is necessary for his adversity to show that he is a slave.

After the judge had finished reading this out, there was a long silence. It was late in the day and only three people remained in the public gallery: John Fitz Miller on one side of the room, and on the other, Salomé Müller, with her sole remaining supporter, Eva Schuber. Upton glanced across at the jury box—and saw that every one of the jurymen was looking directly at Salomé. Upton knew that Salomé's only hope of freedom lay with the jury, regardless of the evidence, refusing to condemn a white-looking woman to slavery. Several of the jurymen were frowning in concern, as if not quite sure what to do. Salomé looked anxiously back at them. Upton's hopes rose. For the first time in weeks, he felt that they might have a chance.

Buchanan broke the moment by ordering the jury to leave the courtroom. They should follow the clerk to a place where they could retire to consider their verdict.

Hours passed and it became dark. In quietness, the lawyers, Miller and the two women waited. There was nothing left to say to one another.

After several hours, Buchanan returned to the bench and the jurymen filed in, not to deliver a verdict but to say that they couldn't agree. Buchanan told the jury to give the discussions more time. He knew it

NULLITY

was difficult and that the details were complex, and much of the evidence conflicted, but they should debate it further and come to a view on what was right. The foreman said it was not that they didn't understand the evidence; they were just never going to reach a unanimous verdict. Buchanan, after urging them to try harder, sent them back to the jury room. They were there late into the night.

The next day, January 7, 1848, the Daily Picayune reported:

THE SALLY MILLER CASE.—The jury in this famous case, which has excited so much interest in the community, was yesterday discharged, not being able to agree. They stood eleven for giving her freedom and one against it. The case will now have to be gone through with again.

It was the worst result for everyone. Miller left the court a devastated man. He had looked forward to his complete vindication by a jury of white Southern gentlemen. Instead, he faced a retrial! How could the jury not see the truth? Surely he had demonstrated that Salomé Müller was a fake? The longer the controversy dragged on, the more his reputation would be tarnished. Eventually, no matter what the outcome, the stain on his character would remain forever. For Eva Schuber it meant more delay, more expense, and more uncertainty. A retrial! All Salomé Müller prayed for was the day when she would be free to recover her children and lead a normal life. This now seemed as far away as ever. Wearily, Upton walked back to his office. He felt as if he was entrapped in litigation without end. Miller would never give up, nor would Eva Schuber, and nor would Salomé Müller. He was locked into yet another round.

There was, however, a solution: a dangerous, unpredictable solution, it was true, but still a solution. Although the jury had been discharged, the trial wasn't quite over, for it was possible for the parties to ask Buchanan to review the facts and make the decision the twelve men couldn't make. There was never any doubt that Miller and his legal team would agree—after all, Buchanan had already ruled once in their favor. All the risks lay with Salomé Müller, but in Upton's mind the alternative was too horrid to contemplate. It would mean months of delay and another trial with the uncertainty of another jury

decision. And then, it had to be faced that no matter what the verdict was, one side or the other would appeal. Thus, as Upton reasoned it through, they might as well let Buchanan decide. If, as he expected, Buchanan returned Salomé Müller to slavery, she could immediately appeal to the Supreme Court.

It wasn't until three and a half months later that both sides agreed to submit the matter to Buchanan. He handed down his judgment on May 17, 1848. To the astonishment of everyone, he ruled that the allegations in Miller's nullity petition had "not been satisfactorily made out." His judgment was only a few lines in length. Presumably, Buchanan thought that because he was performing the role of a jury, and juries never gave reasons, nor should he. With that, Buchanan's part in the story of Salomé Müller ended. Miller had lost and she remained free. But this was litigation that wouldn't lie down, and on the very day of Buchanan's decision, Miller's counsel sought and obtained leave to appeal to the Supreme Court.

The appeal was heard one year later, in May 1849, at a time when the citizens of New Orleans were more concerned that their whole city would be washed away by the Mississippi River. Heavy rains hundreds of miles to the north had raised the river to the highest level seen in two decades, and on the afternoon of May 3, seventeen miles upstream of the city, the levee burst. A thundering torrent a hundred feet wide burst into the plantation of Pierre Sauvé and within hours his estate was inundated. In the following days, water began to advance down roads toward the metropolis. Throughout May, engineers sunk wooden piles into the breach, but the river, seemingly intent on forming a new course to the Gulf through New Orleans itself, proved too strong. Relentlessly, its muddy waters flowed toward the city and by May 15, parts of Rampart Street, at the back of the French Quarter, were underwater.

Amid this crisis, a few blocks away from where water was lapping in suburban streets, the Supreme Court, sitting dry in the Cabildo, began to hear the appeal brought by John Fitz Miller against the judgment of Buchanan. It was Miller's last chance to clear his name, and for that he turned to his old savior, John Randolph Grymes.

NULLITY

Grymes and Miller had reason to approach the appeal with optimism. With the assistance of lawyers Micou and Claiborne, they had written a lengthy brief and had a printer produce it in a booklet of thirty pages, ready to hand up to the judges. The story of the quite separate existences of Bridget Wilson and Salomé Müller was set out in detail and with proof. Everything was there: a summary of the testimony from the three earlier cases and reference to all the documents. Taken together it was a convincing demonstration that the slave from Georgia couldn't possibly be the immigrant from Alsace.

Nor would they have to face any of the judges who had heard the appeal last time. The Supreme Court of Chief Judge Martin no longer existed. In 1845 the Louisiana State Constitutional Convention had in effect decided that if Martin was determined to sit on forever, the only thing to do was to get rid of the court and start another one without him. Accordingly, in March 1846, one Supreme Court was abolished and another created in its place.* Not one of the five judges on the old court was reappointed. A new bench awaited the appellants.

But the Supreme Court of Louisiana showed no wish to entangle itself in the Salomé Müller controversy. Grymes's arguments and his well-reasoned proofs were not even considered. Miller was knocked out on a technicality. It had to be remembered, said the court, that Miller wasn't originally part of this action. Belmonti was the real defendant and he appeared to have acquiesced to Buchanan's judgment. Miller, although a warrantor, hadn't refunded the price of the slave to Belmonti, and therefore he had no legal capacity to challenge the judgment. The appeal was dismissed.

At least in the law reports, the last word went to Miller. The judgment concluded:

We may at the same time state, without impropriety, that we have carefully perused the new evidence discovered by him; that

^{*} On March 18, 1846, the day following his eighty-fourth birthday, Martin completed his term as chief judge of the old Supreme Court, but as a mark of his displeasure at being swept from office, he refused to appear on the bench. The new court, presiding in the same room in the Cabildo as the old, commenced on March 19, 1846. Without the inspiration of the law to keep him alive, Martin faltered and he died eight months later.

it stands in the record unimpeached, and is in direct conflict with that adduced by the defendant in the former suit to prove her birth and condition. If it can be true that the defendant is of German extraction, we consider the plaintiff as exonerated from all knowledge of that fact.¹⁵⁰

Not that Miller gave up without a struggle. He directed his counsel to petition the Supreme Court for a new trial on the grounds that the decision it had handed down a few days earlier was wrong. Never was there a more forlorn lawsuit. It was contemptuously brushed aside.

This was the end of the matter. Salomé Müller was free and there would be no further attempts to enslave her.

It was an event hardly noticed by the people of New Orleans. The fate of Miller's slave was no longer of interest. The news of the day was that the breach in the levee had been repaired. The city was safe. During the following weeks, the water receded, leaving the streets covered in inches of mud.

SEVENIBEN

THE WOMAN WHO REMEMBERED NOTHING

If she be not, then nobody has told who she is.

Judge Bullard, in Sally Miller v. Louis Belmonti (1845)¹⁵¹

ohn Fitz Miller lived until 1857, thriving on the hatred and anger he felt toward Salomé Müller and those who had supported her. He died on his beloved Orange Island, New Iberia, having fended off to the end the persistent attempts by his creditors to wrestle it from him. He was aged seventy-seven. After his death, there was yet another attempt to seize his assets, but the Louisiana Supreme Court, in an opinion that became an authority much quoted in bankruptcy law, ruled that his considerable estate was now out of reach.¹⁵²

Miller may have appreciated the irony that the only favorable decision he ever received from the judges of the court he so detested was after his death—but then perhaps not, because a consequence was to hand his money to Nathan Wheeler, someone he detested even more.

Roselius continued to practice law in New Orleans for another thirty years, while making time to lecture to students at the University of Louisiana, a role he performed for two decades, eventually being appointed a professor. He was one of the few voices raised against ceding from the Union at the State Convention that plunged Louisiana into the Civil War. After Union forces took the city, he was regarded by many as a traitor. He was offered the position of chief justice of the state twice, once by General Shepley during Occupation

and once by Governor Wells during Reconstruction. He refused it both times, citing the failure to guarantee him judicial independence. He died in his sleep, with his affairs in order, in 1873 at the age of seventy-one. On the day of his death, he had been due to appear in court in the morning and to deliver a lecture to his students at the university in the afternoon.

Buchanan wrote judgments reflecting public prejudice that made him seem wise—so wise, indeed, that he was elected by popular vote to the Supreme Court in 1853. There he appeared even wiser by writing judgments that bore heavily on black people.¹⁵³ He sat until the Civil War came to the city in April 1862.

The notoriety of the Sally Miller case did little to advance Wheelock S. Upton's career, as in the eyes of many it marked him as a fool and an abolitionist. His practice suffered for it. He survived, if not particularly prospering, as a lawyer until his death, at age fifty, in Carrollton, a suburb of New Orleans, in 1860.

John Randolph Grymes continued his colorful career at the New Orleans bar. He was counsel for Myra Clark Gaines in the celebrated case involving a disputed inheritance and a lost will, which ran for almost fifty years. Grymes died well before its completion, in New Orleans in 1854, aged sixty-eight.

Litigation over the identity of Sally Miller had consumed six years of the lives of Francis and Eva Schuber. Even when it was over, it continued to weigh upon them, aware, as they were, that many derided them as being the naive victims of an ambitious slave. In the 1850s they moved to Panama, where an elite society, made wealthy by sugar, tobacco, and coffee, was as prosperous as any in the Gulf states. There they disappeared from the sight of history.

John Lawson Lewis, the man who felt compelled to tell the truth, was elected mayor of New Orleans in 1854. During the Civil War, he was a major general, commanding the First Division of the Louisiana militia. He survived the war, to die in 1886. The obituary writer of the *Monroe Bulletin* wrote of him:

The close of the war saw the gallant old General stripped of the wealth he had amassed during his busy and useful life; but he

THE WOMAN WHO REMEMBERED NOTHING

ever remained the same courtly, genial gentleman he had always been, a man among men, ever generous, brave, hospitable and typifying in his own person the high qualities of the ancient Southern chevalier.¹⁵⁴

What happened to Salomé Müller? Cable's version, relying on what he was told by members of the German community forty years after the event, was that she married John Given, a riverboat pilot. "As might readily be supposed," added Cable, "this alliance was only another misfortune to Salomé, and the pair separated." He wrote that Salomé then went to California. Her cousin, Henry Schuber, told Cable that he had seen her in Sacramento City in 1855, "living at last a respectable and comfortable life." Deiler, relying on similar sources, said she married a white man named Frederick King. Deiler agreed with Cable that she went to live in California. 155

According to Cable, "Salomé being free, her sons were, by law, free also." They went to Tennessee and Kentucky and became "stable-boys to famous horses, and disappeared." Cable quoted no authority for this belief, and it is difficult to believe. It wasn't likely that Miller would release Salomé's children; to the contrary, Miller would have relished a freedom petition from the children, since it would have given him yet another opportunity to have battled their mother in the courts. Since Lafayette died in about 1839, presumably Cable was referring to Madison and Charles. Cable seemed to be unaware of the existence of Adeline. When Salomé fled to the Schuber home, she left her son Charles behind in Belmonti's cabaret and seemed happy to leave him there to be brought up by the man who was probably his father. The last time Madison and Adeline were mentioned in court documents was Upton's ill-fated writ of habeas corpus, which was adjourned off, never to return. It is more likely that all of Salomé Müller's children remained as slaves, owned by either Belmonti or Miller.

Who, then, was she?

She was Salomé Müller; she was Bridget Wilson; she was Mary Miller; she was Sally Miller; she was Sally Brigger; she was Polly

Moore; she was Sally Hamilton. She was born on an unknown date; she was born in 1809; she was born in 1813; she was born in 1815. She was raised in Tatnall County, Georgia; she was raised in Langensoultzbach, Alsace. She was a mulatto; she was part Amerindian; she was pure German; she was yellow; she was white. She was a redemptioner and the servant of Grayson, Thomasson, and Gleason. She was a slave and had six owners: Wilson, Rigdon, Thomas, Williams, Miller, Canby, and Belmonti. She never married and had four slave children from four men. She was married, raised two children, and died in 1842 in the arms of her husband, Alexis Hamilton, on a farm on the Ouachita River. She went to California in 1849 and lived happily ever after.

The tale of the Lost German Slave Girl has been a curiosity of Louisiana's history for the past century and a half, and its telling has usually been adapted to suit the writer's particular ideological purpose. The story was first used by abolitionist to warn that slavery had so brutalized the South that even white women were at risk of being taken into bondage. During the 1890s, in Cable's hands, it became a melodrama, with Salomé Müller as the heroine, Upton and Roselius as the gallants, and John Fitz Miller playing the role of the dastardly villain. About the same time, Deiler used the story to show how the German community had rallied to help one of its own. In 1939, a Louisiana historian, John Smith Kendall, after describing the events leading up to the first Supreme Court decision, concluded that "the people of New Orleans in those days, even the slave-holding class, seemed to have been a very humane and justice-loving people, at least as far as concerned the theory of the law, whatever may have been the practice." ¹⁵⁶

Historians writing after Cable and Deiler have uncritically adopted the formulae laid down by them—that Salomé Müller's story is that of a white woman taken in slavery who overcame tremendous obstacles to eventually be released. Cable claimed to have read the court files—if he did, he was guilty of the most disgraceful suppression of information and distortion of the facts. The considerable and persuasive evidence that John Fitz Miller assembled to show that she was an imposter was either disparaged or ignored. Even worse, both he and Deiler ended the tale in 1845 after the Supreme Court victory, with Salomé Müller and her lawyers triumphing over Miller.

THE WOMAN WHO REMEMBERED NOTHING

Cable was a writer with an international following, adept at extracting all he could from Louisiana's exotic and mysterious past. His aim was to write stories that would sell—and the struggle of a German woman escaping from slavery was a formula for a surefire success. He knew his market, and it was predominantly white. He knew that his audience wouldn't want to read about a mulatto who had fooled white people, her own lawyers, and, ultimately, the highest court in the state. So he constructed the plot to suit his readers' prejudices and ignored anything to the contrary.

Yet, if he had been fair about the material on the court files, he could have written about a quite different heroine. He could have written about an illiterate slave woman named Bridget Wilson, who with incredible perseverance, bravery, and guile conducted a lonely six-year struggle to be free. And she succeeded!

If this is what Bridget Wilson did (and I believe it is so), then the artfulness with which she pursued her goal of freedom was simply astonishing. Not once did she say she was of German descent; she left that to her supporters. Not once did she come forward with scraps of information about her childhood, although these could have easily been gained from the Schubers. Not once did she recall events before living at Miller's sawmill; it was for others to discover her past. She didn't falter. Her constant goal was freedom—for herself and for her children. She seized the one chance of liberty that was ever likely to come her way, and she hung on to that chance with a tenacity I could only marvel at. She is a symbol of the human spirit and of the many, many slaves who never accepted their bondage.

This is who Sally Miller was. She was Bridget Wilson, the slave.

In these endnotes:

Cable refers to: George W. Cable, "Salome Müller, the White Slave," in *Strange True Stories of Louisiana*, Charles Scribner's, New York, 1890.

Deiler refers to: J. Hanno Deiler, "The System of Redemption in the State of Louisiana," *Louisiana Historical Quarterly*, vol. 12, 1929.

Docket 1114 refers to: File of *Miller v. Miller et al.*, Docket 1114, Supreme Court of Louisiana Collection, Earl K. Long Library, University of New Orleans. The judgment appears in (1849 La) 4 La An 354.

Docket 5623 refers to: File of Sally Miller v. Louis Belmonti and John Miller (called in warranty). Docket 5623, Supreme Court of Louisiana Collection, Earl K. Long Library, University of New Orleans. The judgment appears in (1845 La) 11 Rob. 339.

Miller's pamphlet refers to: John F. Miller, A Refutation of the Slander and False-hoods Contained in a Pamphlet Entitled Sally Miller, held in the Harvard University Library. It is also reproduced in Paul Finkelman (ed.), Free Blacks, Slaves, and Slaveowners in the Civil and Criminal Courts, series VI, vol. 2, Garland Publishing Inc., New York, 1988.

Upton's pamphlet refers to: *Sally Miller,* a pamphlet held by the Williams Research Center, New Orleans, and the New York Public Library.

Upton new trial refers to: *Sally Muller v. Louis Belmonti and John F. Miller,* Notes for a rule on a new trial, held by the Williams Research Center, New Orleans, and the New York Public Library.

Author's Note

- 1 Howes v. Steamer Red Chief (1860 La) 15 La An 322-3.
- 2 11 Rob. 339.
- 3 Gentry v. McMinnis (1835 Ky) 3 Dana 382, 387-8.

1 Mary Miller

- 4 Hervy v. Armstrong (1854 Ark) 15 Ark 162, 168.
- The history of Deiler and Cable's publications is found in Louis Voss, "Sally Mueller, the German Slave," *Louisiana Historical Quarterly*, vol. 12, 1929, p. 447. Notes of evidence of the discovery of Mary appear in Docket 1114. See also Docket 5623. For reasons unclear to me, Cable called the woman who "discovered" Salomé Müller, Madame *Karl*, while all other sources, including the notes of the court proceedings, refer to her as Madame Carl. Her full name was Madame Carl Rouff.
- Upton's pamphlet, p. 4. Its author, Wheelock S. Upton—about whom a lot will be told as this book proceeds—published it anonymously in 1845.

2 The Children of Slaves

- 7 Charles Mackay, *Life and Liberty in America in 1857–8*, Johnson Reprint Corporation, New York, 1971, pp. 317–18.
- 8 L. Maria Child, *Patriarchal Institutions*, American Anti-slavery Society, New York, 1860, pp. 25–8.
- 9 Bryan v. Walton (1864 Ga) 33 Ga 11, 24.
- 10 Annie Lee West Stahl, "The Free Negro in Ante-Bellum Louisiana," Louisiana Historical Quarterly, vol. 25, 1942, p. 301.
- 11 Maria v. Surbaugh (1824 Va) 2 Rand. 228.
- 12 Johnson v. Johnson (1848 Ky) 8 B. Mon. 470.
- 13 Thomas R. R. Cobb, An Inquiry into the Law of Negro Slavery in the United States of America, with an Historical Sketch of Slavery, Negro University Press, New York, 1968 [1858], article 70.
- 14 Frazier v. Spear (1811 Ky) 2 Bibb 385, 386.
- 15 Bentley v. Cleaveland (1853 Ala) 22 Ala 814, 818.
- 16 Fable v. Brown (1835 SC) 2 Hill Eq. 378.
- 17 Fulton v. Shaw (1827 Va) 4 Randolph 597, 599.
- 18 Marbletown v. Kingston (1822 NY) 20 Johnson 1. It may surprise that a case concerning slavery was decided in New York as late as 1822. The explanation is that although slavery was abolished in the state in 1799, it was by a phased process, and some who were born before 1799 remained in servitude.
- 19 Mayho v. Sears (1842 NC) 3 Iredell 224, 232.
- 20 Article 196 of the Civil Code of the State of Louisiana.

3 The Year Without Summer

21 Friedrich Gerstäcker, "Nach Americka!," quoted in Karl J. R. Arndt (ed.), "A Bavarian's Journey to New Orleans in 1853–1854," *Louisiana Historical Quarterly*, vol. 23, 1940, p. 485.

- An alarmed King of Württemberg asked an official, Friedrich List, to report to him on why people wanted to leave his empire for America. List asked the immigrants and received no shortage of reasons: they were starving, work was scarce, land taxes were too high, rents were too high, and municipal officials were both arrogant and corrupt. Günter Motlmann (ed.), Aufbruch nach Amerika, Metzler, Stuttgart, 1989, pp. 181–6.
- 23 C. Edward Skeen, in "The Year Without a Summer," Journal of the Early Republic, vol. 1, 1981, p. 51, discussed this and other theories for the global chill. See also: Henry Stommel and Elizabeth Stommel, "The Year Without a Summer," Scientific American, vol. 240, June 1979, p. 134; and Fred M. Bullard, Volcanoes of the Earth, University of Queensland Press, St. Lucia, 1977.
- 24 Quoted in Deiler, p. 438.
- Marco H. D. van Leeuwen, "Surviving with a Little Help: The Importance of Charity to the Poor of Amsterdam," *Social History,* vol. 18, 1993, pp. 319, 329.
- The account of this voyage is derived from Cable, pp. 151–2, and Deiler. Cable suggested that the name of the ship was the *Captain Grone*, but I believe he was mistaken. The confusion arises because Madame Hemm, in giving evidence, said that the name of the captain of her ship was Captain Grone.
- 27 Reproduced in Deiler, pp. 428–9.
- The incident of people jumping overboard is mentioned by Louis Voss in "Sally Mueller, the German Slave," *Louisiana Historical Quarterly*, vol. 12, 1929, p. 450. Eva Schuber gave evidence about nursing the children of Daniel Müller in Docket 5623. Cable, who interviewed Ms Thomas, wrote of the vial of water saving her father's life (p. 152).
- 29 The lawyer was Wheelock S. Upton, who appeared in all the Sally Miller cases. His words are taken from the *National Anti-Slavery Standard* of July 31, 1845.
- 30 Upton's pamphlet, p. 1; Cable, p. 156; Deiler, p. 440.
- 31 Upton's pamphlet, p. 1; Deiler, p. 440; Madame Hemm's evidence appears in Docket 5623.
- 32 The *Louisiana Gazette* of March 7, 1818, refers to Krahnstover's ship as the *Tufrou Johanna*, but this appears to be a misprint. See Deiler, p. 440.
- 33 Johannes Ulrich Buechler, Land and Sea Journeys of a Citizen of the Canton of St. Gall to North America and West Indies, quoted in an addenda in Louis Voss, "The System of Redemption in the State of Louisiana," Louisiana Historical Quarterly, vol. 12, 1929, pp. 445–6.
- 34 Henry Bradshaw Fearon, *Sketches of America*, Longman, London, 1819, pp. 148–50.

- 35 Refer to the Civil Code of the State of Louisiana. In respect to the ability of a master to inflict punishment, a minor reform occurred in 1825 when the words "provided he does not make use of a whip" were added. See also Deiler, p. 435.
- 36 Quoted in Deiler, pp. 436–7.
- 37 Louisiana Gazette, March 14, 1818.
- 38 Acts Passed at the Second Session of the Third Legislature of the State of Louisiana, J.C. De St. Romes, State Printer, New Orleans, 1818.

4 New Orleans

- Quoted in Eric L. McKitrick (ed.), *Slavery Defended: The Views of the Old South*, Prentice-Hall, Englewood Cliffs, NJ, 1963, p. 118.
- Originally, most of the refugees from Saint-Domingue fled to Spanish Cuba, but they were expelled when Napoleon invaded Spain and arrived in New Orleans soon after the Louisiana Purchase in 1803.
- 41 Quoted in Henry Bradshaw Fearon, *Sketches of America*, Longman, London, 1819, pp. 274–5.
- 42 Edward Sullivan, *Rambles and Scrambles in North and South America*, Richard Bentley, London, 1852, pp. 223–5.
- 43 Charles Sealsfield (Karl Anton Postl), *The United States of North America as They Are,* Johnson Reprint Corporation, New York, 1970 [1828], pp. 170–1. Postl was born in Moravia and arrived in New Orleans in 1823. Upon becoming a journalist, he adopted the persona of Charles Sealsfield, a native of Pennsylvania, and adopted American attitudes, which he then explained to readers in Germany, England, and America itself.
- 44 James Silk Buckingham, "The Slave States of America, London and Paris," 1842, quoted in Annie Lee West Stahl, "The Free Negro in Ante-Bellum Louisiana," *Louisiana Historical Quarterly*, vol. 25, 1942, pp. 301, 306.
- 45 A table showing the population of New Orleans from 1769 to 1860, broken down into various racial groups, appears in Caryn Cossé Bell, "The New American Racial Order," *The Louisiana Purchase Bicentennial Series in Louisiana History*, vol. XV, University of Southwestern Louisiana, Lafayette, 2000, p. 18.
- 46 Section 40 of the Black Code.
- 47 Article 35 of the Civil Code; Wheelock S. Upton and Needler R. Jennings, The Civil Code of the State of Louisiana with Annotations, E. Johns & Co., New Orleans, 1838.
- 48 Mitchell v. Gregory (1809 Ky) 1 Bibb 449.
- 49 Jones v. Mason (1827 Va) 5 Randolph 577, 593.
- 50 Witherington v. Williams (1798 NC) Taylor NC 134.

- John S. Kendall, "Shadow Over the City," *Louisiana Historical Quarterly*, vol. 22, 1939, pp. 148, 154.
- 52 Thomas v. Davis (1846 Ky) 7 B. Mon. 227.
- 53 Witherington v. Williams (1798 NC) Taylor NC 134.
- 54 Berry v. Hamilton (1868 Ky) 1 Bush 361.
- 55 Such a ceremony is described in *Carter v. Buchannon* (1847 Ga) 3 Ga 513, 514.
- 56 Arnold v. Arnold (1833 NC) 2 Dev. Eq. 467.
- 57 Banks Adm'r v. Marksberry (1823 Ky) 13 Ky (3 Litt) 275.
- 58 Nelson v. Nelson (1849 NC) 6 Ired. Eq. 409.
- 59 Sheppards v. Turpin (1847 Va) 3 Grattan 373, 379.
- 60 Ewing v. Gist (1842 Ky) 2 B. Mon. 465. In another case, witnesses said that a slave named Mary wasn't very saleable because she was too white: Munn v. Perkins (1843 Miss) 1 S. and M. 412, 415.
- 61 John S. Kendall, "Shadow Over the City," *Louisiana Historical Quarterly*, vol. 22, 1939, p. 150.
- 62 Charles Sealsfield (Karl Anton Postl), *The United States of North America* as *They Are*, Johnson Reprint Corporation, New York, 1970 [1828], p. 175.

5 Sally Miller

- 63 Thornton's Case (1849 Ill) 11 Ill 332.
- 64 Solomon Northup, *Twelve Years a Slave*, Louisiana State University Press, Baton Rouge, 1968 [1853], pp. 51–2.
- 65 Cable, p. 176; Miller's pamphlet, p. 22; Docket 5623.
- In the handful of days that the French ruled Louisiana in 1803 before transferring it to the United States, they attempted to amend the slave laws, but these efforts were ignored.
- 67 Julienne (f.w.c.) v. Touriac (1858 La) 13 La An 599.

6 John Fitz Miller

Details of Miller's life may be pieced together from the transcript of evidence in Docket 5623. Other details appear in the case of Miller v. His Creditors, Appeal Docket 5661, Supreme Court of Louisiana Collection, Earl K. Long Library, University of New Orleans. A partial history of Miller's financial woes appears in the law report Harvey Beach v. Miller's Testamentary Executors (1860 La) 15 La 601. See also helpful details in Glenn R. Conrad (ed.), A Dictionary of Louisiana Biography, University of Southwestern Louisiana, Lafayette, 1988; and Glenn R. Conrad, New Iberia: Essays on the Town and Its People, 2nd edn, University of Southwestern Louisiana, Lafayette, 1986.

68 Johnson v. Tompkins (1833) 13 Fed. Cas., 840, 843.

- 69 Miller's pamphlet, pp. 3, 17. Miller's italics appear in the original.
- 70 Miller's pamphlet, p. 3.
- 71 Miller's pamphlet, pp. 16–17.
- 72 Lelen appealed to the Supreme Court, but lost: *Miller v. Lelen* (1841 La) 19 La 331.
- 73 An excellent commentary on Louisiana's economy (from which I derived much assistance) appears in Merl Reed, "Boom or Bust, Louisiana's Economy during 1830," *Louisiana History*, vol. 4, winter 1963, p. 35. A partial history of Miller's financial woes, including his bankruptcy, appears in the law report *Harvey Beach v. Miller's Testamentary Executors* (1860 La) 15 La 601.
- 74 Louisiana Courier, July 2, 1813.

7 Bridget Wilson

- 75 Hudgins v. Wrights (1806 Va) 1 Hen. & M. 134, 140.
- 76 Daily Picayune, May 25, 1844; document entitled "In the Supreme Court John F. Miller Versus Sally Miller et al," held at the Williams Research Center, New Orleans, p. 29; Daily Tropic, June 30, 1845; Upton's pamphlet, pp. 7–8; Miller's pamphlet, p. 14.
- 77 Miller's pamphlet, p. 20.
- 78 Docket 1114. Mrs. Canby, in her statement, claimed that Williams did return and received three hundred and fifty dollars for Bridget Wilson, less deductions for amounts owing, including the doctor's and nurse's fees. No other witness, including her son, mentioned this, and Wheelock S. Upton stated that "there is no evidence of his [Williams] ever demanded or received any money in addition to the one hundred dollars said to have been advanced . . ." Another indication that Mrs. Canby's memory was faulty is that the document recording her purchase of Bridget makes no mention of Miller being paid. Upton's pamphlet, pp. 9–10.
- Article 182 of the Civil Code of the State of Louisiana. An argument admired in lawyerly circles said that since slaves didn't have the right to contract, and marriage was a form of civil contract, it followed that slaves couldn't marry. The Louisiana Supreme Court adopted this argument in 1819, saying that with the consent of their masters slaves may "contract, or connect" with each other, but such acts "cannot produce any civil effect, because slaves are deprived of all civil rights": *Girod v. Lewis* (1819 La) 6 Martin 559.
- 80 Thomas R. R. Cobb, An Inquiry into the Law of Negro Slavery in the United States of America, with an Historical Sketch of Slavery, Negro University Press, New York, 1968 [1858], p. 246.

- 81 Howard v. Howard (1858 NC) 51 NC 237, 238-9.
- 82 State v. Samuel (1836 NC) 2 Dev. and Bat. 177.
- 83 Frances Anne Kemble, *Journal of a Residence on a Georgian Plantation in 1838–9*, New York, 1961, p. 270, appearing in Peter W. Bardaglio, "Rape and the Law in the Old South," *Journal of Southern History*, vol. 60, no. 4, November 1994, p. 758.
- 84 Thomas Jefferson, Notes on the State of Virginia, Peden edn, 1955, p. 163.
- Helen Tunnicliff Catterall, *Judicial Cases Concerning American Slavery and the Negro*, Negro University Press, New York, 1968 [1926].
- 86 George v. State (1859 Miss) 37 Miss 316.
- 87 Acts of the Legislature, 1806, article 7. *Vail v. Bird* (1851 La) 6 La An 223–4.
- 88 Miller pamphlet, p. 22.
- 89 Quoted in B.A. Botkin (ed.), *Lay My Burden Down, a Folk History of Slavery*, Phoenix Books, University of Chicago Press, Chicago, 1945, p. 120.
- Quoted in John S. Kendall, "New Orleans Peculiar Institution," Louisiana Historical Quarterly, vol. 23, 1940, pp. 874–5. Generally on the work of slaves on sugar plantations, see Leslie Howard Owens, This Species of Property, Slave Life and Culture in the Old South, Oxford University Press, Oxford, 1977, pp. 21–2, and Solomon Northup, Twelve Years a Slave, Louisiana State University Press, Baton Rouge, 1968, pp. 159–62.
- 91 Docket 5623.
- 92 The story of Belmonti's quarrelsome slave and his attempts to have Miller take her back come from an affidavit by Peter Curran reproduced in Upton new trial, p. 10.

8 Salomé Müller

- 93 Dred Scott v. Sandford (60 US) 19 Howard 393, 409.
- 94 Docket 5623.
- 95 Herbert Asbury, *The French Quarter*, Pocket Books, New York, 1966, p. 117.
- 96 Charles Gayarré, "The New Orleans Bench and Bar in 1823," first appearing in *Harper's Magazine* in 1888, and was reproduced in Thomas M'Caleb (ed.), *The Louisiana Book*, R. F. Straughan, New Orleans, 1894, pp. 54, 63.

9 The First District Judicial Court of New Orleans

- 97 A. Oakey Hall, *The Manhattaner in New Orleans*, J. S. Redfield, New York, 1851, pp. 78–9.
- 98 Daily Picayune, May 25, 1844.
- 99 The clerk of courts in his notes had this name as Grandsteiner. But

he wasn't consistent—elsewhere it was Grandsteen or Grandsteever. It should be Krahstover, which is the name that appeared in the advertisements in the *Louisiana Gazette* of March 7–10, 1818. In fact Captain Bleeker was skipper of the *Juffer Johanna*, while Krahnstover was in overall command of the three vessels.

- 100 Miller's pamphlet, p. 7.
- 101 Gary v. Stevenson (1858 Ark) 19 Ark 580, 586.
- 102 Daniel v. Guy (1857 Ark) 19 Ark 121, 127.
- 103 Daniel v. Guy (1861 Ark) 23 Ark 50, 52. The emphasis on negro foot is the court's. See also Gaines v. Ann (Tex 1856) 17 Tex 211.

10 The Defense

- 104 Phebe v. Quillin (1860 Ark) 21 Ark 490, 500.
- 105 As late as 1817 the Supreme Court of Louisiana held that American Indians could be held as slaves: Seville v. Chretien (1817 La) 5 Mart. La 275. See also Ulzere v. Poeyfarré (1820 La) 8 Mart. La 155.
- 106 A copy of the affidavit and the extract from the Register of Baptism appears in Docket 5623.
- 107 Miller's pamphlet, p. 10.
- 108 Upton new trial. The italics are Upton's.
- 109 Docket 5623.
- 110 Docket 5623.
- 111 Although most of the final addresses of counsel haven't survived, a good idea of what they said can be gauged by the pamphlets the parties later wrote about the case, appeal papers, and reports in the press. The portion that is reproduced appears in Upton new trial.

11 Judgment

- 112 Bryan v. Walton (1853 Ga) 14 Ga 185, 205.
- 113 Docket 5623.
- 114 Articles 557-61 of the Code of Practice.
- 115 Upton new trial.
- 116 Upton new trial.
- 117 Docket 5623 and Upton new trial.
- 118 Upton new trial.

12 The Appeal

- 119 State v. Mann (1829 NC) 2 Dev. 263, 267.
- 120 Mrs. Canby's comment appears in Miller's pamphlet, p. 22.

- Much of the material on Martin comes from Henry A. Bullard, "A Discourse on the Life and Character of the Honorable François-Xavier Martin," in Judith Kelleher Schafer and Warren M. Billings (eds.), The Louisiana Purchase Bicentennial Series in Louisiana History, vol. XIII, University of Southwestern Louisiana, Lafayette, 1997, pp. 691–707. See also: Appleton's Cyclopaedia of American Biography, New York, 1888; Glenn R. Conrad (ed.), A Dictionary of Louisiana Biography, University of Southwestern Louisiana, Lafayette, 1988; and Henry Rightor, Standard History of New Orleans, Louisiana, The Lewis Publishing Co., Chicago, 1900, p. 96.
- 122 Louisiana Law Journal, 1842, vol. 1, p. 157.
- 123 Adelle v. Beauregard (1810 La) 1 Mart. (O.S.) 183, 184.
- 124 "Slavery," wrote a Mississippi Appeals judge in 1818, "is condemned by reason and laws of nature" (Harry v. Decker & Hopkins [1818 Miss] Walk. Miss 36, 42). A judge of the Virginian Supreme Court in 1828 referred to "the spirit of the Laws of all civilized nations which favor liberty" (Isaac v. West's Ex'r [1828 Va] 6 Randolph 652, 657). In the same year, a Missouri judge stated, "All men are by the law of nature free" and without some positive declaration of the state should be set at liberty (Marguerite v. Chouteau [1828 Mo] 2 Mo 71, 90).
- 125 Virginia was one of the first states to recant. In 1831 the Court of Appeals said that "all who have examined the earlier cases in our books, must admit, that our judges (from the purest motives, I am sure) did, in favorem libertatis, sometimes relax, rather too much, the rules of law" (Gregory v. Baugh [Va 1831] 2 Leigh 665, 680). In 1860 the Supreme Court of the state of Arkansas wrote, "The question of freedom should be determined like every other question made before the courts, solely upon its legal aspects, without partiality to an applicant for freedom because he may be defenseless, and a member of an inferior race" (Phebe v. Quillin [1860 Ark] 21 Ark 490, 500). In the same year the Supreme Court of North Carolina wrote, "the true principle of our law, in relation to the emancipation of slaves, is, that it permits, but does not favor it" (Myers v. Williams [1860 NC] 5 Jones Eq. 362, 367).
- 126 Marie Louise F.W.C. v. Marot (1835 La) 8 La (O.S.) 667, 669–70. There was a retrial and Josephine was eventually freed: Marie Louise F.W.C. v. Marot (1835 La) 9 La (O.S.) 295.
- 127 Mary v. Morris (1834 La) 7 La 135.

13 A Presumption in Favor of Liberty

128 Henry A. Bullard, "A Discourse on the Life and Character of the Honorable François-Xavier Martin," in Judith Kelleher Schafer and Warren M.

- Billings (eds.), *The Louisiana Purchase Bicentennial Series in Louisiana History*, vol. XIII, University of Southwestern Louisiana, Lafayette, 1997, p. 704.
- 129 Sally Miller v. Louis Belmonti (1845 La) 11 Rob. 339.
- 130 Sally Miller v. Louis Belmonti (1845 La) 11 Rob. 339, 343.
- 131 Quoted in Louis Voss, "Sally Mueller, the German Slave," *Louisiana Historical Quarterly*, vol. 12, 1929, pp. 447, 459–60.
- 132 Reports of the celebrations for Sally Miller appear in the *Daily Tropic*, June 30, 1845, the *National Anti-Slavery Standard*, July 31, 1845, and the *Jeffersonian Republic*, June 24, 1845.

14 The Children of Salomé Müller

- 133 Müller v. Miller and Canby, general case 1403 (entry 121, location A1610136), the National Archives—Southwest Region (Fort Worth, TX).
- 134 Müller v. Miller and Canby, general case 1403 (entry 121, location A1610136), the National Archives—Southwest Region (Fort Worth, TX).

15 Polly Moore

- 135 Miller's pamphlet, p. 16.
- 136 Miller's pamphlet, p. 19.
- 137 Miller's pamphlet, p. 3.
- 138 Miller's pamphlet, pp. 6, 12, 15-16.
- 139 Miller's pamphlet, p. 18.
- 140 Miller's pamphlet, p. 17.
- 141 Daily Picayune, June 22, 1845; Daily Tropic, June 23, 1845.
- 142 The depositions are contained in *Müller v. Miller and Canby,* general case 1403 (entry 121, location A1610136), the National Archives—Southwest Region (Fort Worth, TX).
- 143 Docket 1114.

16 Nullity

- 144 The evidence of Brown and Coward appears in Müller v. Miller and Canby, general case 1403 (entry 121, location A1610136), the National Archives—Southwest Region (Fort Worth, TX).
- 145 Docket 1114.
- 146 Article 608 of the Code of Practice.
- 147 The sheriff's notes are to be found on the papers associated with the subsequent appeal. See Docket 1114.

- 148 Docket 1114.
- 149 Docket 1114.
- 150 Miller v. Miller et al. (1849 La) 4 La An 354.

17 The Woman Who Remembered Nothing

- 151 Sally Miller v. Louis Belmont (1845 La) 11 La 339.
- 152 Harvey Breach v. Miller's Testamentary Executors (1860 La) 15 La An 601.
- 153 See Judith Kelleher Schafer and Warren M. Billings (eds.), *The Louisiana Purchase Bicentennial Series in Louisiana History*, vol. XIII, University of Southwestern Louisiana, Lafayette, 1997, pp. 416, 418, 460.
- 154 Monroe Bulletin, May 19, 1886.
- 155 Cable, p. 191; J. Hanno Deiler is quoted in Louis Voss, "Sally Mueller, the German Slave," *Louisiana Historical Quarterly*, vol. 12, 1929, pp. 447, 460.
- 156 John S. Kendall, "Shadow Over the City," *Louisiana Historical Quarterly*, vol. 22, 1939, pp. 148, 165. See also Carol Wilson, "Sally Muller, the White Slave," *Louisiana History*, spring 1999, vol. XL, p. 133. Wilson concludes that Sally Miller was "more likely than not" the lost German girl, but it appears the author wasn't aware of the material relating to the trial at the U.S. Circuit Court.